ISBN 978-1-333-02129-0
PIBN 10452903

1 MONTH OF
FREE
READING

at

www.ForgottenBooks.com

By purchasing this book you are eligible for one month membership to ForgottenBooks.com, giving you unlimited access to our entire collection of over 700,000 titles via our web site and mobile apps.

To claim your free month visit:
www.forgottenbooks.com/free452903

LIBRARY EDITION

THE WORKS OF

EDITED BY

E. T. COOK

AND

ALEXANDER WEDDERBURN

LONDON
GEORGE ALLEN, 156, CHARING CROSS ROAD
NEW YORK: LONGMANS, GREEN, AND CO.
1904

LIBRARY EDITION

VOLUME XV

THE ELEMENTS OF DRAWING

THE ELEMENTS OF PERSPECTIVE

AND

THE LAWS OF FÉSOLE

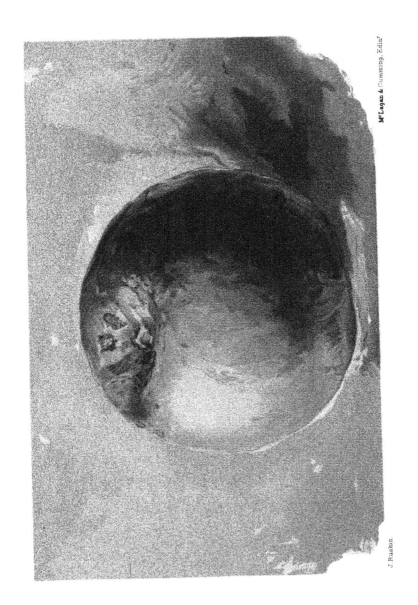

J. Ruskin

BY

JOHN RUSKIN

LONDON
GEORGE ALLEN, 156, CHARING CROSS ROAD
NEW YORK: LONGMANS, GREEN, AND CO.
1904

CONTENTS OF VOLUME XV

LIST OF ILLUSTRATIONS

PLATES

[1] [With the exception of No. II., which was engraved by Henry **Swan,** and No. VII., which was engraved by Mr. Allen from a facsimile of Turner's drawing made by Mr. William Ward. In this edition Plates II., III., IV. and IX. have been reproduced by line process ; the others are printed from the original steels.]

WOODCUTS AND DIAGRAMS

IN "THE ELEMENTS OF DRAWING"

(Drawn and Cut on the Wood by Miss Byfield from Drawings by the Author)

[1] [The above are the pages where the plates themselves will be found. For the author's references to the plates, see also—

For Plate I., pp. 365, 366 | For Plate VII., p. 436
 ,, II., p. 367 | ,, VIII., pp. 477, 479, 480
 ,, III., pp. 385, 387, 389 | ,, IX., pp. 447, 449, 460
 ,, IV., p. 386 | ,, X., pp. 471, 473
 ,, V., pp. 411, 413, 477 | ,, XI., p. 477
 ,, VI., pp. 412, 434, 477 | ,, XII., pp. 478, 479, 480.]

[2] [The later exercises were not numbered by the author; see his note on p. 67, below.]

IN "THE LAWS OF FÉSOLE"

FACSIMILE

INTRODUCTION TO VOL. XV

In this volume we take up the third branch of the work which mainly occupied Ruskin during the years 1856–1860 [1]—namely, the teaching of drawing. In connexion with this work he published in 1857 *The Elements of Drawing*, and in 1859 *The Elements of Perspective*. To those two books are added, in this volume, the revised lessons in drawing, which he entitled *The Laws of Fésole*. This book belongs to a much later date (1877–1878), but is here included on account of its topical connexion with the earlier books.

The Elements of Drawing originated somewhat in the same manner as *Academy Notes*. We have seen (Vol. XIV. p. xx.) how that series of criticisms upon the exhibitions of the year was undertaken as a kind of "circular letter" in answer to requests for Ruskin's opinion and advice about works of current art. He had from a much earlier date been in the habit of giving drawing lessons by letter, as his *Letters to a College Friend* (1842) show; [2] and after the publication of the first volume of *Modern Painters* he was with increasing frequency asked by readers of his books for advice and assistance with regard to the practice of drawing. Such requests came from all sorts and conditions of men and women, from humble students, otherwise unknown to him, and from great ladies or dear friends. Among workmen who sought his aid in this way was Thomas Dixon, the cork-cutter at Sunderland, to whom he afterwards addressed the letters which form the volume entitled *Time and Tide*. Ruskin was at all times ready to give of his best to those in whom he saw a sincere desire to profit by what he might have to bestow. He had

[1] See Vol. XIII. pp. xvii.–xix. ; Vol. XIV. p. xix.
[2] Vol. I. pp. 462–469. See also a long letter, of a similar kind, to Acland, given at pp. 101–104 of J. B. Atlay's *Memoir of Sir Henry Wentworth Acland*, 1903, and reprinted in a later volume of this edition. In this letter, written about 1844, Ruskin remarks: "I know of no book which is a sufficient guide in this study. Most artists learn their rules mechanically, and never trouble themselves about the reason of them."

not always the time to give personal and continuous instruction. In such cases he would put his correspondents in communication with one or other of his assistants—Mr. William Ward or Mr. George Allen—and would himself pay an occasional visit or write a letter of advice and encouragement.[1]

His advice was the more sought when his classes at the Working Men's College began to be talked about. He says of Rossetti, whom he had impressed into the same service, that "he was the only one of our modern painters who taught disciples for love of them."[2] Ruskin's own position in the matter was also unique. He was by this time the acknowledged chief among contemporary writers on art; he was the only critic who had the will — perhaps also the only one who has been competent—to translate his principles into practice, and teach with the pencil and the brush the system which he advocated with the pen. He was appealed to by anxious students and amateurs, as also by official Commissions,[3] as at once a writer and a practical teacher.

It was in order to extend his influence in this direction, and to save his time by printing a " circular letter" to his correspondents, that Ruskin set himself during the winter of 1856–1857 to write *The Elements of Drawing*. The correspondence with a lady, otherwise unknown to him, which is here given in Appendix i. (pp. 489, 490), will show, in one typical instance, the genesis of the book. The publication of it in its turn widened the circle of his pupils. The continued applications which he received for personal advice led to many friendships. At Wallington, where he often stayed with Sir Walter and Pauline, Lady Trevelyan, he gave lessons to Miss Stewart Mackenzie, then about to marry Lord Ashburton.[4] Among other amateurs who set much store by his advice and instructions were Charlotte, Countess Canning, and her sister Louisa, Marchioness of Waterford. "I enclose a nice letter from Lady Waterford," he writes to his father (August 6, 1858); "the sketch of the St. Catherine of which she speaks is one I asked her to do for me of a pet figure of mine at Venice." Ruskin greatly admired the work of both sisters. "I had just got your portfolio back from Clanricarde," writes Lady Stuart de Rothesay (October 5, 1858) to her daughter, Lady Canning, "when Ruskin came

[1] Many details in this connexion will be found in the *Letters to William Ward*, privately issued in 1893 and reprinted in a later volume of this edition.

[2] *Præterita*, iii. ch. i. § 13.

[3] See, for instance, his evidence in Vol. XIII. p. 553.

[4] *Autobiographical Notes of the Life of William Bell Scott*, edited by W. Minto, 1892, vol. ii. p. 12.

to visit Somers. I hardly expected him to appreciate your bold flowers, and only showed him a few specimens, but he was in raptures, and said they were the grandest representations of flowers he had ever seen. He said what a *subtle* use of colour you displayed; it was especially so on a sheet with a sort of trumpet-flower or bignonia, in which there are about two inches in the corner of bougainvillia. He thought that uncommon shade quite marvellous, as well as the orange tone of scarlet in the flower, and the poinsettia perfectly dazzling. He had expended his admiration, I suppose, for when Somers showed his own exhibition, he was captious and said, 'You copy nature too closely! It is the place itself! they are *views*, not *pictures*.'" [1] A few days later (November 3, 1858), Lady Stuart de Rothesay adds: "He begs to be allowed to see some more of your flowers, and he mentions having got Lady Waterford's 'Charity Girl' to look at—'She's stunning!' I told Loo this, and she hates the word so much, she would infinitely have preferred abuse." [2] Abuse, Lady Waterford could never have received from Ruskin; but his admiration for her rare talent was tempered with chastening advice. "I am getting on with a fresco," she writes from Ford Castle (March 21, 1864), "which, thanks to Mr. Ruskin's useful critique, I am making of a much warmer colour"; and again (Sept. 22, 1864), "Ruskin condemned (very justly) my frescoes, and has certainly spirited me up to do better." [3] He was a stimulating, if an exacting critic, and he remained on terms of affectionate friendship with Lady Waterford till her death in 1891.

With the general public *The Elements of Drawing* had an immediate success, which has been steadily sustained. For thirty years, indeed, Ruskin allowed the book to remain out of print—for reasons presently to be stated (see below, p. xxvi.); but during the sixteen years of its currency (1857–1861, 1892–1904) it has gone through sixteen thousands [4] —a considerable circulation for a book of the kind to attain. The reasons of its popularity are not far to seek. It was original in method;

[1] *The Story of Two Noble Lives*, by Augustus J. C. Hare, 1893, vol. ii. p. 478.

[2] *Ibid.*, p. 479. Ruskin's use of the word "stunning" reflects his intercourse with Dante Rossetti, in whose circle "stunning" and "stunner" were the favourite terms of admiration. In a letter to his mother (July 1, 1855) Rossetti wrote : "An astounding event is to come off to-morrow. The Marchioness of Waterford has expressed a wish to Ruskin to see me paint in water-colour, as she says my method is inscrutable to her. She is herself an excellent artist, and would have been really great, I believe, if not born such a swell and such a stunner" (*Dante Gabriel Rossetti : his Family Letters*, 1895, vol. ii. p. 140).

[3] *The Story of Two Noble Lives*, vol. iii. pp. 251, 254.

[4] See the Bibliographical Note below, pp. 5, 6. The remarks given above are exclusive of the indirect circulation of the book through the incorporation of much of it in Mr. Tyrwhitt's *Our Sketching Club*.

it treated a technical matter with rare simplicity of argument; it
illumined details by a constant reference to first principles; and it was
written in a peculiarly apt and graceful style. One of the earliest reviews
of the book expressed a judgment which successive generations of readers
have confirmed : "If all class books were written in the same lucid and
harmonious language, and with the same happy combination of the
useful and agreeable, as may be found in this fascinating volume, the
road to learning would be smoother and more picturesque, and there
would be a far greater number of travellers than at present. It is not
merely to their intellect and judgment that Mr. Ruskin addresses him-
self in attempting to convey information to his readers; he appeals also
to their fancy and affections. He speaks to them in a gentle and endear-
ing tone, as if he had an earnest desire to serve them; and he gives
his advice in language at once so persuasive and so imaginative, that the
student is charmed into wisdom."[1] Among the arts which Ruskin here
employs, to persuade or interest his readers, is one of which he became
increasingly fond—namely, the suggestion of analogies. Sometimes they
are introduced incidentally, with little further object perhaps than to give
point and piquancy to a sentence or an illustration (as, for instance, at
the end of § 42). But more often they are of set purpose, being intended
not merely to arrest the reader's attention and stimulate his thought or
imagination, but also to connect artistic with moral laws, and to suggest
an underlying harmony in the universe (see, for instance, §§ 104, 133, 203,
215). The book is remarkable, too, for its combination of workmanlike
attention to detail with the enunciation of great principles (as, for
instance, in the discussion of composition). Simple and elementary
though it is in some respects, it is yet pre-eminently "a full book." See,
for instance, the wealth of instruction given, as it were, by the way,
and consigned to a footnote, on pp. 27–28, below. The truth that Ruskin
there condenses into the happy phrase—"the innocence of the eye"—
lies at the root of the philosophy of drawing, and may thus be called
elementary, but it has never been so pointedly and so clearly expressed.
 To the student of Ruskin's style *The Elements of Drawing* is of
special interest. Those who examine his style in the light of his
whole literary production will be struck by nothing more than its
admirable flexibility. He wrote about everything, and in all his books,
no doubt, there are some characteristics of his genius which may always
be traced. But he had as many manners as he had audiences; there
were as many notes within his range as there were effects at which to

[1] *The Morning Post*, December 25, 1857.

aim. This is an aspect of Ruskin as a man of letters which is sometimes missed by those who know him perhaps only by one book. An eminent critic has pleaded for "an epoch of a quieter style," and has instanced Ruskin (with Carlyle and Macaulay) among the giants in prose, who have "the rights of giants," but whose splendid excesses are bad examples.[1] But Ruskin, too, had a quiet style. He is a master not only of pomps and diapasons, but also of simplicity and limpid ease. In this simpler style *The Elements of Drawing* is a masterpiece. "The words are now so exact and so illuminous," wrote at the time a critic seldom friendly to the author, "that they fall like lightning to destroy or illumine."[2] Nothing is harder to explain than technicalities of the arts; and nowhere is Ruskin more simple and intelligible.

The simplicity was studied, in the sense that it was carefully attained. The *manuscript* of the book, if anywhere extant, is not known to the editors; but from § 89 onwards the proof-sheets have been available.[3] From § 99 onwards these sheets are double—one set being corrected by Ruskin himself, the other by his old friend and mentor in these matters, W. H. Harrison.[4] An examination of the sheets shows what publishers are apt to consider the greatest of literary vices, and what authors find the costliest of indulgences—namely, a habit of rewriting in proof. The simplicity, of which we have spoken, was attained only by the most careful revision. The rewriting is especially frequent in Lecture iii. A passage of some interest is here supplied from the proof in a note below the text (p. 114). Revisions after the first edition were few and unimportant; they are recorded, as usual, in the Bibliographical Note (pp. 7, 8).

The method of work adopted both in *The Elements of Drawing*, and in Ruskin's classes at the Working Men's College, has often been misunderstood. The book, it should be said, follows in the main the system as taught by the author at the College, with such modifications as the absence of a master rendered desirable (see below, p. 14). The misunderstanding of the system appears very clearly in a criticism of *The*

[1] "On the Study of Literature" in John Morley's *Studies in Literature* (1891).

[2] The *Athenæum*, July 11, 1857.

[3] Most of these are in Mr. Allen's possession; but a few sheets (mostly corrected by Harrison, one by Ruskin) are in that of Mr. Ward. The sheet corrected by Ruskin contains §§ 255–257 ("Things to be Studied"), and shows extensive alterations and additions.

[4] See Vol. I. p. xlviii. Harrison, if conscientious, was somewhat meticulous. The author and his proof-reviser had a stiff fight over the word "by" in § 204 ("interesting by having its main arch," etc.). Harrison stood out for "in." "*By*," he wrote, "is not English; *in* is. But you have," he added sarcastically, "an unfilial hatred of your mother tongue." Ruskin, we must suppose, smiled and passed on, for the word was printed "by."

Elements of Drawing by William Bell Scott, to which Ruskin replied, and which is therefore noted here in an Appendix (see pp. 491–494). Scott was master in the Government School of Design at Newcastle, and afterwards an examiner in the art schools at South Kensington. He was thus closely connected with the system of teaching then followed in the Government schools. This system was regarded by Ruskin as in some respects radically at fault. He considered that it paid too little regard to the forms of natural objects and to delicacy in handling, and, furthermore, that the end which it proposed to itself was erroneous. It confused, he thought, art as applied to manufacture with manufacture itself; it supposed that the art of design could be taught by rule; and thus proposed to give its pupils "such accurate command of mathematical forms as might afterwards enable them to design rapidly and cheaply for manufactures." Ruskin notices this matter briefly in the preface to *The Elements of Drawing* (see below, p. 11), and it was a principal theme in the series of public lectures which he delivered at the time (see the next volume).

Ruskin's class at the Working Men's College and his text-book were, therefore, intended as a practical protest against certain phases and ideas in the current teaching of the time. But they were not intended as a complete substitute for all other methods and agencies. At the College, it should be remembered, Ruskin took only the landscape class, leaving the life class to Rossetti. He neither desired nor attempted to make artists or professional designers. Scott's criticisms fell wide of the mark from a misunderstanding on these points. Scott complained that pupils who studied under Ruskin's system at the Working Men's College did not attain the same facility in designing for the manufacturers that rewarded the students of other systems. The reply is that Ruskin never promised them any such proficiency. "My efforts are directed," he said succinctly to a Royal Commission in 1857, "not to making a carpenter an artist, but to making him happier as a carpenter."[1] This was a distinction which he constantly made in his addresses to the men themselves. Here, for instance, is the recollection of the gist of an address by a visitor to the College :—

> "Now, remember, gentlemen, that I have not been trying to teach you to draw, only to *see*. Two men are walking through Clare Market, one of them comes out at the other end not a bit wiser than when he went in; the other notices a bit of parsley hanging over the

[1] See Vol. XIII. p. 553. See also his evidence to the Public Institutions Committee in an appendix to Vol. XVI.

edge of a butter-woman's basket, and carries away with him images of beauty which in the course of his daily work he incorporates with it for many a day. I want you to see things like these."[1]

Scott complained, again, that Ruskin's system included no drawing from the antique; that "etching with a pen from lichenous sticks" was not a sufficient education in drawing; and that adherence to Ruskin's exercises never had made an artist, and never would. The reply is that Ruskin never said, or supposed, that it would. "As a matter of fact, he always urged young people intending to study art as a profession to enter the Academy Schools, as Turner and the Pre-Raphaelites did."[2] His object was not to instruct professional artists, but to show how the elements of drawing might best be made a factor in general education. What he claimed for his system was that it was calculated to teach refinement of perception; to train the eye in close observation of natural beauties and the hand in delicacy of manipulation; and thus to make his pupils to understand what masterly work meant, and to recognise it when they saw it.

Ruskin himself, as one of his pupils has related, did not always attach supreme importance to the particular methods which he first adopted. In all teaching the personality and genius of the teacher are of more importance than his method; and this is true both of Ruskin's book and of his oral teaching:—

" We were not most strongly impressed (writes the pupil in question) by his influence when he was obviously teaching us; and certainly we were least so when he was most theoretic. Indeed, he did not always remain constant to his own methods of teaching, nor to his own theories. Some years ago an amateur student by chance came across *The Elements of Drawing*, and set to work assiduously making little squares of hatched pen-and-ink lines, reducing them as far as possible to the evenness in tone of a square of grey cloth which Mr. Ruskin wished them to resemble. The student also copied outlines and traced the originals and fitted the two together, which is the

[1] From a letter by the Rev. Henry Solly in the *Inquirer*, February 10, 1900. Mr. Solly went to hear Ruskin's address at the close of one of the terms. " At the close of the address," adds Mr. Solly, " a gentleman sitting next me went up with me to the platform to thank Mr. Ruskin not merely for that address, but for the remarkable good he had been conferring year after year on the English-speaking race. . . . I shall never forget the sad and wistful smile that came over his face as he turned a little away saying, ' Oh, do you think so? it seems to me as if I looked back only on a misspent life and wasted opportunities.' "

[2] *The Life and Work of John Ruskin*, by W. G. Collingwood, 1900, p. 154. See in confirmation what Ruskin said to the St. Martin's School of Art in his address of April 15, 1858 (Vol. XVI., Appendix vi. § 2).

second exercise ordained in that book. These exercises were shown to
Mr. Ruskin, who was so delighted with them that he wished to teach the
student himself. The student painted shells and other objects of still-life
for Mr. Ruskin, and Mr. Ruskin painted shells, etc., for the student, saying
that not only could he not draw anything that was moving, but likewise
nothing that had the power of moving — as it fussed and worried him too
much to feel that at any moment it might begin to move.[1] Alluding to
these drawing lessons a few years later, he said to his pupil, 'They were
all wrong. They were only one side of the matter. *The Elements of Drawing*
are not complete, and therefore they are misguiding and wrong.'" [2]

It may be doubted whether Ruskin said that his old exercises were
"all wrong"; or, if he did, he spoke with the exaggerated self-deprecia-
tion which sometimes marked his conversation. But in saying that
The Elements of Drawing were "not complete," he said what he would
never have denied, and what it is important to remember. The form
into which he threw his work and the method adopted in his teaching
were in large measure conditioned by circumstances of the time. He
desired, in a practical way, to protest against certain tendencies in the
current teaching of drawing. He sought to encourage closeness of
observation rather than mere facility of hand, and to fix the pupil's
attention on natural objects rather than on casts or "nonsense lines."
In these respects his methods have had considerable influence,[3] and

[1] Ruskin makes the same remark of William Hunt (see Vol. XIV. pp. 441, 443).
But Ruskin could work quickly, as well as patiently, as the following reminiscence
shows: "On boat-race day I was in the room of an old art pupil of Mr. Ruskin's
at the Working Men's College in Great Ormond Street. Seeing a very clever sketch
of a dead bird in carmine-lake on the wall, I admired it and asked whose it was.
'John Ruskin's,' said my friend. 'You know how he used to come up to our easels,
one after the other, and tell us where we were right, with a word of praise, and where
wrong, with a "Look here, this is the way to do that!" Well, that bird which you've
just admired, Ruskin did one night, on the edge of my drawing-paper, in less than
ten minutes, to give me a hint. He dashed the sketch in as fast as brush could go,
and the breast, which is so effective, he did by dabbing the inside of his thumb on
the wet paint. I wouldn't part with it for anything. A year or two ago he came
to see me, and I showed him his sketch and reminded him of when and how he did
it. Of course he'd forgotten all about it. But he looked at it, and said smilingly,
"Well, it's very well done." And so it is'" (A correspondent—Dr. Furnivall—in
the *Pall Mall Gazette*, April 9, 1887).
[2] "John Ruskin: by a Former Pupil" (*Westminster Gazette*, January 23, 1900).
Rossetti, it may be noted, thought highly of Ruskin's methods. "Ruskin's class,"
he wrote (January 23, 1855), "has progressed astonishingly, and I must try to keep
pace with him" (*Letters to William Allingham*, p. 98).
[3] Even the "lichenous stems," which aroused W. B. Scott's contemptuous ire,
have been adopted in some official quarters. The Home Office has recently taken
over from the old Science and Art Department the teaching of drawing, etc., in the
Reformatory and Industrial Schools. The officials responsible for the work do not

another fruitful aspect of *The Elements of Drawing* may be mentioned. Ruskin was "the first to point out the advantages of the *Liber Studiorum* of Turner as the best school of Landscape Art." In the fifth volume of *Modern Painters* he gave his analysis of the human motives in that work; in *The Elements* he first laid down a system of study from those specimens of Turner's genius. During his Professorship at Oxford he constantly recurred to the subject, and impressed upon his pupils the importance of patient study from the *Liber.*[1] Such study is now a recognised part of the "South Kensington" system. Mr. Frank Short, of the Royal Society of Painter-Etchers, when a student at the South Kensington Art Schools, had copied some of the plates in the *Liber,* as recommended by Ruskin in *The Elements of Drawing:*—

"Already an accomplished artist and etcher, his progress in acquiring facility in mezzotint-engraving was rapid, and he soon produced successful copies of some of the plates. All this coming to the knowledge of Mr. Ruskin, he was much interested, visited Mr. Short in his studio, and told him that there was 'a great future for landscape mezzotint-engraving, which, in its highest development, had only been foreshadowed by the early men.' He also said to Mr. Short, in his characteristic way, 'Take care of your eyes, and your lungs, and your stomach, and stick to it." Mr. Short subsequently engraved, in facsimile, a number of the plates in such a manner as to call forth high praise from Mr. Ruskin, and admiration from every connoisseur of the *Liber.*"[2]

The result was that Mr. Short was commissioned by the Science and Art Department to prepare, as a volume in "The South Kensington Drawing-Book," *A Selection from the Liber Studiorum: a*

suppose that they will succeed in turning all their reformed hooligans into artists, but their Syllabus shows that they hope to teach the clumsy-fingered lads what deftness of handling means, and to arouse in them, perhaps, some appreciation of the delicacy of natural forms. Among the drawing-copies is included, by permission of Mr. Allen and of Ruskin's executors, his study of an oak spray ("The Dryad's Toil," Plate 51 in vol. v. of *Modern Painters*). See the *Drawing Syllabus for Guidance in Home Office Schools*, 1903.

[1] See, especially, *Lectures on Art*, § 172, and *Lectures on Landscape*, § 39.

[2] A prospectus of these facsimiles (published by Mr. Dunthorne) was revised by Ruskin, who stated in it that Mr. Short's work had obtained his "unqualified approval." The actual words in the letter cited above (February 10, 1886) are: "Now for goodness' sake take care of your eyes, and lungs, and your stomach, and we will have such lovely times." At a later date Mr. Short sent Ruskin impressions of some of the plates. "Aιe these lovely things," he replied (February 10, 1887), "really for me to keep? Any one of them would have been a dazzling birthday present to me; but above all gifts, the pleasure of seeing such work done again, and of knowing that the worker is as happy as he is strong in it, lights the spring of the year for me more than the now cloudless sunshine on its golden hills."

Drawing-Book suggested by the writings of Mr. Ruskin.[1] This was published in 1890; "it aims at placing a selection of the most noted of these works, for practical instruction, within the reach of every Art School in the kingdom, and through the medium of the Government system of Art Prizes, within the grasp of any clever young student." Thus after many years has been realised one of the objects which Ruskin had most at heart in writing *The Elements of Drawing*.

Through his friend, Professor Norton, Ruskin was instrumental also, it may be added, in making the *Liber Studiorum* better known in America. In 1874 Professor Norton delivered a series of lectures on Turner's Works, and in the same year the Cambridge University Press (U.S.A.) published a *Catalogue of the Plates of Turner's Liber Studiorum: with an Introduction and Notes.* The text of this volume consists almost entirely of extracts from Ruskin's writings on the subject. In the catalogue which was issued in connexion with Professor Norton's Lectures,[2] an extract from a letter by Ruskin was given which may here be added:—

> "Even those who know most of art may at first look be disappointed with the Liber Studiorum. For the nobleness of these designs is not more in what *is* done than in what *is not* done in them. Every touch in these plates is related to every other, and has no permission of withdrawn, monastic virtue, but is only good in its connexion with the rest, and in that connexion infinitely and inimitably good. The showing how each of these designs is connected by all manner of strange intellectual chords and nerves with the pathos and history of this old English country of ours, and with the history of European mind from earliest mythology down to modern rationalism and irrationalism,—all this was what I meant to try and show in my closing work; but long before that closing I felt it to be impossible."[3]

[1] The full title of the publication is "The South Kensington Drawing-Book. A Selection from the *Liber Studiorum* of J. M. W. Turner, R.A., for artists, art students, and amateurs. A Drawing-Book suggested by the writings of Mr. Ruskin. With a Historical Introduction by Frederick Wedmore, Practical Notes by Frank Short, and Extracts from the Writings of the Rev. Stopford A. Brooke, M.A., and others. Under the sanction of the Lords of the Committee of Council on Education. London: Blackie & Son, Limited, 49 Old Bailey." The passages cited above are from the Editor's Preface (by John Ward, F.S.A.), pp. 3, 4; and see p. 15. The "Swiss Bridge" or "Via Mala" (see below, p. 99 n.) is given first—"a pure pen drawing," Ruskin remarked to Mr. Short of Turner's etching (p. 23). Of "The Stork and Aqueduct" Mr. Short says (p. 45): "I believe Mr. Ruskin considers the etching of this plate finer than any other, and so I think it is."

[2] For the title, and for another extract, see Vol. XIII. p. 325.

[3] This extract (p. 6 of the catalogue) was reprinted in *Arrows of the Chace*, 1880, vol. i. p. 141 n. See also *Lectures on Landscape*, § 39, where Ruskin quotes

The Elements of Drawing has been widely read in America, and it has also been translated into Italian (see p. 6); thus returning, as we may in a certain sense say, to its country of origin. Ruskin remarks of his system of teaching that, though "at variance with the practice of all recent European academy schools," it was yet founded on that of Da Vinci.[1] "I think," he said in his Inaugural Address as Professor at Oxford, "you need not fear being misled by me if I ask you to do only what Leonardo bids."[2] The similarity of teaching in the *Treatise on Painting* and *The Elements of Drawing* is often very marked. A few references to Leonardo's *Treatise* have, in accordance with Ruskin's appeal to that authority, been cited in footnotes to this edition; many more may be found in the notes added by Signor E. Nicolello to the Italian translation of Ruskin's book.

The Elements of Drawing has also been translated, in an abridged form, into German (see p. 7).

II

The Elements of Perspective followed *The Elements of Drawing* after a space of two years. To the study of theoretical perspective Ruskin attached little importance in art-education;[3] the essential thing was to cultivate in practice precision of observation, and this he sought to inculcate by other exercises.[4] But the theory of perspective was a favourite study of his own; some of his earliest essays were concerned with it.[5] Accordingly he set himself in 1859 to complete his text-book, of elementary drawing by a companion volume on the elements of perspective. The book is not, and could not have been, light reading, and no second edition was ever called for. He attained, however, in it a considerable measure of lucidity, and its mastery is certainly not more difficult than that of Euclid. To the author himself it was a holiday task, and was written in part while he was on a visit at Winnington.[6] Pure geometry was always a favourite study with him,[7]

another passage from his letter on the subject. The date of the letter is 1867; "my closing work" is the last volume of *Modern Painters*, where (pt. ix. ch. xi. §§ 28, 29) "the lessons of the Liber Studiorum" are discussed.

[1] *Lectures on Art*, preface to the edition of 1887.
[2] *Ibid.*, § 26; and compare §§ 107, 129, 142, 164.
[3] See below; p. 17.
[4] See also *Lectures on Art*, § 142.
[5] See the papers on "The Convergence of Perpendiculars" in Vol. I. pp. 215–245.
[6] For his visits there, see the Introduction to the volume containing *The Ethics of the Dust.*
[7] See *Præterita*, i. §§ 93, 228.

and in the reduction of the elements of perspective to a series of propositions in Euclid's manner he found congenial recreation.

He was satisfied with his work, and in his Inaugural lectures at Oxford eleven years later, he referred his pupils to the treatise, as carrying the mathematics of perspective as far as is necessary.[1] The book was, however, disfigured, and its utility somewhat lessened, by several mistakes and omissions both in the diagrams and in the references to them. Perhaps W. H. Harrison was here out of his depth, or was unable to render his usual assistance in reading the proofs. Attention was called in reviews of the time to the existence of serious mistakes in the text,[2] but as a second edition was not called for, they passed uncorrected (being slavishly reproduced, by the way, in the unauthorised American reprint). Ruskin, however, went through the book at some later date, and marked numerous corrections in his own copy. This copy has been at the editors' disposal, as well as the original MS. of the book, and Ruskin's corrections have been made—the diagrams being altered where necessary. In this edition, therefore, *The Elements of Perspective* appears for the first time in a correct form.

III

The Elements of Drawing was allowed, as we have seen already, to remain for many years out of print. The last issue in the original form was made in 1861; and it was not thus reprinted till 1892. At the earlier date Ruskin's attention had become diverted from artistic matters and was largely absorbed in economic and social problems. The book was still often asked for, but the author, as was frequently the case, had become dissatisfied in some measure with his work. In particular, he had come to attach much greater importance to outline as the foundation of art-discipline than was allowed to it in his teaching at the Working Men's College or in *The Elements of Drawing.*[3] When he began once more to concentrate his energies on art-teaching, he desired to rewrite *The Elements*, but could not find the time.[4] He accordingly allowed his friend Mr. St. John Tyrwhitt to use the woodcuts and incorporate so much of the text as he pleased in the manual entitled *Our Sketching Club.* It was in

[1] See again *Lectures on Art*, § 142. See also the reference to the book in *Modern Painters*, vol. v. pt. vii. ch. ii. § 11.

[2] For instance, in the *Builder*, January 28, 1860.

[3] See *Fors Clavigera*, Letter 59; and compare the note added, by way of correction, in *The Laws of Fésole*, p. 134 *n.*, below.

[4] See below, Appendix ii., p. 492.

the form of a review of this book (1875) that William Bell Scott embodied the attack on Ruskin's system which has been noticed already (above, p. xx.). Presently, however, Ruskin set to work on recasting and rewriting *The Elements of Drawing*—partly in connexion with his teaching as Professor at Oxford, and partly as a branch of the general scheme of teaching which he was designing for an ideal community to be established by the St. George's Guild.[1] An account of these schemes belongs to a later volume of this edition, as also does an explanation of the broken and widely-dispersed nature of Ruskin's activities at that time. But it is necessary to bear both of these factors in mind when reading the new version of *The Elements of Drawing*, which Ruskin entitled *The Laws of Fésole*.

First, then, the book is a fragment. It is described on the title-page as " Volume I.," and no second volume was issued. For the most part, though not entirely, the book as it stands deals with outline; the second volume was intended to deal mainly with colour. To it he had at one time intended to give the title *The Laws of Rivo Alto*[2]— teaching from the Rialto, the centre of old Venice, the laws of Venetian colour, as in the first volume he teaches, from the laws of Fésole, the laws of Etruscan and Florentine draughtsmanship. This scheme was, however, abandoned. His later studies at Venice took another turn, and he wrote, instead, the sketch of Venetian history, as reflected in her art, called *St. Mark's Rest*. Moreover, he decided that in colour, no less than in outline, "the laws of Fésole" were "conclusive."[3] He made a large number of notes for the continuation of *The Laws of Fésole*, but, for the most part, they are fragmentary. A few passages are here printed in Appendix iii. (pp. 495–501).

In another respect the book is incomplete. It was intended to be read and used in connexion with the series of Examples which Ruskin was constantly arranging and rearranging in his Drawing School at Oxford. In order to make these Examples more generally available, he intended to issue, as a companion portfolio to *The Laws of Fésole*, a series of drawing copies as folio plates. Several of these were engraved, and were lettered " Oxford Art School Series."[4] The scheme is referred to in *The Laws of Fésole*, at pp. 346, 369 here. But it was not brought

[1] It will be noticed that Ruskin in lettering the plates for the book described them as " Elementary Drawing " exercises for the " Schools of St. George."
[2] See the *Life and Work of John Ruskin*, by W. G. Collingwood, 1900, p. 323.
[3] See Vol. XIII. p. 525.
[4] In December 1877 the following advertisement appeared in Mr. Allen's List : " There will shortly be issued, in connection with this work, a Folio Series of examples for Drawing copies, being Plates engraved from Drawings by Professor Ruskin and others."

to completion. "I have been beaten for the present," he wrote to Mr. Allen from Rome (May 22, 1874), "in trying to get my introduction to folio plates written: so many questions and difficulties occur to me for which I am as yet unprepared; and which need the review of all the knowledge I have, to give a general answer. Finding that this was impossible during my work here, I have put the folio aside for the time and am going on with the botany." Some of the Plates which were prepared but never issued are now reserved for the illustration of Ruskin's Oxford catalogues, where many of the subjects are discussed. *The Laws of Fésole* should thus be read in connexion with those catalogues, as well as with *The Elements of Drawing*. Where in the later book Ruskin reprinted textually passages from earlier books, these have not been repeated in the text, but the references are of course supplied and any variations are noted (see pp. 432 *n.*, 439 *n.*).

The meaning of the title—*The Laws of Fésole*—is sufficiently explained by Ruskin (see below, pp. 344–345, 358, 462), and in a note here added (p. 345) references will be found to other passages in his writings which bear upon it. The spelling "Fésole," for the Italian "Fiesole," was constant with Ruskin; he took it from Milton (see the reference in Vol. XII. p. 233 *n.*)

In its general scope, and in the method of teaching adopted, *The Laws of Fésole* closely follows *The Elements of Drawing*. The object was not, any more than in the earlier book, to train professional artists. It was to suggest the manner in which drawing might most helpfully be made a part of general education, and to lay down a scheme for the elements only of professional education in art. In this latter respect Ruskin describes in the Preface (below, pp. 342-345) how his system differs from that of ordinary Schools of Art. The book as a whole differs yet more widely from ordinary text-books of drawing, and even from his own earlier *Elements*. It sticks less closely to the subject immediately in hand, and the author allows himself many digressions. To some extent this is a characteristic of most of his later writings, and especially of those which he issued at irregular intervals[1] in parts. He was sometimes engaged at the same time on six or seven different works—a condition hardly favourable to concentration.

For the most part, however, Ruskin's discursiveness in *The Laws of Fésole* was deliberate. The book was, as we have seen, intended as

[1] The first part of *The Laws of Fésole* was not published till 1877, but he had begun to write it in 1874 or 1875.

part of a general scheme of education; it was written for Oxford, but also for his ideal commonwealth of St. George. An essential purpose with Ruskin was to link the study of drawing with other things. "The recast *Elements of Drawing* is meant," he said, "to found a system of education in Natural History."[1] He believed in nonsense lines, he says, no more than in nonsense verses as an instrument of education; hence every one of his drawing exercises had "the ulterior object of fixing in the student's mind some piece of accurate knowledge, either in geology, botany, or the natural history of animals"[2]—to which list he might have added "or heraldry, or geography, or astronomy, or etymology." To this comprehensive purpose there has to be added Ruskin's fondness for inventing systems and classifications and nomenclatures of his own. He indulged this fancy somewhat even in *The Elements of Perspective*—in his introduction of the terms "sight-line" (for horizontal line) and "station-line" (for the line on which would be measured the direct distance of the picture or object). But by the time he came to write *The Laws of Fésole*, he had one eye fixed firmly on his "island of Barataria."[3] A pupil might well be puzzled by being told to draw the Captain's line in Clarissa;[4] but Ruskin was writing for his ideal community in which there was to be metaphorically a new heaven and a new earth, and literally a new system of names for all things upon the earth. Turner, says Ruskin, wanted to draw everything;[5] of himself it may be said that, in addition to that, he wanted to teach and rewrite the elements of everything. *The Laws of Fésole* is, on this side, related to, and will only be rightly understood when read in connexion with, *Proserpina*, and *Love's Meinie*, and *Deucalion*, and many parts of *Fors Clavigera*.

The *manuscript* of *The Laws of Fésole*, if extant, has not been before the editors, with the exception of six sheets containing the closing portion of the volume. The last sheet is here given in facsimile (p. 484). These sheets are at Brantwood, where also is preserved Ruskin's copy of the book. In this there are various corrections and notes by the author, which have been embodied in this edition (see the Bibliographical Note, p. 338). There are also among the Hilliard MSS. (see Vol. IV. p. 361)

[1] *Fors Clavigera*, Letter 60. Compare in Vol. XVI. Appendix v.
[2] See below, p. 440.
[3] See *A Joy for Ever*, § 65.
[4] For these terms, see below, pp. 442, 427.
[5] See below, p. 437.

several sheets which appear to have been an early draft of chapter vi. as it now stands; it was ultimately much rewritten.

The contents of the Appendix to this volume have been already mentioned—Appendix i. ("Drawing Lessons by Letter"), on p. xvi.; Appendix ii. ("Ruskin's Controversy with W. B. Scott"), on pp. xx., xxvi.; and Appendix iii. ("Passages intended for the Second Volume of *The Laws of Fésole*"), on p. xxvii.

The *illustrations* in the volume consist of (1) the original woodcuts (by Miss Byfield[1] from the author's drawing) illustrating *The Elements of Drawing*; (2) the diagrams illustrating *The Elements of Perspective*, corrected as described above (p. xxvi.); (3) the original plates illustrating *The Laws of Fésole*; together with (4) some additional plates.

The additional plates are four in number. The *frontispiece* is a reproduction in colour of Ruskin's study of an apple (Blenheim Orange). It was first published at p. 219 of *A Handbook of Pictorial Art*, by the Rev. R. St. John Tyrwhitt (Oxford: Clarendon Press), 1875. Mr. Tyrwhitt's remarks on the drawing were as follow:—

"The Slade Professor has given us the names of all the colours used in his brilliantly-painted apple — gamboge, orange-vermilion, rose-madder, sepia, and cobalt: to be laid on, the lightest tints first, gamboge floated on all over in the first instance, and the scarlet and darker shades in succession. You will observe the graphic way in which the colours are put on, according to the stripes and special form and colour of the fruit. This will introduce you to the greatest difficulty and beauty of high finish,—that is to say, to make the necessary hatchings take expressive forms which add to the ideal completeness of the picture."

The drawing, which is reproduced in its full size, is now in the collection of Mrs. Cunliffe. It was shown at the Ruskin Exhibition at Manchester in 1904 (No. 94). Ruskin's note on the drawing is:

"Mrs. Stacey's present,[2] 22nd November, 1873. Red side first in shade, then in light. Gamboge, orange-vermilion, rose-madder, burnt umber, cobalt and black.—J. R."

[1] For whom, see Vol. V. p. 12.

[2] Mrs. Stacey was the housekeeper in the Keeper's house at the University Galleries, Oxford, and as such looked after the cleaning, etc., of the Ruskin Drawing School. On one occasion she brought Ruskin a fine Blenheim orange from among the apples she was about to cook. Ruskin then and there made a study of it, which he presented to her, although it was kept for some time in the School for use as an example.

The second additional plate (at p. 114) is a reproduction of the drawing by Ruskin, from which he had a small portion drawn and cut on the wood for Fig. 24 in *The Elements of Drawing.* The drawing, which is in pen, pencil, and colour ($11\frac{1}{2} \times 9$), is in the collection of Mr. T. F. Taylor, who has kindly lent it for reproduction here. It also was exhibited at Manchester in 1904 (No. 114).

The third and fourth additional plates are photogravures from the engravings of Turner's drawings of "Lancaster Sands" (in the "England and Wales" Series) and "Heysham" ("Richmondshire") respectively. Both drawings are described in *The Elements of Drawing* (§§ 243, 244). The engraving of the former drawing is referred to in Vol. XIII. p. 495; the latter drawing was in Ruskin's collection (*ibid.*, p. 429).

<div style="text-align: right">E. T. C.</div>

THE ELEMENTS OF DRAWING

(1857)

ELEMENTS OF DRAWING.

IN

THREE LETTERS TO BEGINNERS.

BY

JOHN RUSKIN, M.A.

AUTHOR OF

"MODERN PAINTERS," "SEVEN LAMPS OF ARCHITECTURE," "STONES OF VENICE,"
LECTURES ON ARCHITECTURE AND PAINTING."

WITH ILLUSTRATIONS

Drawn by the Author.

LONDON :
SMITH, ELDER, & CO., 65 CORNHILL.
1857.

[*Bibliographical Note.*—Of this book there have been several issues :—

First Edition (1857).—The title-page was as shown on the preceding page here. Crown 8vo, pp. xxiv.+350. Preface (here pp. 9–19), pp. v.–xxii. ; Contents (here p. 23), pp. xxiii.–xxiv. ; Text, pp. 1–333 ; Appendix, pp. 334–350. The imprint on the reverse of the half-title and at the foot of the last page is—" London : Printed by Spottiswoode & Co., New Street Square." Facing p. 350 is a leaf bearing a notice that "The Fifth and Concluding Volume of *Modern Painters* is in preparation." Except in the case of pp. 334–350, which are headed "Appendix" throughout, the headline on each left-hand page is "The Elements of Drawing," the headlines on the right-hand pages corresponding with the titles of the several Letters. At the end are 16 numbered pages of advertisements of Smith, Elder & Co.'s publications. Issued on June 22, 1857, in green cloth, lettered "The | Elements | of | Drawing | Ruskin | London | Smith, Elder & Co." Price 7s. 6d.

Second Edition (1857).—The title-page differs from that of the First only in punctuation (*e.g.*, a full stop after "Elements of Drawing," instead of a semicolon), and by the addition of the words "Second Edition." Crown 8vo, pp. xxiv.+359. The half-title was omitted, and an "Advertisement to the Second Edition" (here p. 21) added. A few alterations were made in the text, and a series of seven numbered Notes was added at the end, forming Appendix I., pp. 337–342 ; the original Appendix becoming Appendix II., pp. 343–359. In other respects similar to the First Edition. Issued on October 5, 1857. (Of eds. 1 and 2 together 5000 copies were printed.)

Third Edition (1859, 1860, 1861).—This was issued in three separate thousands, a new title-page (with the number of ·the Thousand, and the date) being printed for each ; in all other respects they are identical. The title-page of this edition added "The Two Paths" to the books after the author's name. The number of pages was now xxiv.+360. A footnote was added to p. xiv. of the Preface (here p. 14) ; and a passage of nine lines at the end of Appendix i., p. 342 (here p. 218). In other respects the third edition was identical with its predecessors.

Fourth Edition (1892).—The title-page of this new edition is as follows :

The | Elements of Drawing. | In | Three Letters to Beginners. | By | John Ruskin. | With Illustrations | Drawn by the Author. | New Edition. | George Allen, | Sunnyside, | Orpington, | and | 8, Bell Yard, Temple Bar, London. | 1892.

Crown 8vo, pp. xxvii. + 380. On the reverse of the title-page "*All Rights Reserved.*" Bibliographical Note, p. v. ; Advertisement to the Second Edition, pp. vii.–viii. ; Preface, pp. ix.–xxvi. ; Contents, p. xxvii. ; Text, pp. 1–325 ; Appendix, pp. 329–353 ; Collation of the Editions, pp. 355–357 (this is added to and completed in the list of "Variæ Lectiones" below) ; Index, pp. 359–380. The imprint is at the foot of the last page—"Printed by

Ballantyne, Hanson & Co. | Edinburgh and London." The text is a reprint of ed. 3. This new edition was edited by Mr. W. G. Collingwood, who compiled the Index, etc. The woodcut figures were printed not from the original blocks, but, with the exception of two which were re-cut by Mr. Sulman (for whom, see Vol. V. p. xxxix.), from " process " blocks. Issued on June 4, 1892, in the usual green cloth boards ; price 5s. 3000 copies were printed ; also 210 (large post 8vo) on Arnold's unbleached hand-made paper ; price 10s. The numbering of the paragraphs was introduced in this edition.

Re-issued in November, 1895 (" 5th edition," 1000 copies); February, 1898 (" 6th edition," 1000 copies); April, 1900 (" 14th thousand "); November, 1901 (" 15th thousand "); and May, 1904 (" 16th thousand ").

Pocket Edition (1904).—The title-page of this edition (enclosed in an ornamental frame with the title printed in red) is as follows :—|

The Elements | of Drawing | By | John Ruskin | London : George Allen

On the reverse—" *May 1904* | *19th* | *Thousand* | *All rights reserved.*" Foolscap 8vo, pp. xxvi. + 380. A reprint, page for page, of the Fourth Edition. Issued with gilt tops in terra-cotta cloth at 2s. 6d. net, and in limp leather at 3s. 6d. net. On the front cover a facsimile of the autograph of " John Ruskin " is stamped in gold, thus :—

John Ruskin

On the back the lettering is " Ruskin | The | Elements | of | Drawing | [scroll of roses] | George | Allen." (3000 copies ; 2000 more being printed in October, 1904.)

Extracts (1874).—A considerable portion of the text, and thirty-four of the woodcuts, were reproduced, with the author's consent, in the following book :—

Our Sketching Club. | Letters and Studies on | Landscape Art. | By the | Rev. R. St. John Tyrwhitt, M.A. | Formerly Student and Rhetoric Reader of Ch. Ch. Oxford. | With an authorised reproduction of the Lessons | and Woodcuts in Professor | Ruskin's " Elements of Drawing." | London | Macmillan and Co. | 1874 | All rights reserved.

Crown 8vo, pp. xii. + 374 ; price 7s. 6d. New editions were issued in 1875, 1882, and 1886. Mr. Tyrwhitt, describing in a Preface how the book came to be written, says : " It now further received the approbation of the Slade Professor of Art at Oxford, who, with a kindness which his friends have learned to take as quite a matter of course, gave me leave to use, as illustrations of my various lessons, any or all of the woodblocks employed in his ' Elements of Drawing,' which he does not propose to re-issue. Furthermore, he commissioned me to reproduce in my own way all such parts of his instructions in that book as might seem to suit my purpose."

Italian Translation (1898). —The title-page of this translation is as follows :—

Bibliotheca Artistica—Vol. vii. | John Ruskin | Elementi del Disegno | e della Pittura | Traduzione Italiana dall' ultima edizione inglese | con

prefazione e note | di | E. Nicolello | Con 48 figure nel testo. | Torino | Fratelli Bocca | Milano-Roma-Firenze | 1898.

Crown 8vo, paper covers, pp. xl. +259. The translator's preface occupies pp. iii.-xxiv. ; the author's Preface, pp. xxv.-xl. The text of the fourth English edition is followed, but the appendices are not given, and the lists of Turner engravings (§§ 86, 109) are also omitted. The translator supplied several explanatory footnotes (see above, p. xxv.).

German translation, abridged (1901).—The title-page of this translation is :—

Grunblagen des Zeichnens. | Drei Briefe an Anfänger | von | John Ruskin. | Aus dem Englischen übersetzt und mit einer Ein= leitung versehen | von | Theodor Knorr. | Mit 10 Abbildungen. | Straßburg, | J. H. Ed. Heitz (Heitz und Mündel). |

Crown 8vo, pp. xl.+151, bound in green cloth (price 3 marks). Editor's preface, dated "October 1901" (explaining that the abridgment is made to cheapen the book), pp. vii.-ix. ; editor's Introduction (discussing Ruskin's art-teaching), pp. xi.-xxvii. ; editor's notes on the English artists mentioned in the text, pp. xxix.-xxxiii. ; extracts from Ruskin's preface, pp. xxxv.-xl. ; abridged text of the book, pp. 1-151. The paragraphs which are wholly omitted are 18, 19, 64, 65, 68, 78, 97, 111, 118, 135, 136, 144, 183, 185, 186, 188-246. The appendices are also omitted, though two of the notes in Appendix i. are given under the text. Many other paragraphs are curtailed, and Ruskin's notes, recommending engravings after Turner, are omitted. The ten woodcuts which are represented (not very successfully) are Figs. 1, 2, 5, 8, 13, 14, 15, 18, 19, and 29.

Several *unauthorised American* editions of "The Elements of Drawing" have appeared, in various styles and at various prices from 50 cents upwards.

Reviews appeared in the *Athenæum*, July 11 ; *Daily News*, July 16 ; *Press*, July 18 ; *Literary Gazette*, July 18 ; *Examiner*, September 12 ; *Morning Post*, December 25 ; *British Quarterly Review*, October 1857, vol. 26, pp. 528-551 ; and *Blackwood's Magazine*, January 1860, vol. 87, pp. 32-44. This last was reprinted by the writer, John Paget, in his *Paradoxes and Puzzles*, 1874, pp. 413-436.

Variæ Lectiones.—In the following list all variations (other than the principal alterations already mentioned) are described or referred to ; mere typographical differences in punctuation and pagination excepted. It should be noted further that in ed. 1 the author used italics very freely ; the literary form into which he cast the book—namely, a series of letters to pupils— lending itself to that form of emphasis. For example, in § 21, ed. 1 reads "You will see that *all* the boughs of the tree are *dark* against the sky. Consider them . . ." ; and in § 45, "The real difficulties are to get the *refinement* of the forms and the *evenness* of the gradations. . . ." In revising the book for the second edition Ruskin eliminated most of the italics.

Preface, § 9, the author's footnote was added in ed. 3.

Contents.—The subdivisions of Letter III. are added in this edition.

Letter I., § 44, line 10, ed. 1 reads "draughtsmen"; other eds., "draughts-man": the former reading is here restored; § 47, lines 1 and 2, ed. 1 omits "my sketch in" before "Fig. 5," and reads "Fig. 5" for "my sketch line 8, see p. 52 *n.*; line 14, ed. 1 reads "that shape" for "the shape of the stone"; line 32, see p. 52 *n.*; § 58, last line but one, ed. 1 reads "textures" for "texture"; § 59, line 8, for "*a*, in Fig. 5," ed. 1 reads "Fig. 5"; § 63, line 6, eds. 1 and 2 read "preliminarily"; in all later editions the misprint "preliminary" has occurred; § 64, line 1, for "as directed for Exercise vii.," ed. 1 reads "as before directed"; § 69, line 3, see p. 64 *n.*; § 71, footnote, line 2, "the most neglected is" was altered in ed. 4 to "the most neglected was"; § 75, footnote, ed. 1 omits the reference to the appendix (which was added in ed. 2); § 81, line 2, instead of "drawings you have made," ed. 1 reads "take one of the *drawings*"; § 86, line 19, see p. 75 *n.*; § 86, footnote, for "The plates marked . . . Appendix I.," ed. 1 reads "If you can, get first the plates marked with a star," and omits the star after "Dartmouth Cove," "Launceston," "Drachenfels," "Melrose," "Dryburgh," and "Loch Coriskin"; § 97, footnote added in ed. 2; § 99, page 88, line 4, eds. 1–3 read "*News* or *Times,*" was altered in ed. 4 to "*News* or others," and the alteration has been followed in later editions; Ruskin's word is here restored.

Letter II., § 107, line 21, ed. 1 reads "The" before "figure"; § 109, footnote, "Dumblane" in all previous editions here corrected to "Dunblane"; § 111, line 33, eds. 1–3 read "lately" before "photographed"; § 128, footnote †, ed. 1 reads "Bogue, Fleet St.," at the beginning (*i.e.*, the name of the publisher of the book referred to in the text). §§ 142, 145, 146, 175, 197, footnotes added in ed. 2.

Letter III., § 204, line 10, "over leaf" is altered in this edition to "opposite"; § 207, line 2, eds. 1–3 read "forest of mountain," a misprint (as the author's proofs show) for "forest or mountain"; the misprint was noted in the list of variations in ed. 4, but in the text "forests" has hitherto been printed; §§ 220, 223, "Hakewell" is in this edition corrected to "Hakewill"; § 240, lines 12–17, ed. 1 reads "Among those which I never hope to explain, are chiefly laws of expression, and others bearing simply on simple matters; but, for that very reason, more influential than any others. These are, from the first, as inexplicable as our bodily sensations are, it being just as impossible, I think, to explain why one succession," etc.

Appendix I. added in ed. 2; § 254, see p. 218 *n.*

Appendix II. was the only Appendix in ed. 1; § 255, line 16, ed. 1 reads "our taste of it will not" for "our enjoyment of it will never"; line 17, see p. 219 *n.*; § 257, ed. 1 omits the author's footnote to "Prout"; in line 18 of the passage on Cruikshank, "Tom Thumb" is here corrected to "Hop o' my Thumb"; for alterations under "7. Richter," see p. 224 *n.*; the second note on p. 225 omitted in ed. 1; § 258, line 33, see p. 227 *n.*]

PREFACE

[1857]

1. IT may perhaps be thought, that in prefacing a manual of drawing, I ought to expatiate on the reasons why drawing should be learned; but those reasons appear to me so many and so weighty, that I cannot quickly state or enforce them.[1] With the reader's permission, as this volume is too large already, I will waive all discussion respecting the importance of the subject, and touch only on those points which may appear questionable in the method of its treatment.

2. In the first place, the book is not calculated for the use of children under the age of twelve or fourteen. I do not think it advisable to engage a child in any but the most voluntary practice of art. If it has talent for drawing, it will be continually scrawling on what paper it can get; and should be allowed to scrawl at its own free will, due praise being given for every appearance of care, or truth, in its efforts. It should be allowed to amuse itself with cheap colours almost as soon as it has sense enough to wish for them. If it merely daubs the paper with shapeless stains, the colour-box may be taken away till it knows better: but as soon as it begins painting red coats on soldiers, striped flags to ships, etc., it should have colours at command; and, without restraining its choice of subject in that imaginative and historical art, of a military tendency, which children delight in, (generally quite as valuable, by the way, as any historical art delighted in

[1] ["The Value of Drawing" was taken by Ruskin as the subject of an Address in 1857 to the St. Martin's School of Art (see Vol. XVI., App. iii.); and see in the same volume the paper on " Education in Art" (pp. 143–151).]

by their elders,[1]) it should be gently led by the parents to try to draw, in such childish fashion as may be, the things it can see and likes,—birds, or butterflies, or flowers, or fruit.

3. In later years, the indulgence of using the colour should only be granted as a reward, after it has shown care and progress in its drawings with pencil. A limited number of good and amusing prints should always be within a boy's reach: in these days of cheap illustration he can hardly possess a volume of nursery tales without good woodcuts in it, and should be encouraged to copy what he likes best of this kind; but should be firmly restricted to a *few* prints and to a few books. If a child has many toys, it will get tired of them and break them; if a boy has many prints he will merely dawdle and scrawl over them; it is by the limitation of the number of his possessions that his pleasure in them is perfected, and his attention concentrated.[2] The parents need give themselves no trouble in instructing him, as far as drawing is concerned, beyond insisting upon economical and neat habits with his colours and paper, showing him the best way of holding pencil and rule, and, so far as they take notice of his work, pointing out where a line is too short or too long, or too crooked, when compared with the copy; *accuracy* being the first and last thing they look for. If the child shows talent for inventing or grouping figures, the parents should neither check, nor praise it. They may laugh with it frankly, or show pleasure in what it has done, just as they show pleasure in seeing it well, or cheerful; but they must not praise it for being clever, any more than they would praise it for being stout. They should praise it only for what costs it self-denial, namely, attention and hard work; otherwise they will make it work

[1] [For Ruskin's views on "historical" art, wrongly and rightly so called, see *Modern Painters*, vol. iii. (Vol. V. p. 64); *Lectures on Architecture and Painting*, Vol. XII. pp. 151–153; Vol. XIV. p. 84; *Cestus of Aglaia*, § 2.]

[2] [Ruskin is here speaking from the personal experience of his own childhood: see *Præterita*, i. ch. i. § 14.]

for vanity's sake, and always badly. The best books to put into its hands are those illustrated by George Crnikshank or by Richter. (See Appendix.[1]) At about the age of twelve or fourteen, it is quite time enough to set youth or girl to serious work; and then this book will, I think, be useful to them; and I have good hope it may be so, likewise, to persons of more advanced age wishing to know something of the first principles of art.

4. Yet observe, that the method of study recommended is not brought forward as absolutely the best, but only as the best which I can at present devise for an isolated student. It is very likely that farther experience in teaching may enable me to modify it with advantage in several important respects; but I am sure the main principles of it are sound, and most of the exercises as useful as they can be rendered without a master's superintendence. The method differs, however, so materially from that generally adopted by drawing-masters, that a word or two of explanation may be needed to justify what might otherwise be thought wilful eccentricity.

5. The manuals at present published on the subject of drawing are all directed, as far as I know, to one or other of two objects. Either they propose to give the student a power of dexterous sketching with pencil or water-colour, so as to emulate (at considerable distance) the slighter work of our second-rate artists; or they propose to give him such accurate command of mathematical forms[2] as may afterwards enable him to design rapidly and cheaply for manufactures. When drawing is taught as an accomplishment, the first is the aim usually proposed; while the second is the object kept chiefly in view at Marlborough House,[3] and in the branch Government Schools of Design.

6. Of the fitness of the modes of study adopted in those

[1] [Below, pp. 222, 224.]

[2] [So also in architecture: see *Two Paths*, § 28.]

[3] [Then the seat of the Science and Art Department, afterwards transferred to South Kensington. On the general subject of the Department's methods, see the Introduction to Vol. XVI.]

schools, to the end specially intended, judgment is hardly yet possible; only, it seems to me, that we are all too much in the habit of confusing art as *applied* to manufacture, with manufacture itself.[1] For instance, the skill by which an inventive workman designs and moulds a beautiful cup, is skill of true art; but the skill by which that cup is copied and afterwards multiplied a thousandfold, is skill of manufacture: and the faculties which enable one workman to design and elaborate his original piece, are not to be developed by the same system of instruction as those which enable another to produce a maximum number of approximate copies of it in a given time. Farther: it is surely inexpedient that any reference to purposes of manufacture should interfere with the education of the artist himself. Try first to manufacture a Raphael; then let Raphael direct your manufacture. He will design you a plate, or cup, or a house, or a palace, whenever you want it, and design them in the most convenient and rational way; but do not let your anxiety to reach the platter and the cup interfere with your education of the Raphael. Obtain first the best work you can, and the ablest hands, irrespective of any consideration of economy or facility of production. Then leave your trained artist to determine how far art can be popularised, or manufacture ennobled.

·7. Now, I believe that (irrespective of differences in individual temper and character) the excellence of an artist, as such, depends wholly on refinement of perception, and that it is this, mainly, which a master or a school can teach; so that while powers of invention distinguish man from man, powers of perception distinguish school from school. All great schools enforce delicacy of drawing and subtlety of sight: and the only rule which I have, as yet, found to be without exception respecting art, is that all great art is delicate.[2]

[1] [On this subject, compare *Laws of Fésole*, Preface, § 6 (p. 344, below), and *Two Paths*, §§ 51 *seq.*]

[2] [See below, § 16; and compare *Modern Painters*, vol. iii. (Vol. V. p. 63).]

8. Therefore, the chief aim and bent of the following system is to obtain, first, a perfectly patient, and, to the utmost of the pupil's power, a delicate method of work, such as may ensure his seeing truly. For I. am nearly convinced that, when once we see keenly enough, there is very little difficulty in drawing what we see; but, even supposing that this difficulty be still great, I believe that the sight is a more important thing than the drawing; and I would rather teach drawing that my pupils may learn to love Nature, than teach the looking at Nature that they may learn to draw. It is surely also a more important thing, for young people and unprofessional students, to know how to appreciate the art of others, than to gain much power in art themselves. Now the modes of sketching ordinarily taught are inconsistent with this power of judgment. No person trained to the superficial execution of modern water-colour painting, can understand the work of Titian or Leonardo; they must for ever remain blind to the refinement of such men's pencilling, and the precision of their thinking. But, however slight a degree of manipulative power the student may reach by pursuing the mode recommended to him in these letters, I will answer for it that he cannot go once through the advised exercises without beginning to understand what masterly work means; and, by the time he has gained some proficiency in them, he will have a pleasure in looking at the painting of the great schools, and a new perception of the exquisiteness of natural scenery, such as would repay him for much more labour than I have asked him to undergo.

9. That labour is, nevertheless, sufficiently irksome, nor is it possible that it should be otherwise, so long as the pupil works unassisted by a master. For the smooth and straight road which admits unembarrassed progress must, I fear, be dull as well as smooth; and the hedges need to be close and trim when there is no guide to warn or bring back the erring traveller. The system followed in this work will, therefore, at first, surprise somewhat sorrowfully

those who are familiar with the practice of our class at the
Working Men's College;[1] for there, the pupil, having the
master at his side to extricate him from such embarrassments
as his first efforts may lead into, is *at. once* set to draw
from a solid object, and soon finds entertainment in his
efforts and interest in his difficulties. Of course the sim-
plest object which it is possible to set before the eye is a
sphere; and, practically, I find a child's toy, a white leather
ball, better than anything else; as the gradations on balls
of plaster of Paris, which I use sometimes to try the
strength of pupils who have had previous practice, are a
little too delicate for a beginner to perceive. It has been
objected that a circle, or the outline of a sphere, is one of
the most difficult of all lines to draw. It is so;* but I do
not want it to be drawn. All that his study of the ball is
to teach the pupil, is the way in which shade gives the
appearance of projection. This he learns most satisfactorily
from a sphere; because any solid form, terminated by
straight lines or flat surfaces, owes some of its appearance
of projection to its perspective; but in the sphere, what,
without shade, was a flat circle, becomes, merely by the
added shade, the image of a solid ball; and this fact is just
as striking to the learner, whether his circular outline be
true or false. He is, therefore, never allowed to trouble
himself about it; if he makes the ball look as oval as an
egg, the degree of error is simply pointed out to him, and
he does better next time, and better still the next. But
his mind is always fixed on the gradation of shade, and the
outline left to take, in due time, care of itself. I call it
outline, for the sake of immediate intelligibility,—strictly
speaking, it is merely the edge of the shade; no pupil
in my class being ever allowed to draw an outline, in
the ordinary sense. It is pointed out to him, from the

* Or, more accurately, appears to be so, because any one can see an error
in a circle.

[1] [See above, Introduction, pp. xix.-xxii.; and compare Vol. V. pp. xxxvi.-xli.]

first, that Nature relieves one mass, or one tint, against another; but outlines none.[1] The outline exercise, the second suggested in this letter, is recommended, not to enable the pupil to draw outlines, but as the only means by which, unassisted, he can test his accuracy of eye, and discipline his hand. When the master is by, errors in the form and extent of shadows can be pointed out as easily as in outline, and the handling can be gradually corrected in details of the work. But the solitary student can only find out his own mistakes by help of the traced limit, and can only test the firmness of his hand by an exercise in which nothing but firmness is required; and during which all other considerations (as of softness, complexity, etc.) are entirely excluded.

10. Both the system adopted at the Working Men's College, and that recommended here, agree, however, in one principle, which I consider the most important and special of all that are involved in my teaching: namely, the attaching its full importance, from the first, to local colour.[2] I believe that the endeavour to separate, in the course of instruction, the observation of light and shade from that of local colour, has always been, and must always be, destructive of the student's power of accurate sight, and that it corrupts his taste as much as it retards his progress. I will not occupy the reader's time by any discussion of the principle here, but I wish him to note it as the only distinctive one in my system, so far as it *is* a system. For the recommendation to the pupil to copy faithfully, and without alteration, whatever natural object he chooses to study, is serviceable, among other reasons, just because it gets rid of systematic rules altogether, and teaches people to draw,

[1] [Compare "Addresses on Decorative Colour," § 10, Vol. XII. p. 482.]

[2] [Compare Leonardo's *Treatise on Painting*, § 175 : "The student who is desirous of making great proficiency in the art of imitating the works of Nature, should not only learn the shape of figures or other objects, and be able to delineate them with truth and precision, but he must also accompany them with their proper lights and shadows, *according to the situation in which those objects appear.*" The references in this volume to Leonardo's *Treatise* are to the English version by J. F. Rigaud (" Bohn's Library ").]

as country lads learn to ride, without saddle or stirrups;┐ my main object being, at first, not to get my pupils to hold their reins prettily, but to "sit like a jackanapes, never off." [1]

11. In these written instructions, therefore, it has always been with regret that I have seen myself forced to advise anything like monotonous or formal discipline. But, to the unassisted student, such formalities are indispensable, and I am not without hope that the sense of secure advancement, and the pleasure of independent effort, may render the following out of even the more tedious exercises here proposed, possible to the solitary learner, without weariness. But if it should be otherwise, and he finds the first steps painfully irksome, I can only desire him to consider whether the acquirement of so great a power as that of pictorial expression of thought be not worth some toil; or whether it is likely, in the natural order of matters in this working world, that so great a gift should be attainable by those who will give no price for it.

12. One task, however, of some difficulty, the student will find I have not imposed upon him: namely, learning the laws of perspective. It would be worth while to learn them, if he could do so easily; but without a master's help, and in the way perspective is at present explained in treatises, the difficulty is greater than the gain. For perspective is not of the slightest use, except in rudimentary work. You can draw the rounding line of a table in perspective, but you cannot draw the sweep of a sea bay; you can foreshorten a log of wood by it, but you cannot foreshorten an arm. Its laws are too gross and few to be applied to any subtle form; therefore, as you must learn to draw the subtle forms by the eye, certainly you may draw the simple ones. No great painters ever trouble themselves about perspective, and very few of them know its laws; they draw everything by the eye, and, naturally enough, disdain in the easy parts of their work rules which cannot help them in difficult ones.

[1] [*Henry V.*, v. 2.]

It would take about a month's labour to draw imperfectly, by laws of perspective, what any great Venetian will draw perfectly in five minutes, when he is throwing a wreath of leaves round a head, or bending the curves of a pattern in and out among the folds of drapery. It is true that when perspective was first discovered, everybody amused themselves with it; and all the great painters put fine saloons and arcades behind their Madonnas, merely to show that they could draw in perspective: but even this was generally done by them only to catch the public eye, and they disdained the perspective so much, that though they took the greatest pains with the circlet of a crown, or the rim of a crystal cup, in the heart of their picture, they would twist their capitals of columns and towers of churches about in the background in the most wanton way, wherever they liked the lines to go, provided only they left just perspective enough to please the public.

13. In modern days, I doubt if any artist among us, except David Roberts, knows so much perspective as would enable him to draw a Gothic arch to scale at a given angle and distance.[1] Turner, though he was professor of perspective to the Royal Academy, did not know what he professed,[2] and never, as far as I remember, drew a single building in true perspective in his life; he drew them only with as much perspective as suited him. Prout also knew nothing of perspective, and twisted his buildings, as Turner did, into whatever shapes he liked.[3] I do not justify this; and would recommend the student at least to treat perspective with common civility, but to pay no court to it. The best way he can learn it, by himself, is by taking a pane of glass, fixed in a frame, so that it can be

[1] [For a similar statement, see *Pre-Raphaelitism*, § 19 (Vol. XII. p. 356); and for Roberts as an architectural draughtsman, see also *Modern Painters*, vol. i. (Vol. III. p. 223).]

[2] [But see *Modern Painters*, vol. i. (Vol. III. p. 607), and for his diagrams prepared for his Academy lectures—"of the most difficult perspective subjects"—*ibid.*, vol. v. pt. ix. ch. xii. § 4 *n.*, and Vol. XIII. p. 307.]

[3] [For a full discussion of Prout's characteristic virtues and limitations, see Vol. XIV. pp. 384–404.]

set upright before the eye, at the distance at which the proposed sketch is intended to be seen.[1] Let the eye be placed at some fixed point, opposite the middle of the pane of glass, but as high or as low as the student likes; then with a brush at the end of a stick, and a little body-colour that will adhere to the glass, the lines of the landscape may be traced on the glass, as you see them through it. When so traced they are all in true perspective. If the glass be sloped in any direction, the lines are still in true perspective, only it is perspective calculated for a sloping plane, while common perspective always supposes the plane of the picture to be vertical. It is good, in early practice, to accustom yourself to enclose your subject, before sketching it, with a light frame of wood held upright before you; it will show you what you may legitimately take into your picture, and what choice there is between a narrow foreground near you, and a wide one farther off; also, what height of tree or building you can properly take in, etc.*

14. Of figure drawing, nothing is said in the following pages, because I do not think figures, as chief subjects, can be drawn to any good purpose by an amateur. As accessaries in landscape, they are just to be drawn on the same principles as anything else.

15. Lastly: If any of the directions given subsequently to the student should be found obscure by him, or if at any stage of the recommended practice he find himself in difficulties which I have not enough provided against, he may apply by letter to Mr. Ward,[2] who is my under drawing-master at the Working Men's College (45 Great Ormond

* If the student is fond of architecture, and wishes to know more of perspective than he can learn in this rough way, Mr. Runciman (of 49 Acacia Road, St. John's Wood), who was my first drawing-master, and to whom I owe many happy hours, can teach it him quickly, easily, and rightly.[3]

[1] [See the opening of Ruskin's own *Elements of Perspective*, below, p. 241.]
[2] [Mr. William Ward's present address (1904) is 2 Church Terrace, Richmond, Surrey; but he is no longer engaged in teaching.]
[3] [For some account of Mr. Runciman, see *Præterita*, i. ch. iv. § 84.]

Street[1]), and who will give any required assistance, on the lowest terms that can remunerate him for the occupation of his time. I have not leisure myself in general to answer letters of inquiry, however much I may desire to do so; but Mr. Ward has always the power of referring any question to me when he thinks it necessary. I have good hope, however, that enough guidance is given in this work to prevent the occurrence of any serious embarrassment; and I believe that the student who obeys its directions will find, on the whole, that the best answerer of questions is perseverance; and the best drawing-masters are the woods and hills.

[1] [Now (1904) about to be removed to new buildings on a site facing Oakley Square, a little north of St. Pancras Station.]

ADVERTISEMENT TO THE SECOND EDITION
[1857]

As one or two questions, asked of me since the publication of this work, have indicated points requiring elucidation, I have added a few short notes in the first Appendix. It is not, I think, desirable otherwise to modify the form or add to the matter of a book as it passes through successive editions; I have, therefore, only mended the wording of some obscure sentences;[1] with which exception the text remains, and will remain, in its original form, which I had carefully considered. Should the public find the book useful, and call for further editions of it, such additional notes as may be necessary will be always placed in the first Appendix, where they can be at once referred to, in any library, by the possessors of the earlier editions; and I will take care they shall not be numerous.[2]

August 3, 1857.

[1] [See the list of " Variæ Lectiones " above, pp. 7, 8.]
[2] [No such notes were, however, added.]

CONTENTS

LETTER I

THE

ELEMENTS OF DRAWING

LETTER I

ON FIRST PRACTICE

1. MY DEAR READER,—Whether this book is to be of use
to you or not, depends wholly on your reason for wishing
to learn to draw. If you desire only to possess a graceful
accomplishment, to be able to converse in a fluent manner
about drawing, or to amuse yourself listlessly in listless
hours, I cannot help you: but if you wish to learn drawing
that you may be able to set down clearly, and usefully,
records of such things as cannot be described in words,
either to assist your own memory of them, or to convey
distinct ideas of them to other people;[1] if you wish to obtain
quicker perceptions of the beauty of the natural world, and
to preserve something like a true image of beautiful things
that pass away, or which you must yourself leave; if, also,
you wish to understand the minds of great painters, and to
be able to appreciate their work sincerely, seeing it for your-
self, and loving it, not merely taking up the thoughts of
other people about it; then I *can* help you, or, which is
better, show you how to help yourself.

2. Only you must understand, first of all, that these
powers, which indeed are noble and desirable, cannot be got
without work. It is much easier to learn to draw well, than
it is to learn to play well on any musical instrument; but
you know that it takes three or four years of practice, giving

[1] [Compare the paper on "Education in Art" in *A Joy for Ever*, § 153 (Vol. XVI.
p. 143).]

three or four hours a day, to acquire even ordinary command over the keys of a piano; and you must not think that a masterly command of your pencil, and the knowledge of what may be done with it, can be acquired without pains-taking, or in a *very* short time. The kind of drawing which is taught, or supposed to be taught, in our schools, in a term or two, perhaps at the rate of an hour's practice a week, is not drawing at all. It is only the performance of a few dexterous (not always even that) evolutions on paper with a black-lead pencil; profitless alike to performer and beholder, unless as a matter of vanity, and that the smallest possible vanity. If any young person, after being taught what is, in polite circles, called " drawing," will try to copy the commonest piece of real work—suppose a lithograph on the title-page of a new opera air, or a woodcut in the cheapest illustrated newspaper of the day,—they will find themselves entirely beaten. And yet that common lithograph was drawn with coarse chalk, much more difficult to manage than the pencil of which an accomplished young lady is supposed to have command; and that woodcut was drawn in urgent haste, and half spoiled in the cutting after-wards; and both were done by people whom nobody thinks of as artists, or praises for their power; both were done for daily bread, with no more artist's pride than any simple handicraftsmen feel in the work they live by.

3. Do not, therefore, think that you can learn drawing, any more than a new language, without some hard and disagreeable labour. But do not, on the other hand, if you are ready and willing to pay this price, fear that you may be unable to get on for want of special talent. It is in-deed true that the persons who have peculiar talent for art, draw instinctively, and get on almost without teaching; though never without toil. It is true, also, that of inferior talent for drawing there are many degrees: it will take one person a much longer time than another to attain the same results, and the results thus painfully attained are never quite so satisfactory as those got with greater ease

when the faculties are naturally adapted to the study. But I have never yet, in the experiments I have made, met with a person who could not learn to draw at all; and, in general, there is a satisfactory and available power in every one to learn drawing if he wishes, just as nearly all persons have the power of learning French, Latin, or arithmetic, in a decent and useful degree, if their lot in life requires them to possess such knowledge.

4. Supposing then that you are ready to take a certain amount of pains, and to bear a little irksomeness and a few disappointments bravely, I can promise you that an hour's practice a day for six months, or an hour's· practice every other day for twelve months, or, disposed in whatever way you find convenient, some hundred and fifty hours' practice, will give you sufficient power of drawing faithfully whatever you want to draw, and a good judgment, up to a certain point, of other people's work: of which hours if you have one to spare at present, we may as well begin at once.

<div align="center">EXERCISE I.</div>

5. Everything that you can see in the world around you, presents itself to your eyes only as an arrangement of patches of different colours variously shaded.* Some of

* (*N.B.*—This note is only for the satisfaction of incredulous or curious readers. You may miss it if you are in a hurry, or are willing to take the statement in the text on trust.)

The perception of solid Form is entirely a matter of experience. We *see* nothing but flat colours; and it is only by a series of experiments that we find out that a stain of black or grey indicates the dark side of a solid substance, or that a faint hue indicates that the object in which it appears is far away. The whole technical power of painting depends on our recovery of what may be called the *innocence of the eye*; that is to say, of a sort of childish perception of these flat stains of colour, merely as such, without consciousness of what they signify,—as a blind man would see them if suddenly gifted with sight.

For instance: when grass is lighted strongly by the sun in certain directions, it is turned from green into a peculiar and somewhat dusty-looking yellow. If we had been born blind, and were suddenly endowed with sight on a piece of grass thus lighted in some parts by the sun, it

these patches of colour have an appearance of lines or texture within them, as a piece of cloth or silk has of threads, or an animal's skin shows texture of hairs: but whether this be the case or not, the first broad aspect of the thing is that of a patch of some definite colour; and the first thing to be learned is, how to produce extents of smooth colour, without texture.

6. This can only be done properly with a brush; but a brush, being soft at the point, causes so much uncertainty in the touch of an unpractised hand, that it is hardly possible to learn to draw first with it, and it is better to take, in early practice, some instrument with a hard and fine point, both that we may give some support to the hand, and that by working over the subject with so delicate a point, the attention may be properly directed to all the most minute

would appear to us that part of the grass was green, and part a dusty yellow (very nearly of the colour of primroses); and, if there were primroses near, we should think that the sunlighted grass was another mass of plants of the same sulphur-yellow colour. We should try to gather some of them, and then find that the colour went away from the grass when we stood between it and the sun, but not from the primroses; and by a series of experiments we should find out that the sun was really the cause of the colour in the one,—not in the other. We go through such processes of experiment unconsciously in childhood; and having once come to conclusions touching the signification of certain colours, we always suppose that we *see* what we only know, and have hardly any consciousness of the real aspect of the signs we have learned to interpret. Very few people have any idea that sunlighted grass is yellow.

Now, a highly accomplished artist has always reduced himself as nearly as possible to this condition of infantine sight. He sees the colours of nature exactly as they are, and therefore perceives at once in the sun-lighted grass the precise relation between the two colours that form its shade and light. To him it does not seem shade and light, but bluish green barred with gold.

Strive, therefore, first of all, to convince yourself of this great fact about sight. This, in your hand, which you know by experience and touch to be a book, is to your eye nothing but a patch of white, variously gradated and spotted; this other thing near you, which by experience you know to be a table, is to your eye only a patch of brown, variously darkened and veined; and so on: and the whole art of Painting consists merely in perceiving the shape and depth of these patches of colour, and putting patches of the same size, depth, and shape on canvas. The only obstacle to the success of painting is, that many of the real colours are brighter and paler than it is possible to put on canvas: we must put darker ones to represent them.

parts of it. Even the best artists need occasionally to study subjects with a pointed instrument, in order thus to discipline their attention : and a beginner must be content to do so for a considerable period.

7. Also, observe that before we trouble ourselves about differences of colour, we must be able to lay on *one* colour properly, in whatever gradations of depth and whatever shapes we want. We will try, therefore, first to lay on tints or patches of grey, of whatever depth we want, with a pointed instrument. Take any finely pointed steel pen (one of Gillott's lithographic crowquills is best), and a piece of quite smooth, but not shining, note-paper, cream laid, and get some ink that has stood already some time in the inkstand, so as to be quite black, and as thick as it can be without clogging the pen. Take a rule, and draw four straight lines, so as to enclose a square, or nearly a square, about as large as *a*, Fig. 1. I say nearly a square, because it does not in

a *b*

Fig. 1

the least matter whether it is quite square or not, the object being merely to get a space enclosed by straight lines.

8. Now, try to fill in that square space with crossed lines, so completely and evenly that it shall look like a square patch of grey silk or cloth, cut out and laid on the white paper, as at *b*. Cover it quickly, first with straightish lines, in any direction you like, not troubling yourself to draw them much closer or neater than those in the square *a*. Let them quite dry before retouching them. (If you draw three or four squares side by side, you may always be going on with one while the others are drying.) Then cover these lines with others in a different direction, and let those dry ; then in another direction still, and let those dry. Always wait long enough to run no risk of blotting, and then draw the lines as quickly as you can. Each ought to be laid on as swiftly as the dash of the pen of a good writer ; but if you try to reach this great speed at

first, you will go over the edge of the square, which is a fault in this exercise. Yet it is better to do so now and then than to draw the lines very slowly; for if you do, the pen leaves a little dot of ink at the end of each line, and these dots spoil your work. So draw each line quickly, stopping always as nearly as you can at the edge of the square. The ends of lines which go over the edge are afterwards to be removed with the penknife, but not till you have done the whole work, otherwise you roughen the paper, and the next line that goes over the edge makes a blot.

9. When you have gone over the whole three or four times, you will find some parts of the square look darker than other parts. Now try to make the lighter parts as dark as the rest, so that the whole may be of equal depth or darkness. You will find, on examining the work, that where it looks darkest the lines are closest, or there are some much darker lines than elsewhere; therefore you must put in other lines, or little scratches and dots, *between* the lines in the paler parts; and where there are any very conspicuous dark lines, scratch them out lightly with the penknife, for the eye must not be attracted by any line in particular. The more carefully and delicately you fill in the little gaps and holes, the better; you will get on faster by doing two or three squares perfectly than a great many badly. As the tint gets closer and begins to look even, work with very little ink in your pen, so as hardly to make any mark on the paper; and at last, where it is too dark, use the edge of your penknife very lightly, and for some time, to wear it softly into an even tone. You will find that the greatest difficulty consists in getting evenness: one bit will always look darker than another bit of your square; or there will be a granulated and sandy look over the whole. When you find your paper quite rough and in a mess, give it up and begin another square, but do not rest satisfied till you have done your best with every square. The tint at last ought at least to be as close and even as that in *b*, Fig. 1. You will find, however, that it is very difficult to

get a pale tint; because, naturally, the ink lines necessary to produce a close tint at all, blacken the paper more than you want. You must get over this difficulty not so much by leaving the lines wide apart as by trying to draw them excessively fine, lightly and swiftly; being very cautious in filling in; and, at last, passing the penknife over the whole. By keeping several squares in progress at one time, and reserving your pen for the light one just when the ink is nearly exhausted, you may get on better. The paper ought, at last, to look lightly and evenly toned all over, with no lines distinctly visible.

<center>EXERCISE II.</center>

10. As this exercise in shading is very tiresome, it will be well to vary it by proceeding with another at the same time. The power of shading rightly depends mainly on lightness of hand and keenness of sight; but there are other qualities required in drawing, dependent not merely on lightness, but steadiness of hand; and the eye, to be perfect in its power, must be made accurate as well as keen, and not only see shrewdly, but measure justly.

11. Possess yourself therefore of any cheap work on botany containing *outline* plates of leaves and flowers, it does not matter whether bad or good: Baxter's *British Flowering Plants*[1] is quite good enough. Copy any of the simplest outlines, first with a soft pencil, following it, by the eye, as nearly as you can; if it does not look right in proportions, rub out and correct it, always by the eye, till you think it is right: when you have got it to your mind, lay tracing-paper on the book; on this paper trace the outline you have been copying, and apply it to your own; and having thus ascertained the faults, correct them all patiently, till you have got it as nearly accurate as may be. Work with

[1] [William Baxter (Curator of the Oxford Botanic Gardens): *British Phænogamous Botany; or, Figures and Descriptions of the genera of British Flowering Plants*, Oxford, 1834–1843, 6 vols.]

a very soft pencil, and do not rub out so hard* as to spoil
the surface of your paper; never mind how dirty the paper
gets, but do not roughen it; and let the false outlines alone
where they do not really interfere with the true one. It is
a good thing to accustom yourself to hew and shape your
drawing out of a dirty piece of paper. When you have got
it as right as you can, take a quill pen, not very fine at the
point; rest your hand on a book about an inch and a half
thick, so as to hold the pen long; and go over your pencil
outline with ink, raising your pen point as seldom as pos-
sible, and never leaning more heavily on one part of the line
than on another. In most outline drawings of the present
day, parts of the curves are thickened to give an effect of
shade; all such outlines are bad, but they will serve well
enough for your exercises, provided you do not imitate this
character: it is better, however, if you can, to choose a book
of pure outlines. It does not in the least matter whether
your pen outline be thin or thick; but it matters greatly
that it should be *equal,* not heavier in one place than in
another. The power to be obtained is that of drawing an
even line slowly and in any direction; all dashing lines, or
approximations to penmanship, are bad. The pen should, as
it were, walk slowly over the ground, and you should be
able at any moment to stop it, or to turn it in any other
direction, like a well-managed horse.

12. As soon as you can copy every curve *slowly* and
accurately, you have made satisfactory progress; but you
will find the difficulty is in the slowness. It is easy to draw
what appears to be a good line with a sweep of the hand, or

* Stale crumb of bread is better, if you are making a delicate drawing,
than India-rubber, for it disturbs the surface of the paper less: but it
crumbles about the room and makes a mess; and, besides, you waste the
good bread, which is wrong; and your drawing will not for a long while
be worth the crumbs. So use India-rubber very lightly; or, if heavily,
pressing it only, not passing it over the paper, and leave what pencil marks
will not come away so, without minding them. In a finished drawing the
uneffaced pencilling is often serviceable, helping the general tone, and en-
abling you to take out little bright lights.

with what is called freedom;* the real difficulty and master-
liness is in never letting the hand *be* free, but keeping it
under entire control at every part of the line.

13. Meantime, you are always to be going on with your
shaded squares, and chiefly with these, the outline exercises
being taken up only for rest.

As soon as you find you have some command of the

Fig. 2

pen as a shading instrument, and can lay a pale or dark tint
as you choose, try to produce gradated spaces like Fig. 2,
the dark tint passing gradually into the lighter ones. Nearly

* What is usually so much sought after under the term "freedom" is
the character of the drawing of a great master in a hurry, whose hand is
so thoroughly disciplined, that when pressed for time he can let it fly as it
will, and it will not go far wrong. But the hand of a great master at real
work is *never* free: its swiftest dash is under perfect government. Paul
Veronese or Tintoret could pause within a hair's-breadth of any appointed
mark, in their fastest touches; and follow, within a hair's-breadth, the
previously intended curve. You must never, therefore, aim at freedom.
It is not required of your drawing that it should be free, but that it should
be right; in time you will be able to do right easily, and then your work
will be free in the best sense; but there is no merit in doing wrong easily.

These remarks, however, do not apply to the lines used in shading,
which, it will be remembered, are to be made as quickly as possible. The
reason of this is, that the quicker a line is drawn, the lighter it is at the
ends, and therefore the more easily joined with other lines, and concealed
by them; the object in perfect shading being to conceal the lines as much
as possible.

And observe, in this exercise, the object is more to get firmness of hand
than accuracy of eye for outline; for there are no outlines in Nature, and
the ordinary student is sure to draw them falsely if he draws them at all.
Do not, therefore, be discouraged if you find mistakes continue to occur in
your outlines; be content at present if you find your hand gaining com-
mand over the curves.

xv.

all expression of form, in drawing, depends on your power of gradating delicately; and the gradation is always most skilful which passes from one tint into another very little paler. Draw, therefore, two parallel lines for limits to your work, as in Fig. 2, and try to gradate the shade evenly from white to black, passing over the greatest possible distance, yet so that every part of the band may have visible change in it. The perception of gradation is very deficient in all beginners (not to say, in many artists), and you will probably, for some time, think your gradation skilful enough, when it is quite patchy and imperfect. By getting a piece of grey shaded riband, and comparing it with your drawing, you may arrive, in early stages of your work, at a wholesome dissatisfaction with it. Widen your band little by little as you get more skilful, so as to give the gradation more lateral space, and accustom yourself at the same time to look for gradated spaces in Nature. The sky is the largest and the most beautiful; watch it at twilight, after the sun is down, and try to consider each pane of glass in the window you look through as a piece of paper coloured blue, or grey, or purple, as it happens to be, and observe how quietly and continuously the gradation extends over the space in the window, of one or two feet square. Observe the shades on the outside and inside of a common white cup or bowl, which make it look round and hollow;* and then on folds of white drapery; and thus gradually you will be led to observe the more subtle transitions of the light as it increases or declines on flat surfaces. At last, when your eye gets keen and true, you will see gradation on everything in Nature.

14. But it will not be in your power yet awhile to draw from any objects in which the gradations are varied and complicated; nor will it be a bad omen for your future progress, and for the use that art is to be made of by you,

* If you can get any pieces of dead white porcelain, not glazed, they will be useful models.

if the first thing at which you aim should be a little bit of sky. So take any narrow space of evening sky, that you can usually see, between the boughs of a tree, or between two chimneys, or through the corner of a pane in the window you like best to sit at, and try to gradate a little space of white paper as evenly as that is gradated—as *tenderly*, you cannot gradate it without colour, no, nor with colour either; but you may do it as evenly; or, if you get impatient with your spots and lines of ink, when you look at the beauty of the sky, the sense you will have gained of that beauty is something to be thankful for. But you ought not to be impatient with your pen and ink; for all great painters, however delicate their perception of colour, are fond of the peculiar effect of light which may be got in a pen-and-ink sketch, and in a woodcut, by the gleaming of the white paper between the black lines; and if you cannot gradate well with pure black lines, you will never gradate well with pale ones. By looking at any common woodcuts, in the cheap publications of the day, you may see how gradation is given to the sky by leaving the lines farther and farther apart; but you must make your lines as fine as you can, as well as far apart, towards the light; and do not try to make them long or straight, but let them cross irregularly in any direction easy to your hand, depending on nothing but their gradation for your effect. On this point of direction of lines, however, I shall have to tell you more, presently; in the meantime, do not trouble yourself about it.

EXERCISE IV.

15. As soon as you find you can gradate tolerably with the pen, take an H. or HH. pencil, using its point to produce shade, from the darkest possible to the palest, in exactly the same manner as the pen, lightening, however, now with India-rubber instead of the penknife. You will

find that all *pale* tints of shade are thus easily producible with great precision and tenderness, but that you cannot get the same dark power as with the pen and ink, and that the surface of the shade is apt to become glossy and metallic, or dirty-looking, or sandy. Persevere, however, in trying to bring it to evenness with the fine point, removing any single speck or line that may be too black, with the *point* of the knife: you must not scratch the whole with the knife as you do the ink. If you find the texture very speckled-looking, lighten it all over with India-rubber, and recover it again with sharp, and excessively fine touches of the pencil point, bringing the parts that are too pale to perfect evenness with the darker spots.

You cannot use the point too delicately or cunningly in doing this; work with it as if you were drawing the down on a butterfly's wing.

16. At this stage of your progress, if not before, you may be assured that some clever friend will come in, and hold up his hands in mocking amazement, and ask you who could set you to that " niggling "; and if you persevere in it, you will have to sustain considerable persecution from your artistical acquaintances generally, who will tell you that all good drawing depends on " boldness." But never mind them. You do not hear them tell a child, beginning music, to lay its little hand with a crash among the keys, in imitation of the great masters: yet they might, as reasonably as they may tell you to be bold in the present state of your knowledge.[1] Bold, in the sense of being undaunted, yes; but bold in the sense of being careless, confident, or exhibitory, — no,—no, and a thousand times no; for, even if you were not a beginner, it would be bad advice that made you bold. Mischief may easily be done quickly, but good and beautiful work is generally done slowly; you will find no boldness in the way a flower or a

[1] [So Leonardo in his *Treatise*, § 167, which is headed "Accuracy ought to be learnt before despatch in the execution."]

bird's wing is painted; and if Nature is not bold at her work, do you think you ought to be at yours? So never mind what people say, but work with your pencil point very patiently; and if you can trust me in anything, trust me when I tell you, that though there are all kinds and ways of art,—large work for large places, small work for narrow places, slow work for people who can wait, and quick work for people who cannot,—there is one quality, and, I think, only one, in which all great and good art agrees;— it is all delicate art. Coarse art is always bad art.[1] You cannot understand this at present, because you do not know yet how much tender thought, and subtle care, the great painters put into touches that at first look coarse; but, believe me, it is true, and you will find it is so in due time.

17. You will be perhaps also troubled, in these first essays at pencil drawing, by noticing that more delicate gradations are got in an instant by a chance touch of the India-rubber, than by an hour's labour with the point; and you may wonder why I tell you to produce tints so painfully, which might, it appears, be obtained with ease. But there are two reasons: the first, that when you come to draw forms, you must be able to gradate with absolute precision, in whatever place and direction you wish; not in any wise vaguely, as the India-rubber does it: and, secondly, that all natural shadows are more or less mingled with gleams of light. In the darkness of ground there is the light of the little pebbles or dust; in the darkness of foliage, the glitter of the leaves; in the darkness of flesh, trans- parency; in that of a stone, granulation: in every case there is some mingling of light, which cannot be repre- sented by the leaden tone which you get by rubbing, or by an instrument known to artists as the "stump." When you can manage the point properly, you will indeed be able to do much also with this instrument, or with your fingers;

[1] [See above, Preface, § 7, p. 14.]

but then you will have to retouch the flat tints afterwards, so as to put life and light into them, and that can only be done with the point. Labour on, therefore, courageously, with that only.

<div align="center">EXERCISE V.</div>

18. When you can manage to tint and gradate tenderly with the pencil point, get a good large alphabet, and try to *tint* the letters into shape with the pencil point. Do not outline them first, but measure their height and ex-

treme breadth with the compasses,[1] as *a b, a c,* Fig. 3, and then scratch in their shapes gradually; the letter A, enclosed within the lines, being in what Turner would have called a "state of for-

Fig. 3

wardness." Then, when you are satisfied with the shape of the letter, draw pen-and-ink lines firmly round the tint, as at *d,* and remove any touches outside the limit, first with the India-rubber, and then with the penknife, so that all may look clear and right. If you rub out any of the pencil inside the outline of the letter, retouch it, closing it up to the inked line. The straight lines of the outline are all to be ruled,* but the curved lines are to be drawn by

* Artists who glance at this book may be surprised at this permission. My chief reason is, that I think it more necessary that the pupil's eye should be trained to accurate perception of the relations of curve and right lines, by having the latter absolutely true, than that he should practise drawing straight lines. But also, I believe, though I am not quite sure of this, that he never *ought* to be able to draw a straight line. I do not believe a perfectly trained hand ever can draw a line without some curvature in it, or some variety of direction. Prout could draw a straight line, but I do not believe Raphael could, nor Tintoret. A great draughtsman can, as far as I have observed, draw every line *but* a straight one.

[1] [So in §§ 30 and 47, below, pp. 44, 51, the use of compasses is recommended; compare the Preface to *The Laws of Fésole,* below, p. 342.]

the eye and hand; and you will soon find what good practice there is in getting the curved letters, such as Bs, Cs, etc., to stand quite straight, and come into accurate form.

19. All these exercises are very irksome, and they are not to be persisted in alone; neither is it necessary to acquire perfect power in any of them. An entire master of the pencil or brush ought, indeed, to be able to draw any form at once, as Giotto his circle;[1] but such skill as this is only to be expected of the consummate master, having pencil in hand all his life, and all day long,—hence the force of Giotto's proof of his skill; and it is quite possible to draw very beautifully, without attaining even an approximation to such a power; the main point being, not that every line should be precisely what we intend or wish, but that the line which we intended or wished to draw should be right. If we always see rightly and mean rightly, we shall get on, though the hand may stagger a little; but if we mean wrongly, or mean nothing, it does not matter how firm the hand is. Do not therefore torment yourself because you cannot do as well as you would like; but work patiently, sure that every square and letter will give you a certain increase of power; and as soon as you can draw your letters pretty well, here is a more amusing exercise for you.

EXERCISE VI.

20. Choose any tree that you think pretty, which is nearly bare of leaves, and which you can see against the sky, or against a pale wall, or other light ground: it must not be against strong light, or you will find the looking at it hurt your eyes; nor must it be in sunshine, or you will be puzzled by the lights on the boughs. But the tree must be in shade; and the sky blue, or grey, or dull

[1] [The reference is to Vasari's story of the round O of Giotto, quoted in full by Ruskin in *Giotto and his Works in Padua*, § 5; referred to also at p. 372 below, and n *Queen of the Air*, § 144, and *Lectures on Art*, § 74.]

white. A wholly grey or rainy day is the best for this practice.

21. You will see that all the boughs of the tree are dark against the sky. Consider them as so many dark rivers, to be laid down in a map with absolute accuracy; and, without the least thought about the roundness of the stems, map them all out in flat shade, scrawling them in with pencil, just as you did the limbs of your letters; then correct and alter them, rubbing out and out again, never minding how much your paper is dirtied (only not destroying its surface), until every bough is exactly, or as near as your utmost power can bring it, right in curvature and in thickness. Look at the white interstices between them with as much scrupulousness as if they were little estates which you had to survey, and draw maps of, for some important lawsuit, involving heavy penalties if you cut the least bit of a corner off any of them, or give the hedge anywhere too deep a curve; and try continually to fancy the whole tree nothing but a flat ramification on a white ground. Do not take any trouble about the little twigs, which look like a confused network or mist; leave them all out,* drawing only the main branches as far as you can see them distinctly, your object at present being not to draw a tree, but to learn how to do so. When you have got the thing as nearly right as you can,—and it is better to make one good study, than twenty left unnecessarily inaccurate,—take your pen, and put a fine outline to all the boughs, as you did to your letter, taking care, as far as possible, to put the outline within the edge of the shade, so as not to make the boughs thicker: the main use of the outline is to affirm the whole more clearly; to do away with little accidental roughnesses and excrescences, and especially to mark where boughs cross, or come in front of each other, as at such points their

* Or, if you feel able to do so, scratch them in with confused quick touches, indicating the general shape of the cloud or mist of twigs round the main branches; but do not take much trouble about them.

arrangement in this kind of sketch is unintelligible without the outline. It may perfectly well happen that in Nature it should be less distinct than your outline will make it; but it is better in this kind of sketch to mark the facts clearly. The temptation is always to be slovenly and careless, and the outline is like a bridle,[1] and forces our indolence into attention and precision. The outline should be about the thickness of that in Fig. 4, which represents the ramification of a small stone pine, only I have not endeavoured to represent the pencil shading within the outline, as I could not easily express it in a woodcut; and you have nothing to do at present with the indication of foliage above, of which in another place. You may also draw your trees as much larger than this figure as you like; only, however large they

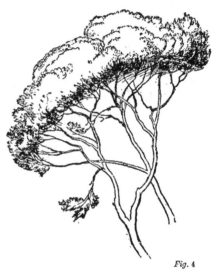

Fig. 4

may be, keep the outline as delicate, and draw the branches far enough into their outer sprays to give quite as slender ramification as you have in this figure, otherwise you do not get good enough practice out of them.

22. You cannot do too many studies of this kind: every one will give you some new notion about trees. But when you are tired of tree boughs, take any forms whatever which are drawn in flat colour, one upon another; as patterns on any kind of cloth, or flat china (tiles, for instance), executed in two colours only; and practise drawing

[1] [So Leonardo (§ 113): "Perspective is to painting what the bridle is to a horse."]

them of the right shape and size by the eye, and filling them in with shade of the depth required.

In doing this, you will first have to meet the difficulty of representing depth of colour by depth of shade. Thus a pattern of ultramarine blue will have to be represented by a darker tint of grey than a pattern of yellow.

23. And now it is both time for you to begin to learn the mechanical use of the brush; and necessary for you to do so in order to provide yourself with the gradated scale of colour which you will want. If you can, by any means, get acquainted with any ordinary skilful water-colour painter, and prevail on him to show you how to lay on tints with a brush, by all means do so; not that you are yet, nor for a long while yet, to begin to colour, but because the brush is often more convenient than the pencil for laying on masses or tints of shade, and the sooner you know how to manage it as an instrument the better. If, however, you have no opportunity of seeing how water-colour is laid on by a workman of any kind, the following directions will help you :—

EXERCISE VII.

24. Get a shilling cake of Prussian blue.[1] Dip the end of it in water so as to take up a drop, and rub it in a white saucer till you cannot rub much more, and the colour gets dark, thick, and oily-looking. Put two teaspoonfuls of water to the colour you have rubbed down, and mix it well up with a camel's-hair brush about three-quarters of an inch long.

25. Then take a piece of smooth, but not glossy, Bristol board or pasteboard; divide it, with your pencil and rule, into squares as large as those of the very largest chess-board: they need not be perfect squares, only as nearly so

[1] [So in §§ 121, 156, 163, colour in cakes is recommended. That was in 1857. Now that moist water-colours are sold in tubes, so that they can be set on the palette, clean every morning, the tubes are recommended (see *The Laws of Fésole*, x. 13, below, p. 469).—*Editor's note in index, ed. 1892 and later.*]

as you can quickly guess. Rest the pasteboard on something sloping as much as an ordinary desk; then, dipping your brush into the colour you have mixed, and taking up as much of the liquid as it will carry, begin at the top of one of the squares, and lay a pond or runlet of colour along the top edge. Lead this pond of colour gradually downwards, not faster at one place than another, but as if you were adding a row of bricks to a building, all along (only building down instead of up), dipping the brush frequently so as to keep the colour as full in that, and in as great quantity on the paper, as you can, so only that it does not run down anywhere in a little stream. But if it should, never mind; go on quietly with your square till you have covered it all in. When you get to the bottom, the colour will lodge there in a great wave. Have ready a piece of blotting-paper; dry your brush on it, and with the dry brush take up the superfluous colour as you would with a sponge, till it all looks even.

26. In leading the colour down, you will find your brush continually go over the edge of the square, or leave little gaps within it. Do not endeavour to retouch these, nor take much care about them; the great thing is to get the colour to lie smoothly where it reaches, not in alternate blots and pale patches; try, therefore, to lead it over the square as fast as possible, with such attention to your limit as you are able to give. The use of the exercise is, indeed, to enable you finally to strike the colour up to the limit with perfect accuracy; but the first thing is to get it even,—the power of rightly striking the edge comes only by time and practice: even the greatest artists rarely can do this quite perfectly.

27. When you have done one square, proceed to do another which does not communicate with it. When you have thus done all the alternate squares, as on a chessboard, turn the pasteboard upside down, begin again with the first, and put another coat over it, and so on over all the others. The use of turning the paper upside down

is to neutralise the increase of darkness towards the bottom of the squares, which would otherwise take place from the ponding of the colour.

28. Be resolved to use blotting-paper, or a piece of rag, instead of your lips, to dry the brush. The habit of doing so, once acquired, will save you from much partial poisoning. Take care, however, always to draw the brush from root to point, otherwise you will spoil it. You may even wipe it as you would a pen when you want it very dry, without doing harm, provided you do not crush it upwards. Get a good brush at first, and cherish it; it will serve you longer and better than many bad ones.

29. When you have done the squares all over again, do them a third time, always trying to keep your edges as neat as possible. When your colour is exhausted, mix more in the same proportions, two teaspoonfuls to as much as you can grind with a drop; and when you have done the alternate squares three times over, as the paper will be getting very damp, and dry more slowly, begin on the white squares, and bring them up to the same tint in the same way. The amount of jagged dark line which then will mark the limits of the squares will be the exact measure of your unskilfulness.

30. As soon as you tire of squares draw circles (with compasses); and then draw straight lines irregularly across circles, and fill up the spaces so produced between the straight line and the circumference; and then draw any simple shapes of leaves, according to the exercise No. II., and fill up those, until you can lay on colour quite evenly in any shape you want.

31. You will find in the course of this practice, as you cannot always put exactly the same quantity of water to the colour, that the darker the colour is, the more difficult it becomes to lay it on evenly. Therefore, when you have gained some definite degree of power, try to fill in the forms required with a full brush, and a dark tint, at once, instead of laying several coats one over another; always

taking care that the tint, however dark, be quite liquid; and that, after being laid on, so much of it is absorbed as to prevent its forming a black line at the edge as it dries. A little experience will teach you how apt the colour is to do this, and how to prevent it; not that it needs always to be prevented, for a great master in water-colours will sometimes draw a firm outline, when he *wants* one, simply by letting the colour dry in this way at the edge.

32. When, however, you begin to cover complicated forms with the darker colour, no rapidity will prevent the tint from drying irregularly as it is led on from part to part. You will then find the following method useful. Lay in the colour very pale and liquid; so pale, indeed, that you can only just see where it is on the paper. Lead it up to all the outlines, and make it precise in form, keeping it thoroughly wet everywhere. Then, when it is all in shape, take the darker colour, and lay some of it *into* the middle of the liquid colour. It will spread gradually in a branchy kind of way, and you may now lead it up to the outlines already determined, and play it with the brush till it fills its place well; then let it dry, and it will be as flat and pure as a single dash, yet defining all the complicated forms accurately.

33. Having thus obtained the power of laying on a tolerably flat tint, you must try to lay on a gradated one. Prepare the colour with three or four teaspoonfuls of water; then, when it is mixed, pour away about two thirds of it, keeping a teaspoonful of pale colour. Sloping your paper as before, draw two pencil lines all the way down, leaving a space between them of the width of a square on your chess-board. Begin at the top of your paper, between the lines; and having struck on the first brushful of colour, and led it down a little, dip your brush deep in water, and mix up the colour on the plate quickly with as much more water as the brush takes up at that one dip: then, with this paler colour, lead the tint farther down. Dip in water again, mix the colour again, and thus

lead down the tint, always dipping in water once between each replenishing of the brush, and stirring the colour on the plate well, but as quickly as you can. Go on until the colour has become so pale that you cannot see it; then wash your brush thoroughly in water, and carry the wave down a little farther with that, and then absorb it with the dry brush, and leave it to dry.

34. If you get to the bottom of your paper before your colour gets pale, you may either take longer paper, or begin, with the tint as it was when you left off, on another sheet; but be sure to exhaust it to pure whiteness at last. When all is quite dry, recommence at the top with another similar mixture of colour, and go down in the same way. Then again, and then again, and so continually until the colour at the top of the paper is as dark as your cake of Prussian blue, and passes down into pure white paper at the end of your column, with a perfectly smooth gradation from one into the other.

35. You will find at first that the paper gets mottled or wavy, instead of evenly gradated; this is because at some places you have taken up more water in your brush than at others, or not mixed it thoroughly on the plate, or led one tint too far before replenishing with the next. Practice only will enable you to do it well; the best artists cannot always get gradations of this kind quite to their minds; nor do they ever leave them on their pictures without after-touching.

36. As you get more power, and can strike the colour more quickly down, you will be able to gradate in less compass;* beginning with a small quantity of colour, and adding a drop of water, instead of a brushful; with finer brushes, also, you may gradate to a less scale. But slight skill will enable you to test the relations of colour to shade

* It is more difficult, at first, to get, in colour, a narrow gradation than an extended one; but the ultimate difficulty is, as with the pen, to make the gradation go *far*.

as far as is necessary for your immediate progress, which is to be done thus:—

37. Take cakes of lake, of gamboge, of sepia, of blue-black, of cobalt, and vermilion; and prepare gradated columns (exactly as you have done with the Prussian blue) of the lake and blue-black.* Cut a narrow slip, all the way down, of each gradated colour, and set the three slips side by side; fasten them down, and rule lines at equal distances across all the three, so as to divide them into fifty degrees, and number the degrees of each, from light to dark, 1, 2, 3, etc. If you have gradated them rightly, the darkest part either of the red or blue will be nearly equal in power to the darkest part of the blue-black, and any degree of the black slip will also, accurately enough for our purpose, balance in weight the degree similarly numbered in the red or the blue slip. Then, when you are drawing from objects of a crimson or blue colour, if you can match their colour by any compartment of the crimson or blue in your scales, the grey in the compartment of the grey scale marked with the same number is the grey which must represent that crimson or blue in your light and shade drawing.

38. Next, prepare scales with gamboge, cobalt, and vermilion. You will find that you cannot darken these beyond a certain point;† for yellow and scarlet, so long as they remain yellow and scarlet, cannot approach to black; we cannot have, properly speaking, a dark yellow or dark scarlet. Make your scales of full yellow, blue, and scarlet, half-way down; passing *then* gradually to white. Afterwards use lake to darken the upper half of the vermilion and gamboge; and Prussian blue to darken the cobalt. You will thus have three more scales, passing from white nearly to black, through yellow and orange, through

* Of course, all the columns of colour are to be of equal length.

† The degree of darkness you can reach with the given colour is always indicated by the colour of the solid cake in the box.

sky-blue, and through scarlet. By mixing the gamboge and
Prussian blue you may make another with green; mixing
the cobalt and lake, another with violet; the sepia alone
will make a forcible brown one; and so on, until you have
as many scales as you like, passing from black to white
through different colours. Then, supposing your scales
properly gradated and equally divided, the compartment or
degree No. 1 of the grey will represent in chiaroscuro the
No. 1 of all the other colours; No. 2 of grey the No. 2
of the other colours, and so on.

39. It is only necessary, however, in this matter that
you should understand the principle; for it would never
be possible for you to gradate your scales so truly as to
make them practically accurate and serviceable; and even
if you could, unless you had about ten thousand scales,
and were able to change them faster than ever juggler
changed cards, you could not in a day measure the tints
on so much as one side of a frost-bitten apple. But when
once you fully understand the principle, and see how all
colours contain as it were a certain quantity of darkness,
or power of dark relief from white—some more, some less;
and how this pitch or power of each may be represented
by equivalent values of grey, you will soon be able to
arrive shrewdly at an approximation by a glance of the
eye, without any measuring scale at all.

40. You must now go on, again with the pen, drawing
patterns, and any shapes of shade that you think pretty,
as veinings in marble or tortoiseshell, spots in surfaces of
shells, etc., as tenderly as you can, in the darknesses that
correspond to their colours; and when you find you can
do this successfully, it is time to begin rounding.

EXERCISE VIII.

41. Go out into your garden, or into the road, and pick
up the first round or oval stone you can find, not very
white, nor very dark; and the smoother it is the better,

only it must not *shine*. Draw your table near the window, and put the stone, which I will suppose is about the size of *a* in Fig. 5 (it had better not be much larger), on a piece of not very white paper, on the table in front of you. Sit so that the light may come from your left, else the shadow of the pencil point interferes with your sight of your work. You must not let the *sun* fall on the stone, but only ordinary light: therefore choose a window which the sun does not come in at.[1] If you can shut the shutters

b

Fig. 5

of the other windows in the room it will be all the better; but this is not of much consequence.

42. Now if you can draw that stone, you can draw anything;[2] I mean, anything that is drawable. Many things (sea foam, for instance) cannot be drawn at all, only the idea of them more or less suggested; but if you can draw the stone *rightly*, everything within reach of art is also within yours.[3]

[1] [Compare Leonardo, § 186: "To paint well from nature, your window should be to the north, that the lights may not vary. If it be to the south, you must have paper blinds, that the sun, in going round, may not alter the shadows. The situation of the light should be such as to produce upon the ground a shadow from your model as long as that is high."]

[2] [So in *Modern Painters*, vol. v. pt. vi. ch. v. § 2: "If you can paint *one* leaf, you can paint the world."]

[3] [For a discussion of stone-drawing, illustrated by various examples, see *Modern Painters*, vol. iv. ch. xviii. §§ 10 *seq.* (Vol. VI. pp. 370 *seq.*).]

For all drawing depends, primarily, on your power of representing *Roundness.* If you can once do that, all the rest is easy and straightforward; if you cannot do that, nothing else that you may be able to do will be of any use. For Nature is all made up of roundnesses; not the roundness of perfect globes, but of variously curved surfaces. Boughs are rounded, leaves are rounded, stones are rounded, clouds are rounded, cheeks are rounded, and curls are rounded: there is no more flatness in the natural world than there is vacancy. The world itself is round, and so is all that is in it, more or less, except human work, which is often very flat indeed.

Therefore, set yourself steadily to conquer that round stone, and you have won the battle.

43. Look your stone antagonist boldly in the face. You will see that the side of it next the window is lighter than most of the paper; that the side of it farthest from the window is darker than the paper; and that the light passes into the dark gradually, while a shadow is thrown to the right on the paper itself by the stone: the general appearance of things being more or less as in *a*, Fig. 5, the spots on the stone excepted, of which more presently.

44. Now, remember always what was stated in the outset, that everything you can see in Nature is seen only so far as it is lighter or darker than the things about it, or of a different colour from them. It is either seen as a patch of one colour on a ground of another; or as a pale thing relieved from a dark thing, or a dark thing from a pale thing. And if you can put on patches of colour or shade of exactly the same size, shape, and gradations as those on the object and its ground, you will produce the appearance of the object and its ground. The best draughtsmen—Titian and Paul Veronese themselves—could do no more than this; and you will soon be able to get some power of doing it in an inferior way, if you once understand the exceeding simplicity of what is to be done. Suppose you have a brown book on a white sheet of paper, on a red

tablecloth. You have nothing to do but to put on spaces of red, white, and brown, in the same shape, and gradated from dark to light in the same degrees, and your drawing is done. If you will not look at what you see, if you try to put on brighter or duller colours than are there, if you try to put them on with a dash or a blot, or to cover your paper with "vigorous" lines, or to produce anything, in fact, but the plain, unaffected, and finished tranquillity of the thing before you, you need not hope to get on. Nature will show you nothing if you set yourself up for her master. But forget yourself, and try to obey her, and you will find obedience easier and happier than you think.

45. The real difficulties are to get the refinement of the forms and the evenness of the gradations. You may depend upon it, when you are dissatisfied with your work, it is always too coarse or too uneven. It may not be wrong—in all probability is not wrong, in any (so-called) great point. But its edges are not true enough in outline; and its shades are in blotches, or scratches, or full of white holes. Get it more tender and more true, and you will find it is more powerful.[1]

46. Do not, therefore, think your drawing must be weak because you have a finely pointed pen in your hand. Till you can draw with that, you can draw with nothing; when you can draw with that, you can draw with a log of wood charred at the end. True boldness and power are only to be gained by care. Even in fencing and dancing, all ultimate ease depends on early precision in the commencement; much more in singing or drawing.

47. Now I do not want you to copy my sketch in Fig. 5, but to copy the stone before you in the way that my sketch is done. To which end, first measure the extreme length of the stone with compasses, and mark that

[1] [So Leonardo (§ 181): "Take care that the shadows and lights be united, or lost in each other; without any hard strokes or lines; as smoke loses itself in the air, so are your lights and shadows to pass from the one to the other, without any apparent separation."]

length on your paper; then, between the points marked, leave something like the form of the stone in light, scrawling the paper all over, round it; *b*, in Fig. 5, is a beginning of this kind.[1] Rather leave too much room for the high light, than too little; and then more cautiously fill in the shade, shutting the light gradually up, and putting in the dark slowly on the dark side. You need not plague yourself about accuracy of shape, because, till you have practised a great deal, it is impossible for you to draw the shape of the stone quite truly, and you must gradually gain correctness by means of these various exercises: what you have mainly to do at present is, to get the stone to look solid and round, not much minding what its exact contour is—only draw it as nearly right as you can without vexation; and you will get it more right by thus feeling your way to it in shade, than if you tried to draw the outline at first. For you can *see* no outline; what you see is only a certain space of gradated shade, with other such spaces about it; and those pieces of shade you are to imitate as nearly as you can, by scrawling the paper over till you get them to the right shape, with the same gradations which they have in Nature. And this is really more likely to be done well, if you have to fight your way through a little confusion in the sketch, than if you have an accurately traced outline. For instance, having sketched the fossil sea-urchin at *a*, in Fig. 5, whose form, though irregular, required more care in following than that of a common stone, I was going to draw it also under another effect;[2] reflected light bringing its dark side out from the background: but when I had laid on the first few touches I thought it would be better to stop, and let you see how I had begun it, at *b*. In which beginning it will be observed

[1] [Ed. 1 adds:—
"You cannot rightly see what the form of the stone really is till you begin finishing, so sketch it in quite rudely; only rather leave too *much* room for the high light . . ."]

[2] [Here ed. 1 reads simply:—
"For instance, I was going to draw, beside *a*, another effect on the stone; reflected light . . ."]

that nothing is so determined but that I can more or less modify, and add to or diminish the contour as I work on, the lines which suggest the outline being blended with the others if I do not want them; and the having to fill up the vacancies and conquer the irregularities of such a sketch will probably secure a higher completion at last, than if half an hour had been spent in getting a true outline before beginning.

48. In doing this, however, take care not to get the drawing too dark. In order to ascertain what the shades of it really are, cut a round hole, about half the size of a pea, in a piece of white paper the colour of that you use to draw on. Hold this bit of paper with the hole in it, between you and your stone; and pass the paper backwards and forwards, so as to see the different portions of the stone (or other subject) through the hole. You will find that, thus, the circular hole looks like one of the patches of colour you have been accustomed to match, only changing in depth as it lets different pieces of the stone be seen through it. You will be able thus actually to *match* the colour of the stone at any part of it, by tinting the paper beside the circular opening. And you will find that this opening never looks quite *black*, but that all the roundings of the stone are given by subdued greys.*

49. You will probably find, also, that some parts of the stone, or of the paper it lies on, look luminous through the opening; so that the little circle then tells as a light spot instead of a dark spot. When this is so, you cannot imitate it, for you have no means of getting light brighter than white paper: but by holding the paper more sloped towards the light, you will find that many parts of the stone, which before looked light through the hole, then look dark through it; and if you can place the paper in such a position that every part of the stone looks slightly dark, the little hole will tell always as a spot of shade, and

* The figure *a*, Fig. 5, is very dark, but this is to give an example of all kinds of depths of tint, without repeated figures.

if your drawing is put in the same light, you can imitate
or match every gradation. You will be amazed to find,
under these circumstances, how slight the differences of tint
are, by which, through infinite delicacy of gradation, Nature
can express form.

If any part of your subject will obstinately show itself
as a light through the hole, that part you need not hope
to imitate. Leave it white; you can do no more.

50. When you have done the best you can to get the
general form, proceed to finish, by imitating the texture
and all the cracks and stains of the stone as closely as you
can; and note, in doing this, that cracks or fissures of any
kind, whether between stones in walls, or in the grain of
timber or rocks, or in any of the thousand other conditions
they present, are never expressible by single black lines,
or lines of simple shadow. A crack must always have its
complete system of light and shade, however small its scale.
It is in reality a little ravine, with a dark or shady side,
and light or sunny side, and, usually, shadow in the bottom.
This is one of the instances in which it may be as well to
understand the reason of the appearance; it is not often so
in drawing, for the aspects of things are so subtle and con-
fused that they cannot in general be explained; and in the
endeavour to explain some, we are sure to lose sight of
others, while the natural over-estimate of the importance of
those on which the attention is fixed causes us to exaggerate
them, so that merely scientific draughtsmen caricature a third
part of Nature, and miss two thirds. The best scholar is
he whose eye is so keen as to see at once how the thing
looks, and who need not therefore trouble himself with any
reasons why it looks so: but few people have this acuteness
of perception; and to those who are destitute of it, a little
pointing out of rule and reason will be a help, especially
when a master is not near them. I never allow my
own pupils to ask the reason of anything, because, as I
watch their work, I can always show them how the thing
is, and what appearance they are missing in it; but when

a master is not by to direct the sight, science may, here
and there, be allowed to do so in his stead.

51. Generally, then, every solid illumined object—for in-
stance, the stone you are drawing—has a light side turned
towards the light, a dark side turned away from the light,
and a shadow, which is cast on something else (as by the
stone on the paper it is set upon). You may sometimes
be placed so as to see only the light side and shadow, some-
times only the dark side and shadow, and sometimes both
or either without the shadow; but in most positions solid
objects will show all the three, as the stone does here.

52. Hold up your hand with the edge of it towards you,
as you sit now with your side to the window, so that the
flat of your hand is turned to the window. You will see
one side of your hand distinctly lighted, the other distinctly
in shade. Here are light side and dark side, with no seen
shadow; the shadow being detached, perhaps on the table,
perhaps on the other side of the room; you need not look
for it at present.

53. Take a sheet of note-paper, and holding it edgewise,
as you hold your hand, wave it up and down past the side
of your hand which is turned from the light, the paper
being of course farther from the window. You will see, as
it passes, a strong gleam of light strike on your hand, and
light it considerably on its dark side. This light is *reflected*
light. It is thrown back from the paper (on which it strikes
first in coming from the window) to the surface of your
hand, just as a ball would be if somebody threw it through
the window at the wall and you caught it at the rebound.[1]

Next, instead of the note-paper, take a red book, or a
piece of scarlet cloth. You will see that the gleam of
light falling on your hand, as you wave the book, is now
reddened. Take a blue book, and you will find the gleam

[1] [So Leonardo (§ 213): "Reverberations are produced by all bodies of a bright
nature, that have a smooth and tolerably hard surface, which, repelling the light it
receives, makes it rebound like a football (*balzo della palla*) against the first object
opposed to it."]

is blue. Thus every object will cast some of its own colour back in the light that it reflects.

54. Now it is not only these books or papers that reflect light to your hand: every object in the room on that side of it reflects some, but more feebly, and the colours mixing all together form a neutral* light, which lets the colour of your hand itself be more distinctly seen than that of any object which reflects light to it; but if there were no reflected light, that side of your hand would look as black as a coal.

55. Objects are seen therefore, in general, partly by direct light, and partly by light reflected from the objects around them, or from the atmosphere and clouds. The colour of their light sides depends much on that of the direct light, and that of the dark sides on the colours of the objects near them. It is therefore impossible to say beforehand what colour an object will have at any point of its surface, that colour depending partly on its own tint, and partly on infinite combinations of rays reflected from other things. The only certain fact about dark sides is, that their colour will be changeful, and that a picture which gives them merely darker shades of the colour of the light sides must assuredly be bad.[1]

56. Now, lay your hand flat on the white paper you are drawing on. You will see one side of each finger lighted, one side dark, and the shadow of your hand on the paper. Here, therefore, are the three divisions of shade seen at once. And although the paper is white, and your hand of a rosy colour somewhat darker than white, yet you will see that the shadow all along, just under the finger

* Nearly neutral in ordinary circumstances, but yet with quite different tones in its neutrality, according to the colours of the various reflected rays that compose it.

[1] [Ultimately Ruskin found it advisable to direct beginners in his Oxford Drawing School to "shade simply with a deeper and (if you already know what the word means) a warmer tone of the colour you are using" (*Laws of Fésole*, viii. 9, below, p. 434), this being an approach to the practice of the Venetians, as opposed to that of the Bolognese and Roman schools (*Lectures on Art*, § 134).—*Editor's note in index*, ed. 1892 *and later*.]

which casts it, is darker than the flesh, and is of a very
deep grey. The reason of this is, that much light is re-
flected from the paper to the dark side of your finger, but
very little is reflected from other things to the paper itself
in that chink under your finger.

57. In general, for this reason, a shadow, or, at any
rate, the part of the shadow nearest the object, is darker
than the dark side of the object. I say in general, because
a thousand accidents may interfere to prevent its being so.
Take a little bit of glass, as a wine-glass, or the ink-bottle,
and play it about a little on the side of your hand farthest
from the window ; you will presently find you are throwing
gleams of light all over the dark side of your hand, and
in some positions of the glass the reflection from it will
annihilate the shadow altogether, and you will see your
hand dark on the white paper. Now a stupid painter
would represent, for instance, a drinking-glass beside the
hand of one of his figures, and because he had been taught
by rule that "shadow was darker than the dark side," he
would never think of the reflection from the glass, but
paint a dark grey under the hand, just as if no glass were
there. But a great painter would be sure to think of the
true effect, and paint it ; and then comes the stupid critic,
and wonders why the hand is so light on its dark side.

58. Thus it is always dangerous to assert anything as
a *rule* in matters of art ; yet it is useful for you to re-
member that, in a general way, a shadow is darker than the
dark side of the thing that casts it, supposing the colours
otherwise the same ; that is to say, when a white object
casts a shadow on a white surface, or a dark object on a
dark surface : the rule will not hold if the colours are
different, the shadow of a black object on a white surface
being, of course, not so dark, usually, as the black thing
casting it. The only way to ascertain the ultimate truth
in such matters is to *look* for it ; but, in the meantime,
you will be helped by noticing that the cracks in the stone
are little ravines, on one side of which the light strikes

sharply, while the other is in shade. This dark side usually casts a little darker shadow at the bottom of the crack; and the general tone of the stone surface is not so bright as the light bank of the ravine. And, therefore, if you get the surface of the object of a uniform tint, more or less indicative of shade, and then scratch out a white spot or streak in it of any shape; by putting a dark touch beside this white one, you may turn it, as you choose, into either a ridge or an incision, into either a boss or a cavity. If you put the dark touch on the side of it nearest the sun, or rather, nearest the place that the light comes from, you will make it a cut or cavity; if you put it on the opposite side, you will make it a ridge or mound; and the complete success of the effect depends less on depth of shade than on the rightness of the drawing; that is to say, on the evident correspondence of the form of the shadow with the form that casts it. In drawing rocks, or wood, or anything irregularly shaped, you will gain far more by a little patience in following the forms carefully, though with slight touches, than by laboured finishing of texture of surface and transparencies of shadow.

59. When you have got the whole well into shape, proceed to lay on the stains and spots with great care, quite as much as you gave to the forms. Very often, spots or bars of local colour do more to express form than even the light and shade, and they are always interesting as the means by which Nature carries light into her shadows, and shade into her lights; an art of which we shall have more to say hereafter, in speaking of composition. *a*, in Fig. 5, is a rough sketch of a fossil sea-urchin, in which the projections of the shell are of black flint, coming through a chalky surface. These projections form dark spots in the light; and their sides, rising out of the shadow, form smaller whiter spots in the dark. You may take such scattered lights as these out with the penknife, provided you are just as careful to place them rightly as if you got them by a more laborious process.

60. When you have once got the feeling of the way in which gradation expresses roundness and projection, you may try your strength on anything natural or artificial that happens to take your fancy, provided it be not too complicated in form. I have asked you to draw a stone first, because any irregularities and failures in your shading will be less offensive to you, as being partly characteristic of the rough stone surface, than they would be in a more delicate subject; and you may as well go on drawing rounded stones of different shapes for a little while, till you find you can really shade delicately. You may then take up folds of thick white drapery, a napkin or towel thrown carelessly on the table is as good as anything, and try to express them in the same way; only now you will find that your shades must be wrought with perfect unity and tenderness, or you will lose the flow of the folds. Always remember that a little bit perfected is worth more than many scrawls; whenever you feel yourself inclined to scrawl, give up work resolutely, and do not go back to it till next day. Of course your towel or napkin must be put on something that may be locked up, so that its folds shall not be disturbed till you have finished. If you find that the folds will not look right, get a photograph of a piece of drapery (there are plenty now to be bought, taken from the sculpture of the cathedrals of Rheims, Amiens, and Chartres, which will at once educate your hand and your taste), and copy some piece of that; you will then ascertain what it is that is wanting in your studies from Nature, whether more gradation, or greater watchfulness of the disposition of the folds. Probably for some time you will find yourself failing painfully in both, for drapery is very difficult to follow in its sweeps; but do not lose courage, for the greater the difficulty, the greater the gain in the effort. If your eye is more just in measurement of form than delicate in perception of tint, a pattern on the folded surface will help you. Try whether it does or not: and if the patterned drapery confuses you, keep for a time to the simple white one; but if

it helps you, continue to choose patterned stuffs (tartans and simple chequered designs are better at first than flowered ones), and even though it should confuse you, begin pretty soon to use a pattern occasionally, copying all the distortions and perspective modifications of it among the folds with scrupulous care.

61. Neither must you suppose yourself condescending in doing this. The greatest masters are always fond of drawing patterns; and the greater they are, the more pains they take to do it truly.* Nor can there be better practice at any time, as introductory to the nobler complication of natural detail. For when you can draw the spots which follow the folds of a printed stuff, you will have some chance of following the spots which fall into the folds of the skin of a leopard as he leaps; but if you cannot draw the manufacture, assuredly you will ' never be able to draw the creature. So the cloudings on a piece of wood, carefully drawn, will be the best introduction to the drawing of the clouds of the sky, or the waves of the sea; and the dead leaf-patterns on a damask drapery, well rendered, will enable you to disentangle masterfully the living leaf-patterns of a thorn thicket or a violet bank.

62. Observe, however, in drawing any stuffs, or bindings of books, or other finely textured substances, do not trouble yourself, as yet, much about the woolliness or gauziness of the thing; but get it right in shade and fold, and true in pattern. We shall see, in the course of after-practice, how the penned lines may be made indicative of texture; but at present attend only to the light and shade and pattern.

* If we had any business with the reasons of this, I might perhaps be able to show you some metaphysical ones for the enjoyment, by truly artistical minds, of the changes wrought by light and shade and perspective in patterned surfaces; but this is at present not to the point; and all that you need to know is that the drawing of such things is good exercise, and moreover a kind of exercise which Titian, Veronese, Tintoret, Giorgione, and Turner, all enjoyed, and strove to excel in.[1]

[1] [Compare *Inaugural Address at Cambridge*, § 10 (Vol. XVI.).]

You will be puzzled at first by *lustrous* surfaces, but a little attention will show you that the expression of these depends merely on the right drawing of their light and shade, and reflections. Put a small black ¡japanned tray on the table in front of some books; and you will see it reflects the objects beyond it as in a little black rippled pond; its own colour mingling always with that of the reflected objects. Draw these reflections of the books properly, making them dark and distorted, as you will see that they are, and you will find that this gives the lustre to your tray. It is not well, however, to draw polished objects in general practice; only you should do one or two in order to understand the aspect of any lustrous portion of other things, such as you cannot avoid; the gold, for instance, on the edges of books, or the shining of silk and damask, in which lies a great part of the expression of their folds. Observe also that there are very few things which are totally without lustre; you will frequently find a light which puzzles you, on some apparently dull surface, to be the dim image of another object.

63. And now, as soon as you can conscientiously assure me that with the point of the pen or pencil you can lay on any form and shade you like, I give you leave to use the brush with one colour,—sepia, or blue black, or mixed cobalt and blue black, or neutral tint; and this will much facilitate your study, and refresh you. But, preliminarily, you must do one or two more exercises in tinting.

EXERCISE IX.

64. Prepare your colour as directed for Exercise vii. Take a brush full of it, and strike it on the paper in any irregular shape; as the brush gets dry, sweep the surface of the paper with it as if you were dusting the paper very lightly; every such sweep of the brush will leave a number of more or less minute interstices in the colour. The lighter and faster every dash the better. Then leave the

whole to dry; and, as soon as it is dry, with little colour in your brush, so that you can bring it to a fine point, fill up all the little interstices one by one, so as to make the whole as even as you can, and fill in the larger gaps with more colour, always trying to let the edges of the first and of the newly applied colour exactly meet, and not lap over each other. When your new colour dries, you will find it in places a little paler than the first. Retouch it therefore, trying to get the whole to look quite one piece. A very small bit of colour thus filled up with your very best care, and brought to look as if it had been quite even from the first, will give you better practice and more skill than a great deal filled in carelessly; so do it with your best patience, not leaving the most minute spot of white; and do not fill in the large pieces first and then go to the small, but quietly and steadily cover in the whole up to a marked limit; then advance a little farther, and so on; thus always seeing distinctly what is done and what undone.

EXERCISE X.

65. Lay a coat of the blue, prepared as usual, over a whole square of paper. Let it dry. Then another coat over four fifths of the square, or thereabouts, leaving the edge rather irregular than straight, and let it dry. Then another coat over three fifths; another over two fifths; and the last over one fifth; so that the square may present the appearance of gradual increase in darkness in five bands, each darker than the one beyond it. Then, with the brush rather dry, (as in the former exercise, when filling up the interstices), try, with small touches, like those used in the pen etching, only a little broader, to add shade delicately beyond each edge, so as to lead the darker tints into the paler ones imperceptibly. By touching the paper very lightly, and putting a multitude of little touches, crossing and recrossing in every direction, you will gradually be

able to work up to the darker tints, outside of each, so as quite to efface their edges, and unite them tenderly with the next tint. The whole square, when done, should look evenly shaded from dark to pale, with no bars, only a crossing texture of touches, something like chopped straw, over the whole.*

66. Next, take your rounded pebble; arrange it in any light and shade you like; outline it very loosely with the pencil. Put on a wash of colour, prepared *very* pale, quite flat over all of it, except the highest light, leaving the edge of your colour quite sharp. Then another wash, extending only over the darker parts, leaving the edge of that sharp also, as in tinting the square. Then another wash over the still darker parts, and another over the darkest, leaving each edge to dry sharp. Then, with the small touches, efface the edges, reinforce the darks, and work the whole delicately together as you would with the pen, till you have got it to the likeness of the true light and shade. You will find that the tint underneath is a great help, and that you can now get effects much more subtle and complete than with the pen merely.

67. The use of leaving the edges always sharp is that you may not trouble or vex the colour, but let it lie as it falls suddenly on the paper: colour looks much more lovely when it has been laid on with a dash of the brush, and left to dry in its own way, than when it has been dragged about and disturbed; so that it is always better to let the edges and forms be a little wrong, even if one cannot correct them afterwards, than to lose this fresh quality of the tint. Very great masters in water colour can lay on the true forms at once with a dash, and bad masters in water colour lay on grossly false forms with a dash, and leave them false; for people in general, not knowing false from true, are as much pleased with the appearance of power in

* The use of acquiring this habit of execution is that you may be able, when you begin to colour, to let one hue be seen in minute portions, gleaming between the touches of another.

the irregular blot as with the presence of power in the determined one; but *we*, in our beginnings, must do as much as we can with the broad dash, and then correct with the point, till we are quite right. We must take care to be right, at whatever cost of pains; and then gradually we shall find we can be right with freedom.

68. I have hitherto limited you to colour mixed with two or three teaspoonfuls of water; but, in finishing your light and shade from the stone, you may, as you efface the edge of the palest coat towards the light, use the colour for the small touches with more and more water, till it is so pale as not to be perceptible. Thus you may obtain a perfect gradation to the light. And in reinforcing the darks, when they are very dark, you may use less and less water. If you take the colour tolerably dark on your brush, only always liquid (not pasty), and dash away the superfluous colour on blotting paper, you will find that, touching the paper very lightly with the dry brush, you can, by repeated touches, produce a dusty kind of bloom, very valuable in giving depth to shadow; but it requires great patience and delicacy of hand to do this properly. You will find much of this kind of work in the grounds and shadows of William Hunt's drawings.*

69. As you get used to the brush and colour, you will gradually find out their ways for yourself, and get the management of them. And you will often save[1] yourself much discouragement by remembering what I have so often asserted,[2]—that if anything goes wrong, it is nearly sure to be refinement that is wanting, not force; and connexion, not alteration. If you dislike the state your drawing is in, do not lose patience with it, nor dash at it, nor alter its

* William Hunt, of the Old Water-Colour Society.[3]

[1] [Ed. 1 reads :—
" . . . management of them. Nothing but practice will do this perfectly ; but you will often save . . ."]
[2] [See above, Preface, § 7, and §§ 16, 45.]
[3] [For whose technique, see Vol. XIV. pp. 376, 383, 437 ; *Two Paths*, § 69 (Vol. XVI.). See also § 175, below, p. 152.]

plan, nor rub it desperately out, at the place you think wrong; but look if there are no shadows you can gradate more perfectly; no little gaps and rents you can fill; no forms you can more delicately define: and do not *rush* at any of the errors or incompletions thus discerned, but efface or supply slowly, and you will soon find your drawing take another look. A very useful expedient in producing some effects, is to wet the paper, and then lay the colour on it, more or less wet, according to the effect you want. You will soon see how prettily it gradates itself as it dries; when dry, you can reinforce it with delicate stippling when you want it darker. Also, while the colour is still damp on the paper, by drying your brush thoroughly, and touching the colour with the brush so dried, you may take out soft lights with great tenderness and precision. Try all sorts of experiments of this kind, noticing how the colour behaves; but remembering always that your final results must be obtained, and can only be obtained, by pure work with the point, as much as in the pen drawing.

70. You will find also, as you deal with more and more complicated subjects, that Nature's resources in light and shade are so much richer than yours, that you cannot possibly get all, or anything like all, the gradations of shadow in any given group. When this is the case, determine first to keep the broad masses of things distinct: if, for instance, there is a green book, and a white piece of paper, and a black inkstand in the group, be sure to keep the white paper as a light mass, the green book as a middle tint mass, the black inkstand as a dark mass; and do not shade the folds in the paper, or corners of the book, so as to equal in depth the darkness of the inkstand. The great difference between the masters of light and shade, and imperfect artists, is the power of the former to draw so delicately as to express form in a dark-coloured object with little light, and in a light-coloured object with little darkness; and it is better even to leave the forms here and there unsatisfactorily rendered than to lose the general

xv. E

relations of the great masses. And this, observe, not be-
cause masses are grand or desirable things in your compo-
sitiou (for with composition at present you have nothing
whatever to do), but because it is a fact that things do so
present themselves to the eyes of men, and that we see
paper, book, and inkstand as three separate things, before
we see the wrinkles, or chinks, or corners of any of the
three. Understand, therefore, at once, that no detail can
be as strongly expressed in drawing as it is in reality; and
strive to keep all your shadows and marks and minor
markings on the masses, lighter than they appear to be in
Nature; you are sure otherwise to get them too dark. You
will in doing this find that you cannot get the projection
of things sufficiently shown; but never mind that; there is
no need that they should appear to project, but great need
that their relations of shade to each other should be pre-
served. All deceptive projection is obtained by partial ex-
aggeration of shadow; and whenever you see it, you may
be sure the drawing is more or less bad: a thoroughly fine
drawing or painting will always show a slight tendency
towards flatness.

71. Observe, on the other hand, that, however white an
object may be, there is always some small point of it whiter
than the rest. You must therefore have a slight tone of
grey over everything in your picture except on the extreme
high lights; even the piece of white paper, in your subject,
must be toned slightly down, unless (and there are thousand
chances against its being so) it should all be turned so as
fully to front the light. By examining the treatment of the
white objects in any pictures accessible to you by Paul
Veronese or Titian, you will soon understand this.*

* At Marlborough House, among the four principal examples of Turner's
later water-colour drawing, perhaps the most neglected was that of fishing-
boats and fish at sunset.[1] It is one of his most wonderful works, though

[1] [The reference is to the first exhibition of Turner's water-colour sketches; see
Vol. XIII. p. xxxiii. The drawing referred to is No. 372 in the National Gallery;
ibid., p. 97.]

72. As soon as you feel yourself capable of expressing with the brush the undulations of surfaces and the relations of masses, you may proceed to draw more complicated and beautiful things.* And first, the boughs of trees, now not in mere dark relief, but in full rounding. Take the first bit of branch or stump that comes to hand, with a fork in it; cut off the ends of the forking branches, so as to leave the whole only about a foot in length; get a piece of paper the same size, fix your bit of branch in some place where its position will not be altered, and draw it thoroughly, in all its light and shade, full size; striving, above all things, to get an accurate expression of its structure at the fork of the branch. When once you have mastered the tree at its arm-pits, you will have little more trouble with it.

73. Always draw whatever the background happens to be, exactly as you see it. Wherever you have fastened the bough, you must draw whatever is behind it, ugly or not, else you will never know whether the light and shade are right;[1] they may appear quite wrong to you, only for want of the background. And this general law is to be observed in all your studies: whatever you draw, draw completely and unalteringly, else you never know if what you have done is right, or whether you *could* have done it rightly had you tried. There is nothing *visible* out of which you may not get useful practice.

unfinished. If you examine the larger white fishing-boat sail, you will find it has a little spark of pure white in its right-hand upper corner, about as large as a minute pin's head, and that all the surface of the sail is gradated to that focus. Try to copy this sail once or twice, and you will begin to understand Turner's work. Similarly, the wing of the Cupid in Correggio's large picture in the National Gallery is focussed to two little grains of white at the top of it. The points of light on the white flower in the wreath round the head of the dancing child-faun, in Titian's Bacchus and Ariadne, exemplify the same thing.[2]

* I shall not henceforward number the exercises recommended; as they are distinguished only by increasing difficulty of subject, not by difference of method.

[1] [Compare Leonardo's *Treatise*, § 262.]
[2] [The Correggio is No. 10; the Titian, No. 35.]

74. Next, to put the leaves on your boughs. Gather a small twig with four or five leaves on it, put it into water, put a sheet of light-coloured or white paper behind it, so that all the leaves may be relieved in dark from the white field; then sketch in their dark shape carefully with pencil as you did the complicated boughs, in order to be sure that all their masses and interstices are right in shape before you begin shading, and complete as far as you can with pen and ink, in the manner of Fig. 6, which is a young shoot of lilac.

Fig. 6

75. You will probably, in spite of all your pattern drawings, be at first puzzled by leaf foreshortening; especially because the look of retirement or projection depends not so much on the perspective of the leaves themselves as on the double sight of the two eyes. Now there are certain artifices by which good painters can partly conquer this difficulty; as slight exaggerations of force or colour in the nearer parts, and of obscurity in the more distant ones; but you must not attempt anything of this kind. When you are first sketching the leaves, shut one of your eyes, fix a point in the background, to bring the point of one of the leaves against; and so sketch the whole bough as you see it in a fixed position, looking with one eye only. Your drawing never can be made to look like the object itself, as you see that object with *both* eyes,* but it can be made perfectly like the object seen with one, and you must be content when you have got a resemblance on these terms.

* If you understand the principle of the stereoscope you will know why; if not, it does not matter; trust me for the truth of the statement,

76. In order to get clearly at the notion of the thing to be done, take a single long leaf, hold it with its point towards you, and as flat as you can, so as to see nothing of it but its thinness, as if you wanted to know how thin it was; outline it so. Then slope it down gradually towards you, and watch it as it lengthens out to its full length, held perpendicularly down before you. Draw it in three or four different positions between these extremes, with its ribs as they appear in each position, and you will soon find out how it must be.

77. Draw first only two or three of the leaves; then larger clusters; and practise, in this way, more and more complicated pieces of bough and leafage, till you find you can master the most difficult arrangements, not consisting of more than ten or twelve leaves. You will find as you do this, if you have an opportunity of visiting any gallery of pictures, that you take a much more lively interest than before in the work of the great masters; you will see that very often their best backgrounds are composed of little more than a few sprays of leafage, carefully studied, brought against the distant sky; and that another wreath or two form the chief interest of their foregrounds. If you live in London you may test your progress *accurately* by the degree of admiration you feel for the leaves of vine round the head of the Bacchus, in Titian's Bacchus and Ariadne.[1] All this, however, will not enable you to draw a mass of foliage. You will find, on looking at any rich piece of vegetation, that it is only one or two of the nearer clusters that you can by any possibility draw

as I cannot explain the principle without diagrams and much loss of time.[2] See, however, Note 1, in Appendix I. [p. 215].

[1] [No. 35 in the National Gallery: see § 71 *n*., above, and compare *Academy Notes*, 1855 (Vol. XIV. p. 21).]

[2] [See the diagram in Leonardo's *Treatise* (§ 124), where he says . " Painters often despair of being able to imitate Nature, from observing, that their pictures have not the same relief, nor the same life, as natural objects have in a looking-glass. . . . It is impossible that objects in painting should appear with the same relief as those in the looking-glass, unless we look at them with only one eye."]

in this complete manner. The mass is too vast, and too intricate, to be thus dealt with.

78. You must now therefore have recourse to some confused mode of execution, capable of expressing the confusion of Nature. And, first, you must understand what the character of that confusion is. If you look carefully at the outer sprays of any tree at twenty or thirty yards' distance, you will see them defined against the sky in masses, which, at first, look quite definite; but if you examine them, you will see, mingled with the real shapes of leaves, many indistinct lines, which are, some of them, stalks of leaves, and some, leaves seen with the edge turned towards you, and coming into sight in a broken way; for, supposing the real leaf shape to be as at *a*, Fig. 7, this, when removed some yards from the eye, will appear dark against the sky, as at *b*; then, when removed some yards farther still, the stalk and point disappear altogether, the middle of the leaf becomes little more than a line; and the result is the condition at *c*, only with this farther subtlety in the look of it, inexpressible in the woodcut, that the stalk and point of the leaf, though they have disappeared to the eye, have yet some influence in *checking the light* at the places where they exist, and cause a slight dimness about the part of the leaf which remains visible, so that its perfect effect could only be rendered by two layers of colour, one subduing the sky tone a little, the next drawing the broken portions of the leaf, as at *c*, and carefully indicating the greater darkness of the spot in the middle, where the under side of the leaf is.

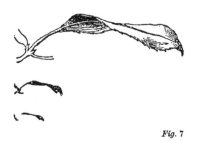

Fig. 7

This is the perfect theory of the matter. In practice we cannot reach such accuracy; but we shall be able to

render the general look of the foliage satisfactorily by the following mode of practice.

79. Gather a spray of any tree, about a foot or eighteen inches long. Fix it firmly by the stem in anything that will support it steadily; put it about eight feet away from you, or ten if you are far-sighted. Put a sheet of not very white paper behind it, as usual. Then draw very carefully, first placing them with pencil, and then filling them up with ink, every leaf-mass and stalk of it in simple black profile, as you see them against the paper: Fig. 8 is a bough of Phillyrea so drawn. Do not be afraid of running the leaves into a black mass when they come together; this exercise is only to teach you what the actual shapes of such masses are when seen against the sky.

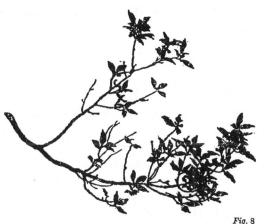

Fig. 8

80. Make two careful studies of this kind of one bough of every common tree,—oak, ash, elm, birch, beech, etc.; in fact, if you are good, and industrious, you will make one such study carefully at least three times a week, until you have examples of every sort of tree and shrub you can get branches of. You are to make two studies of each bough, for this reason,—all masses of foliage have an upper and under surface, and the side view of them, or profile, shows a wholly different organisation of branches from that seen in the view from above. They are generally seen more or less in profile, as you look at the whole tree, and Nature puts her best composition into the profile arrangement. But the view from above or below occurs not unfrequently,

also, and it is quite necessary you should draw it if you
wish to understand the anatomy of the tree. The difference
between the two views is often far greater than you could
easily conceive. For instance, in Fig. 9, *a* is the upper
view and *b* the profile, of a single spray of Phillyrea.
Fig. 8 is an intermediate view of a larger bough; seen
from beneath, but at some lateral distance also.

81. When you have done a few branches in this manner,
take one of the drawings you have made, and put it first
a yard away from you, then
a yard and a half, then
two yards; observe how the
thinner stalks and leaves
gradually disappear, leaving
only a vague and slight
darkness where they were;
and make another study of

Fig. 9

the effect at each distance, taking care to draw nothing
more than you really see, for in this consists all the dif-
ference between what would be merely a miniature draw-
ing of the leaves seen near, and a full-size drawing of
the same leaves at a distance. By full size, I mean the
size which they would really appear of if their outline were
traced through a pane of glass held at the same distance
from the eye at which you mean to hold your drawing.[1]
You can always ascertain this full size of any object by
holding your paper upright before you, at the distance
from your eye at which you wish your drawing to be
seen. Bring its edge across the object you have to draw,
and mark upon this edge the points where the outline of
the object crosses, or goes behind, the edge of the paper.
You will always find it, thus measured, smaller than you
supposed.

82. When you have made a few careful experiments
of this kind on your own drawings, (which are better for

[1] [Compare Leonardo's advice (§ 126): "Take a glass as large as your paper,
fasten it well between your eye and the object you mean to draw," etc.]

practice, at first, than the real trees, because the black pro-
file in the drawing is quite stable, and does not shake, and
is not confused by sparkles of lustre on the leaves,) you
may try the extremities of the real trees, only not doing
much at a time, for the brightness of the sky will dazzle
and perplex your sight. And this brightness causes, I be-
lieve, some loss of the outline itself; at least the chemical
action of the light in a photograph extends much within
the edges of the leaves, and, as it were, eats them away,
so that no tree extremity, stand it ever so still, nor any
other form coming against bright sky, is truly drawn by
a photograph; and if you once succeed in drawing a few
sprays rightly, you will find the result much more lovely
and interesting than any photograph can be.

83. All this difficulty, however, attaches to the rendering
merely the dark form of the sprays as they come against
the sky. Within those sprays, and in the heart of the tree,
there is a complexity of a much more embarrassing kind;
for nearly all leaves have some lustre, and all are more or
less translucent (letting light through them); therefore, in
any given leaf, besides the intricacies of its own proper
shadows and foreshortenings, there are three series of cir-
cumstances which alter or hide its forms. First, shadows
cast on it by other leaves,—often very forcibly. Secondly,
light reflected from its lustrous surface, sometimes the blue
of the sky, sometimes the white of clouds, or the sun itself
flashing like a star. Thirdly, forms and shadows of other
leaves, seen as darknesses through the translucent parts of
the leaf; a most important element of foliage effect, but
wholly neglected by landscape artists in general.

84. The consequence of all this is, that except now and
then by chance, the form of a complete leaf is never seen;
but a marvellous and quaint confusion, very definite, in-
deed, in its evidence of direction of growth, and unity of
action, but wholly indefinable and inextricable, part by part,
by any amount of patience. You cannot possibly work it
out in facsimile, though you took a twelvemonth's time to

a tree; and you must therefore try to discover some mode of execution which will more or less imitate, by its own variety and mystery, the variety and mystery of Nature, without absolute delineation of detail.

85. Now I have led you to this conclusion by observation of tree form only, because in that the thing to be proved is clearest. But no natural object exists which does not involve in some part or parts of it this inimitableness, this mystery of quantity, which needs peculiarity of handling and trick of touch to express it completely. If leaves are intricate, so is moss, so is foam, so is rock cleavage, so are fur and hair, and texture of drapery, and of clouds. And although methods and dexterities of handling are wholly useless if you have not gained first the thorough knowledge of the form of the thing; so that if you cannot draw a branch perfectly, then much less a tree; and if not a wreath of mist perfectly, much less a flock of clouds; and if not a single grass blade perfectly, much less a grass bank; yet having once got this power over decisive form, you may safely — and must, in order to perfection of work — carry out your knowledge by every aid of method and dexterity of hand.

86. But, in order to find out what method can do, you must now look at Art as well as at Nature, and see what means painters and engravers have actually employed for the expression of these subtleties. Whereupon arises the question, what opportunity you have to obtain engravings? You ought, if it is at all in your power, to possess yourself of a certain number of good examples of Turner's engraved works: if this be not in your power, you must just make the best use you can of, the shop windows, or of any plates of which you can obtain a loan. Very possibly, the difficulty of getting sight of them may stimulate you to put them to better use. But, supposing your means admit of your doing so, possess yourself, first, of the illustrated edition either of Rogers's *Italy* or Rogers's *Poems*, and then of about a dozen of the plates named in the annexed lists.

The prefixed letters indicate the particular points deserving your study in each engraving.* Be sure, therefore, that your selection includes, at all events, one plate marked with each letter.[1] Do not get more than twelve of these plates,

* The plates marked with a star are peculiarly desirable. See note at the end of Appendix I. [p. 217].[2] The letters mean as follows :—

a stands for architecture, including distant grouping of towns, cottages, etc.
c clouds, including mist and aerial effects.
f foliage.
g ground, including low hills, when not rocky.
l effects of light.
m mountains, or bold rocky ground.
p power of general arrangement and effect.
q quiet water.
r running or rough water; or rivers, even if calm, when their line of flow is beautifully marked.

From the " England Series."

a c f r.	Arundel.	*a g f*.	Launceston.*
a f l.	Ashby de la Zouche.	*c f l r*.	Leicester Abbey.
a l q r.	Barnard Castle.*	*f r*.	Ludlow.
f m r.	Bolton Abbey.	*a f l*.	Margate.
f g r.	Buckfastleigh.*	*a l* q.	Orford.
a l p.	Caernarvon.	*c p*.	Plymouth.
c l q.	Castle Upnor.	*f*.	Powis Castle.
a f l.	Colchester.	*l m* q.	Prudhoe Castle.
l q.	Cowes.	*f l m* r.	Chain Bridge over Tees.*
c f p.	Dartmouth Cove.*	*m* r.	High Force of Tees.*
c l q.	Flint Castle.*	*a f* q.	Trematon.
a f g l.	Knaresborough.*	*m* q.	Ulleswater.
a f p.	Lancaster.	*f m*.	Valle Crucis.
c l m r.	Lancaster Sands.*		

From the " Keepsake.

m p q.	Arona.	*p*.	St. Germain en Laye.
l m.	Drachenfels.*	*l p* q.	Florence.
f l.	Marly.*	*l m*.	Ballyburgh Ness.*

[1] [Ed. 1 adds here :—
" . . . each letter—of course the plates marked with two or three letters are, for the most part, the best. Do not . . ."]
[2] [For other references—in some cases very numerous—to these engraved drawings, see General Index. The years of the *Keepsake* containing the plates mentioned are 1829 (Arona, *i.e.*, Lago Maggiore "), 1832 (Marly and St. Germain en Laye), and 1828 (Florence). "Drachenfels" was engraved, not in the *Keepsake*, but in vol. 2 of Finden's *Landscape and Portrait Illustrations to the Life and Works of Byron* (1833); and "Ballyburgh Ness" in *The Prose Works of Scott*, 1834 (*The Antiquary*).]

nor even all the twelve at first; for the more engravings
you have, the less attention you will pay to them. It is a
general truth, that the enjoyment derivable from art cannot
be increased in quantity, beyond a certain point, by quantity
of possession; it is only spread, as it were, over a larger
surface, and very often dulled by finding ideas repeated in
different works.[1] Now, for a beginner, it is always better
that his attention should be concentrated on one or two
good things, and all his enjoyment founded on them, than
that he should look at many, with divided thoughts. He
has much to discover; and his best way of discovering it is
to think long over few things, and watch them earnestly.
It is one of the worst errors of this age to try to know and
to see too much: the men who seem to know everything,
never in reality know anything rightly. Beware of *hand-
book* knowledge.

87. These engravings are, in general, more for you to
look at than to copy; and they will be of more use to you

From the "Bible Series." [2]

f m. Mount Lebanon.	*c l p* q. Solomon's Pools.*
m. Rock of Moses at Sinai.	*a l.* Santa Saba.
a l m. Jericho.	*a l.* Pool of Bethesda.
a c g. Joppa.	

From "Scott's Works."

p r. Melrose.*	*c m.* Glencoe.
f r. Dryburgh.*	*c m.* Loch Coriskin.*
	a l. Caerlaverock.

From the "Rivers of France."

a q. Château of Amboise, with large bridge on right.	*a p.* Rouen Cathedral.
	f p. Pont de l'Arche.
l p r. Rouen, looking down the river, poplars on right.*	*f l p.* View on the Seine, with avenue.
a l p. Rouen, with cathedral and rainbow, avenue on left.	*a c p.* Bridge of Meulan.
	c g p r. Caudebec.*

[1] [A fact constantly insisted upon by Ruskin: see, for example, Vol. XIII. p. 501,
and Vol. XVI., Appendix i. § 4.]
[2] [See below, Appendix i. § 254, p. 217.]

when we come to talk of composition, than they are at present; still, it will do you a great deal of good, sometimes to try how far you can get their delicate texture, or gradations of tone: as your pen-and-ink drawing will be apt to incline too much to a scratchy and broken kind of shade. For instance, the texture of the white convent wall, and the drawing of its tiled roof, in the vignette at p. 227 of Rogers's *Poems*, is as exquisite as work can possibly be; and it will be a great and profitable achievement if you can at all approach it. In like manner, if you can at all imitate the dark distant country at p. 7, or the sky at p. 80, of the same volume, or the foliage at pp. 12 and 144, it will be good gain; and if you can once draw the rolling clouds and running river at p. 9 of the *Italy*, or the city in the vignette of Aosta at p. 25, or the moonlight at p. 223, you will find that even Nature herself cannot afterwards very terribly puzzle you with her torrents, or towers, or moonlight.[1]

88. You need not copy touch for touch, but try to get the same effect. And if you feel discouraged by the delicacy required, and begin to think that engraving is not drawing, and that copying it cannot help you to draw, remember that it differs from common drawing only by the difficulties it has to encounter. You perhaps have got into a careless habit of thinking that engraving is a mere business, easy enough when one has got into the knack of it. On the contrary, it is a form of drawing more difficult than common drawing, by exactly so much as it is more difficult to cut steel than to move the pencil over paper. It is true that there are certain mechanical aids and methods which reduce it at certain stages either to pure machine work, or to more or less a habit of hand and arm; but this is not so in the foliage you are trying to copy, of which the best

[1] [The drawings for all these vignettes are in the National Gallery. They are, in the order named, 246 ("Columbus at La Rabida"); 226 ("Twilight"); 230 ("Tornaro"); 231 ("Gipsies"); 243 ("The Falls at Vallombré"); 205 ("St. Maurice"); 203 ("Aosta"); and 223 ("Padua: moonlight").]

and prettiest parts are always etched—that is, drawn with a fine steel point and free hand : only the line made is white instead of black, which renders it much more difficult to judge of what you are about. And the trying to copy these plates will be good for you, because it will awaken you to the real labour and skill of the engraver, and make you understand a little how people must work, in this world, who have really to *do* anything in it.

89. Do not, however, suppose that I give you the engraving as a model—far from it; but it is necessary you should be able to do as well* before you think of doing better, and you will find many little helps and hints in the various work of it. Only remember that *all* engravers foregrounds are bad; whenever you see the peculiar wriggling parallel lines of modern engravings become distinct, you must not copy; nor admire : it is only the softer, masses, and distances, and portions of the foliage in the plates marked *f*, which you may copy. The best for this purpose, if you can get it, is the "Chain bridge over the Tees," of the England series; the thicket on the right is very beautiful and instructive, and very like Turner. The foliage in the "Ludlow" and "Powis" is also remarkably good.

90. Besides these line engravings, and to protect you from what harm there is in their influence, you are to provide yourself, if possible, with a Rembrandt etching, or a photograph of one (of figures, not landscape). It does not matter of what subject, or whether a sketchy or finished one, but the sketchy ones are generally cheapest, and will teach you most. Copy it as well as you can, noticing especially that Rembrandt's most rapid lines have steady purpose; and that they are laid with almost inconceivable precision when the object becomes at all interesting. The "Prodigal Son," "Death of the Virgin," "Abraham and

* As *well*;—not as minutely: the diamond cuts finer lines on the steel than you can draw on paper with your pen; but you must be able to get tones as even, and touches as firm.

Isaac,"[1] and such others, containing incident and character rather than chiaroscuro, will be the most instructive. You can buy one; copy it well; then exchange it, at little loss, for another; and so, gradually, obtain a good knowledge of his system. Whenever you have an opportunity of examining his work at museums, etc., do so with the greatest care, not looking at *many* things, but a long time at each. You must also provide yourself, if possible, with an engraving of Albert Dürer's. This you will not be able to copy; but you must keep it beside you, and refer to it as, a standard of precision in line. If you can get one with a *wing* in it, it will be best.[2] The crest with the cock, that with the skull and satyr, and the "Melancholy," are the best you could have, but any will do. Perfection in chiaroscuro drawing lies between these two masters, Rembrandt and Dürer. Rembrandt is often too loose and vague; and Dürer has little or no effect of mist or uncertainty. If you can see anywhere a drawing by Leonardo, you will find it balanced between the two characters; but there are no engravings which present this perfection, and your style will be best formed, therefore, by alternate study of Rembrandt and Dürer. Lean rather to Dürer; it is better, for amateurs, to err on the side of precision than on that of vagueness: and though, as I have just said, you cannot copy a Dürer, yet try every now and then a quarter of an inch square or so, and see how much nearer you can come; you cannot possibly try to draw the leafy crown of the "Melancholia" too often.

91. If you cannot get either a Rembrandt or a Dürer, you may still learn much by carefully studying any of George Cruikshank's etchings, or Leech's woodcuts in *Punch*,

[1] [Fine states of these etchings may be seen in the Print Room of the British Museum. The "Death of the Virgin" is dated 1639; "Abraham caressing Isaac," 1636; and the "Prodigal Son," 1636.]

[2] [See Fig. 49 in *Modern Painters*, vol. iv. (Vol. VI. p. 247). Fine states of the engravings by Dürer here mentioned may also be seen in the British Museum. A reproduction of the "Coat of Arms, with a Cock" is given at p. 55 of Lionel Cust's *Albert Dürer's Engravings*, 1894; for another reference to it, see *A Joy for Ever*, § 164 (Vol. XVI. p. 151). For other references to the "Melancholia," see Vol. VI. p. 64 n.]

on the free side; with Alfred Rethel's and Richter's* on the severe side. But in so doing you will need to notice the following points:

92. When either the material (as the copper or wood) or the time of an artist does not permit him to make a perfect drawing,—that is to say, one in which no lines shall be prominently visible,—and he is reduced to show the black lines, either drawn by the pen, or on the wood, it is better to make these lines help, as far as may be, the expression of texture and form. You will thus find many textures, as of cloth or grass or flesh, and many subtle effects of light, expressed by Leech with zigzag or crossed or curiously broken lines; and you will see that Alfred Rethel and Richter constantly express the direction and rounding of surfaces by the direction of the lines which shade them. All these various means of expression will be useful to you, as far as you can learn them, provided you remember that they are merely a kind of shorthand; telling certain facts not in quite the right way, but in the only possible way under the conditions: and provided in any after use of such means, you never try to show your own dexterity; but only to get as much record of the object as you can in a given time; and that you continually make efforts to go beyond such shorthand, and draw portions of the objects rightly.

93. And touching this question of direction of lines as indicating that of surface, observe these few points:

If lines are to be distinctly shown, it is better that, so far as they *can* indicate anything by their direction, they should explain rather than oppose the general character of the object. Thus, in the piece of woodcut from Titian, Fig. 10, the lines are serviceable by expressing, not only the shade of the trunk, but partly also its roundness, and the flow of its grain. And Albert Dürer, whose work

* See, for account of these plates, the Appendix on "Works to be studied."[1]

[1] [Below, pp. 222–224; but the Appendix is headed "Things to be Studied."]

was chiefly engraving, sets himself always thus to make his lines as *valuable* as possible; telling much by them, both of shade and direction of surface: and if you were always to be limited to engraving on copper (and did not want to express effects of mist or darkness, as well as delicate forms), Albert Dürer's way of work would be the best example for you. But, inasmuch as the perfect way of drawing is by shade without lines, and the great painters always conceive their subject as complete, even when they are sketching it most rapidly, you will find that, when they are not limited in means, they do not much trust to diree-

Fig. 10

tion of line, but will often scratch in the shade of a rounded surface with nearly straight lines, that is to say, with the easiest and quickest lines possible to themselves. When the hand is free, the easiest line for it to draw is one inclining from the left upwards to the right, or *vice versâ*, from the right downwards to the left; and when done very quickly, the line is hooked a little at the end by the effort at return to the next. Hence, you will always find the pencil, chalk, or pen sketch of a *very* great master full of these kind of lines; and even if he draws carefully, you will find him using simple straight lines from left to right, when an inferior master would have used curved ones. Fig. 11 is a fair facsimile of part of a sketch of Raphael's, which exhibits these characters very distinctly. Even the careful drawings of

Leonardo da Vinci are shaded most commonly with straight
lines; and you may always assume it as a point increasing
the probability of a drawing being by a great master if you
find rounded surfaces, such as
those of cheeks or lips, shaded
with straight lines.

94. But you will also now
understand how easy it must be
for dishonest dealers to forge or
imitate scrawled sketches like
Fig. 11, and pass them for the
work of great masters; and
how the power of determining
the genuineness of a drawing
depends entirely on your know-
ing the facts of the objects
drawn, and perceiving whether
the hasty handling is *all* con-
ducive to the expression of
those truths. In a great man's
work, at its fastest, no line is
thrown away, and it is not by
the rapidity, but the *economy* of
the execution that you know
him to be great. Now to
judge of this economy, you
must know exactly what he

Fig 11

meant to do, otherwise you cannot of course discern how
far he has done it; that is, you must know the beauty and
nature of the thing he was drawing. All judgment of art
thus finally founds itself on knowledge of Nature.

95. But farther observe, that this scrawled, or economic,
or impetuous execution is never affectedly impetuous. If
a great man is not in a hurry, he never pretends to be;
if he has no eagerness in his heart, he puts none into his
hand; if he thinks his effect would be better got with *two*
lines, he never, to show his dexterity, tries to do it with one.

Be assured, therefore (and this is a matter of great importance), that you will never produce a great drawing by imitating the execution of a great master. Acquire his knowledge and share his feelings, and the easy execution will fall from your hand as it did from his: but if you merely scrawl because he scrawled, or blot because he blotted, you will not only never advance in power, but every able draughtsman, and every judge whose opinion is worth having, will know you for a cheat, and despise you accordingly.

96. Again, observe respecting the use of outline:

All merely outlined drawings are bad, for the simple reason, that an artist of any power can always do more, and tell more, by quitting his outlines occasionally, and scratching in a few lines for shade, than he can by restricting himself to outline only. Hence the fact of his so restricting himself, whatever may be the occasion, shows him to be a bad draughtsman, and not to know how to apply his power economically. This hard law, however, bears only on drawings meant to remain in the state in which you see them; not on those which were meant to be proceeded with, or for some mechanical use. It is sometimes necessary to draw pure outlines, as an incipient arrangement of a composition, to be filled up afterwards with colour, or to be pricked through and used as patterns or tracings; but if, with no such ultimate object, making the drawing wholly for its own sake, and meaning it to remain in the state he leaves it, an artist restricts himself to outline, he is a bad draughtsman, and his work is bad. There is no exception to this law. A good artist habitually sees masses, not edges, and can in every case make his drawing more expressive (with any given quantity of work) by rapid shade than by contours; so that all good work whatever is more or less touched with shade, and more or less interrupted as outline.

97. Hence, the published works of Retzsch,[1] and all the

[1] [For whom, see Vol. IV. pp. 259, 371; Vol. XIII. p. 275; and *Art of England*, § 101.]

English imitations of them, and all outline engravings from pictures, are bad work, and only serve to corrupt the public taste. And of such outlines, the worst are those which are darkened in some part of their course by way of expressing the dark side, as Flaxman's from Dante,[1] and such others; because an outline can only be true so long as it accurately represents the form of the given object with *one* of its edges. Thus, the outline *a* and the outline *b*, Fig. 12, are both *true* outlines of a ball; because, however thick the line may be, whether we take the interior or exterior edge of it, that edge of it always draws a true circle. But *c* is a false outline of a ball, because either the inner or outer edge of the black line must be an untrue circle, else the line could not be thicker in one place than another. Hence all "force," as it is called, is gained by falsification of the contours; so that no artist whose eye is true and fine could endure to look at it. It does indeed often happen that a painter, sketching rapidly, and trying again and again for some line which he cannot quite strike, blackens or loads the first line by setting others beside and across it; and then a careless observer supposes it has been thickened on purpose: or, sometimes also, at a place where shade is afterwards to enclose the form, the painter will strike a broad dash of this shade beside his outline at once, looking as if he meant to thicken the outline; whereas this broad line is only the first instalment of the future shadow, and the outline is really drawn with its inner edge.* And thus, far from good draughtsmen darkening the lines which turn away from the light, the *tendency* with them is rather to darken them towards the light, for it is there in general that shade will ultimately enclose them. The best example of this treatment that I know is Raphael's sketch, in the Louvre, of the head of the

a b

c

Fig. 12

* See Note 2 in Appendix I. [p. 215].

[1] [For other criticisms of Flaxman's outlines in illustration of Dante, see *Modern Painters*, vol. iv. (Vol. VI. pp. 371–373).]

angel pursuing Heliodorus,[1] the one that shows part of the left eye; where the dark strong lines which terminate the nose and forehead towards the light are opposed to tender and light ones behind the ear, and in other places towards the shade. You will see in Fig. 11 the same principle variously exemplified; the principal dark lines, in the head and drapery of the arms, being on the side turned to the light.

98. All these refinements and ultimate principles, however, do not affect your drawing for the present. You must try to make your outlines as *equal* as possible; and employ pure outline only for the two following purposes: either (1.) to steady your hand, as in Exercise ii., for if you cannot draw the line itself, you will never be able to terminate your shadow in the precise shape required, when the line is absent; or (2.) to give you shorthand memoranda of forms, when you are pressed for time. Thus the forms of distant trees in groups are defined, for the most part, by the light edge of the rounded mass of the nearer one being shown against the darker part of the rounded mass of a more distant one; and to draw this properly, nearly as much work is required to round each tree as to round the stone in Fig. 5. Of course you cannot often get time to do this; but if you mark the terminal line of each tree as is done by Dürer in Fig. 13,[2] you will get a most useful memorandum of their arrangement, and a very interesting drawing. Only observe in doing this, you must not, because the procedure is a quick one, hurry that procedure itself. You will find, on copying that bit of Dürer, that every one of his lines is firm, deliberate, and accurately descriptive as far as it goes.

[1] [Ruskin had noted this point in studying the drawings in 1856. The entry in his diary (Paris, September 22) is this ·
> "I find in the Louvre drawings that no great artist *ever* can draw a straight line, it is always a little curved—so [a sketch]; if architectural, so [another sketch]; and that all the great men incline to draw the dark outline towards the light, and light towards dark; though there are many exceptions to this, it is clearly the tendency; and *vice versâ* of the inferior men. The clearest example is the head of the angel—Raphael's sketch—driving out Heliodorus; the one which shows the left eye, and is on the whole the finest drawing. The lip and forehead towards the light outlined with black; the ears and shadow behind the ear, in the shade quite pale."]

[2] [Part of the distance in Dürer's plate of "The Cannon"; for a further notice of it, see *Modern Painters*, vol. v. pt. ix. ch. iv. § 7.]

It means a bush of such a size and such a shape, definitely observed and set down; it contains a true "signalement."[1] of every nut-tree, and apple-tree, and higher bit of hedge, all round that village. If you have not time to draw thus carefully, do not draw at all—you are merely wasting your work and spoiling your taste. When you have had four or five years' practice you may be able to make useful memoranda at a rapid rate, but not yet; except sometimes of light and shade, in a way of which I will tell you presently. And

Fig. 13

this use of outline, note farther, is wholly confined to objects which have edges or limits. You can outline a tree or a stone, when it rises against another tree or stone; but you cannot outline folds in drapery, or waves in water; if these are to be expressed at all, it must be by some sort of shade, and therefore the rule that no good drawing can consist throughout of pure outline remains absolute. You see, in that woodcut of Dürer's, his reason for even limiting himself so much to outline as he has, in those distant woods and plains, is that he may leave them in bright light, to be thrown out still more by the dark sky and the dark village

[1]. [The technical term, in French law and science, for a schedule of particulars serving to identify an individual or a *genus.*]

spire: and the scene becomes real and sunny only by the addition of these shades.

99. Understanding, then, thus much of the use of outline, we will go back to our question about tree-drawing left unanswered at page 74.[1]

We were, you remember, in pursuit of mystery among the leaves. Now, it is quite easy to obtain mystery and disorder, to any extent; but the difficulty is to keep organization in the midst of mystery. And you will never succeed in doing this

Fig. 14

unless you lean always to the definite side, and allow yourself rarely to become quite vague, at least through all your early practice. So, after your single groups of leaves, your first step must be to conditions like Figs. 14 and 15, which are careful facsimiles of two portions of a beautiful woodcut of Dürer's, the "Flight into Egypt." Copy these carefully,—never mind how little at a time, but thoroughly; then trace the Dürer, and apply it to your drawing, and do not be content till the one fits the other, else your eye is not true enough to carry you safely through meshes of real leaves. And in the course of doing this, you will find that not a line nor dot of Dürer's can be displaced without harm; that all add to the effect, and either express something, or illumine something, or relieve something. If, afterwards,

Fig. 15

[1] [See also below, p. 111.]

you copy any of the pieces of modern tree-drawing, of which so many rich examples are given constantly in our cheap illustrated periodicals (any of the Christmas numbers of last year's *Illustrated News* or *Times*[1] are full of them),' you will see that, though good and forcible general effect is produced, the lines are thrown in by thousands without

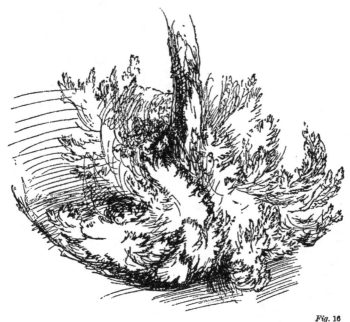

Fig. 16

special intention, and might just as well go one way as another, so only that there be enough of them to produce all together a well-shaped effect of intricacy: and you will find that a little careless scratching about with your pen will bring you very near the same result without an effort; but that no scratching of pen, nor any fortunate chance, nor anything but downright skill and thought, will imitate so much as one leaf of Dürer's. Yet there is considerable

[1] [The *Illustrated Times Weekly Newspaper*, 1855-1872.]

intricacy and glittering confusion in the interstices of those vine leaves of his, as well as of the grass.

100. When you have got familiarised to his firm manner, you may draw from Nature as much as you like in the same way; and when you are tired of the intense care required for this, you may fall into a little more easy massing of the leaves, as in Fig. 10 (p. 81). This is facsimilëd from an engraving after Titian, but an engraving not quite first-rate in manner, the leaves being a little too formal; still, it is a good enough model for your times of rest; and when you cannot carry the thing even so far as this, you may sketch the forms of the masses, as in Fig. 16,* taking care always to have thorough command over your hand; that is, not to let the mass take a free shape because your hand ran glibly over the paper, but because in Nature it has actually a free and noble shape, and you have ·faithfully followed the same.

101. And now that we have come to questions of noble shape, as well as true shape, and that we are going · to draw from Nature at our pleasure, other considerations enter into the business, which are by no means confined to first practice, but extend to all practice; these (as this letter is long enough, I should think, to satisfy even the most exacting of correspondents) I will arrange in a second letter; praying you only to excuse the tiresomeness of this first one—tiresomeness inseparable from directions touching the beginning of any art,—and to believe me, even though I am trying to set you to dull and hard work,

<div style="text-align:right">Very faithfully yours,
J. RUSKIN.</div>

* This sketch is not of a tree standing on its head, though it looks like it. You will find it explained presently.[1]

<div style="text-align:center">[1] [See below, § 104, p. 91.]</div>

LETTER II

SKETCHING FROM NATURE

102. · MY DEAR READER, — The work we have already gone through together has, I hope, enabled you to draw with fair success either rounded and simple masses, like stones, or complicated arrangements of form, like those of leaves; provided only these masses or complexities will stay quiet for you to copy, and do not extend into quantity so great as to baffle your patience. But if we are now to go out to the fields, and to draw anything like a complete landscape, neither of these conditions will any more be observed for us. The clouds will not wait while we copy their heaps or clefts; the shadows will escape from us as we try to shape them, each, in its stealthy minute march, still leaving light where its tremulous edge had rested the moment before, and involving in eclipse objects that had seemed safe from its influence; and instead of the small clusters of leaves which we could reckon point by point, embarrassing enough even though numerable, we have now leaves as little to be counted as the sands of the sea, and restless, perhaps, as its foam.

103. In all that we have to do now, therefore, direct imitation becomes more or less impossible. It is always to be aimed at so far as it *is* possible; and when you have time and opportunity, some portions of a landscape may, as you gain greater skill, be rendered with an approximation almost to mirrored portraiture. Still, whatever skill you may reach, there will always be need of judgment to choose, and of speed to seize, certain things that are principal or fugitive; and you must give more and more effort daily

90

to the observance of characteristic points, and the attainment of concise methods.

104. I have directed your attention early to foliage for two reasons, First, that it is always accessible as a study; and secondly, that its modes of growth present simple examples of the importance of leading or governing lines. It is by seizing these leading lines, when we cannot seize all, that likeness and expression are given to a portrait, and grace and a kind of vital truth to the rendering of every natural form. I call it vital truth, because these chief lines are always expressive of the past history and present action of the thing. They show in a mountain, first, how it was built or heaped up; and secondly, how it is now being worn away, and from what quarter the wildest storms strike it. In a tree, they show what kind of fortune it has had to endure from its childhood: how troublesome trees have come in its way, and pushed it aside, and tried to strangle or starve it; where and when kind trees have sheltered it, and grown up lovingly together with it, bending as it bent; what winds torment it most; what boughs of it behave best, and bear most fruit; and so on. In a wave or cloud, these leading lines show the run of the tide and of the wind, and the sort of change which the water or vapour is at any moment enduring in its form, as it meets shore, or counter-wave, or melting sunshine. Now remember, nothing distinguishes great men from inferior men more than their always, whether in life or in art, *knowing the way things are going.* Your dunce thinks they are standing still, and draws them all fixed; your wise man sees the change or changing in them, and draws them so,—the animal in its motion, the tree in its growth, the cloud in its course, the mountain in its wearing away. Try always, whenever you look at a form, to see the lines in it which have had power over its past fate and will have power over its futurity. Those are its *awful* lines; see that you seize on those, whatever else you miss. Thus, the leafage in Fig. 16 (p. 88) grew round the root of a stone pine, on the brow

of a crag at Sestri near Genoa, and all the sprays of it are thrust away in their first budding by the great rude root, and spring out in every direction round it, as water splashes when a heavy stone is thrown into it. Then, when they have got clear of the root, they begin to bend up again; some of them, being little stone pines themselves, have a great notion of growing upright, if they can; and this struggle of theirs to recover their straight road towards the sky, after being obliged to grow sideways in their early years, is the effort that will mainly influence their future destiny, and determine if they are to be crabbed, forky pines, striking from that rock of Sestri, whose clefts nourish them, with bared red lightning of angry arms towards the sea; or if they are to be goodly and solemn pines, with trunks like pillars of temples, and the purple burning of their branches sheathed in deep globes of cloudy green. Those, then, are their fateful lines; see that you give that spring and resilience, whatever you leave ungiven: depend upon it, their chief beauty is in these.

105. So in trees in general, and bushes, large or small, you will notice that, though the boughs spring irregularly and at various angles, there is a tendency in all to stoop less and less as they near the top of the tree. This structure, typified in the simplest possible terms at c, Fig. 17, is common to all trees that I know of, and it gives them a certain plumy character, and aspect of unity in the hearts of their branches, which are essential to their beauty. The stem does not merely send off a wild branch here and there to take its own way, but all the branches share in one great fountain-like impulse; each has a curve and a path to take, which fills a definite place, and each terminates all its minor branches at its outer extremity, so as to form a great outer curve, whose character and proportion are peculiar for each species. That is to say, the general type or idea of a tree is not as a, Fig. 17, but as b, in which, observe, the boughs all carry their minor divisions right out to the bounding curve; not but that smaller branches, by

thousands, terminate in the heart of the tree, but the idea and main purpose in every branch are to carry all its child branches well out to the air and light, and let each of them, however small, take its part in filling the united flow of the bounding curve, so that the type of each separate bough is again not *a*, but *b*, Fig. 18; approximating, that is to say, so far to the structure of a plant of broccoli as to throw the great mass of spray and leafage out to a rounded sur-

Fig. 17

face. Therefore beware of getting into a careless habit of drawing boughs with successive sweeps of the pen or brush, one hanging to the other, as in Fig. 19. If you look at the tree-boughs in any painting of Wilson's you will see this structure, and nearly every other that is to be avoided, in their intensest types.[1] You will also notice that Wilson never conceives a tree as a round mass, but flat, as if it had been pressed and dried. Most people in drawing pines seem to fancy, in the same way, that the boughs come out only on two sides of the trunk, instead of all round it: always, therefore, take more pains in trying to draw the boughs of trees that grow *towards* you than those that go off to the sides; any-body can draw the latter, but the fore-shortened ones are not so easy. It will

b

Fig. 18

help you in drawing them to observe that in most trees the ramification of each branch, though not of the tree itself, is more or less flattened, and approximates, in its position, to the look of a hand held out to receive something, or shelter something. If you take a looking-glass, and hold your hand

[1] [For the "two-pronged barbarisms of Wilson," see Vol. XIII. p. 145, and compare *Modern Painters*, vol. iii. ch. ix. (Vol. V. pp. 162 *seq.*).]

before it slightly hollowed, with the palm upwards, and the fingers open, as if you were going to support the base of some great bowl, larger than you could easily hold; and sketch your hand as you see it in the glass with the points of the fingers towards you; it will materially help you in understanding the way trees generally hold out their hands: and if then you will turn yours with its palm downwards, as if you were going to try to hide something, but with the fingers expanded, you will get a good type of the action of the lower boughs in cedars and such other spreading trees.

Fig. 19

106. Fig. 20 will give you a good idea of the simplest way in which these and other such facts can be rapidly expressed; if you copy it carefully, you will be surprised to find how the touches all group together, in expressing the plumy toss of the tree branches, and the springing of the bushes out of the bank, and the undulation of the ground: note the careful drawing of the footsteps made by the climbers of the little mound on the left.* It is facsimiléd from an etching of Turner's, and is as good an example as you can have of the use of pure and firm lines; it will also show you how the particular action in foliage, or anything else to which you wish to direct attention, may be intensified by the adjuncts. The tall and upright trees are made to look more tall and upright still, because their line is continued below by the figure of the farmer with his stick; and the rounded bushes on the bank are made to look more rounded because their line is continued in one broad sweep by the black dog and the boy climbing the wall. These figures are placed entirely with this object, as we shall see

* It is meant, I believe, for "Salt Hill." [1]

[1] [Fig. 20 is a portion of "Sheep-washing: Windsor from Slough," an unpublished plate for *Liber Studiorum*: see below, § 109 *n.*, p. 99. The drawing is No. 880 in the National Gallery. "Salt Hill" was the scene of the Eton "Montem."]

more fully hereafter when we come to talk about composi-
tion; but, if you please, we will not talk about that yet

Fig. 20

awhile. What I have been telling you about the beautiful
lines and action of foliage has nothing to do with compo-
sition, but only with fact, and the brief and expressive
representation of fact. But there will be no harm in your

looking forward, if you like to do so, to the account, in
Letter III., of the "Law of Radiation,"[1] and reading what
is said there about tree growth: indeed it would in some
respects have been better to have said it here than there,
only it would have broken up the account of the principles
of composition somewhat awkwardly.

107. Now, although the lines indicative of action are
not always quite so manifest in other things as in trees, a
little attention will soon enable you to see that there are
such lines in everything. In an old house roof, a bad ob-
server and bad draughtsman will only see and draw the
spotty irregularity of tiles or slates all over; but a good
draughtsman will see all the bends of the under timbers,
where they are weakest and the weight is telling on them
most, and the tracks of the run of the water in time of
rain, where it runs off fastest, and where it lies long and
feeds the moss; and he will be careful, however few slates
he draws, to mark the way they bend together towards
those hollows (which have the future fate of the roof in
them), and crowd gradually together at the top of the gable,
partly diminishing in perspective, partly, perhaps, diminished
on purpose (they are so in most English old houses) by the
slate-layer. So in ground, there is always the direction of
the run of the water to be noticed, which rounds the earth
and cuts it into hollows; and, generally, in any bank or
height worth drawing, a trace of bedded or other internal
structure besides. Figure 20 will give you some idea of
the way in which such facts may be expressed by a few
lines. Do you not feel the depression in the ground all
down the hill where the footsteps are, and how the people
always turn to the left at the top, losing breath a little, and
then how the water runs down in that other hollow towards
the valley, behind the roots of the trees?

108. Now, I want you in your first sketches from Nature
to aim exclusively at understanding and representing these

[1] [Below, p. 180.]

vital facts of form; using the pen—not now the steel, but the quill—firmly and steadily, never scrawling with it, but saying to yourself before you lay on a single touch,—"*that* leaf is the main one, *that* bough is the guiding one, and this touch, *so* long, *so* broad, means that part of it,"—point or side or knot, as the case may be. Resolve always, as you look at the thing, what you will take, and what miss of it, and never let your hand run away with you, or get into any habit or method of touch. If you want a continuous line, your hand should pass calmly from one end of it to the other without a tremor; if you want a shaking and broken line, your hand should shake, or break off, as easily as a musician's finger shakes or stops on a note: only remember this, that there is no general way of doing *any* thing; no recipe can be given you for so much as the drawing of a cluster of grass. The grass may be ragged and stiff, or tender and flowing; sunburnt and sheep-bitten, or rank and languid; fresh or dry; lustrous or dull: look at it, and try to draw it as it is, and don't think how somebody "told you to *do* grass." So a stone may be round or angular, polished or rough, cracked all over like an ill-glazed teacup, or as united and broad as the breast of Hercules. It may be as flaky as a wafer, as powdery as a field puffball; it may be knotted like a ship's hawser, or kneaded like hammered iron, or knit like a Damascus sabre, or fused like a glass bottle, or crystallised like hoar-frost, or veined like a forest leaf: look at it, and don't try to remember how anybody told you to "do a stone."

109. As soon as you find that your hand obeys you thoroughly, and that you can render any form with a firmness and truth approaching that of Turner's or Dürer's work,* you must add a simple but equally careful light and shade to your pen drawing, so as to make each study as complete as possible; for which you must prepare yourself

* I do not mean that you can approach Turner or Dürer in their strength, that is to say, in their imagination or power of design. But you may approach them, by perseverance, in truth of manner.

thus. Get, if you have the means, a good impression of one plate of Turner's Liber Studiorum; if possible, one of the subjects named in the note below.* If you cannot obtain, or even borrow for a little while, any of these engravings, you must use a photograph instead (how, I will

* The following are the most desirable plates :—

Grande Chartreuse.	Pembury Mill.
Æsacus and Hesperic.	Little Devil's Bridge.
Cephalus and Procris.	River Wye (not Wye and Severn).
Source of Arveron.	Holy Island.
Ben Arthur.	Clyde.
Watermill.	Lauffenburg.
Hindhead Hill.	Blair Athol.
Hedging and Ditching.	Alps from Grenoble.
Dunblane Abbey.	Raglan. (Subject with quiet
Morpeth.	brook, trees, and castle on the
Calais Pier.	right.)

If you cannot get one of these, any of the others will be serviceable except only the twelve following, which are quite useless :—

1. Scene in Italy, with goats on a walled road, and trees above.
2. Interior of church.
3. Scene with bridge, and trees above; figures on left, one playing a pipe.
4. Scene with figure playing on tambourine.
5. Scene on Thames with high trees, and a square tower of a church seen through them.
6. Fifth Plague of Egypt.
7. Tenth Plague of Egypt.
8. Rivaulx Abbey.
9. Wye and Severn.
10. Scene with castle in centre, cows under trees on the left.
11. Martello Towers.
12. Calm.

It is very unlikely that you should meet with one of the original etchings; if you should, it will be a drawing-master in itself alone, for it is not only equivalent to a pen-and-ink drawing by Turner, but to a very careful one; only observe, the Source of Arveron, Raglan, and Dunblane were not etched by Turner; and the etchings of those three are not good for separate study, though it is deeply interesting to see how Turner, apparently provoked at the failure of the beginnings in the Arveron and Raglan, took the plates up himself, and either conquered or brought into use the bad etching by his marvellous engraving. The Dunblane was, however, well etched by Mr. Lupton, and beautifully engraved by him. The finest Turner etching is of an aqueduct with a stork standing in a mountain stream, not in the published series; and next to it, are the

tell you presently); but, if you can get the Turner, it will be best. You will see that it is composed of a firm etching in line, with mezzotint shadow laid over it. You must first copy the etched part of it accurately; to which end put the print against the window, and trace slowly with the greatest care every black line; retrace this on smooth drawing-paper; and, finally, go over the whole with your pen, looking at the original plate always, so that if you err at all, it may be on the right side, not making a line which is too curved or too straight already in the tracing, more curved or more straight, as you go over it. And in doing this, never work after you are tired, nor to " get the thing done," for if it is badly done, it will be of no use to you. The true zeal and patience of a quarter of an hour are better than the sulky and inattentive labour of a whole day. If you have not made the touches right at the first going over with the pen, retouch them delicately, with little ink in your pen, thickening or reinforcing them as they need: you cannot give too much care to the facsimile. Then keep this etched outline by you in order to study at your ease the way in which Turner uses his line as preparatory for the subsequent shadow; * it is only in getting the two separate that you will be able to reason on this. Next, copy once more, though for the fourth time, any part of this etching which

unpublished etchings of the Via Mala[1] and Crowhurst. Turner seems to have been so fond of these plates that he kept retouching and finishing them, and never made up his mind to let them go. The Via Mala is certainly, in the state in which Turner left it, the finest of the whole series : its etching is, as I said, the best after that of the aqueduct. Figure 20, above, is part of another fine unpublished etching, "Windsor, from Salt Hill." Of the published etchings, the finest are the Ben Arthur, Æsacus, Cephalus, and Stone Pines, with the Girl washing at a Cistern ; the three latter are the more generally instructive. Hindhead Hill, Isis, Jason, and Morpeth, are also very desirable.

* You will find more notice of this point in the account of Harding's tree-drawing, a little farther on [p. 113].

[1] [This is the plate more correctly called "Swiss Bridge, Mont St. Gothard" : see *Modern Painters*, vol. iv. (Vol. VI. p. 40), and Fig. 1 (which is a representation of a p of it). See also Vol. XIII. p. 96. The "Stone Pines, etc." is usually called 6rthymph at a Well."]

you like, and put on the light and shade with the brush, and any brown colour that matches that of the plate; * working it with the point of the brush as delicately as if you were drawing with pencil, and dotting and cross-hatching as lightly as you can touch the paper, till you get the gradations of Turner's engraving.

110. In this exercise, as in the former one, a quarter of an inch worked to close resemblance of the copy is worth more than the whole subject carelessly done. Not that in drawing afterwards from Nature you are to be obliged to finish every gradation in this way, but that, once having fully accomplished the drawing *something* rightly, you will thenceforward feel and aim at a higher perfection than you could otherwise have conceived, and the brush will obey you, and bring out quickly and clearly the loveliest results, with a submissiveness which it would have wholly refused if you had not put it to severest work. Nothing is more strange in art than the way that chance and materials seem to favour you, when once you have thoroughly conquered them. Make yourself quite independent of chance, get your result in spite of it, and from that day forward all things will somehow fall as you would have them. Show the camel's hair, and the colour in it, that no bending nor blotting is of any use to escape your will; that the touch and the shade *shall* finally be right, if it costs you a year's toil; and from that hour of corrective conviction, said camel's hair will bend itself to all your wishes, and no blot will dare to transgress its appointed border. If you cannot obtain a print from the Liber Studiorum, get a photograph † of some general landscape subject, with high hills and a village or picturesque town, in the middle distance, and some calm water of varied character (a stream with stones in it, if possible), and copy any part

* The impressions vary so much in colour that no brown can be specified.

† You had better get such a photograph, even though you have a Liber print as well.

of it you like, in this same brown colour, working, as I have just directed you to do from the Liber, a great deal with the point of the brush. You are under a twofold disadvantage here, however; first, there are portions in every photograph too delicately done for you at present to be at all able to copy; and, secondly, there are portions always more obscure or dark than there would be in the real scene, and involved in a mystery which you will not be able, as yet, to decipher. Both these characters will be advantageous to you for future study, after you have gained experience, but they are a little against you in early attempts at tinting; still you must fight through the difficulty, and get the power of producing delicate gradations with brown or grey, like those of the photograph.

111. Now observe; the perfection of work would be tinted shadow, like photography, without any obscurity or exaggerated darkness; and as long as your effect depends in anywise on visible lines, your art is not perfect, though it may be first-rate of its kind. But to get complete results in tints merely, requires both long time and consummate skill; and you will find that a few well-put pen lines, with a tint dashed over or under them, get more expression of facts than you could reach in any other way, by the same expenditure of time. The use of the Liber Studiorum print to you is chiefly as an example of the simplest shorthand of this kind, a shorthand which is yet capable of dealing with the most subtle natural effects; for the firm etching gets at the expression of complicated details, as leaves, masonry, textures of ground, etc., while the overlaid tint enables you to express the most tender distances of sky, and forms of playing light, mist, or cloud. Most of the best drawings by the old masters are executed on this principle, the touches of the pen being useful also to give a look of transparency to shadows, which could not otherwise be attained but by great finish of tinting; and if you have access to any ordinarily good

public gallery, or can make friends of any printsellers who have folios either of old drawings, or facsimiles of them, you will not be at a loss to find some example of this unity of pen with tinting. Multitudes of photographs also are now taken from the best drawings by the old masters, and I hope that our Mechanics' Institutes, and other societies organised with a view to public instruction, will not fail to possess themselves of examples of these, and to make them accessible to students of drawing in the vicinity; a single print from Turner's Liber, to show the unison of tint with pen etching, and the "St. Catherine," photographed by Thurston Thompson[1] from Raphael's drawing in the Louvre, to show the unity of the soft tinting of the stump with chalk, would be all that is necessary, and would, I believe, be in many cases more serviceable than a larger collection, and certainly than a whole gallery of second-rate prints. Two such examples are peculiarly desirable, because all other modes of drawing, with pen separately, or chalk separately, or colour separately, may be seen by the poorest student in any cheap illustrated book, or in shop windows. But this unity of tinting with line he cannot generally see but by some special enquiry, and in some out of the way places he could not find a single example of it. Supposing that this should be so in your own case, and that you cannot meet with any example of this kind, try to make the matter out alone, thus:

112. Take a small and simple photograph; allow yourself half an hour to express its subjects with the pen only, using some permanent liquid colour instead of ink, outlining its buildings or trees firmly, and laying in the deeper shadows, as you have been accustomed to do in your bolder pen drawings; then, when this etching is dry, take your sepia or grey, and tint it over, getting now the finer gradations of the photograph; and finally taking out the higher lights

[1] [For Thompson, see Vol. XII. p. 7 n.; and for the head of St. Catherine, Vol. XII. p. 488.]

with penknife or blotting paper. You will soon find what
can be done in this way; and by a series of experiments
you may ascertain for yourself how far the pen may be
made serviceable to reinforce shadows, mark characters of
texture, outline unintelligible masses, and so on. The more
time you have, the more delicate you may make the pen
drawing, blending it with the tint; the less you have, the
more distinct you must keep the two. Practise in this way
from one photograph, allowing yourself sometimes only a
quarter of an hour for the whole thing, sometimes an hour,
sometimes two or three hours; in each case drawing the
whole subject in full depth of light and shade, but with
such degree of finish in the parts as is possible in the
given time. And this exercise, observe, you will do well
to repeat frequently, whether you can get prints and draw-
ings as well as photographs, or not.

113. And now at last, when you can copy a piece of
Liber Studiorum, or its photographic substitute, faithfully,
you have the complete means in your power of working
from Nature on all subjects that interest you, which you
should do in four different ways.

First. When you have full time, and your subject is
one that will stay quiet for you, make perfect light and
shade studies, or as nearly perfect as you can, with grey or
brown colour of any kind, reinforced and defined with the
pen.

114. Secondly. When your time is short, or the subject
is so rich in detail that you feel you cannot complete it in-
telligibly in light and shade, make a hasty study of the
effect, and give the rest of the time to a Düreresque ex-
pression of the details. If the subject seems to you in-
teresting, and there are points about it which you cannot
understand, try to get five spare minutes to go close up to
it, and make a nearer memorandum; not that you are ever
to bring the details of this nearer sketch into the farther
one, but that you may thus perfect your experience of the
aspect of things, and know that such and such a look of a

tower or cottage at five hundred yards off means *that* sort of tower or cottage near; while, also, this nearer sketch will be useful to prevent any future misinterpretation of your own work. If you have time, however far your light and shade study in the distance may have been carried, it is always well, for these reasons, to make also your Dürer-esque and your near memoranda; for if your light and shade drawing be good, much of the interesting detail must be lost in it, or disguised.

115. Your hasty study of effect may be made most easily and quickly with a soft pencil, dashed over when done with one tolerably deep tone of grey, which will fix the pencil. While this fixing colour is wet, take out the higher lights with the dry brush; and, when it is quite dry, scratch out the highest lights with the penknife. Five minutes, carefully applied, will do much by these means. Of course the paper is to be white. I do not like studies on grey paper so well; for you can get more gradation by the taking off your wet tint, and laying it on cunningly a little darker here and there, than you can with body-colour white, unless you are consummately skilful. There is no objection to your making your Düreresque memoranda on grey or yellow paper, and touching or relieving them with white; only, do not depend much on your white touches, nor make the sketch for their sake.

116. Thirdly. When you have neither time for careful study nor for Düreresque detail, sketch the outline with pencil, then dash in the shadows with the brush boldly, trying to do as much as you possibly can at once, and to get a habit of expedition and decision; laying more colour again and again into the tints as they dry, using every expedient which your practice has suggested to you of carrying out your chiaroscuro in the manageable and moist material, taking the colour off here with the dry brush, scratching out lights in it there with the wooden handle of the brush, rubbing it in with your fingers, drying it off with your sponge, etc. Then, when the colour is in, take

your pen and mark the outline characters vigorously, in the manner of the Liber Studiorum. This kind of study is very convenient for carrying away pieces of effect which depend not so much on refinement as on complexity, strange shapes of involved shadows, sudden effects of sky, etc.; and it is most useful as a safeguard against any too servile or slow habits which the minute copying may induce in you; for although the endeavour to obtain velocity merely for velocity's sake, and dash for display's sake, is as baneful as it is despicable; there *are* a velocity and a dash which not only are compatible with perfect drawing, but obtain certain results which cannot be had otherwise. And it is perfectly safe for you to study occasionally for speed and decision, while your continual course of practice is such as to ensure your retaining an accurate judgment and a tender touch. Speed, under such circumstances, is rather fatiguing than tempting; and you will find yourself always beguiled rather into elaboration than negligence.

117. Fourthly. You will find it of great use, whatever kind of landscape scenery you are passing through, to get into the habit of making memoranda of the shapes of shadows. You will find that many objects of no essential interest in themselves, and neither deserving a finished study, nor a Düreresque one, may yet become of singular value in consequence of the fantastic shapes of their shadows; for it happens often, in distant effect, that the shadow is by much a more important element than the substance. Thus, in the Alpine bridge, Fig. 21, seen within a few yards of it, as in the figure, the arrangement of timbers to which the shadows are owing is perceptible; but at half a mile's distance, in bright sunlight, the timbers would not be seen; and a good painter's expression of the bridge would be merely the large spot, and the crossed bars, of pure grey; wholly without indication of their cause, as in Fig. 22 *a*; and if we saw it at still greater distances, it would appear as in Fig. 22 *b* and *c*, diminishing at last to a strange, unintelligible, spider-like spot of grey on the light hillside.

there, for practice; even the fire-irons or the pattern on the carpet: be sure that it *is* for practice, and not because it is a beloved carpet, or a friendly poker and tongs, nor because you wish to please your friend by drawing her room.

121. Also, never make presents of your drawings. Of course I am addressing you as a beginner — a time may come when your work will be precious to everybody; but be resolute not to give it away till you know that it is worth something (as soon as it is worth anything you will know that it is so). If any one asks you for a present of a drawing, send them a couple of cakes of colour and a piece of Bristol board: those materials are, for the present, of more value in that form than if you had spread the one over the other.

The main reason for this rule is, however, that its observance will much protect you from the great danger of trying to make your drawings pretty.

122. (2.) Never, by choice, draw anything polished; especially if complicated in form. Avoid all brass rods and curtain ornaments, chandeliers, plate, glass, and fine steel. A shining knob of a piece of furniture does not matter if it comes in your way; but do not fret yourself if it will not look right, and choose only things that do not shine.

(3.) Avoid all very neat things. They are exceedingly difficult to draw, and very ugly when drawn. Choose rough, worn, and clumsy-looking things as much as possible; for instance, you cannot have a more difficult or profitless study than a newly painted Thames wherry, nor a better study than an old empty coal-barge, lying ashore at low tide: in general, everything that you think very ugly will be good for you to draw.

(4.) Avoid, as much as possible, studies in which one thing is seen through another. You will constantly find a thin tree standing before your chosen cottage, or between you and the turn of the river; its near branches all en-tangled with the distance. It is intensely difficult to represent this; and though, when the tree *is* there, you must not

imaginarily cut it down, but do it as well as you can, yet always look for subjects that fall into definite masses, not into network; that is, rather for a cottage with a dark tree beside it, than for one with a thin tree in front of it, rather for a mass of wood, soft, blue, and rounded, than for a ragged copse, or confusion of intricate stems.

(5.) Avoid, as far as possible, country divided by hedges. Perhaps nothing in the whole compass of landscape is so utterly unpicturesque and unmanageable as the ordinary English patchwork of field and hedge,[1] with trees dotted over it in independent spots, gnawed straight at the cattle line.

Still, do not be discouraged if you find you have chosen ill, and that the subject overmasters you. It is much better that it should, than that you should think you had entirely mastered *it*. But at first, and even for some time, you must be prepared for very discomfortable failure; which, nevertheless, will not be without some wholesome result.

123. As, however, I have told you what most definitely to avoid, I may, perhaps, help you a little by saying what to seek. In general, all banks are beautiful things, and will reward work better than large landscapes. If you live in a lowland country, you must look for places where the ground is broken to the river's edges, with decayed posts, or roots of trees; or, if by great good luck there should be such things within your reach, for remnants of stone quays or steps, mossy mill-dams, etc. Nearly every other mile of road in chalk country will present beautiful bits of broken bank at its sides; better in form and colour than high chalk cliffs. In woods, one or two trunks, with the flowery ground below, are at once the richest and easiest kind of study: a not very thick trunk, say nine inches or a foot in diameter, with ivy running up it sparingly, is an easy, and always a rewarding subject.

[1] [Compare *The Poetry of Architecture*, §§ 14, 15 (Vol. I. p. 14), where Ruskin contrasts the "snug" appearance of English landscape "minutely chequered into fields," with the open spaciousness of France—a contrast noted also in *Modern Painters*, vol. iv. ch. i.]

there, for practice; even the fire-irons or the pattern on the carpet: be sure that it *is* for practice, and not because it is a beloved carpet, or a friendly poker and tongs, nor because you wish to please your friend by drawing her room.

121. Also, never make presents of your drawings. Of course I am addressing you as a beginner — a time may come when your work will be precious to everybody; but be resolute not to give it away till you know that it is worth something (as soon as it is worth anything you will know that it is so). If any one asks you for a present of a drawing, send them a couple of cakes of colour and a piece of Bristol board: those materials are, for the present, of more value in that form than if you had spread the one over the other.

The main reason for this rule is, however, that its observance will much protect you from the great danger of trying to make your drawings pretty.

122. (2.) Never, by choice, draw anything polished; especially if complicated in form. Avoid all brass rods and curtain ornaments, chandeliers, plate, glass, and fine steel. A shining knob of a piece of furniture does not matter if it comes in your way; but do not fret yourself if it will not look right, and choose only things that do not shine.

(3.) Avoid all very neat things. They are exceedingly difficult to draw, and very ugly when drawn. Choose rough, worn, and clumsy-looking things as much as possible; for instance, you cannot have a more difficult or profitless study than a newly painted Thames wherry, nor a better study than an old empty coal-barge, lying ashore at low tide: in general, everything that you think very ugly will be good for you to draw.

(4.) Avoid, as much as possible, studies in which one thing is seen through another. You will constantly find a thin tree standing before your chosen cottage, or between you and the turn of the river; its near branches all entangled with the distance. It is intensely difficult to represent this; and though, when the tree *is* there, you must not

imaginarily cut it down, but do it as well as you can, yet always look for subjects that fall into definite masses, not into network; that is, rather for a cottage with a dark tree beside it, than for one with a thin tree in front of it, rather for a mass of wood, soft, blue, and rounded, than for a ragged copse, or confusion of intricate stems.

(5.) Avoid, as far as possible, country divided by hedges. Perhaps nothing in the whole compass of landscape is so utterly unpicturesque and unmanageable as the ordinary English patchwork of field and hedge,[1] with trees dotted over it in independent spots, gnawed straight at the cattle line.

Still, do not be discouraged if you find you have chosen ill, and that the subject overmasters you. It is much better that it should, than that you should think you had entirely mastered *it*. But at first, and even for some time, you must be prepared for very discomfortable failure; which, nevertheless, will not be without some wholesome result.

123. As, however, I have told you what most definitely to avoid, I may, perhaps, help you a little by saying what to seek. In general, all banks are beautiful things, and will reward work better than large landscapes. If you live in a lowland country, you must look for places where the ground is broken to the river's edges, with decayed posts, or roots of trees; or, if by great good luck there should be such things within your reach, for remnants of stone quays or steps, mossy mill-dams, etc. Nearly every other mile of road in chalk country will present beautiful bits of broken bank at its sides; better in form and colour than high chalk cliffs. In woods, one or two trunks, with the flowery ground below, are at once the richest and easiest kind of study: a not very thick trunk, say nine inches or a foot in diameter, with ivy running up it sparingly, is an easy, and always a rewarding subject.

[1] [Compare *The Poetry of Architecture*, §§ 14, 15 (Vol. I. p. 14), where Ruskin contrasts the "snug" appearance of English landscape "minutely chequered into fields," with the open spaciousness of France—a contrast noted also in *Modern Painters*, vol. iv. ch. i.]

124. Large nests of buildings in the middle distance are always beautiful, when drawn carefully, provided they are not modern rows of pattern cottages, or villas with Ionic and Doric porticoes. Any old English village, or cluster of farm-houses, drawn with all its ins and outs, and haystacks, and palings, is sure to be lovely; much more a French one. French landscape is generally as much superior to English as Swiss landscape is to French; in some respects, the French is incomparable. Such scenes as that avenue on the Seine, which I have recommended you to buy the engraving of,[1] admit no rivalship in their expression of graceful rusticity and cheerful peace, and in the beauty of component lines.

In drawing villages, take great pains with the gardens; a rustic garden is in every way beautiful. If you have time, draw all the rows of cabbages, and hollyhocks, and broken fences, and wandering eglantines, and bossy roses; you cannot have better practice, nor be kept by anything in purer thoughts.

Make intimate friends with all the brooks in your neighbourhood, and study them ripple by ripple.

Village churches in England are not often good subjects; there is a peculiar meanness about most of them and awkwardness of line. Old manor-houses are often pretty. Ruins are usually, with us, too prim, and cathedrals too orderly. I do not think there is a single cathedral in England from which it is possible to obtain *one* subject for an impressive drawing. There is always some discordant civility, or jarring vergerism about them.[2]

125. If you live in a mountain or hill country, your only danger is redundance of subject. Be resolved, in the first place, to draw a piece of rounded rock, with its variegated lichens, quite rightly, getting its complete roundings, and all the patterns of the lichen in true local colour. Till

[1] [See above, § 86 n. The engraving is "The View on the Seine, between Mantes and Vernon"; the drawing is No. 138 in the National Gallery. For Ruskin's fondness for French landscape, see Vol. III. p. 238.]

[2] [Compare the *Seven Lamps*, Vol. VIII. p. 188, and *Stones of Venice*, vol. ii. (Vol. X. p. 78).]

you can do this, it is of no use your thinking of sketching among hills; but when once you have done this, the forms of distant hills will be comparatively easy.

126. When you have practised for a little time from such of these subjects as may be accessible to you, you will certainly find difficulties arising which will make you wish more than ever for a master's help: these difficulties will vary according to the character of your own mind (one question occurring to one person, and one to another), so that it is impossible to anticipate them all; and it would make this too large a book if I answered all that I *can* anticipate; you must be content to work on, in good hope that Nature will, in her own time, interpret to you much for herself; that farther experience on your own part will make some difficulties disappear; and that others will be removed by the occasional observation of such artists' work as may come in your way. Nevertheless, I will not close this letter without a few general remarks, such as may be useful to you after you are somewhat advanced in power; and these remarks may, I think, be conveniently arranged under three heads, having reference to the drawing of vegetation, water, and skies.

127. And, first, of vegetation. You may think, perhaps, we have said enough about trees already; yet if you have done as you were bid, and tried to draw them frequently enough, and carefully enough, you will be ready by this time to hear a little more of them. You will also recollect that we left our question, respecting the mode of expressing intricacy of leafage, partly unsettled in the first letter.[1] I left it so because I wanted you to learn the real structure of leaves, by drawing them for yourself, before I troubled you with the most subtle considerations as to method in drawing them. And by this time, I imagine, you must have found out two principal things, universal facts, about leaves; namely, that they always, in the main tendencies

[1] [See above, pp. 74, 87.]

of their lines, indicate a beautiful divergence of growth, according to the law of radiation, already[1] referred to ; * and the second, that this divergence is never formal, but carried out with endless variety of individual line. I must now press both these facts on your attention a little farther.

128. You may, perhaps, have been surprised that I have not yet spoken of the works of J. D. Harding, especially if you happen to have met with the passages referring to them in *Modern Painters*, in which they are highly praised.[2] They are deservedly praised, for they are the only works by a modern draughtsman which express in any wise the energy of trees, and the laws of growth, of which we have been speaking. There are no lithographic sketches which, for truth of general character, obtained with little cost of time, at all rival Harding's. Calame,[3] Robert, and the other lithographic landscape sketchers are altogether inferior in power, though sometimes a little deeper in meaning. But you must not take even Harding for a model, though you may use his works for occasional reference ; and if you can afford to buy his Lessons on Trees, † it will be serviceable to you in various ways, and will at present help me to explain the point under consideration. And it is well that I should illustrate this point by reference to Harding's works, because their great influence on young students renders it desirable that their real character should be thoroughly understood.

129. You will find, first, in the title-page of the Lessons

* See the closing letter in this volume.

† If you are not acquainted with Harding's works, (an unlikely supposition, considering their popularity,) and cannot meet with the one in question, the diagrams given here will enable you to understand all that is needful for our purposes.[4]

[1] [See above, p. 96.]

[2] [See, for instance, Vol. III. pp. 201, 600.]

[3] [For Calame, see Vol. III. p. 449 n., and Vol. VI. p. 101. The artist next mentioned is Louis Léopold Robert (1794–1835), painter and engraver.]

[4] [The *Lessons on Trees* was published by Bogue in 1850. Plate 1 contains "Lessons" "to afford practice in drawing the forms of stems and branches, and also to show how the character of the bark may be indicated by the simplest means."]

on Trees, a pretty woodcut, in which the tree stems are drawn with great truth, and in a very interesting arrangement of lines. Plate 1 is not quite worthy of Mr. Harding, tending too much to make his pupil, at starting, think everything depends on black dots; still, the main lines are good, and very characteristic of tree growth. Then, in Plate 2, we come to the point at issue. The first examples in that plate are given to the pupil that he may .practise from them till his hand gets into the habit of arranging lines freely in a similar manner; and they are stated by Mr. Harding to be universal in application; " all outlines expressive of foliage," he says, " are but modifications of them." They consist of groups of lines, more or less resembling our Fig. 23 below; and the characters especially insisted upon are, that they " tend at their inner ends to a common

Fig. 23

centre"; that "their ends terminate in [are enclosed by][1] ovoid curves"; and that " the outer ends are most emphatic."

130. Now, as thus expressive of the great laws of radiation and enclosure, the main principle of this method of execution confirms, in a very interesting way, our conclusions respecting foliage composition. The reason of the last rule, that the outer end of the line is to be most emphatic, does not indeed at first appear; for the line at one end of a natural leaf is not more emphatic than the line at the other; but ultimately, in Harding's method, this darker part of the touch stands more or less for the shade at the outer extremity of the leaf mass; and, as Harding uses these touches, they express as much of tree character as any mere habit of touch *can* express. But, unfortunately, there is another law of tree growth, quite as fixed as the law of radiation, which this and all other conventional modes of execution wholly lose sight of. This second law is, that

[1] [This is an addition made by Ruskin to Harding's text (in the notes on Plate 2 in his book).]

the radiating tendency shall be carried out only as a ruling spirit in reconcilement with perpetual individual caprice on the part of the separate leaves. So that the moment a touch is monotonous, it must be also false, the liberty of the leaf individually being just as essential a truth, as its unity of growth with its companions in the radiating group.

131. It does not matter how small or apparently symmetrical the cluster may be, nor how large or vague. You can hardly have a more formal

Fig. 24

one than *b* in Fig. 9, p. 72, nor a less formal one than this shoot of Spanish chestnut, shedding its leaves, Fig. 24;[1] but in either of them, even the general reader, unpractised in any of the previously recommended exercises, must see that there are wandering lines mixed with the radiating ones, and radiating lines with the wild ones: and if he takes the pen, and tries to copy either of these examples, he will find that neither play of hand to left nor to right, neither a free touch nor a firm touch, nor any learnable or describable touch whatsoever, will enable him to produce, currently, a resemblance of it; but that he must either draw it slowly

[1] [This shoot of Spanish chestnut was drawn by Ruskin at Carrara; the original drawing, here reproduced, was given at vol. i. p. 121 of W. G. Collingwood's *Life and Work of John Ruskin* (1893), under the incorrect title "Olive at Carrara." The drawing (now in the collection of Mr. T. F. Taylor) was shown at the Ruskin Exhibition, Manchester (1904), No. 114, and is here reproduced. Ruskin had intended to contrast his sketch with one of Harding's and to add further illustrations, as appears from the passage (cancelled when the intended illustrations were withdrawn) in the proof-sheets, which reads thus :—

"... its unity of growth with its companions in the radiating group. Let us take an instance. Plate 19, in this work of Harding's [*Lessons on Trees*], is a sketch of a Spanish chestnut, and on the right-hand side, a dark bough of it comes against the sky. The formal habit of the hand, brought into the best possible application to the character of chestnut foliage, results in conditions which, though they of course look better in the soft colour of the chalk than in the black of the woodcut, present in reality no truer profiles against the sky than those in Fig. . Now, here is a spray of real

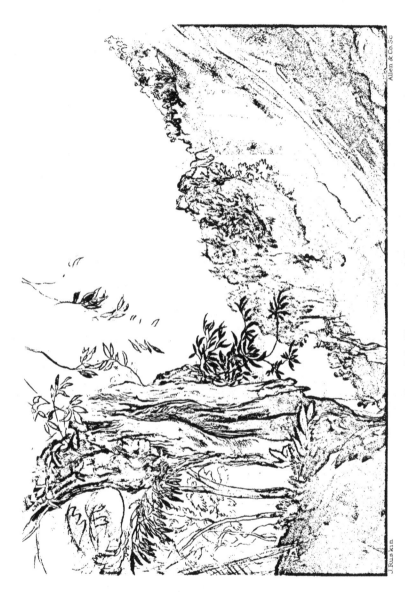

J.Ruskin

Allen & Co.Sc

Spanish Chestnut at Carrara

From the drawing in the possession of T.F.Taylor. Esq

or give it up. And (which makes the matter worse still) though gathering the bough, and putting it close to you, or seeing a piece of near foliage against the sky, you may draw the entire outline of the leaves, yet if the spray has light upon it, and is ever so little a way off, you will miss, as we have seen, a point of a leaf here, and an edge there; some of the surfaces will be confused by glitter, and some spotted with shade; and if you look carefully through this confusion for the edges or dark stems which you really *can* see and put only those down, the result will be neither like Fig. 9 nor Fig. 24, but such an interrupted and puzzling piece of work as Fig. 25.*

Fig. 25

132. Now, it is in the perfect acknowledgment and expression of these *three* laws that all good drawing of landscape consists. There is, first, the organic unity; the law, whether of radiation, or parallelism, or concurrent action, which rules the masses of herbs and trees, of rocks, and clouds, and waves; secondly,

* I draw this figure (a young shoot of oak) in outline only, it being impossible to express the refinements of shade in distant foliage in a woodcut.

Spanish chestnut, thrown in similarly black profile against the white paper. (It may perhaps add a little to the interest the reader takes in it, if I tell him that it is not a bit of Greenwich Park chestnut, but of one growing, I doubt not to this day, on a projecting crag of sculptors' marble at Massa Carrara.) I have not taken particular pains in drawing it; but I think the reader will feel in a moment that, though there are indeed radiating lines governing the groups, there are other lines, by no means radiating, but wilful and wild, mingling with them continually. And this is just as true of every other tree as it is of chestnut, nor of every tree only but of every herb that grows. It does not matter how formal their arrangement of foliage may at first appear, no regular method of execution will express it. Take a spray of cross-wort madder, for instance, Fig. . Legal enough it is, certainly, in the stated repetitions of its four crossed leaves, at regular distances on the stalk; yet you cannot express such a leaf as that, when seen a little way off, by any quick crossing touch of pen, as, for instance, *b*. The plant in no way resembles that; it is much more perfect and less regular; every one of its leaves is a little out of law—a little too short or too long, or turned too much down or too much up. And if he takes the pen . . ."]

the individual liberty of the members subjected to these laws of unity; and, lastly, the mystery under which the separate character of each is more or less concealed.

I say, first, there must be observance of the ruling organic law. This is the first distinction between good artists and bad artists. Your common sketcher or bad painter puts his leaves on the trees as if they were moss tied to sticks; he cannot see the lines of action or growth; he scatters the shapeless clouds over his sky, not perceiving the sweeps of associated curves which the real clouds are following as they fly; and he breaks his mountain side into rugged fragments, wholly unconscious of the lines of force with which the real rocks have risen, or of the lines of couch in which they repose. On the contrary it is the main delight of the great draughtsman, to trace these laws of government; and his tendency to error is always in the exaggeration of their authority rather than in its denial.

133. Secondly, I say, we have to show the individual character and liberty of the separate leaves, clouds, or rocks. And herein the great masters separate themselves finally from the inferior ones; for if the men of inferior genius ever express law at all, it is by the sacrifice of individuality. Thus, Salvator Rosa has great perception of the sweep of foliage and rolling of clouds, but never draws a single leaflet or mist wreath accurately.[1] Similarly, Gainsborough, in his landscape, has great feeling for masses of form and harmony of colour; but in the detail gives nothing but meaningless touches; not even so much as the species of tree, much less the variety of its leafage, being ever discernible. Now, although both these expressions of government and individuality are essential to masterly work, the individuality is the *more* essential, and the more difficult of attainment; and, therefore, that attainment separates the great masters *finally* from the inferior ones. It is the more

[1] [On these points in Salvator, see *Modern Painters*, vol. i. (Vol. III. p. 375); and in Gainsborough, *ibid.* (Vol. III. p. 190).]

essential, because, in these matters of beautiful arrangement in visible things, the same rules hold that hold in moral things.[1] It is a lamentable and unnatural thing to see a number of men subject to no government, actuated by no ruling principle, and associated by no common affection: but it would be a more lamentable thing still, were it possible, to see a number of men so oppressed into assimilation as to have no more any individual hope or character, no differences in aim, no dissimilarities of passion, no irregularities of judgment; a society in which no man could help another, since none would be feebler than himself; no man admire another, since none would be stronger than himself; no man be grateful to another, since by none he could be relieved; no man reverence another, since by none he could be instructed; a society in which every soul would be as the syllable of a stammerer instead of the word of a speaker, in which every man would walk as in a frightful dream, seeing spectres of himself, in everlasting multiplication, gliding helplessly around him in a speechless darkness. Therefore it is that perpetual difference, play, and change in groups of form are more essential to them even than their being subdued by some great gathering law: the law is needful to them for their perfection and their power, but the difference is needful to them for their life.

134. And here it may be noted in passing, that, if you enjoy the pursuit of analogies and types, and have any ingenuity of judgment in discerning them, you may always accurately ascertain what are the noble characters in a piece of painting by merely considering what are the noble characters of man in his association with his fellows. What grace of manner and refinement of habit are in society, grace of line and refinement of form are in the association of visible objects. What advantage or harm there may be in sharpness, ruggedness, or quaintness in the dealings or conversations of men; precisely that relative degree of

[1] [On Ruskin's use of such analogies, see above, Introduction, p. xviii.]

advantage or harm there is in them as elements of pictorial composition. What power is in liberty or relaxation to strengthen or relieve human souls; that power precisely in the same relative degree, play and laxity of line have to strengthen or refresh the expression of a picture. And what goodness or greatness we can conceive to arise in companies of men, from chastity of thought, regularity of life, simplicity of custom, and balance of authority; precisely that kind of goodness and greatness may be given to a picture by the purity of its colour, the severity of its forms, and the symmetry of its masses.

135. You need not be in the least afraid of pushing these analogies too far. They cannot be pushed too far; they are so precise and complete, that the farther you pursue them, the clearer, the more certain, the more useful you will find them. They will not fail you in one particular, or in any direction of enquiry. There is no moral vice, no moral virtue, which has not its *precise* prototype in the art of painting; so that you may at your will illustrate the moral habit by the art, or the art by the moral habit. Affection and discord, fretfulness and quietness, feebleness and firmness, luxury and purity, pride and modesty, and all other such habits, and every conceivable modification and mingling of them, may be illustrated, with mathematical exactness, by conditions of line and colour; and not merely these definable vices and virtues, but also every conceivable shade of human character and passion, from the righteous or unrighteous majesty of the king to the innocent or faultful simplicity of the shepherd boy.

136. The pursuit of this subject belongs properly, however, to the investigation of the higher branches of composition, matters which it would be quite useless to treat of in this book; and I only allude to them here, in order that you may understand how the utmost noblenesses of art are concerned in this minute work, to which I have set you in your beginning of it. For it is only by the closest

attention, and the most noble execution, that it is possible to express these varieties of individual character, on which all excellence of portraiture depends, whether of masses of mankind, or of groups of leaves.

137. Now you will be able to understand, among other matters, wherein consists the excellence, and wherein the shortcoming, of the tree-drawing of Harding. It is excellent in so far as it fondly observes, with more truth than any other work of the kind, the great laws of growth and action in trees: it fails,—and observe, not in a minor, but in the principal point,—because it cannot rightly render any one individual detail or incident of foliage. And in this it fails, not from mere carelessness or incompletion, but of necessity; the true drawing of detail being for evermore impossible to a hand which has contracted a *habit* of execution. The noble draughtsman draws a leaf, and stops, and says calmly,—That leaf is of such and such a character; I will give him a friend who will entirely suit him: then he considers what his friend ought to be, and having determined, he draws his friend. This process may be as quick as lightning when the master is great—one of the sons of the giants; or it may be slow and timid: but the process is always gone through; no touch or form is ever added to another by a good painter without a mental determination and affirmation. But when the hand has got into a habit, leaf No. 1 necessitates leaf No. 2; you cannot stop, your hand is as a horse with the bit in its teeth; or rather is, for the time, a machine, throwing out leaves to order and pattern, all alike. You must stop that hand of yours, however painfully; make it understand that it is not to have its own way any more, that it shall never more slip from one touch to another without orders; otherwise it is not you who are the master, but your fingers. You may therefore study Harding's drawing, and take pleasure in it; *

* His lithographic sketches, those for instance in the *Park and the Forest,* and his various lessons on foliage, possess greater merit than the

and you may properly admire the dexterity which applies the habit of the hand so well, and produces results on the whole so satisfactory: but you must never copy it; otherwise your progress will be at once arrested. The utmost you can ever hope to do would be a sketch in Harding's manner, but of far inferior dexterity; for he has given his life's toil to gain his dexterity, and you, I suppose, have other things to work at besides drawing. You would also incapacitate yourself from ever understanding what truly great work was, or what Nature was; but, by the earnest and complete study of facts, you will gradually come to understand the one and love the other more and more, whether you can draw well yourself or not.

138. I have yet to say a few words respecting the third law above stated, that of mystery; the law, namely, that nothing is ever seen perfectly, but only by fragments, and under various conditions of obscurity.* This last fact renders the visible objects of Nature complete as a type of the human nature. We have, observe, first, Subordination; secondly, Individuality; lastly, and this not the least essential character, Incomprehensibility; a perpetual lesson, in every serrated point and shining vein which escapes or deceives our sight among the forest leaves, how little we may hope to discern clearly, or judge justly, the rents and veins of the human heart; how much of all that is round us, in men's actions or spirits, which we at first think we understand, a closer and more loving watchfulness would show to be full of mystery, never to be either fathomed or withdrawn.

more ambitious engravings in his *Principles and Practice of Art.*[1] There are many useful remarks, however, dispersed through this latter work.

* On this law you do well, if you can get access to it, to look at the fourth chapter of the fourth volume of *Modern Painters.*

[1] [*The Park and the Forest,* by J. D. Harding: London, Thomas Maclean, 1841— a large folio volume containing twenty-six lithographs. For his *Lessons on Trees,* see above, p. 112. *The Principles and Practice of Art* was published by Chapman and Hall in 1845, "with illustrations drawn and engraved by the author."]

139. The expression of this final character in landscape has never been completely reached by any except Turner; nor can you hope to reach it at all until you have given much time to the practice of art. Only try always when you are sketching any object with a view to completion in light and shade, to draw only those parts of it which you really see definitely; preparing for the after development of the forms by chiaroscuro. It is this preparation by isolated touches for a future ar-rangement of superimposed light and shade which renders the etch-ings of the Liber Studiorum so inestimable as examples, and so peculiar. The character exists more or less in them exactly in proportion to the pains that Turner has taken. Thus the Æsacus and Hesperie[1] was wrought out with the greatest possible care; and the principal branch on the near tree is etched as in Fig. 26. The work looks at first like a scholar's instead of a master's; but when the light

Fig. 26

and shade are added, every touch falls into its place, and a perfect expression of grace and complexity results. Nay, even before the light and shade are added, you ought to be able to see that these irregular and broken lines, especi-ally where the expression is given of the way the stem loses itself in the leaves, are more true than the mono-tonous though graceful leaf-drawing which, before Turner's time, had been employed, even by the best masters, in their distant masses. Fig. 27 is sufficiently characteristic of the manner of the old woodcuts after Titian; in which, you see, the leaves are too much of one shape, like bunches

[1] [Reproduced and referred to in *Lectures on Landscape,* § 73 ; see also Vol. III. pp. 586, 595 *n.* ; Vol. XIII. p. 462.]

of fruit; and the boughs too completely seen, besides being somewhat soft and leathery in aspect, owing to the want of angles in their outline. By great men like Titian,

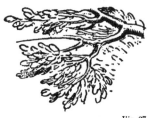

this somewhat conventional structure was only given in haste to distant masses; and their exquisite delineation of the foreground, kept their conventionalism from degeneracy: but in the drawings of the Carracci[1] and other derivative masters, the conventionalism prevails everywhere,

Fig. 27

and sinks gradually into scrawled work, like Fig. 28, about the worst which it is possible to get into the habit of using, though an ignorant person might perhaps suppose it more "free," and therefore better than Fig. 26. Note also, that in noble outline drawing, it does not follow that a bough is wrongly drawn, because it looks contracted unnaturally somewhere, as in Fig. 26, just above the foliage. Very often the muscular action which is to be expressed by the line runs into the middle of the branch, and the actual outline of the branch at that place may be dimly seen, or not at all; and it is then only by the future shade that its actual shape, or the cause of its disappearance, will be indicated.

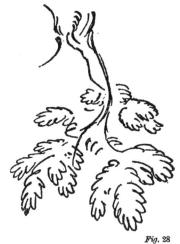

Fig. 28

140. One point more remains to be noted about trees, and I have done. In the minds of our ordinary water-colour artists a distant tree seems only to be conceived as a flat green blot, grouping pleasantly with other

[1] [For another reference to the worthlessness of their landscape, see *Modern Painters*, vol. iii. (Vol. V. p. 400).]

masses, and giving cool colour to the landscape, but differing no wise, in texture, from the blots of other shapes which these painters use to express stones, or water, or figures. But as soon as you have drawn trees carefully a little while, you will be impressed, and impressed more strongly the better you draw them, with the idea of their *softness* of surface. A distant tree is not a flat and even piece of colour, but a more or less globular mass of a downy or bloomy texture, partly passing into a misty vagueness. I find, practically, this lovely softness of far-away trees the most difficult of all characters to reach, because it cannot be got by mere scratching or roughening the surface, but is always associated with such delicate expressions of form and growth as are only imitable by very careful drawing. The pen-knife passed lightly *over* this careful drawing will do a good deal; but you must accustom yourself, from the beginning, to aim much at this softness in the lines of the drawing itself, by crossing them delicately, and more or less effacing and confusing the edges. You must invent, according to the character of tree, various modes of execution adapted to express its texture; but always keep this character of softness in your mind, and in your scope of aim; for in most landscapes it is the intention of Nature that the tenderness and transparent infinitude of her foliage should be felt, even at the far distance, in the most distinct opposition to the solid masses and flat surfaces of rocks or buildings.

141. II. We were, in the second place, to consider a little the modes of representing water, of which important feature of landscape I have hardly said anything yet.

Water is expressed, in common drawings, by conventional lines, whose horizontality is supposed to convey the idea of its surface. In paintings, white dashes or bars of light are used for the same purpose.

But these and all other such expedients are vain and absurd. A piece of calm water always contains a picture in itself, an exquisite reflection of the objects above it. If

you give the time necessary to draw these reflections, dis-
turbing them here and there as you see the breeze or current
disturb them, you will get the effect of the water; but if
you have not patience to draw the reflections, no expedient
will give you a true effect. The picture in the pool needs
nearly as much delicate drawing as the picture above the
pool; except only that if there be the least motion on the
water, the horizontal lines of the images will be diffused
and broken, while the vertical ones will remain decisive,
and the oblique ones decisive in proportion to their steep-
ness.

142. A few close studies will soon teach you this: the
only thing you need to be told is to watch carefully the
lines of disturbance on the surface, as when a bird swims
across it, or a fish rises, or the current plays round a stone,
reed, or other obstacle. Take the greatest pains to get the
curves of these lines true; the whole value of your careful
drawing of the reflections may be lost by your admitting a
single false curve of ripple from a wild duck's breast. And
(as in other subjects) if you are dissatisfied with your result,
always try for more unity and delicacy: if your reflections
are only soft and gradated enough, they are nearly sure to
give you a pleasant effect.* When you are taking pains,
work the softer reflections, where they are drawn out by
motion in the water, with touches as nearly horizontal as
may be; but when you are in a hurry, indicate the place
and play of the images with vertical lines. The actual
construction of a calm elongated reflection is with horizontal
lines: but it is often impossible to draw the descending
shades delicately enough with a horizontal touch; and it is
best always when you are in a hurry, and sometimes when
you are not, to use the vertical touch. When the ripples
are large, the reflections become shaken, and must be drawn
with bold undulatory descending lines.

148. I need not, I should think, tell you that it is of

* See Note 3 in Appendix I. [p. 216].

the greatest possible importance to draw the curves of the shore rightly. Their perspective is, if not more subtle, at least more stringent than that of any other lines in Nature. It will not be detected by the general observer, if you miss the curve of a branch, or the sweep of a cloud, or the perspective of a building;* but every intelligent spectator will feel the difference between a rightly-drawn bend of shore or shingle, and a false one. *Absolutely* right, in difficult river perspectives seen from heights, I believe no one but Turner ever has been yet; and observe, there is NO rule for them. To develop the curve mathematically would require a knowledge of the exact quantity of water in the river, the shape of its bed, and the hardness of the rock or shore; and even with these data, the problem would be one which no mathematician could solve but approximatively. The instinct of the eye can do it; nothing else.

144. If, after a little study from Nature, you get puzzled by the great differences between the aspect of the reflected image and that of the object casting it; and if you wish to know the law of reflection, it is simply this: Suppose all the objects above the water *actually* reversed (not in appearance, but in fact) beneath the water, and precisely the same in form and in relative position, only all topsy-turvy. Then, whatever you could see, from the place in which you stand, of the solid objects so reversed under the water, you will see in the reflection, always in the true perspective of the solid objects so reversed.

If you cannot quite understand this in looking at water, take a mirror, lay it horizontally on the table, put some books and papers upon it, and draw them and their reflections; moving them about, and watching how their reflections alter, and chiefly how their reflected colours and shades differ from their own colours and shades, by being

* The student may hardly at first believe that the perspective of buildings is of little consequence; but he will find it so ultimately. See the remarks on this point in the Preface [p. 19].

brought into other oppositions. This difference in chiaroscuro is a more important character in water-painting than mere difference in form.

145. When you are drawing shallow or muddy water, you will see shadows on the bottom, or on the surface, continually modifying the reflections; and in a clear mountain stream, the most wonderful complications of effect resulting from the shadows and reflections of the stones in it, mingling with the aspect of the stones themselves seen through the water. Do not be frightened at the complexity; but, on the other hand, do not hope to render it hastily. Look at it well, making out everything that you see, and distinguishing each component part of the effect. There will be, first, the stones seen through the water, distorted always by refraction, so that, if the general structure of the stone shows straight parallel lines above the water, you may be sure they will be bent where they enter it; then the reflection of the part of the stone above the water crosses and interferes with the part that is seen through it, so that you can hardly tell which is which; and wherever the reflection is darkest, you will see through the water best,* and *vice versâ*. Then the real shadow of the stone crosses both these images, and where that shadow falls, it makes the water more reflective, and where the sunshine falls, you will see more of the surface of the water, and of any dust or motes that may be floating on it: but whether you are to see, at the same spot, most of the bottom of the water, or of the reflection of the objects above, depends on the position of the eye. The more you look down into the water, the better you see objects through it; the more you look along it, the eye being low, the more you see the reflection of objects above it. Hence the colour of a given space of surface in a stream will entirely change while you stand still in the same spot, merely as you stoop or raise your head; and thus the colours with which water

* See Note 4 in Appendix I. [p. 216].

is painted are an indication of the position of the spectator, and connected inseparably with the perspective of the shores. The most beautiful of all results that I know in mountain streams is when the water is shallow, and the stones at the bottom are rich reddish-orange and black, and the water is seen at an angle which exactly divides the visible colours between those of the stones and that of the sky, and the sky is of clear, full blue. The resulting purple, obtained by the blending of the blue and the orange-red, broken by the play of innumerable gradations in the stones, is indescribably lovely.

146. All this seems complicated enough already; but if there be a strong colour in the clear water itself, as of green or blue in the Swiss lakes, all these phenomena are doubly involved; for the darker reflections now become of the colour of the water. The reflection of a black gondola, for instance, at Venice, is never black, but pure dark green. And, farther, the colour of the water itself is of three kinds: one, seen on the surface, is a kind of milky bloom; the next is seen where the waves let light through them, at their edges; and the third, shown as a change of colour on the objects seen through the water. Thus, the same wave that makes a white object look of a clear blue, when seen through it, will take a red or violet-coloured bloom on its surface, and will be made pure emerald green by transmitted sunshine through its edges. With all this, however, you are not much concerned at present, but I tell it you partly as a preparation for what we have afterwards to say about colour, and partly that you may approach lakes and streams with reverence,* and study them as carefully as other things, not hoping to express them by a few horizontal dashes of white, or a few tremulous blots.† Not but

* See Note 5 in Appendix I. [p. 216].

† It is a useful piece of study to dissolve some Prussian blue in water, so as to make the liquid definitely blue: fill a large white basin with the solution, and put anything you like to float on it, or lie in it; walnut shells, bits of wood, leaves of flowers, etc. Then study the effects of the reflections,

that much may be done by tremulous blots, when you know precisely what you mean by them, as you will see by many of the Turner sketches, which are now framed at the National Gallery; but you must have painted water many and many a day—yes, and all day long—before you can hope to do anything like those.

147. III. Lastly. You may perhaps wonder why, before passing to the clouds, I say nothing special about *ground.** But there is too much to be said about that to admit of my saying it here. You will find the principal laws of its structure examined at length in the fourth volume of *Modern Painters;*[1] and if you can get that volume, and copy carefully Plate 21, which I have etched after Turner with great pains, it will give you as much help as you need in the linear expression of ground-surface. Strive to get the retirement and succession of masses in irregular ground: much may be done in this way by careful watching of the perspective diminutions of its herbage, as well as by contour; and much also by shadows. If you draw the shadows of leaves and tree trunks on any undulating ground with entire carefulness, you will be surprised to find how much they explain of the form and distance of the earth on which they fall.

148. Passing then to skies, note that there is this great peculiarity about sky subject, as distinguished from earth subject;—that the clouds, not being much liable to man's interference, are always beautifully arranged. You cannot be

and of the stems of the flowers or submerged portions of the floating objects, as they appear through the blue liquid; noting especially how, as you lower your head and look along the surface, you see the reflections clearly; and how, as you raise your head, you lose the reflections, and see the submerged stems clearly.

* Respecting Architectural Drawing, see the notice of the works of Prout in the Appendix [p. 221].

[1] [See, in this edition, Vol. VI. Plate 21 in "The Pass of Faido."]

sure of this in any other features of landscape. The rock on which the effect of a mountain scene especially depends is always precisely that which the roadmaker blasts or the landlord quarries; and the spot of green which Nature left with a special purpose by her dark forest sides, and finished with her most delicate grasses, is always that which the farmer ploughs or builds upon. But the clouds, though we can hide them with smoke, and mix them with poison, cannot be quarried nor built over, and they are always therefore gloriously arranged; so gloriously, that unless you have notable powers of memory you need not hope to approach the effect of any sky that interests you. For both its grace and its glow depend upon the united influence of every cloud within its compass: they all move and burn together in a marvellous harmony; not a cloud of them is out of its appointed place, or fails of its part in the choir: and if you are not able to recollect (which in the case of a complicated sky it is impossible you should) precisely the form and position of all the clouds at a given moment, you cannot draw the sky at all; for the clouds will not fit if you draw one part of them three or four minutes before another.

149. You must try therefore to help what memory you have, by sketching at the utmost possible speed the whole range of the clouds; marking, by any shorthand or symbolic work you can hit upon, the peculiar character of each, as transparent, or fleecy, or linear, or undulatory; giving afterwards such completion to the parts as your recollection will enable you to do. This, however, only when the sky is interesting from its general aspect; at other times, do not try to draw all the sky, but a single cloud: sometimes a round cumulus will stay five or six minutes quite steady enough to let you mark out his principal masses; and one or two white or crimson lines which cross the sunrise will often stay without serious change for as long. And in order to be the readier in drawing them, practise occasionally drawing lumps of cotton, which will teach you better

than any other stable thing the kind of softness there is in clouds. For you will find when you have made a few genuine studies of sky, and then look at any ancient or modern painting, that ordinary artists have always fallen into one of two faults: either, in rounding the clouds, they make them as solid and hard-edged as a heap of stones tied up in a sack, or they represent them not as rounded at all, but as vague wreaths of mist or flat lights in the sky; and think they have done enough in leaving a little white paper between dashes of blue, or in taking an irregular space out with the sponge. Now clouds are not as solid as flour-sacks; but, on the other hand, they are neither spongy nor flat. They are definite and very beautiful forms of sculp-tured mist; sculptured is a perfectly accurate word; they are not more *drifted* into form than they are *carved* into form, the warm air around them cutting them into shape by absorbing the visible vapour beyond certain limits; hence their angular and fantastic outlines, as different from a swollen, spherical, or globular formation, on the one hand, as from that of flat films or shapeless mists on the other. And the worst of all is, that while these forms are difficult enough to draw on any terms, especially considering that they never stay quiet, they must be drawn also at greater disadvantage of light and shade than any others, the force of light in clouds being wholly unattainable by art; so that if we put shade enough to express their form as positively as it is expressed in reality, we must make them painfully too dark on the dark sides. Nevertheless, they are so beauti-ful, if you in the least succeed with them, that you will hardly, I think, lose courage.

150. Outline them often with the pen, as you can catch them here and there; one of the chief uses of doing this will be, not so much the memorandum so obtained, as the lesson you will get respecting the softness of the cloud-outlines. You will always find yourself at a loss to see where the outline really is; and when drawn it will always look hard and false, and will assuredly be either too round

or too square, however often you alter it, merely passing from the one fault to the other and back again, the real cloud striking an inexpressible mean between roundness and squareness in all its coils or battlements. I speak at present, of course, only of the cumulus cloud : the lighter wreaths and flakes of the upper sky cannot be outlined ;—they can only be sketched, like locks of hair, by many lines of the pen. Firmly developed bars of cloud on the horizon are in general easy enough, and may be drawn with decision. When you have thus accustomed yourself a little to the placing and action of clouds, try to work out their light and shade, just as carefully as you do that of other things, looking exclusively for examples of treatment to the vignettes in Rogers's *Italy* and *Poems,* and to the Liber Studiorum, unless you have access to some examples of Turner's own work. No other artist ever yet drew the sky: even Titian's clouds, and Tintoret's, are conventional. The clouds in the " Ben Arthur," " Source of Arveron," and " Calais Pier," are among the best of Turner's storm studies ; and of the upper clouds, the vignettes to Rogers's *Poems* furnish as many examples as you need.

151. And now, as our first lesson was taken from the sky,[1] so, for the present, let our last be. I do not advise you to be in any haste to master the contents of my next letter. If you have any real talent for drawing, you will take delight in the discoveries of natural loveliness, which the studies I have already proposed will lead you into, among the fields and hills ; and be assured that the more quietly and single-heartedly you take each step in the art, the quicker, on the whole, will your progress be. I would rather, indeed, have discussed the subjects of the following letter at greater length, and in a separate work addressed to more advanced students ; but as there are one or two things to be said on composition which may set the young artist's mind somewhat more at rest, or furnish him with

[1] [See above, § 14, pp. 34–35.]

defence from the urgency of ill-advisers, I will glance over the main heads of the matter here; trusting that my doing so may not beguile you, my dear reader, from your serious work, or lead you to think me, in occupying part of this book with talk not altogether relevant to it, less entirely or

Faithfully yours,

J. RUSKIN.

LETTER III

ON COLOUR AND COMPOSITION[1]

152. MY DEAR READER,—If you have been obedient, and have hitherto done all that I have told you, I trust it has not been without much subdued remonstrance, and some serious vexation. For I should be sorry if, when you were led by the course of your study to observe closely such things as are beautiful in colour,[2] you had not longed to paint them, and felt considerable difficulty in complying with your restriction to the use of black, or blue, or grey. You *ought* to love colour, and to think nothing quite beautiful or perfect without it; and if you really do love it, for its own sake, and are not merely desirous to colour because you think painting a finer thing than drawing, there is some chance you may colour well. Nevertheless, you need not hope ever to produce anything more than pleasant helps to memory, or useful and suggestive sketches in colour, unless you mean to be wholly an artist. You may, in the time which other vocations leave at your disposal, produce finished, beautiful, and masterly drawings in light and shade. But to colour well, requires your life. It cannot be done cheaper. The difficulty of doing right is increased—not twofold nor threefold, but a thousandfold, and more—by the addition of colour to your work. For the

[1] [§§ 152–154 here were reprinted as §§ 1–4 in ch. viii. of *The Laws of Fésole*: see below, p. 432. The notes and modifications there introduced are here given in footnotes.]

[2] [In *The Laws of Fésole* Ruskin here introduced the words "(feathers, and the like, not to say rocks and clouds)," and appended the following footnote :—

"The first four paragraphs of this chapter, this connecting parenthesis excepted, are reprinted from *The Elements of Drawing*. Read, however, carefully, the modifying notes."]

chances are more than a thousand to one against your being right both in form and colour with a given touch: it is difficult enough to be right in form, if you attend to that only; but when you have to attend, at the same moment, to a much more subtle thing than the form, the difficulty is strangely increased, — and multiplied almost to infinity by this great fact, that, while form is absolute, so that you can say at the moment you draw any line that it is either right or wrong, colour is wholly *relative*.[1] Every hue throughout your work is altered by every touch that you add in other places; so that what was warm[2] a minute ago, becomes cold when you have put a hotter colour in another place, and what was in harmony when you left it, becomes discordant as you set other colours beside it; so that every touch must be laid, not with a view to its effect at the time, but with a view to its effect in futurity, the result upon it of all that is afterwards to be done being previously considered. You may easily understand that, this being so, nothing but the devotion of life, and great genius besides, can make a colourist.

153. But though you cannot produce finished coloured drawings of any value, you may give yourself much pleasure,

[1] [In *The Laws of Fésole* Ruskin bracketed the word "wholly," and appended the following note :
 "No, not 'wholly' by any means. This is one of the over-hasty statements which render it impossible for me to republish, without more correction than they are worth, the books I wrote before the year 1860. Colour is no less positive than line, considered as a representation of fact; and you either match a given colour, or do not, as you either draw a given ellipse or square, or do not. Nor, on the other hand, are lines, in their grouping, destitute of relative influence; they exalt or depress their individual powers by association; and the necessity for the correction of the above passage in this respect was pointed out to me by Miss Hill, many and many a year ago, when she was using the *Elements* in teaching design for glass. But the influence of lines on each other is restricted within narrow limits, while the sequences of colour are like those of sound, and susceptible of all the complexity and passion of the most accomplished music."
Miss Octavia Hill was at this time (1856 onwards) assisting Ruskin's work in various ways; see, for instance, *Modern Painters*, vol. v., Preface, § 6 n.]
[2] [Here in *The Laws of Fésole* Ruskin appended the following note :—
 "I assumed in *The Elements of Drawing* the reader's acquaintance with this and other ordinary terms of art. But see § 30 of the last chapter :" in *The Laws of Fésole* (below, p. 430).]

and be of great use to other people, by occasionally sketching with a view to colour only; and preserving distinct statements of certain colour facts—as that the harvest moon at rising was of such and such a red, and surrounded by clouds of such and such a rosy grey; that the mountains at evening were in truth so deep in purple; and the waves by the boat's side were indeed of that incredible green. This only, observe, if you have an eye for colour; but you may presume that you have this, if you enjoy colour.

154. And, though of course you should always give as much form to your subject as your attention to its colour will admit of, remember that the whole value of what you are about depends, in a coloured sketch, on the colour merely. If the colour is wrong, everything is wrong: just as, if you are singing, and sing false notes, it does not matter how true the words are. If you sing at all, you must sing sweetly; and if you colour at all, you must colour rightly. Give up all the form, rather than the slightest part of the colour: just as, if you felt yourself in danger of a false note, you would give up the word, and sing a meaningless sound, if you felt that so you could save the note. Never mind though your houses are all tumbling down,—though your clouds are mere blots, and your trees mere knobs, and your sun and moon like crooked sixpences,—so only that trees, clouds, houses, and sun or moon, are of the right colours. Of course,[1] the discipline you have gone through will enable you to hint something of form, even in the fastest sweep of the brush; but do not let the thought of form hamper you in the least, when you begin to make coloured memoranda. If you want the form of the subject, draw it in black and white. If you want its colour, take its colour, and be sure you *have* it, and not a spurious, treacherous, half-measured

[1] [In *The Laws of Fésole* Ruskin made a new section here, and thus revised :—
"4. Of course, the collateral discipline to which you are submitting—(if you are)—will soon enable you"]

piece of mutual concession, with the colours all wrong, and the forms still anything but right. It is best to get into the habit of considering the coloured work merely as supplementary to your other studies; making your careful drawings of the subject first, and then a coloured memorandum separately, as shapeless as you like, but faithful in hue, and entirely minding its own business. This principle, however, bears chiefly on large and distant subjects: in foregrounds and near studies, the colour cannot be had without a good deal of definition of form. For if you do not map[1] the mosses on the stones accurately, you will not have the right quantity of colour in each bit of moss pattern, and then none of the colours will look right; but it always simplifies the work much if you are clear as to your point of aim, and satisfied, when necessary, to fail of all but that.

155. Now, of course, if I were to enter into detail respecting colouring, which is the beginning and end of a painter's craft, I should need to make this a work in three volumes instead of three letters, and to illustrate it in the costliest way. I only hope, at present, to set you pleasantly and profitably to work, leaving you, within the tethering of certain leading-strings, to gather what advantages you can from the works of art of which every year brings a greater number within your reach;—and from the instruction which, every year, our rising artists will be more ready to give kindly, and better able to give wisely.

156. And, first, of materials. Use hard cake colours,[2] not moist colours: grind a sufficient quantity of each on your palette every morning, keeping a separate plate, large and deep, for colours to be used in broad washes, and wash both plate and palette every evening, so as to be able always to get good and pure colour when you need it; and force yourself into cleanly and orderly habits about your colours. The two best colourists of modern times, Turner

[1] [In *The Laws of Fésole* Ruskin altered "map" to "shape."]
[2] [But see note on p. 42, above.]

and Rossetti,* afford us, I am sorry to say, no confirmation of this precept by their practice. Turner was, and Rossetti is, as slovenly in all their procedures as men can well be; but the result of this was, with Turner, that the colours have altered in all his pictures, and in many of his drawings; and the result of it with Rossetti is, that though his colours are safe, he has sometimes to throw aside work that was half done, and begin over again. William Hunt, of the Old Water-colour, is very neat in his practice; so, I believe, is Mulready; so is John Lewis; and so are the leading Pre-Raphaelites, Rossetti only excepted. And there can be no doubt about the goodness of the advice, if it were only for this reason, that the more particular you are about your colours the more you will get into a deliberate and methodical habit in using them, and all true speed in colouring comes of this deliberation.

157. Use Chinese white, well ground, to mix with your colours in order to pale them, instead of a quantity of water. You will thus be able to shape your masses more quietly, and play the colours about with more ease; they will not damp your paper so much, and you will be able to go on continually, and lay forms of passing cloud and other fugitive or delicately shaped lights, otherwise unattainable except by time.

158. This mixing of white with the pigments, so as to render them opaque, constitutes body-colour drawing as opposed to transparent-colour drawing, and you will, perhaps, have it often said to you that this body-colour is

* I give Rossetti this preëminence, because, though the leading Pre-Raphaelites have all about equal power over colour in the abstract, Rossetti and Holman Hunt are distinguished above the rest for rendering colour under effects of light; and of these two, Rossetti composes with richer fancy, and with a deeper sense of beauty, Hunt's stern realism leading him continually into harshness. Rossetti's carelessness, to do him justice, is only in water-colour, never in oil.[1]

[1] [For Rossetti and Holman Hunt as colourists, see *Art of England*, Lecture i. "Rossetti's carelessness" is the subject of admonitions in letters to the artist (see a later volume).]

"illegitimate." It is just as legitimate as oil-painting, being, so far as handling is concerned, the same process, only without its uncleanliness, its unwholesomeness, or its inconvenience; for oil will not dry quickly, nor carry safely, nor give the same effects of atmosphere without tenfold labour. And if you hear it said that the body-colour looks chalky or opaque, and, as is very likely, think so yourself, be yet assured of this, that though certain effects of glow and transparencies of gloom are not to be reached without transparent colour, those glows and glooms are *not* the noblest aim of art. After many years' study of the various results of fresco and oil painting in Italy, and of body-colour and transparent colour in England, I am now entirely convinced that the greatest things that are to be done in art must be done in dead colour. The habit of depending on varnish or on lucid tints for transparency, makes the painter comparatively lose sight of the nobler translucence which is obtained by breaking various colours amidst each other: and even when, as by Correggio, exquisite play of hue is joined with exquisite transparency, the delight in the depth almost always leads the painter into mean and false chiaroscuro; it leads him to like dark backgrounds instead of luminous ones,* and to enjoy, in

* All the degradation of art which was brought about, after the rise of the Dutch school, by asphaltum, yellow varnish, and brown trees[1] would have been prevented, if only painters had been forced to work in dead colour. Any colour will do for some people, if it is browned and shining; but fallacy in dead colour is detected on the instant. I even believe that whenever a painter begins to *wish* that he could touch any portion of his work with gum, he is going wrong.

It is necessary, however, in this matter, carefully to distinguish between translucency and lustre. Translucency, though, as I have said above, a dangerous temptation, is, in its place, beautiful; but lustre or *shininess* is always, in painting, a defect. Nay, one of my best painter-friends (the "best" being understood to attach to both divisions of that awkward compound word), tried the other day to persuade me that lustre was an ignobleness in anything; and it was only the fear of treason to ladies' eyes, and to mountain streams, and to morning dew, which kept me from yielding the

[1] [For the "brown tree," see Vol. III. p. 45.]

general, quality of colour more than grandeur of composition, and confined light rather than open sunshine: so that the really greatest thoughts of the greatest men have always, so far as I remember, been reached in dead colour, and the noblest oil pictures of Tintoret and Veronese are those which are likest frescoes.

159. Besides all this, the fact is, that though sometimes a little chalky and coarse-looking body-colour is, in a sketch, infinitely liker Nature than transparent colour: the bloom and mist of distance are accurately and instantly represented by the film of opaque blue (*quite* accurately, I think, by nothing else); and for ground, rocks, and buildings, the earthy and solid surface is, of course, always truer than the most finished and carefully wrought work in transparent tints can ever be.

160. Against one thing, however, I must steadily caution you. All kinds of colour are equally illegitimate, if you think they will allow you to alter at your pleasure, or blunder at your ease. There is *no* vehicle or method of colour which admits of alteration or repentance; you must be right at once, or never; and you might as well hope to catch a rifle bullet in your hand, and put it straight, when it was going wrong, as to recover a tint once spoiled. The secret of all good colour in oil, water, or anything else, lies primarily in that sentence spoken to me by Mulready: "Know what you have to do."[1] The process may be a long one, perhaps: you may have to ground with one colour; to touch it with fragments of a second; to crumble a third into the interstices; a fourth into the interstices of the third; to glaze the whole with a fifth; and to reinforce

point to him. One is apt always to generalise too quickly in such matters; but there can be no question that lustre is destructive of loveliness in colour, as it is of intelligibility in form. Whatever may be the pride of a young beauty in the knowledge that her eyes shine (though perhaps even eyes are most beautiful in dimness), she would be sorry if her cheeks did; and which of us would wish to polish a rose?

[1] [See *Seven Lamps of Architecture*, Vol. VIII. p. 19.]

in points with a sixth: but whether you have one, or ten, or twenty processes to go through, you must go *straight* through them knowingly and foreseeingly all the way; and if you get the thing once wrong, there is no hope for you but in washing or scraping boldly down to the white ground, and beginning again.

161. The drawing in body-colour will tend to teach you all this, more than any other method, and above all it will prevent you from falling into the pestilent habit of sponging to get texture; a trick which has nearly ruined our modern water-colour school of art. There are sometimes places in which a skilful artist will roughen his paper a little to get certain conditions of dusty colour with more ease than he could otherwise; and sometimes a skilfully rased piece of paper will, in the midst of transparent tints, answer nearly the purpose of chalky body-colour in representing the surfaces of rocks or building. But artifices of this kind are always treacherous in a tyro's hands, tempting him to trust in them: and you had better always work on white or grey paper as smooth as silk; * and never disturb the surface of your colour or paper, except finally to scratch out the very highest lights if you are using transparent colours.

162. I have said above that body-colour drawing will teach you the use of colour better than working with merely transparent tints; but this is not because the process is an easier one, but because it is a more complete one, and also because it involves some working with transparent tints in the best way. You are not to think that because you use body-colour you may make any kind of mess that you like, and yet get out of it. But you are to avail yourself of the characters of your material, which enable you

* But not shiny or greasy. Bristol board, or hot-pressed imperial, or grey paper that feels slightly adhesive to the hand, is best. Coarse, gritty, and sandy papers are fit only for blotters and blunderers; no good draughtsman would lay a line on them. Turner worked much on a thin tough paper, dead in surface; rolling up his sketches in tight bundles that would go deep into his pockets.

most nearly to imitate the processes of Nature. Thus, suppose you have a red rocky cliff to sketch, with blue clouds floating over it. You paint your cliff first firmly, then take your blue, mixing it to such a tint (and here is a great part of the skill needed) that when it is laid over the red, in the thickness required for the effect of the mist, the warm rock-colour showing through the blue cloud-colour, may bring it to exactly the hue you want (your upper tint, therefore, must be mixed colder than you want it); then you lay it on, varying it as you strike it, getting the forms of the mist at once, and, if it be rightly done, with exquisite quality of colour, from the warm tint's showing through and between the particles of the other. When it is dry, you may add a little colour to retouch the edges where they want shape, or heighten the lights where they want roundness, or put another tone over the whole: but you can take none away. If you touch or disturb the surface, or by any untoward accident mix the under and upper colours together, all is lost irrecoverably. Begin your drawing from the ground again if you like, or throw it into the fire if you like. But do not waste time in trying to mend it.*

163. This discussion of the relative merits of transparent and opaque colour has, however, led us a little beyond the point where we should have begun; we must go back to our palette, if you please. Get a cake of each of the hard colours named in the note below † and try experiments on their simple combinations, by mixing each colour with every other. If you like to do it in an orderly way, you may prepare a squared piece of pasteboard, and put the pure colours in columns at the top and side; the mixed

* I insist upon this unalterability of colour the more because I address you as a beginner, or an amateur: a great artist can sometimes get out of a difficulty with credit, or repent without confession. Yet even Titian's alterations usually show as stains on his work.

† It is, I think, a piece of affectation to try to work with few colours: it saves time to have enough tints prepared without mixing, and you may at once allow yourself these twenty-four. If you arrange them in your

tints being given at the intersections, thus (the letters standing for colours):

```
        b       c       d       e       f     etc.
a     a b     a c     a d     a e       f
b     —       b c     b d     b e       b
c     —       —       c d     c e       c
d     —       —       —       d e       d
e     —       —       —       —         e
etc.
```

This will give you some general notion of the characters of mixed tints of two colours only, and it is better in practice to confine yourself as much as possible to these, and to get more complicated colours, either by putting the third *over* the first blended tint, or by putting the third into its interstices. Nothing but watchful practice will teach you the effects that colours have on each other when thus put over, or beside, each other.

164. When you have got a little used to the principal

colour-box in the order I have set them down, you will always easily put your finger on the one you want.

Cobalt	Smalt	Antwerp blue	Prussian blue
Black	Gamboge	Emerald green	Hooker's green
Lemon yellow	Cadmium yellow	Yellow ochre	Roman ochre
Raw sienna	Burnt sienna	Light red	Indian red
Mars orange	Extract of vermilion	Carmine	Violet carmine
Brown madder	Burnt umber	Vandyke brown	Sepia

Antwerp blue and Prussian blue are not very permanent colours, but you need not care much about permanence in your work as yet, and they are both beautiful; while Indigo is marked by Field as more fugitive still, and is very ugly. Hooker's green is a mixed colour, put in the box merely to save you loss of time in mixing gamboge and Prussian blue. No. 1 is the best tint of it. Violet carmine is a noble colour for laying broken shadows with, to be worked into afterwards with other colours.

If you wish to take up colouring seriously you had better get Field's *Chromatography*[1] at once; only do not attend to anything it says about principles or harmonies of colour; but only to its statements of practical serviceableness in pigments, and of their operations on each other when mixed, etc.

[1] [For this book, see Vol. IV. p. 362.]

combinations, place yourself at a window which the sun
does not shine in at,[1] commanding some simple piece of
landscape: outline this landscape roughly; then take a piece
of white cardboard, cut out a hole in it about the size of
a large pea; and supposing ʀ is the room, *a d* the window,
and you are sitting at *a*, Fig. 29, hold this
cardboard a little outside of the window,
upright, and in the direction *b d*, parallel to
the side of the window, or a little turned,
so as to catch more light, as at *a d*, never
turned as at *c d*, or the paper will be dark.
Then you will see the landscape, bit by
bit, through the circular hole. Match the
colours of each important bit as nearly as

Fig. 29.

you can, mixing your tints with white, beside the aperture.
When matched, put a touch of the same tint at the top of
your paper, writing under it: "dark tree colour," "hill
colour," "field colour," as the case may be. Then wash
the tint away from beside the opening, and the cardboard
will be ready to match another piece of the landscape.*
When you have got the colours of the principal masses
thus indicated, lay on a piece of each in your sketch in
its right place, and then proceed to complete the sketch in
harmony with them, by your eye.

165. In the course of your early experiments, you will
be much struck by two things: the first, the inimitable
brilliancy of light in sky and in sun-lighted things; and the
second, that among the tints which you can imitate, those

* A more methodical, though under general circumstances uselessly
prolix way, is to cut a square hole, some half an inch wide, in the sheet
of cardboard, and a series of small circular holes in a slip of cardboard an
inch wide. Pass the slip over the square opening, and match each colour
beside one of the circular openings. You will thus have no occasion to
wash any of the colours away. But the first rough method is generally
all you want, as, after a little practice, you only need to *look* at the
hue through the opening in order to be able to transfer it to your draw-
ing at once.

[1] [Compare the passage from Leonardo cited above, p. 49.]

which you thought the darkest will continually turn out to be in reality the lightest. Darkness of objects is estimated by us, under ordinary circumstances, much more by knowledge than by sight; thus, a cedar or Scotch fir, at 200 yards off, will be thought of darker green than an elm or oak near us; because we know by experience that the peculiar colour they exhibit, at that distance, is the *sign* of darkness of foliage. But when we try them through the cardboard, the near oak will be found, indeed, rather dark green, and the distant cedar, perhaps, pale grey-purple.[1] The quantity of purple and grey in Nature is, by the way, another somewhat surprising subject of discovery.

166. Well, having ascertained thus your principal tints, you may proceed to fill up your sketch; in doing which observe these following particulars:

(1.) Many portions of your subject appeared through the aperture in the paper brighter than the paper, as sky, sun-lighted grass, etc. Leave these portions, for the present, white; and proceed with the parts of which you can match the tints.

(2.) As you tried your subject with the cardboard, you must have observed how many changes of hue took place over small spaces. In filling up your work, try to educate your eye to perceive these differences of hue without the help of the cardboard, and lay them deliberately, like a mosaic-worker, as separate colours, preparing each carefully on your palette, and laying it as if it were a patch of coloured cloth, cut out, to be fitted neatly by its edge to the next patch; so that the *fault* of your work may be, not a slurred or misty look, but a patched bed-cover look, as if it had all been cut out with scissors. For instance, in drawing the trunk of a birch tree, there will be probably white high lights, then a pale rosy grey round them on the light side, then a (probably greenish) deeper grey on the dark side, varied by reflected colours, and, over all,

[1] [On the colour of distant trees, compare *Modern Painters*, vol. iv. (Vol. VI. p. 421 and *n*.).]

rich black strips of bark and brown spots of moss. Lay first the rosy grey, leaving white for the high lights *and for the spots of moss*, and not touching the dark side. Then lay the grey for the dark side, fitting it well up to the rosy grey of the light, leaving also in this darker grey the white paper in the places for the black and brown moss; then prepare the moss colours separately for each spot, and lay each in the white place left for it. Not one grain of white, except that purposely left for the high lights, must be visible when the work is done, even through a magnifying-glass, so cunningly must you fit the edges to each other. Finally, take your background colours, and put them on each side of the tree trunk, fitting them carefully to its edge.

167. Fine work you would make of this, wouldn't you, if you had not learned to draw first, and could not now draw a good outline for the stem, much less terminate a colour mass in the outline you wanted?

Your work will look very odd for some time, when you first begin to paint in this way, and before you can modify it, as I shall tell you presently how;[1] but never mind; it is of the greatest possible importance that you should practise this separate laying on of the hues, for all good colouring finally depends on it. It is, indeed, often necessary, and sometimes desirable, to lay one colour and form boldly over another: thus, in laying leaves on blue sky, it is impossible always in large pictures, or when pressed for time, to fill in the blue through the interstices of the leaves; and the great Venetians constantly lay their blue ground first, and then, having let it dry, strike the golden brown over it in the form of the leaf, leaving the under blue to shine through the gold, and subdue it to the olive-green they want. But in the most precious and perfect work each leaf is inlaid, and the blue worked round it; and, whether you use one or other mode of getting

[1] [Below, p. 201.]

your result, it is equally necessary to be absolute and decisive in your laying the colour. Either your ground must be laid firmly first, and then your upper colour struck upon it in perfect form, for ever, thenceforward, unalterable; or else the two colours must be individually put in their places, and led up to each other till they meet at their appointed border, equally, thenceforward, unchangeable. Either process, you see, involves absolute decision. If you once begin to slur, or change, or sketch, or try this way and that with your colour, it is all over with it and with you. You will continually see bad copyists trying to imitate the Venetians, by daubing their colours about, and retouching, and finishing, and softening: when every touch and every added hue only lead them farther into chaos. There is a dog between two children in a Veronese in the Louvre,[1] which gives the copyists much employment. He has a dark ground behind him, which Veronese has painted first, and then when it was dry, or nearly so, struck the locks of the dog's white hair over it with some half-dozen curling sweeps of his brush, right at once, and for ever. Had one line or hair of them gone wrong, it would have been wrong for ever; no retouching could have mended it. The poor copyists daub in first some background, and then some dog's hair; then retouch the background, then the hair; work for hours at it, expecting it always to come right to-morrow—"when it is finished." They *may* work for centuries at it, and they will never do it. If they can do it with Veronese's allowance of work, half a dozen sweeps of the hand over the dark background, well; if not, they may ask the dog himself whether it will ever come right, and get true answer from him—on Launce's conditions: "If he say 'ay,' it will; if he say 'no,' it will; if he shake his tail and say nothing, it will."[2]

168. (3.) Whenever you lay on a mass of colour, be sure

[1] [The group is in the picture of "The Supper at Emmaus": see "Notes on the Louvre," § 8, Vol. XII. p. 451.]

[2] [*Two Gentlemen of Verona*, ii. 5.]

that however large it may be, or however small, it shall be
gradated. No colour exists in Nature under ordinary cir-
cumstances without gradation. If you do not see this, it
is the fault of your inexperience: you will see it in due
time, if you practise enough. But in general you may see
it at once. In the birch trunk, for instance, the rosy grey
must be gradated by the roundness of the stem till it meets
the shaded side; similarly the shaded side is gradated by
reflected light. Accordingly, whether by adding water, or
white paint, or by unequal force of touch (this you will do
at pleasure, according to the texture you wish to produce),
you must, in every tint you lay on, make it a little paler
at one part than another, and get an even gradation be-
tween the two depths. This is very like laying down a
formal law or recipe for you; but you will find it is merely
the assertion of a natural.fact. It is not indeed physically
impossible to meet with an ungradated piece of colour,
but it is so supremely improbable, that you had better get
into the habit of asking yourself invariably, when you are
going to copy a tint—not " Is that gradated?" but " Which
way is that gradated?" and at least in ninety-nine out of a
hundred instances, you will be able to answer decisively
after a careful glance, though the gradation may have been
so subtle that you did not see it at first. And it does not
matter how small the touch of colour may be, though not
larger than the smallest pin's head, if one part of it is not
darker than the rest, it is a bad touch; for it is not merely
because the natural fact is so, that your colour should be
gradated; the preciousness and pleasantness of the colour
itself depends more on this than on any other of its quali-
ties, for gradation is to colours just what curvature is to
lines, both being felt to be beautiful by the pure instinct of
every human mind, and both, considered as types, express-
ing the law of gradual change and progress in the human
soul itself. What the difference is in mere beauty between
a gradated and ungradated colour, may be seen easily by
laying an even tint of rose-colour on paper, and putting a

rose leaf beside it. The victorious beauty of the rose as
compared with other flowers, depends wholly on the delicacy
and quantity of its colour gradations,[1] all other flowers being
either less rich in gradation, not having so many folds of
leaf; or less tender, being patched and veined instead of
flushed.

169. (4.) But observe, it is not enough in general that
colour should be gradated by being made merely paler or
darker at one place than another. Generally colour changes
as it diminishes, and is not merely darker at one spot, but
also purer at one spot than anywhere else. It does not in
the least follow that the darkest spot should be the purest;
still less so that the lightest should be the purest. Very
often the two gradations more or less cross each other, one
passing in one direction from paleness to darkness, another
in another direction from purity to dulness, but there will
almost always be both of them, however reconciled; and
you must never be satisfied with a piece of colour until you
have got both: that is to say, every piece of blue that
you lay on must be *quite* blue only at some given spot,
nor that a large spot; and must be gradated from that into
less pure blue,—greyish blue, or greenish blue, or purplish
blue,—over all the rest of the space it occupies. And this
you must do in one of three ways: either, while the colour
is wet, mix with it the colour which is to subdue it, adding
gradually a little more · and a little more; or else, when
the colour is quite dry, strike a gradated touch of another
colour over it, leaving only a point of the first tint visible;
or else, lay the subduing tints on in small touches, as in
the exercise of tinting the chess-board. Of each of these
methods I have something to tell you separately; but that
is distinct from the subject of gradation, which I must not
quit without once more pressing upon you the preëminent
necessity of introducing it everywhere. I have profound
dislike of anything like habit of hand, and yet, in this one

[1] [Compare *Modern Painters*, vol. iv. (Vol. VI. p. 62).]

instance, I feel almost tempted to encourage you to get into a habit of never touching paper with colour, without securing a gradation. You will not, in Turner's largest oil pictures, perhaps six or seven feet long by four or five high, find one spot of colour as large as a grain of wheat ungradated : and you will find in practice, that brilliancy of hue, and vigour of light, and even the aspect of transparency in shade, are essentially dependent on this character alone ; hardness, coldness, and opacity resulting far more from *equality* of colour than from nature of colour. Give me some mud off a city crossing, some ochre out of a gravel pit, a little whitening, and some coal-dust, and I will paint you a luminous picture, if you give me time to gradate my mud, and subdue my dust : but though you had the red of the ruby, the blue of the gentian, snow for the light, and amber for the gold, you cannot paint a luminous picture, if you keep the masses of those colours unbroken in purity, and unvarying in depth.

170. (5.) Next, note the three processes by which gradation and other characters are to be obtained :

A. Mixing while the colour is wet.

You may be confused by my first telling you to lay on the hues in separate patches, and then telling you to mix hues together as you lay them on : but the separate masses are to be laid, when colours distinctly oppose each other at a given limit; the hues to be mixed, when they palpitate one through the other, or fade one into the other. It is better to err a little on the distinct side. Thus I told you to paint the dark and light sides of the birch trunk separately, though, in reality, the two tints change, as the trunk turns away from the light, gradually one into the other ; and, after being laid separately on, will need some farther touching to harmonise them : but they do so in a very narrow space, marked distinctly all the way up the trunk, and it is easier and safer, therefore, to keep them separate at first. Whereas it often happens that the whole beauty of two colours will depend on the one being continued well

through the other, and playing in the midst of it: blue and green often do so in water; blue and grey, or purple and scarlet, in sky: in hundreds of such instances the most beautiful and truthful results may be obtained by laying one colour into the other while wet; judging wisely how far it will spread, or blending it with the brush in somewhat thicker consistence of wet body-colour; only observe, never mix in this way two *mixtures;* let the colour you lay into the other be always a simple, not a compound tint.

171. B. Laying one colour over another.

If you lay on a solid touch of vermilion, and after it is quite dry, strike a little very wet carmine quickly over it, you will obtain a much more brilliant red than by mixing the carmine and vermilion. Similarly, if you lay a dark colour first, and strike a little blue or white body-colour lightly over it, you will get a more beautiful grey than by mixing the colour and the blue or white. In very perfect painting, artifices of this kind are continually used; but I would not have you trust much to them: they are apt to make you think too much of quality of colour. I should like you to depend on little more than the dead colours, simply laid on, only observe always this, that the *less* colour you do the work with, the better it will always be:* so that if you had laid a red colour, and you want a purple one above, do not mix the purple on your palette and lay it on so thick as to overpower the red, but take a little thin blue from your palette, and lay it lightly over the red, so as to let the red be seen through, and thus produce the required purple; and if you want a green hue over a blue one, do not lay a quantity of green on the blue, but a *little* yellow, and so on, always bringing the under colour into

* If colours were twenty times as costly as they are, we should have many more good painters. If I were Chancellor of the Exchequer I would lay a tax of twenty shillings a cake on all colours except black, Prussian blue, Vandyke brown, and Chinese white, which I would leave for students. I don't say this jestingly; I believe such a tax would do more to advance real art than a great many schools of design.

service as far as you possibly can. If, however, the colour beneath is wholly opposed to the one you have to lay on, as, suppose, if green is to be laid over scarlet, you must either remove the required parts of the under colour daintily first with your knife, or with water; or else, lay solid white over it massively, and leave that to dry, and then glaze the white with the upper colour. This is better, in general, than laying the upper colour itself so thick as to conquer the ground, which, in fact, if it be a transparent colour, you cannot do. Thus, if you have to strike warm boughs and leaves of trees over blue sky, and they are too intricate to have their places left for them in laying the blue, it is better to lay them first in solid white, and then glaze with sienna and ochre, than to mix the sienna and white; though, of course, the process is longer and more troublesome. Nevertheless, if the forms of touches required are very delicate, the after glazing is impossible. You must then mix the warm colour thick at once, and so use it: and this is often necessary for delicate grasses, and such other fine threads of light in foreground work.

172. C. Breaking one colour in small points through or over another.

This is the most important of all processes in good modern * oil and water-colour painting, but you need not hope to attain very great skill in it. To do it well is very laborious, and requires such skill and delicacy of hand as can only be acquired by unceasing practice. But you will find advantage in noting the following points:

173. (a.) In distant effects of rich subject, wood, or rippled water, or broken clouds, much may be done by touches or crumbling dashes of rather dry colour, with other colours afterwards put cunningly into the interstices. The more you practise this, when the subject evidently calls

* I say *modern*, because Titian's quiet way of blending colours, which is the perfectly right one, is not understood now by any artist. The best colour we reach is got by stippling; but this is not quite right.

for it, the more your eye will enjoy the higher qualities of colour. The process is, in fact, the carrying out of the principle of separate colours to the utmost possible refinement; using atoms of colour in juxtaposition, instead of large spaces. And note, in filling up minute interstices of this kind, that if you want the colour you fill them with to show brightly, it is better to put a rather positive point of it, with a little white left beside or round it in the interstice, than to put a pale tint of the colour over the whole interstice. Yellow or orange will hardly show, if pale, in small spaces; but they show brightly in firm touches, however small, with white beside them.

174. (b.) If a colour is to be darkened by superimposed portions of another, it is, in many cases, better to lay the uppermost colour in rather vigorous small touches, like finely chopped straw, over the under one, than to lay it on as a tint, for two reasons: the first, that the play of the two colours together is pleasant to the eye; the second, that much expression of form may be got by wise administration of the upper dark touches. In distant mountains they may be made pines of, or broken crags, or villages, or stones, or whatever you choose; in clouds they may indicate the direction of the rain, the roll and outline of the cloud masses; and in water, the minor waves. All noble effects of dark atmosphere are got in good watercolour drawing by these two expedients, interlacing the colours, or retouching the lower one with fine darker drawing in an upper. Sponging and washing for dark atmospheric effect is barbarous, and mere tyro's work, though it is often useful for passages of delicate atmospheric light.

175. (c.) When you have time, practise the production of mixed tints by interlaced touches of the pure colours out of which they are formed, and use the process at the parts of your sketches where you wish to get rich and luscious effects. Study the works of William Hunt,[1] of the Old

[1] [See also Vol. XIV. p. 384, where Ruskin refers to William Hunt as the best model in water-colour painting. Compare § 68 above, p. 64.]

Water-colour Society, in this respect, continually, and make frequent memoranda of the variegations in flowers; not painting the flower completely, but laying the ground colour of one petal, and painting the spots on it with studious precision: a series of single petals of lilies, geraniums, tulips, etc., numbered with proper reference to their position in the flower, will be interesting to you on many grounds besides those of art. Be careful to get the gradated distribution of the spots well followed in the calceolarias, foxgloves, and the like; and work out the odd, indefinite hues of the spots themselves with minute grains of pure interlaced colour, otherwise you will never get their richness or bloom. You will be surprised to find as you do this, first, the universality of the law of gradation we have so much insisted upon; secondly, that Nature is just as economical of *her* fine colours as I have told you to be of yours. You would think, by the way she paints, that her colours cost her something enormous; she will only give you a single pure touch, just where the petal turns into light; but down in the bell all is subdued, and under the petal all is subdued, even in the showiest flower. What you thought was bright blue is, when you look close, only dusty grey, or green, or purple, or every colour in the world at once, only a single gleam or streak of pure blue in the centre of it. And so with all her colours. Sometimes I have really thought her miserliness intolerable: in a gentian, for instance, the way she economises her ultramarine down in the bell is a little too bad.*

176. Next, respecting general tone. I said, just now, that, for the sake of students, my tax should not be laid on black or on white pigments; but if you mean to be a colourist, you must lay a tax on them yourself when you begin to use true colour; that is to say, you must use them little, and make of them much. There is no better test of your colour tones being good, than your having

* See Note 6 in Appendix I. [p. 217].

made the white in your picture precious, and the black conspicuous.[1]

177. I say, first, the white precious. I do not mean merely glittering or brilliant: it is easy to scratch white sea-gulls out of black clouds, and dot clumsy foliage with chalky dew; but when white is well managed, it ought to be strangely delicious,—tender as well as bright,—like inlaid mother of pearl, or white roses washed in milk. The eye ought to seek it for rest, brilliant though it may be; and to feel it as a space of strange, heavenly paleness in the midst of the flushing of the colours. This effect you can only reach by general depth of middle tint, by absolutely refusing to allow any white to exist except where you need it, and by keeping the white itself subdued by grey, except at a few points of chief lustre.

178. Secondly, you must make the black conspicuous. However small a point of black may be, it ought to catch the eye, otherwise your work is too heavy in the shadow. All the ordinary shadows should be of some *colour*,— never black, nor approaching black, they should be evidently and always of a luminous nature, and the black should look strange among them; never occurring except in a black object, or in small points indicative of intense shade in the very centre of masses of shadow. Shadows of absolutely negative grey, however, may be beautifully used with white, or with gold; but still though the black thus, in subdued strength, becomes spacious, it should always be conspicuous; the spectator should notice this grey neutrality with some wonder, and enjoy, all the more intensely on account of it, the gold colour and the white which it relieves. Of all the great colourists Velasquez is the greatest master of the black chords. His black is more precious than most other people's crimson.

179. It is not, however, only white and black which you must make valuable; you must give rare worth to

[1] [Compare *Lectures on Landscape*, § 73, where Ruskin repeats and illustrates this " testing rule for good colour," and *Lectures on Art*, § 138.]

every colour you use; but the white and black ought to separate themselves quaintly from the rest, while the other colours should be continually passing one into the other, being all evidently companions in the same gay world; while the white, black, and neutral grey should stand monkishly aloof in the midst of them. You may melt your crimson into purple, your purple into blue, and your blue into green, but you must not melt any of them into black. You should, however, try, as I said, to give preciousness to all your colours; and this especially by never using a grain more than will just do the work, and giving each hue the highest value by opposition. All fine colouring, like fine drawing, is delicate; and so delicate that if, at last, you *see* the colour you are putting on, you are putting on too much. You ought to feel a change wrought in the general tone, by touches of colour which individually are too pale to be seen; and if there is one atom of any colour in the whole picture which is unnecessary to it, that atom hurts it.[1]

180. Notice also that nearly all good compound colours are *odd* colours. You shall look at a hue in a good painter's work ten minutes before you know what to call it. You thought it was brown, presently you feel that it is red; next that there is, somehow, yellow in it; presently afterwards that there is blue in it. If you try to copy it you will always find your colour too warm or too cold—no colour in the box will seem to have an affinity with it; and yet it will be as pure as if it were laid at a single touch with a single colour.

181. As to the choice and harmony of colours in general, if you cannot choose and harmonise them by instinct, you will never do it at all. If you need examples of utterly harsh and horrible colour, you may find plenty given in treatises upon colouring, to illustrate the laws of harmony;

[1] [On this subject, of delicacy in art, see above, pp. 14, 37, and compare *Lectures on Colour*, § 35, Vol. XII. p. 503; and see Vol. XIII. p. 336, where this passage is quoted and illustrated.]

and if you want to colour beautifully, colour as best pleases yourself at *quiet times*, not so as to catch the eye, nor look as if it were clever or difficult to colour in that way, but so that the colour may be pleasant to you when you are happy or thoughtful. Look much at the morning and evening sky, and much at simple flowers—dog-roses, wood-hyacinths, violets, poppies, thistles, heather, and such like,—as Nature arranges them in the woods and fields. If ever any scientific person tells you that two colours are "discordant," make a note of the two colours, and put them together whenever you can. I have actually heard people say that blue and green were discordant; the two colours which Nature seems to intend never to be separated, and never to be felt, either of them, in its full beauty without the other!—a peacock's neck, or a blue sky through green leaves, or a blue wave with green lights through it, being precisely the loveliest things, next to clouds at sunrise, in this coloured world of ours. If you have a good eye for colours, you will soon find out how constantly Nature puts purple and green together, purple and scarlet, green and blue, yellow and neutral grey, and the like; and how she strikes these colour-concords for general tones, and then works into them with innumerable subordinate ones; and you will gradually come to like what she does, and find out new and beautiful chords of colour in her work every day. If you enjoy them, depend upon it you will paint them to a certain point right: or, at least, if you do not enjoy them, you are certain to paint them wrong. If colour does not give you intense pleasure, let it alone; depend upon it, you are only tormenting the eyes and senses of people who feel colour, whenever you touch it; and that is unkind and improper.

182. You will find, also, your power of colouring depend much on your state of health and right balance of mind; when you are fatigued or ill you will not see colours well, and when you are ill-tempered you will not choose them well: thus, though not infallibly a test of character in

individuals, colour power is a great sign of mental health in nations;[1] when they are in a state of intellectual decline, their colouring always gets dull.* You must also take great care not to be misled by affected talk about colours from people who have not the gift of it: numbers are eager and voluble about it who probably never in all their lives received one genuine colour-sensation. The modern religionists of the school of Overbeck are just like people who eat slate-pencil and chalk, and assure everybody that they are nicer and purer than strawberries and plums.[2]

183. Take care also never to be misled into any idea that colour can help or display *form;* colour † always disguises form, and is meant to do so.

184. It is ι. favourite dogma among modern writers on colour that " warm colours" (reds and yellows) "approach," or express nearness, and "cold colours" (blue and grey) "retire," or express distance.[3] So far is this from being the case, that no expression of distance in the world is so great as that of the gold and orange in twilight sky. Colours,

* The worst general character that colour can possibly have is a prevalent tendency to a dirty yellowish green, like that of a decaying heap of vegetables; this colour is *accurately* indicative of decline or paralysis in missal-painting.

† That is to say, local colour inherent in the object. The gradations of colour in the various shadows belonging to various lights exhibit form, and therefore no one but a colourist can ever draw *forms* perfectly (see *Modern Painters*, vol. iv. chap. iii. at the end [4]); but all notions of explaining form by superimposed colour, as in architectural mouldings, are absurd. Colour adorns form, but does not interpret it. An apple is prettier because it is striped, but it does not look a bit rounder; and a cheek is prettier because it is flushed, but you would see the form of the cheek bone better if it were not. Colour may, indeed, detach one shape from another, as in grounding a bas-relief, but it always diminishes the appearance of projection, and whether you put blue, purple, red, yellow, or green, for your ground, the bas-relief will be just as clearly or just as imperfectly relieved, as long as the colours are of equal depth. The blue ground will not retire the hundredth part of an inch more than the red one.

[1] [Compare Vol. X. p. 173.]
[2] [For Overbeck, see Vol. V. p. 50; and for the "muddy" German school, Vol. III. p. 351.]
[3] [See Vol. XIII. p. 218, where Ruskin illustrates the argument here from Turner's sketch, No. 73 in the National Gallery.]
[4] [In this edition, Vol. VI. pp. 71.]

as such, are ABSOLUTELY inexpressive respecting distance. It is their quality (as depth, delicacy, etc.) which expresses distance, not their tint. A blue bandbox set on the same shelf with a yellow one will not look an inch farther off, but a red or orange cloud, in the upper sky, will always appear to be beyond a blue cloud close to us, as it is in reality. It is quite true that in certain objects, blue is a *sign* of distance; but that is not because blue is a retiring colour, but because the mist in the air is blue, and therefore any warm colour which has not strength of light enough to pierce the mist is lost or subdued in its blue: but blue is no more, on this account, a "retiring colour," than brown is a retiring colour, because, when stones are seen through brown water, the deeper they lie the browner they look; or than yellow is a retiring colour, because, when objects are seen through a London fog, the farther off they are the yellower they look. Neither blue, nor yellow, nor red, can have, as such, the smallest power of expressing either nearness or distance: they express them only under the peculiar circumstances which render them at the moment, or in that place, *signs* of nearness or distance. Thus, vivid orange in an orange is a sign of nearness, for if you put the orange a great way off, its colour will not look so bright; but vivid orange in sky is a sign of distance, because you cannot get the colour of orange in a cloud near you. So purple in a violet or a hyacinth is a sign of nearness, because the closer you look at them the more purple you see. But purple in a mountain is a sign of distance, because a mountain close to you is not purple, but green or grey. It may, indeed, be generally assumed that a tender or pale colour will more or less express distance, and a powerful or dark colour nearness; but even this is not always so. Heathery hills will usually give a pale and tender purple near, and an intense and dark purple far away; the rose colour of sunset on snow is pale on the snow at your feet, deep and full on the snow in the distance; and the green of a Swiss lake is pale in the clear waves on the beach, but intense as an

emerald in the sunstreak six miles from shore. And in any case, when the foreground is in strong light, with much water about it, or white surface, casting intense reflections, all its colours may be perfectly delicate, pale, and faint; while the distance, when it is in shadow, may relieve the whole foreground with intense darks of purple, blue green, or ultramarine blue. So that, on the whole, it is quite hopeless and absurd to expect any help from laws of "aërial perspective."[1] Look for the natural effects, and set them down as fully as you can, and as faithfully, and *never* alter a colour because it won't look in its right place. Put the colour strong, if it be strong, though far off; faint, if it be faint, though close to you. Why should you suppose that Nature always means you to know exactly how far one thing is from another? She certainly intends you always to enjoy her colouring, but she does not wish you always to measure her space. You would be hard put to it, every time you painted the sun setting, if you had to express his 95,000,000 miles of distance in "aërial perspective."

185. There is, however, I think, one law about distance, which has some claims to be considered a constant one: namely, that dulness and heaviness of colour are more or less indicative of nearness. All distant colour is *pure* colour: it may not be bright, but it is clear and lovely, not opaque nor soiled; for the air and light coming between us and any earthy or imperfect colour, purify or harmonise it; hence a bad colourist is peculiarly incapable of expressing distance. I do not of course mean that you are to use bad colours in your foreground by way of making it come forward; but only that a failure in colour, there, will not put it out of its place; while a failure in colour in the distance will at once do away with its remoteness; your dull-coloured foreground will still be a foreground, though ill-painted; but your ill-painted distance will not be merely a dull distance,—it will be no distance at all.

[1] [On this subject, see Vol. III. p. 260, Vol. XI. pp. 59-60.]

186. I have only one thing more to advise you, namely, never to colour petulantly or hurriedly. You will not, indeed, be able, if you attend properly to your colouring, to get anything like the quantity of form you could in a chiaroscuro sketch ; nevertheless, if you do not dash or rush at your work, nor do it lazily, you may always get enough form to be satisfactory. An extra quarter of an hour, distributed in quietness over the course of the whole study, may just make the difference between a quite intelligible drawing, and a slovenly and obscure one. If you determine well beforehand what outline each piece of colour is to have, and, when it is on the paper, guide it without nervousness, as far as you can, into the form required ; and then, after it is dry, consider thoroughly what touches are needed to complete it, before laying one of them on ; you will be surprised to find how masterly the work will soon look, as compared with a hurried or ill-considered sketch. In no process that I know of—least of all in sketching—can time be really gained by precipitation. It is gained only by caution; and gained in all sorts of ways; for not only truth of form, but force of light, is always added by an intelligent and shapely laying of the shadow colours. You may often make a simple flat tint, rightly gradated and edged, express a complicated piece of subject without a single retouch. The two Swiss cottages, for instance, with their balconies, and glittering windows, and general character of shingly eaves, are expressed in Fig. 30 with one tint of grey, and a few dispersed spots and lines of it; all of which you ought to be able to lay on without more than thrice dipping your brush, and without a single touch after the tint is dry.

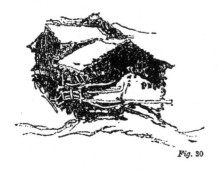

Fig. 30

187. Here, then, for I cannot without coloured illustrations tell you more, I must leave you to follow out the subject for yourself, with such help as you may receive from the water-colour drawings accessible to you ; or from any of the little treatises on their art which have been published lately[1] by our water-colour painters.* But do not trust much to works of this kind. You may get valuable hints from them as to mixture of colours; and here and there you will find a useful artifice or process explained; but nearly all such books are written only to help idle amateurs to a meretricious skill, and they are full of precepts and principles which may, for the most part, be interpreted by their *precise* negatives, and then acted upon with advantage. Most of them praise boldness,[2] when the only safe attendant spirit of a beginner is caution;—advise velocity, when the first condition of success is deliberation; —and plead for generalisation, when all the foundations of power must be laid in knowledge of speciality.

188. And now, in the last place, I have a few things to tell you respecting that dangerous nobleness of consummate art,—COMPOSITION. For though it is quite unnecessary for you yet awhile to attempt it, and it *may* be inexpedient for you to attempt it at all, you ought to know what it means, and to look for and enjoy it in the art of others.

Composition means, literally and simply, putting several things together, so as to make *one* thing out of them ; the nature and goodness of which they all have a share in producing. Thus a musician composes an air, by putting notes together in certain relations; a poet composes a poem, by putting thoughts and words in pleasant order; and a

* See, however, at the close of this letter, the notice of one more point connected with the management of colour, under the head "Law of Harmony" [p. 200].

[1] [Such as the works of Harding and Prout already referred to ; also *On Painting in Oil and Water Colours*, by T. H. Fielding (brother of Copley Fielding), 1839, and *A Treatise on Landscape Painting and Effect in Water Colours*, by David Cox, 1841.]

[2] [See above, § 16, p. 36.]

xv.

painter a picture, by putting thoughts, forms, and colours in pleasant order.

In all these cases, observe, an intended unity must be the result of composition. A paviour cannot be said to compose the heap of stones which he empties from his cart, nor the sower the handful of seed which he scatters from his hand. It is the essence of composition that everything should be in a determined place, perform an intended part, and act, in that part, advantageously for everything that is connected with it.

189. Composition, understood in this pure sense, is the type, in the arts of mankind, of the Providential government of the world.* It is an exhibition, in the order given to notes, or colours, or forms, of the advantage of perfect fellowship, discipline, and contentment. In a well-composed air, no note, however short or low, can be spared, but the least is as necessary as the greatest : no note, however prolonged, is tedious; but the others prepare for, and are benefited by, its duration: no note, however high, is tyrannous; the others prepare for, and are benefited by, its exaltation: no note, however low, is over-powered; the others prepare for, and sympathise with, its humility: and the result is, that each and every note has a value in the position assigned to it, which, by itself, it never possessed, and of which, by separation from the others, it would instantly be deprived.

190. Similarly, in a good poem, each word and thought enhances the value of those which precede and follow it; and every syllable has a loveliness which depends not so much on its abstract sound as on its position. Look at the same word in a dictionary, and you will hardly recognise it.

Much more in a great picture; every line and colour is so arranged as to advantage the rest. None are inessential, however slight; and none are independent, however forcible.

* See farther, on this subject, *Modern Painters*, vol. iv. chap. viii. § 6 [Vol. VI. p. 132].

It is not enough that they truly represent natural objects; but they must fit into certain places, and gather into certain harmonious groups: so that, for instance, the red chimney of a cottage is not merely set in its place as a chimney, but that it may affect, in a certain way pleasurable to the eye, the pieces of green or blue in other parts of the picture; and we ought to see that the work is masterly, merely by the positions and quantities of these patches of green, red, and blue, even at a distance which renders it perfectly impossible to determine what the colours represent: or to see whether the red is a chimney, or an old woman's cloak; and whether the blue is smoke, sky, or water.

191. It seems to be appointed, in order to remind us, in all we do, of the great laws of Divine government and human polity, that composition in the arts should strongly affect every order of mind, however unlearned or thoughtless. Hence the popular delight in rhythm and metre, and in simple musical melodies. But it is also appointed that *power* of composition in the fine arts should be an exclusive attribute of great intellect. All men can more or less copy what they see, and, more or less, remember it: powers of reflection and investigation are also common to us all, so that the decision of inferiority in these rests only on questions of *degree*. A. has a better memory than B., and C. reflects more profoundly than D. But the gift of composition is not given *at all* to more than one man in a thousand; in its highest range, it does not occur above three or four times in a century.

192. It follows, from these general truths, that it is impossible to give rules which will enable you to compose. You might much more easily receive rules to enable you to be witty. If it were possible to be witty by rule, wit would cease to be either admirable or amusing: if it were possible to compose melody by rule, Mozart and Cimarosa need not have been born: if it were possible to compose pictures by rule, Titian and Veronese would be ordinary

men. The essence of composition lies precisely in the fact of its being unteachable, in its being the operation of an individual mind of range and power exalted above others.[1]

But though no one can *invent* by rule, there are some simple laws of arrangement which it is well for you to know, because, though they will not enable you to produce a good picture, they will often assist you to set forth what goodness may be in your work in a more telling way than you could have done otherwise; and by tracing them in the work of good composers, you may better understand the grasp of their imagination, and the power it possesses over their materials. I shall briefly state the chief of these laws.

1. THE LAW OF PRINCIPALITY.

193. The great object of composition being always to secure unity; that is, to make out of many things one whole; the first mode in which this can be effected is, by determining that *one* feature shall be more important than all the rest, and that the others shall group with it in subordinate positions.

This is the simplest law of ordinary ornamentation. Thus the group of two leaves, *a*, Fig. 31, is unsatisfactory,

because it has no leading leaf; but that at *b is* prettier, because it has a head or master leaf; and *c* more satisfactory still, because the subordination of the other members to this head leaf is made more manifest by their gradual loss of size as they fall back from it.

a *b* *c*

Fig. 31

Hence part of the pleasure we have in the Greek honeysuckle ornament,[2] and such others.

194. Thus, also, good pictures have always one light larger and brighter than the other lights, or one figure

[1] [Compare Vol. V. pp. 118–122.]
[2] [For which see *Stones of Venice*, vol. i. (Vol. IX. pp. 287, 368, 369).]

more prominent than the other figures, or one mass of colour dominant over all the other masses; and in general you will find it much benefit your sketch if you manage that there shall be one light on the cottage wall, or one blue cloud in the sky, which may attract the eye as leading light, or leading gloom, above all others. But the observance of the rule is often so cunningly concealed by the great composers, that its force is hardly at first traceable; and you will generally find they are vulgar pictures in which the law is strikingly manifest.

195. This may be simply illustrated by musical melody· for instance, in such phrases as this—

one note (here the upper G) rules the whole passage, and has the full energy of it concentrated in itself. Such passages, corresponding to completely subordinated compositions in painting, are apt to be wearisome if often repeated. But, in such a phrase as this—

it is very difficult to say which is the principal note.[1] The A in the last bar is slightly dominant, but there is a very equal current of power running through the whole; and such passages rarely weary. And this principle holds through vast scales of arrangement; so that in the grandest

[1] [The former phrase is from Bellini's *Somnambula:* "Ah! perchè non posso"; the latter, from Mozart's *Don Juan:* "Horch auf den Klang der Zither."]

compositions, such as Paul Veronese's Marriage in Cana, or Raphael's Disputa,[1] it is not easy to fix at once on the principal figure ; and very commonly the figure which is really chief does not catch the eye at first, but is gradually felt to be more and more conspicuous as we gaze. Thus in Titian's grand composition of the Cornaro Family,[2] the figure meant to be principal is a youth of fifteen or sixteen, whose portrait it was evidently the

Fig. 32

painter's object to make as interesting as possible. But a grand Madonna, and a St. George with a drifting banner, and many figures more, occupy the centre of the picture, and first catch the eye ; little by little we are led away from them to a gleam of pearly light in the lower corner, and find that, from the head which it shines upon, we can turn our eyes no more.

196. As, in every good picture, nearly all laws of design are more or less exemplified, it will, on the whole, be an easier way of explaining them to, analyse one composition

[1] [For the "Marriage in Cana," see Vol. XII. pp. 451, 452, etc. ; for the "Disputa," A Joy for Ever, § 147, and Two Paths, § 21 (Vol. XVI. p. 134) ; Eagle's Nest, § 46 ; and Mornings in Florence, § 75 n.]

[2] [A slip of the pen for "Pesaro Family" ; the picture is in the Frari, at Venice (see Vol. XI. p. 380) ; there is a reproduction of it in Claude Phillips' Earlier Work of Titian, p. 92.]

thoroughly, than to give instances from various works. I shall therefore take one of Turner's simplest; which will allow us, so to speak, easily to decompose it, and illustrate each law by it as we proceed.

Fig. 32 is a rude sketch of the arrangement of the whole subject; the old bridge over the Moselle at Coblentz, the town of Coblentz on the right, Ehrenbreitstein on the left.[1] The leading or master feature is, of course, the tower on the bridge. It is kept from being *too* principal by an important group on each side of it; the boats, on the right, and Ehrenbreitstein beyond. The boats are large in mass, and more forcible in colour, but they are broken into small divisions, while the tower is simple, and therefore it still leads. Ehrenbreitstein is noble in its mass, but so reduced by aërial perspective of colour that it cannot contend with the tower, which therefore holds the eye, and becomes the key of the picture. We shall see presently how the very objects which seem at first to contend with it for the mastery are made, occultly, to increase its preëminence.

2. THE LAW OF REPETITION.

197. Another important means of expressing unity is to mark some kind of sympathy among the different objects, and perhaps the pleasantest, because most surprising, kind of sympathy, is when one group imitates or repeats another; not in the way of balance or symmetry, but subordinately, like a far-away and broken echo of it. Prout has insisted much on this law in all his writings on composition;[2] and I think it is even more authoritatively present in the minds

[1] [This drawing of Coblentz was in Ruskin's collection : see his *Notes on his Drawings by Turner*, No. 62 (Vol. XIII. p. 454).]

[2] [See, for instance, the remarks on Plate I. in his *Hints on Light and Shadow, Composition, etc.* : "In No. 1, the boat and figures nearly occupy the centre ; some object, equally *dark* and *light*, therefore was necessary, *in a less quantity*, to prevent the principal group from appearing as if by itself and unconnected with the whole." In the same work he gives other illustrations of the same law.]

of most great composers than the law of principality.* It is quite curious to see the pains that Turner sometimes takes to echo an important passage of colour; in the Pembroke Castle, for instance,[1] there are two fishing-boats, one with a red, and another with a white sail. In a line with them, on the beach, are two fish in precisely the same relative positions; one red and one white. It is observable that he uses the artifice chiefly in pictures where he wishes to obtain an expression of repose: in my notice of the plate of Scarborough, in the series of the *Harbours of England*, I have already had occasion to dwell on this point; and I extract in the note † one or two sentences which explain the principle. In the composition I have chosen for our illustration, this reduplication is employed to a singular extent. The tower, or leading feature, is first repeated by the low echo of it to the left; put your finger over this lower tower, and see how the picture is spoiled. Then the spires of Coblentz are all arranged in couples (how they are arranged in reality does not matter; when we are composing a great picture, we must play the towers about till they come right, as fearlessly as if they were chessmen instead of cathedrals). The dual arrangement of these towers would have been too easily seen, were it not for the little one which pretends to make a triad of the last group on the right, but is so faint as hardly to be discernible; it just takes off the attention from the artifice, helped in doing so

* See Note 7 in Appendix I. [p. 217].

† "In general, throughout Nature, reflection and repetition are peaceful things, associated with the idea of quiet succession in events; that one day should be like another day, or one history the repetition of another history, being more or less results of quietness, while dissimilarity and non-succession are results of interference and disquietude. Thus, though an echo actually increases the quantity of sound heard, its repetition of the note or syllable gives an idea of calmness attainable in no other way; hence also the feeling of calm given to a landscape by the voice of a cuckoo."[2]

[1] [In No. 12 of *England and Wales*.]
[2] [Vol. XIII. pp. 73, 74.]

by the mast at the head of the boat, which, however, has instantly its own duplicate put at the stern.* Then there is the large boat near, and its echo beyond it. That echo is divided into two again, and each of those two smaller boats has two figures in it; while two figures are also sitting together on the great rudder that lies half in the water, and half aground. Then, finally, the great mass of Ehrenbreitstein, which appears at first to have no answering form, has almost its *facsimile* in the bank on which the girl is sitting; this bank is as absolutely essential to the completion of the picture as any object in the whole series. All this is done to deepen the effect of repose.

198. Symmetry, or the balance of parts or masses in nearly equal opposition, is one of the conditions of treatment under the law of Repetition. For the opposition, in a symmetrical object, is of like things reflecting each other: it is not the balance of contrary natures (like that of day and night), but of like natures or like forms; one side of a leaf being set like the reflection of the other in water.

Symmetry in Nature is, however, never formal nor accurate. She takes the greatest care to secure some difference between the corresponding things or parts of things; and an approximation to accurate symmetry is only permitted in animals, because their motions secure perpetual difference between the balancing parts. Stand before a mirror; hold your arms in precisely the same position at each side, your head upright, your body straight; divide your hair exactly in the middle and get it as nearly as you can into exactly the same shape over each ear; and you will see the effect of accurate symmetry: you will see, no less, how all grace and power in the human form result from the interference of motion and life with symmetry, and from the reconciliation of its balance with its changefulness.

* This is obscure in the rude woodcut, the masts being so delicate that they are confused among the lines of reflection. In the original they have orange light upon them, relieved against purple behind.

Your position, as seen in the mirror, is the highest type of symmetry as understood by modern architects.

199. In many sacred compositions, living symmetry, the balance of harmonious opposites, is one of the profoundest sources of their power: almost any works of the early painters, Angelico, Perugino, Giotto, etc., will furnish you with notable instances of it. The Madonna of Perugino in the National Gallery, with the angel Michael on one side and Raphael on the other, is as beautiful an example as you can have.[1]

In landscape, the principle of balance is more or less carried out, in proportion to the wish of the painter to express disciplined calmness. In bad compositions, as in bad architecture, it is formal, a tree on one side answering a tree on the other; but in good compositions, as in graceful statues, it is always easy and sometimes hardly traceable. In the Coblentz, however, you cannot have much difficulty in seeing how the boats on one side of the tower and the figures on the other are set in nearly equal balance; the tower, as a central mass, uniting both.

3. THE LAW OF CONTINUITY.

200. Another important and pleasurable way of expressing unity, is by giving some orderly succession to a number of objects more or less similar. And this succession is most interesting when it is connected with some gradual change in the aspect or character of the objects. Thus the succession of the pillars of a cathedral aisle is most interesting when they retire in perspective, becoming more and more obscure in distance: so the succession of mountain promontories one behind another, on the flanks of a valley; so the succession of clouds, fading farther and farther towards the horizon; each promontory and each cloud being of different shape, yet all evidently following in a calm and appointed

[1] [No. 288. For other references by Ruskin to the picture, see Vol. XIII. p. 173 n., and Vol. XIV. p. 344.]

order. If there be no change at all in the shape or size of
the objects, there is no continuity; there is only repetition
—monotony. It is the change in shape which suggests the
idea of their being individually free, and able to escape, if
they liked, from the law that rules them, and yet submitting
to it.

201. I will leave our chosen illustrative composition for
a moment to take up another, still more expressive of this

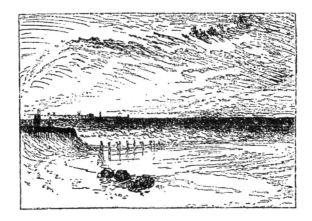

Fig. 33

law. It is one of Turner's most tender studies, a sketch on
Calais Sands at sunset;[1] so delicate in the expression of
wave and cloud, that it is of no use for me to try to reach
it with any kind of outline in a woodcut; but the rough
sketch, Fig. 33, is enough to give an idea of its arrange-
ment. The aim of the painter has been to give the in-
tensest expression of repose, together with the enchanted,
lulling, monotonous motion of cloud and wave. All the
clouds are moving in innumerable ranks after the sun,
meeting towards that point in the horizon where he has set;
and the tidal waves gain in winding currents upon the sand,
with that stealthy haste in which they cross each other so

[1] [The editors are unable to trace this sketch.]

quietly, at their edges; just folding one over another as they meet, like a little piece of ruffled silk, and leaping up a little as two children kiss and clap their hands, and then going on again, each in its silent hurry, drawing pointed arches on the sand as their thin edges intersect in parting. But all this would not have been enough expressed without the line of the old pier-timbers, black with weeds, strained and bent by the storm waves, and now seeming to stoop in following one another, like dark ghosts escaping slowly from the cruelty of the pursuing sea.

202. I need not, I hope, point out to the reader the illustration of this law of continuance in the subject chosen for our general illustration. It was simply that gradual succession of the retiring arches of the bridge which induced Turner to paint the subject at all; and it was this same principle which led him always to seize on subjects including long bridges wherever he could find them; but especially, observe, unequal bridges, having the highest arch at one side rather than at the centre. There is a reason for this, irrespective of general laws of composition, and connected with the nature of rivers, which I may as well stop a minute to tell you about, and let you rest from the study of composition.

203. All rivers, small or large, agree in one character, they like to lean a little on one side: they cannot bear to have their channels deepest in the middle, but will always, if they can, have one bank to sun themselves upon, and another to get cool under; one shingly shore to play over, where they may be shallow, and foolish, and childlike, and another steep shore, under which they can pause, and purify themselves, and get their strength of waves fully together for due occasion. Rivers in this way are just like wise men, who keep one side of their life for play, and another for work; and can be brilliant, and chattering, and transparent, when they are at ease, and yet take deep counsel on the other side when they set themselves to their main purpose. And rivers are just in this divided, also, like

wicked and good men: the good rivers have serviceable
deep places all along their banks, that ships can sail in;
but the wicked rivers go scooping irregularly under their
banks until they get full of strangling eddies, which no
boat can row over without being twisted against the rocks;
and pools like wells, which no one can get out of but the
water-kelpie that lives at the bottom; but, wicked or good,
the rivers all agree in having two kinds of sides. Now the
natural way in which a village stone-mason therefore throws
a bridge over a strong stream is, of course, to build a great
door to let the cat through, and little doors to let the
kittens through; a great arch for the great current, to give
it room in flood time, and little arches for the little currents
along the shallow shore. This, even without any prudential
respect for the floods of the great current, he would do in
simple economy of work and stone; for the smaller your
arches are, the less material you want on their flanks. Two
arches over the same span of river, supposing the butments
are at the same depth, are cheaper than one, and that by a
great deal; so that, where the current is shallow, the village
mason makes his arches many and low: as the water gets
deeper, and it becomes troublesome to build his piers up
from the bottom, he throws his arches wider; at last
he comes to the deep stream, and, as he cannot build at
the bottom of that, he throws his largest arch over it
with a leap, and with another little one or so gains the
opposite shore. Of course as arches are wider they must
be higher, or they will not stand; so the roadway must
rise as the arches widen. And thus we have the general
type of bridge, with its highest and widest arch towards one
side, and a train of minor arches running over the flat shore
on the other: usually a steep bank at the river-side next
the large arch; always, of course, a flat shore on the side of
the small ones: and the bend of the river assuredly con-
cave towards this flat, cutting round, with a sweep into
the steep bank; or, if there is no steep bank, still assuredly
cutting into the shore at the steep end of the bridge.

Now this kind of bridge, sympathising, as it does, with the spirit of the river, and marking the nature of the thing it has to deal with and conquer, is the ideal of a bridge; and all endeavours to do the thing in a grand engineer's manner, with a level roadway and equal arches, are barbarous; not only because all monotonous forms are ugly in themselves, but because the mind perceives at once that there has been cost uselessly thrown away for the sake of formality.*

204. Well, to return to our continuity. We see that the Turnerian bridge in Fig. 32 is of the absolutely perfect type, and is still farther interesting by having its main arch crowned by a watch-tower. But as I want you to note especially what perhaps was not the case in the real bridge, but is entirely Turner's doing, you will find that though the arches diminish gradually, not one is *regularly* diminished—they are all of different shapes and sizes: you cannot see this clearly in Fig. 32, but in the larger diagram, Fig. 34, opposite, you will with ease. This is indeed also part of the ideal of a bridge, because the lateral currents near the shore are of course irregular in size, and a simple

* The cost of art in getting a bridge level is *always* lost, for you must get up to the height of the central arch at any rate, and you only can make the whole bridge level by putting the hill farther back, and pretending to have got rid of it when you have not, but have only wasted money in building an unnecessary embankment. Of course, the bridge should not be difficultly or dangerously steep, but the necessary slope, whatever it may be, should be in the bridge itself, as far as the bridge can take it, and not pushed aside into the approach, as in our Waterloo road; the only rational excuse for doing which is that when the slope must be long it is inconvenient to put on a drag at the top of the bridge, and that any restiveness of the horse is more dangerous on the bridge than on the embankment. To this I answer: first, it is not more dangerous in reality, though it looks so, for the bridge is always guarded by an effective parapet, but the embankment is sure to have no parapet, or only a useless rail; and secondly, that it is better to have the slope on the bridge and make the roadway wide in proportion, so as to be quite safe, because a little waste of space on the river is no loss, but your wide embankment at the side loses good ground; and so my picturesque bridges are right as well as beautiful, and I hope to see them built again some day instead of the frightful straight-backed things which we fancy are fine, and accept from the pontifical rigidities of the engineering mind.

Fig. 34

builder would naturally vary his arches accordingly; and also, if the bottom was rocky, build his piers where the rocks came. But it is not as a part of bridge ideal, but as a necessity of all noble composition, that this irregularity is introduced by Turner. It at once raises the object thus treated from the lower or vulgar unity of rigid law to the greater unity of clouds, and waves, and trees, and human souls, each different, each obedient, and each in harmonious service.

<div align="center">4. THE LAW OF CURVATURE.</div>

205. There is, however, another point to be noticed in this bridge of Turner's. Not only does it slope away unequally at its sides, but it slopes in a gradual though very subtle curve. And if you substitute a straight line for this curve (drawing one with a rule from the base of the tower on each side to the ends of the bridge, in Fig. 34, and effacing the curve), you will instantly see that the design has suffered grievously. You may ascertain, by experiment, that all beautiful objects whatsoever are thus terminated by delicately curved lines, except where the straight line is indispensable to their use or stability; and that when a complete system of straight lines, throughout the form, is necessary to that stability, as in crystals, the beauty, if any exists, is in colour and transparency, not in form. Cut out the shape of any crystal you like, in white wax or wood, and put it beside a white lily, and you will feel the force of the curvature in its purity, irrespective of added colour, or other interfering elements of beauty.

206. Well, as curves are more beautiful than straight lines, it is necessary to a good composition that its continuities of object, mass, or colour should be, if possible, in curves, rather than straight lines or angular ones. Perhaps one of the simplest and prettiest examples of a graceful continuity of this kind is in the line traced at any moment by the corks of a net as it is being drawn: nearly every

person is more or less attracted by the beauty of the dotted line. Now, it is almost always possible, not only to secure such a continuity in the arrangement or boundaries of objects which, like these bridge arches or the corks of the net, are actually connected with each other, but—and this is a still more noble and interesting kind of continuity—among features which appear at first entirely separate. Thus the

Fig. 35

towers of Ehrenbreitstein, on the left, in Fig. 32, appear at first independent of each other; but when I give their profile, on a larger scale, Fig. 35, the reader may easily perceive that there is a subtle cadence and harmony among them. The reason of this is, that they are all bounded by one grand curve, traced by the dotted line; out of the seven towers, four precisely touch this curve, the others only falling back from it here and there to keep the eye from discovering it too easily.

207. And it is not only always possible to obtain continuities of this kind: it is, in drawing large forest or

M

mountain forms, essential to truth. The towers of Ehrenbreitstein might or might not in reality fall into such a curve, but assuredly the basalt rock on which they stand did; for all mountain forms not cloven into absolute precipice, nor covered by straight slopes of shales, are more or less governed by these great curves, it being one of the aims of Nature in all her work to produce them. The reader must already know this, if he has been able to sketch at all among mountains; if not, let him merely draw for himself, carefully, the outlines of any low hills accessible to him, where they are tolerably steep, or of the woods which grow on them. The steeper shore of the Thames at Maidenhead, or any of the downs at Brighton or Dover, or, even nearer, about Croydon (as Addington Hills), is easily accessible to a Londoner; and he will soon find not only how constant, but how graceful the curvature is. Graceful curvature is distinguished from ungraceful by two characters; first in its moderation, that is to say, its close approach to straightness in some part of its course; * and, secondly, by its variation, that is to say, its never remaining equal in degree at different parts of its course.

208. This variation is itself twofold in all good curves

A. There is, first, a steady change through the whole line, from less to more curvature, or more to less, so that

Fig. 36

no part of the line is a segment of a circle, or can be drawn by compasses in any way whatever. Thus, in Fig. 36, a is a bad curve because it is part of a circle, and is therefore monotonous throughout; but b is a good curve, because it continually changes its direction as it proceeds.

* I cannot waste space here by reprinting what I have said in other books; but the reader ought, if possible, to refer to the notices of this part of our subject in *Modern Painters*, vol. iv. chap. xvii.; and *Stones of Venice*, vol. iii. chap. i. § 8. [Vol. VI. pp. 322 *seq.*, Vol. XI. p. 8.]

The *first* difference between good and bad drawing of tree boughs consists in observance of this fact. Thus, when I put leaves on the line *b*, as in Fig. 37, you can immediately feel the springiness of character dependent on the changefulness of the curve. You may put leaves on the other line for yourself, but

Fig. 37

you will find you cannot make a right tree spray of it. For *all* tree boughs, large or small, as well as all noble natural lines whatsoever, agree in this character; and it is a point of primal necessity that your eye should always seize and your hand trace it. Here are two more portions of good curves, with leaves put on them at the extremities instead of the flanks, Fig. 38; and two showing the arrangement of masses of foliage seen a little farther off, Fig. 39, which you may in like manner amuse yourself by turning into segments of circles—

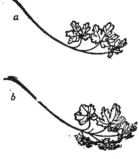

Fig. 38

you will see with what result. I hope however you have beside you, by this time, many good studies of tree boughs carefully made, in which you may study variations of curvature in their most complicated and lovely forms.*

209. B. Not only does every good curve vary in general tendency, but it is modulated, as it proceeds, by myriads of subordinate curves. Thus the outlines of a tree trunk are never as at *a*, Fig. 40, but as at *b*. So also in waves, clouds, and all other nobly

Fig. 39

* If you happen to be reading at this part of the book, without having gone through any previous practice, turn back to the sketch of the ramification of stone pine, Fig. 4, p. 41, and examine the curves of its boughs one by one, trying them by the conditions here stated under the heads A and B.

formed masses. Thus another essential difference between good and bad drawing, or good and bad sculpture, depends on the quantity and refinement of minor curvatures carried, by good work, into the great lines. Strictly speaking, however, this is not variation in large curves, but composition of large curves out of small ones; it is an increase in the quantity of the beautiful element, but not a change in its nature.

5. THE LAW OF RADIATION.[1]

210. We have hitherto been concerned only with the binding of our various objects into beautiful lines or processions. The next point we have to consider is, how we may unite these lines or processions themselves, so as to make groups of *them*.

Now, there are two kinds of harmonies of lines. One in which, moving more or less side by side, they variously, but evidently with consent, retire from or approach each other, intersect or oppose each other; currents of melody in music, for different voices, thus approach and cross, fall and rise, in harmony; so the waves of the sea, as they approach the shore, flow into one another or cross, but with a great unity through all; and so various lines of composition often flow harmoniously through and across each other in a picture. But the most simple and perfect connexion of lines is by radiation; that is, by their all springing from one point, or closing towards it; and this harmony is often. in Nature almost always, united with the other; as the boughs of trees, though they intersect and play amongst

Fig. 40

[1] [On the subject of radiant curvature, compare *Modern Painters*, vol. iv. (Vol. VI. p. 248).]

each other irregularly, indicate by their general tendency their origin from one root. An essential part of the beauty of all vegetable form is in this radiation; it is seen most simply in a single flower or leaf, as in a convolvulus bell, or chestnut leaf; but more beautifully in the complicated arrangements of the large boughs and sprays. For a leaf is only a flat piece of radiation; but the tree throws its branches on all sides, and even in every profile view of it, which presents a radiation more or less correspondent to that of its leaves, it is more beautiful, because varied by the freedom of the separate branches. I believe it has been ascertained that, in all trees, the angle at which, in their leaves, the lateral ribs are set on their central rib is approximately the same at which the branches leave the great stem; and thus each section of the tree would present a kind of magnified view of its own leaf, were it not for the interfering force of gravity on the masses of foliage. This force in proportion to their age, and the lateral leverage upon them, bears them downwards at

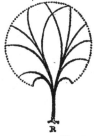

Fig. 41

the extremities, so that, as before noticed, the lower the bough grows on the stem, the more it droops (Fig. 17, p. 93); besides this, nearly all beautiful trees have a tendency to divide into two or more principal masses, which give a prettier and more complicated symmetry than if one stem ran all the way up the centre. Fig. 41 may thus be considered the simplest type of tree radiation, as opposed to leaf radiation. In this figure, however, all secondary ramification is unrepresented, for the sake of simplicity; but if we take one half of such a tree, and merely give two secondary branches to each main branch (as represented in the general branch structure shown at *b*, Fig. 18, p. 93), we shall have the form Fig. 42. This I consider the perfect general type of tree structure; and it is curiously connected with certain forms of Greek, Byzantine, and Gothic ornamentation, into the discussion of which, however, we must not enter here.

It will be observed, that both in Figs. 41 and 42 all the branches so spring from the main stem as very nearly to suggest their united radiation from the root R. This is by no means universally the case; but if the branches do not

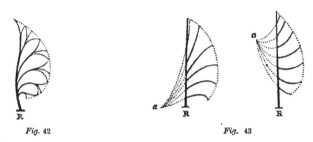

Fig. 42 Fig. 43

bend towards a point in the root, they at least converge to some point or other. In the examples in Fig. 43, the mathematical centre of curvature, a, is thus, in one case, on the ground, at some distance from the root, and in the other, near the top of the tree. Half, only, of each tree is given, for the sake of clearness: Fig. 44 gives both sides of another example, in which the origins of curvature are below the root. As the positions of such points may be varied without end, and as the arrangement of the lines is also farther complicated by the fact of the boughs springing for the most part in a spiral order round the tree, and at proportionate distances, the systems of curvature which regulate the form of vegetation are quite infinite. Infinite is a word easily said, and easily written, and people do not always mean it when they say it; in this case I *do* mean it: the number of systems is incalculable, and even to furnish anything like a representative number of types, I should have to give several hundreds of figures such as Fig. 44.*

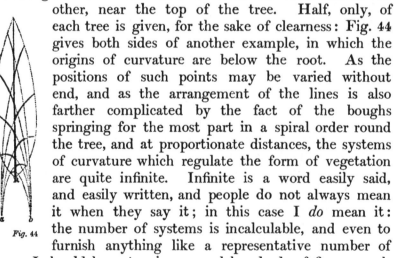

Fig. 44

* The reader, I hope, observes always that every line in these figures is itself one of varying curvature, and cannot be drawn by compasses.

211. Thus far, however, we have only been speaking of the great relations of stem and branches. The forms of the branches themselves are regulated by still more subtle laws, for they occupy an intermediate position between the form of the tree and of the leaf. The leaf has a flat ramification; the tree a completely rounded one; the bough is neither rounded nor flat, but has a structure exactly balanced between the two, in a half-flattened, half-rounded flake, closely resembling in shape one of the thick leaves of an artichoke or the flake of a fir cone; by combination forming the solid mass of the tree, as the leaves compose the artichoke head. I have before pointed out to you the general resemblance of these branch flakes to an extended hand;[1] but they may be more accurately represented by the ribs of a boat. If you can imagine a very broad-headed and flattened boat applied by its keel to the end of a main branch,* as in Fig. 45, the lines which its ribs will take, supposing them out-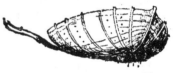

Fig. 45

side of its timbers instead of inside, and the general contour of it, as seen in different directions, from above and below, will give you the closest approximation to the perspectives and foreshortenings of a well-grown branch-flake. Fig. 25 above, p. 115, is an unharmed and unrestrained shoot of healthy young oak; and, if you compare it with Fig. 45, you will understand at once the action of the lines of leafage; the boat only failing as a type in that its ribs are too nearly parallel to each other at the sides, while the bough sends all its ramification well forwards, rounding

* I hope the reader understands that these woodcuts are merely facsimiles of the sketches I make at the side of my paper to illustrate my meaning as I write—often sadly scrawled if I want to get on to something else. This one is really a little too careless; but it would take more time and trouble to make a proper drawing of so odd a boat than the matter is worth. It will answer the purpose well enough as it is.

[1] [See above, p. 93.]

to the head, that it may accomplish its part in the outer form of the whole tree, yet always securing the compliance with the great universal law that the branches nearest the root bend most back; and, of course, throwing *some* always back as well as forwards; the appearance of reversed action being much increased, and rendered more striking and beautiful, by perspective. Fig. 25 shows the perspective of such a bough as it is seen from below; Fig. 46 gives rudely the look it would have from above.

Fig. 46

212. You may suppose, if you have not already discovered, what subtleties of perspective and light and shade are involved in the drawing of these branch-flakes, as you see them in different directions and actions; now raised, now depressed: touched on the edges by the wind, or lifted up and bent back so as to show all the white under surfaces of the leaves shivering in light, as the bottom of a boat rises white with spray at the surge-crest; or drooping in quietness towards the dew of the grass beneath them in windless mornings, or bowed down under oppressive grace of deep-charged snow. Snow time, by the way, is one of the best for practice in the placing of tree masses; but you will only be able to understand them thoroughly by begin-ning with a single bough and a few leaves placed tolerably even, as in Fig. 38, p. 179. First one with three leaves, a central and two lateral ones, as at *a;* then with five, as at *b*, and so on; directing your whole attention to the ex-pression, both by contour and light and shade, of the boat-like arrangements, which, in your earlier studies, will have been a good deal confused, partly owing to your inexperi-ence, and partly to the depth of shade, or absolute blackness of mass required in those studies.

213. One thing more remains to be noted, and I will let you out of the wood. You see that in every gene-rally representative figure I have surrounded the radiating branches with a dotted line: such lines do indeed terminate

every vegetable form; and you see that they are them-
selves beautiful curves, which, according to their flow, and
the width or narrowness of the spaces they enclose, char-
acterise the species of tree or leaf, and express its free or
formal action, its grace of youth or weight of age. So
that, throughout all the freedom of her wildest foliage,
Nature is resolved on expressing an encompassing limit;
and marking a unity in the whole tree, caused not only
by the rising of its branches from a common root, but by
their joining in one work, and being bound by a common
law. And having ascertained this, let us turn back for a
moment to a point in leaf structure which, I doubt not,
you must already have observed in your earlier studies,
but which it is well to state here, as connected with the
unity of the branches in the great trees. You must have
noticed, I should think, that whenever a leaf is compound,
—that is to say, divided into other leaflets which in any
way repeat or imitate the form of the whole leaf,—those
leaflets are not symmetrical, as the whole leaf is, but always
smaller on the side towards the point of the great leaf, so
as to express their subordination to it, and show, even
when they are pulled off, that they are not small inde-
pendent leaves, but members of one large leaf.[1]

214. Fig. 47, which is a block-plan of a leaf of colum-
bine, without its minor divisions on the edges, will illustrate
the principle clearly. It is composed of a central large
mass, A, and two lateral ones, of which the one on the
right only is lettered, B. Each of these masses is again
composed of three others, a central and two lateral ones;
but observe, the minor one, a of A, is balanced equally
by its opposite; but the minor b 1 of B is larger than its
opposite b 2. Again, each of these minor masses is divided
into three; but while the central mass, A of A, is sym-
metrically divided, the B of B is unsymmetrical, its largest
side-lobe being lowest. Again, in b 2, the lobe c 1 (its

[1] [On this subject, compare *Modern Painters,* vol. v. pt. iv. ch. iv. § 6.]

lowest lobe in relation to B) is larger than *c* 2; and so also in *b* 1. So that universally one lobe of a lateral leaf is always larger than the other, and the smaller lobe is that which is nearer the central mass; the lower leaf, as it were by courtesy, subduing some of its own dignity or power, in the immediate presence of the greater or captain leaf, and always expressing, therefore, its own subordination and secondary character. This law is carried out even in single leaves. As far as I know, the upper half, towards the point of the spray, is always the smaller; and a slightly different curve, more convex at the springing, is used for the lower side, giving an exquisite variety to the form of the whole leaf; so that one of the chief elements in the beauty of every subordinate leaf throughout the tree is made to depend on its confession of its own lowliness and subjection.

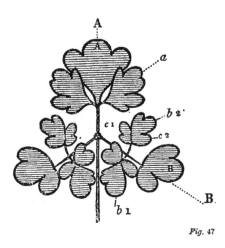

Fig. 47

215. And now, if we bring together in one view the principles we have ascertained in trees, we shall find they may be summed under four great laws; and that all perfect * vegetable form is appointed to express these four laws in noble balance of authority.

1. Support from one living root.

2. Radiation, or tendency of force from some one given point, either in the root, or in some stated connection with it.

* Imperfect vegetable form I consider that which is in its nature dependent, as in runners and climbers; or which is susceptible of continual injury without materially losing the power of giving pleasure by its aspect, as in the case of the smaller grasses. I have not, of course, space here to explain these minor distinctions, but the laws above stated apply to all the more important trees and shrubs likely to be familiar to the student.

3. Liberty of each bough to seek its own livelihood and happiness according to its needs, by irregularities of action both in its play and its work, either stretching out to get its required nourishment from light and rain, by finding some sufficient breathing-place among the other branches, or knotting and gathering itself up to get strength for any load which its fruitful blossoms may lay upon it, and for any stress of its storm-tossed luxuriance of leaves; or playing hither and thither as the fitful sunshine may tempt its young shoots, in their undecided states of mind about their future life.

4. Imperative requirement of each bough to stop within certain limits, expressive of its kindly fellowship and fraternity with the boughs in its neighbourhood; and to work with them according to its power, magnitude, and state of health, to bring out the general perfectness of the great curve, and circumferent stateliness of the whole tree.

216. I think I may leave you, unhelped, to work out the moral analogies of these laws; you may, perhaps, however, be a little puzzled to see the meaning of the second one. It typically expresses that healthy human actions should spring radiantly (like rays) from some single heart motive; the most beautiful systems of action taking place when this motive lies at the root of the whole life, and the action is clearly seen to proceed from it; while also many beautiful secondary systems of action taking place from motives not so deep or central, but in some beautiful subordinate connection with the central or life motive.

The other laws, if you think over them, you will find equally significative; and as you draw trees more and more in their various states of health and hardship, you will be every day more struck by the beauty of the types they present of the truths most essential for mankind to know;*

* There is a very tender lesson of this kind in the shadows of leaves upon the ground; shadows which are the most likely of all to attract attention, by their pretty play and change. If you examine them, you will find that the shadows do not take the forms of the leaves, but that, through each interstice,

and you will see what this vegetation of the earth, which is necessary to our life, first, as purifying the air for us and then as food, and just as necessary to our joy in all places of the earth,—what these trees and leaves, I say, are meant to teach us as we contemplate them, and read or hear their lovely language, written or spoken for us, not in frightful black letters nor in dull sentences, but in fair green and shadowy shapes of waving words, and blossomed brightness of odoriferous wit, and sweet whispers of unintrusive wisdom, and playful morality.

217. Well, I am sorry myself to leave the wood, whatever my reader may be; but leave it we must, or we shall compose no more pictures to-day.

This law of radiation, then, enforcing unison of action in arising from, or proceeding to, some given point, is perhaps, of all principles of composition, the most influential in producing the beauty of groups of form. Other laws make them forcible or interesting, but this generally is chief in rendering them beautiful. In the arrangement of masses in pictures, it is constantly obeyed by the great composers; but, like the law of principality, with careful concealment of its imperativeness, the point to which the lines of main curvature are directed being very often far away out of the picture. Sometimes, however, a system of curves will be employed definitely to exalt, by their concurrence, the value of some leading object, and then the law becomes traceable enough.

218. In the instance before us, the principal object being,

the light falls, at a little distance, in the form of a round or oval spot; that is to say, it produces the image of the sun itself, cast either vertically or obliquely, in circle or ellipse according to the slope of the ground. Of course the sun's rays produce the same effect, when they fall through any small aperture: but the openings between leaves are the only ones likely to show it to an ordinary observer, or to attract his attention to it by its frequency, and lead him to think what this type may signify respecting the greater Sun; and how it may show us that, even when the opening through which the earth receives light is too small to let us see the Sun Himself, the ray of light that enters, if it comes straight from Him, will still bear with it His image.

as we have seen, the tower on the bridge, Turner has de-
termined that his system of curvature should have its origin
in the top of this tower. The diagram Fig. 34, p. 175, com-
pared with Fig. 32, p. 166, will show how this is done. One
curve joins the two towers, and is continued by the back
of the figure sitting on the bank into the piece of bent
timber. This is a limiting curve of great importance, and
Turner has drawn a considerable part of it with the edge of
the timber very carefully, and then led the eye up to the
sitting girl by some white spots and indications of a ledge
in the bank; then the passage to the tops of the towers
cannot be missed.

219. The next curve is begun and drawn carefully for
half an inch of its course by the rudder; it is then taken up
by the basket and the heads of the figures, and leads ac-
curately to the tower angle. The gunwales of both the
boats begin the next two curves, which meet in the same
point; and all are centralised by the long reflection which
continues the vertical lines.

220. Subordinated to this first system of curves there
is another, begun by the small crossing bar of wood inserted
in the angle behind the rudder; continued by the bottom
of the bank on which the figure sits, interrupted forcibly
beyond it,* but taken up again by the water-line leading to
the bridge foot, and passing on in delicate shadows under
the arches, not easily shown in so rude a diagram, towards
the other extremity of the bridge. This is a most important
curve, indicating that the force and sweep of the river have
indeed been in old times under the large arches; while the
antiquity of the bridge is told us by a long tongue of land,
either of carted rubbish, or washed down by some minor

* In the smaller figure (32), it will be seen that this interruption is
caused by a cart coming down to the water's edge; and this object is
serviceable as beginning another system of curves leading out of the picture
on the right, but so obscurely drawn as not to be easily represented in out-
line. As it is unnecessary to the explanation of our point here, it has been
omitted in the larger diagram, the direction of the curve it begins being
indicated by the dashes only.

stream, which has interrupted this curve, and is now used
as a landing-place for the boats, and for embarkation of
merchandise, of which some bales and bundles are laid in a
heap, immediately beneath the great tower. A common
composer would have put these bales to one side or the
other, but Turner knows better; he uses them as a founda-
tion for his tower, adding to its importance precisely as the
sculptured base adorns a pillar; and he farther increases the
aspect of its height by throwing the reflection of it far down
in the nearer water. All the great composers have this
same feeling about sustaining their vertical masses: you will
constantly find Prout using the artifice most dexterously
(see, for instance, the figure with the wheelbarrow under
the great tower, in the sketch of St. Nicholas, at Prague,
and the white group of figures under the tower in the sketch
of Augsburg *); and Veronese, Titian, and Tintoret continually
put their principal figures at bases of pillars. Turner found
out their secret very early, the most prominent instance of
his composition on this principle being the drawing of Turin
from the Superga, in Hakewill's Italy.[1] I chose Fig. 20,
already given to illustrate foliage drawing, chiefly because,
being another instance of precisely the same arrangement, it
will serve to convince you of its being intentional. There,
the vertical, formed by the larger tree, is continued by the
figure of the farmer, and that of one of the smaller trees by
his stick. The lines of the interior mass of the bushes
radiate, under the law of radiation, from a point behind the
farmer's head; but their outline curves are carried on and
repeated, under the law of continuity, by the curves of the
dog and boy—by the way, note the remarkable instance in
these of the use of darkest lines towards the light—all more
or less guiding the eye up to the right, in order to bring it
finally to the Keep of Windsor, which is the central object

* Both in the *Sketches in Flanders and Germany*.

[1] [No. 17 in Ruskin's *Notes on his Drawings by Turner* (Vol. XIII. p. 423). The
drawing is reproduced in Vol. XVI. (Plate vi.).]

of the picture, as the bridge tower is in the Coblentz. The wall on which the boy climbs answers the purpose of contrasting, both in direction and character, with these greater curves; thus corresponding as nearly as possible to the minor tongue of land in the Coblentz. This, however, introduces us to another law, which we must consider separately.

6. THE LAW OF CONTRAST.

221. Of course the character of everything is best manifested by Contrast. Rest can only be enjoyed after labour; sound to be heard clearly, must rise out of silence; light is exhibited by darkness, darkness by light; and so on in all things. Now in art every colour has an opponent colour, which, if brought near it, will relieve it more completely than any other; so, also, every form and line may be made more striking to the eye by an opponent form or line near them; a curved line is set off by a straight one, a massy form by a slight one, and so on; and in all good work nearly double the value, which any given colour or form would have uncombined, is given to each by contrast.*

In this case again, however, a too manifest use of the artifice vulgarises a picture. Great painters do not commonly, or very visibly, admit violent contrast. They introduce it by stealth, and with intermediate links of tender change; allowing, indeed, the opposition to tell upon the mind as a surprise, but not as a shock.†

222. Thus in the rock of Ehrenbreitstein, Fig. 35, the main current of the lines being downwards, in a convex

* If you happen to meet with the plate of Dürer's representing a coat-of-arms with a skull in the shield,[1] note the value given to the concave curves and sharp point of the helmet by the convex leafage carried round it in front; and the use of the blank white part of the shield in opposing the rich folds of the dress.

† Turner hardly ever, as far as I remember, allows a strong light to oppose a full dark, without some intervening tint. His suns never set behind dark mountains without a film of cloud above the mountain's edge.

[1] [For this plate, see *Stones of Venice*, vol. iii. (Vol. XI. p. 172).]

swell, they are suddenly stopped at the lowest tower by a counter series of beds, directed nearly straight across them. This adverse force sets off and relieves the great curvature, but it is reconciled to it by a series of radiating lines below, which at first sympathise with the oblique bar, then gradually get steeper, till they meet and join in the fall of the great curve. No passage, however intentionally monotonous, is ever introduced by a good artist without *some* slight counter current of this kind; so much, indeed, do the great composers feel the necessity of it, that they will even do things purposely ill or unsatisfactorily, in order to give greater value to their well-doing in other places. In a skilful poet's versification the so-called bad or inferior lines are not inferior because he could not do them better, but because he feels that if all were equally weighty, there would be no real sense of weight anywhere; if all were equally melodious, the melody itself would be fatiguing; and he purposely introduces the labouring or discordant verse, that the full ring may be felt in his main sentence, and the finished sweetness in his chosen rhythm.* And continually in painting, inferior artists destroy their work by giving too much of all that they think is good, while the great painter gives just enough to be enjoyed, and passes to an opposite kind of enjoyment, or to an inferior state of enjoyment: he gives a passage of rich, involved, exquisitely wrought colour, then passes away into slight, and pale, and simple colour; he paints for a minute or two with intense decision, then suddenly becomes, as the spectator thinks, slovenly; but he is not slovenly: you could not have *taken* any more decision from him just then; you have had as much as is good for you: he paints over a

* " A prudent chief not always must display
 His powers in equal ranks and fair array,
 But with the occasion and the place comply,
 Conceal his force; nay, seem sometimes to fly.
 Those oft are stratagems which errors seem,
 Nor is it Homer nods, but we that dream."
 Essay on Criticism [i. 172–177].

great space of his picture forms of the most rounded and melting tenderness, and suddenly, as you think by a freak, gives you a bit as jagged and sharp as a leafless blackthorn. Perhaps the most exquisite piece of subtle contrast in the world of painting is the arrow point, laid sharp against the white side and among the flowing hair of Correggio's Antiope.[1] It is quite singular how very little contrast will sometimes serve to make an entire group of forms interesting which would otherwise have been valueless. There is a good deal of picturesque material, for instance,

Fig. 48

in this top of an old tower, Fig. 48, tiles and stones and sloping roof not disagreeably mingled; but all would have been unsatisfactory if there had not happened to be that iron ring on the inner wall, which by its vigorous black *circular* line precisely opposes all the square and angular characters of the battlements and roof. Draw the tower without the ring, and see what a difference it will make.

223. One of the most important applications of the law of contrast is in association with the law of continuity, causing an unexpected but gentle break in a continuous series. This artifice is perpetual in music, and perpetual

[1] [For other references to this picture, see Vol. V. p. 93 *n.* (*Modern Painters*, vol. iii.), and Vol. XII. p. 472.]

xv.

also in good illumination; the way in which little surprises of change are prepared in any current borders, or chains of ornamental design, being one of the most subtle characteristics of the work of the good periods. We take, for instance, a bar of ornament between two written columns of an early fourteenth century MS., and at the first glance we suppose it to be quite monotonous all the way up, composed of a winding tendril, with alternately a blue leaf and a scarlet bud. Presently, however, we see that, in order to observe the law of principality, there is one large scarlet leaf instead of a bud, nearly half-way up, which forms a centre to the whole rod; and when we begin to examine the order of the leaves, we find it varied carefully. Let A stand for scarlet bud, *b* for blue leaf, *c* for two blue leaves on one stalk, *s* for a stalk without a leaf, and R for the large red leaf. Then, counting from the ground, the order begins as follows:

b, *b*, A; *b*, *s*, *b*, A; *b*, *b*, A; *b*, *b*, A; and we think we shall have two *b*'s and an A all the way, when suddenly it becomes *b*, A; *b*, R; *b*, A; *b*, A; *b*, A; and we think we are going to have *b*, A continued; but no: here it becomes *b*, *s*; *b*, *s*; *b*, A; *b*, *s*; *b*, *s*; *c*, *s*; *b*, *s*; *b*, *s*; and we think we are surely going to have *b*, *s* continued, but behold it runs away to the end with a quick *b*, *b*, A; *b*, *b*, *b*, *b*!* Very often, however, the designer is satisfied with *one* surprise, but I never saw a good illuminated border without one at least; and no series of any kind was ever introduced by a great composer in a painting without a snap somewhere. There is a pretty one in Turner's drawing of Rome with the large balustrade for a foreground in the Hakewill's Italy series:[1] the single baluster struck out of the line, and showing the street below through the gap, simply makes

* I am describing from an MS., *circa* 1300, of Gregory's Decretalia, in my own possession.

[1] [The plate referred to is "Rome from the Farnese Gardens:" No. x. in *A Picturesque Tour of Italy, from Drawings made in* 1816–1817. By James Hakewill, Architect. 1820.]

the whole composition right, when otherwise it would have been stiff and absurd.

224. If you look back to Fig. 48 you will see, in the arrangement of the battlements, a simple instance of the use of such variation. The whole top of the tower, though actually three sides of a square, strikes the eye as a continuous series of five masses. The first two, on the left, somewhat square and blank, then the next two higher and richer, the tiles being seen on their slopes. Both these groups being couples, there is enough monotony in the series to make a change pleasant; and the last battlement, therefore, is a little higher than the first two,—a little lower than the second two,—and different in shape from either. Hide it with your finger, and see how ugly and formal the other four battlements look.

225. There are in this figure several other simple illustrations of the laws we have been tracing. Thus the whole shape of the walls' mass being square, it is well, still for the sake of contrast, to oppose it not only by the element of curvature, in the ring, and lines of the roof below, but by that of sharpness; hence the pleasure which the eye takes in the projecting point of the roof. Also, because the walls are thick and sturdy, it is well to contrast their strength with weakness; therefore we enjoy the evident decrepitude of this roof as it sinks between them. The whole mass being nearly white, we want a contrasting shadow somewhere; and get it, under our piece of decrepitude. This shade, with the tiles of the wall below, forms another pointed mass, necessary to the first by the law of repetition. Hide this inferior angle with your finger, and see how ugly the other looks. A sense of the law of symmetry, though you might hardly suppose it, has some share in the feeling with which you look at the battlements; there is a certain pleasure in the opposed slopes of their top, on one side down to the left,. on the other to the right. Still less would you think the law of radiation had anything to do with the matter: but if you take the extreme point of

the black shadow on the left for a centre, and follow first
the low curve of the eaves of the wall, it will lead you, if
you continue it, to the point of the tower cornice; follow
the second curve, the top of the tiles of the wall, and it will
strike the top of the right-hand battlement; then draw a
curve from the highest point of the angled battlement on
the left, through the points of the roof and its dark echo;
and you will see how the whole top of the tower radiates
from this lowest dark point. There are other curvatures
crossing these main ones, to keep them from being too
conspicuous. Follow the curve of the upper roof, it will
take you to the top of the highest battlement; and the
stones indicated at the right-hand side of the tower are
more extended at the bottom, in order to get some less
direct expression of sympathy, such as irregular stones may
be capable of, with the general flow of the curves from
left to right.

226. You may not readily believe, at first, that all these
laws are indeed involved in so trifling a piece of composi-
tion. But, as you study longer, you will discover that
these laws, and many more, are obeyed by the powerful
composers in every *touch:* that literally, there is never a
dash of their pencil which is not carrying out appointed
purposes of this kind in twenty various ways at once; and
that there is as much difference, in way of intention and
authority, between one of the great composers ruling his
colours, and a common painter confused by them, as there
is between a general directing the march of an army, and
an old lady carried off her feet by a mob.

7. THE LAW OF INTERCHANGE.

227. Closely connected with the law of contrast is a
law which enforces the unity of opposite things, by giving
to each a portion of the character of the other. If, for
instance, you divide a shield into two masses of colour, all

the way down—suppose blue and white, and put a bar, or figure of an animal, partly on one division, partly on the other, you will find it pleasant to the eye if you make the part of the animal blue which comes upon the white half, and white which comes upon the blue half. This is done in heraldry, partly for the sake of perfect intelligibility, but yet more for the sake of delight in interchange of colour, since, in all ornamentation whatever, the practice is continual, in the ages of good design.

228. Sometimes this alternation is merely a reversal of contrasts; as that, after red has been for some time on one side, and blue on the other, red shall pass to blue's side and blue to red's. This kind of alternation takes place simply in four-quartered shields; in more subtle pieces of treatment, a little bit only of each colour is carried into the other, and they are as it were dovetailed together. One of the most curious facts which will impress itself upon you, when you have drawn some time carefully from Nature in light and shade, is the appearance of intentional artifice with which contrasts of this alternate kind are produced by her; the artistry with which she will darken a tree trunk as long as it comes against light sky, and throw sunlight on it precisely at the spot where it comes against a dark hill, and similarly treat all her masses of shade and colour, is so great, that if you only follow her closely, every one who looks at your drawing with attention will think that you have been inventing the most artificially and unnaturally delightful interchanges of shadow that could possibly be devised by human wit.

229. You will find this law of interchange insisted upon at length by Prout in his Lessons on Light and Shade:[1] it seems of all his principles of composition to be the one he is most conscious of; many others he obeys by instinct, but this he formally accepts and forcibly declares.

[1] [For another reference to this book, see above, § 197. In the remarks on Plate I. Prout notes that "in Nos. 6 and 7 (of the figures there given) light and shadow are respectively interchanged by way of contrast, but in similar proportions." He illustrates the same law in the notes on other plates (especially Plate VI.).]

The typical purpose of the law of interchange is, of course, to teach us how opposite natures may be helped and strengthened by receiving each, as far as they can, some impress or reflection, or imparted power, from the other.

8. THE LAW OF CONSISTENCY.

230. It is to be remembered, in the next place, that while contrast exhibits the *characters* of things, it very often neutralises or paralyses their *power*. A number of white things may be shown to be clearly white by opposition of a black thing, but if we want the full power of their gathered light, the black thing may be seriously in our way. Thus, while contrast displays things, it is unity and sympathy which employ them, concentrating the power of several into a mass. And, not in art merely, but in all the affairs of life, the wisdom of man is continually called upon to reconcile these opposite methods of exhibiting, or using, the materials in his power. By change he gives them pleasantness, and by consistency value; by change he is refreshed, and by perseverance strengthened.

231. Hence many compositions address themselves to the spectator by aggregate force of colour or line, more than by contrasts of either; many noble pictures are painted almost exclusively in various tones of red, or grey, or gold, so as to be instantly striking by their breadth of flush, or glow, or tender coldness, these qualities being exhibited only by slight and subtle use of contrast. Similarly as to form; some compositions associate massive and rugged forms, others slight and graceful ones, each with few interruptions by lines of contrary character. And, in general, such compositions possess higher sublimity than those which are more mingled in their elements. They tell a special tale, and summon a definite state of feeling, while the grand compositions merely please the eye.

232. This unity or breadth of character generally attaches

most to the works of the greatest men; their separate pictures have all separate aims. We have not, in each, grey colour set against sombre, and sharp forms against soft, and loud passages against low: but we have the bright picture, with its delicate sadness; the sombre picture, with its single ray of relief; the stern picture, with only one tender group of lines; the soft and calm picture, with only one rock angle at its flank; and so on. Hence the variety of their work, as well as its impressiveness. The principal bearing of this law, however, is on the separate masses or divisions of a picture: the character of the whole composition may be broken or various, if we please, but there must certainly be a tendency to consistent assemblage in its divisions. As an army may act on several points at once, but can only act effectually by having somewhere formed and regular masses, and not wholly by skirmishers; so a picture may be various in its tendencies, but must be somewhere united and coherent in its masses. Good composers are always associating their colours in great groups; binding their forms together by encompassing lines, and securing, by various dexterities of expedient, what they themselves call "breadth": that is to say, a large gathering of each kind of thing into one place; light being gathered to light, darkness to darkness, and colour to colour. If, however, this be done by introducing false lights or false colours, it is absurd and monstrous; the skill of a painter consists in obtaining breadth by rational arrangement of his objects, not by forced or wanton treatment of them. It is an easy matter to paint one thing all white, and another all black or brown; but not an easy matter to assemble all the circumstances which will naturally produce white in one place, and brown in another. Generally speaking, however, breadth will result in sufficient degree from fidelity of study: Nature is always broad; and if you paint her colours in true relations, you will paint them in majestic masses. If you find your work look broken and scattered, it is, in all probability, not only ill composed, but untrue.

233. The opposite quality to breadth, that of division or scattering of light and colour, has a certain contrasting charm, and is occasionally introduced with exquisite effect by good composers.* Still it is never the mere scattering, but the order discernible through this scattering, which is the real source of pleasure; not the mere multitude, but the constellation of multitude. The broken lights in the work of a good painter wander like flocks upon the hills, not unshepherded, speaking of life and peace: the broken lights of a bad painter fall like hailstones, and are capable only of mischief, leaving it to be wished they were also of dissolution.

9. THE LAW OF HARMONY.

234. This last law is not, strictly speaking, so much one of composition as of truth, but it must guide composition, and is properly, therefore, to be stated in this place.

Good drawing is, as we have seen, an *abstract* of natural facts; you cannot represent all that you would, but must continually be falling short, whether you will or no, of the force, or quantity, of Nature. Now, suppose that your means and time do not admit of your giving the depth of colour in the scene, and that you are obliged to paint it paler. If you paint all the colours proportionately paler, as if an equal quantity of tint had been washed away from each of them, you still obtain a harmonious, though not an equally forcible, statement of natural fact. But if you take away the colours unequally, and leave some tints nearly as deep as they are in Nature, while others are much subdued, you have no longer a true statement. You

* One of the most wonderful compositions of Tintoret in Venice is little more than a field of subdued crimson, spotted with flakes of scattered gold.[1] The upper clouds in the most beautiful skies owe great part of their power to infinitude of division; order being marked through this division.

[1] ["The Circumcision" in the Scuola di San Rocco; see Vol. XI. p. 409.]

cannot say to the observer, "Fancy all those colours a little deeper, and you will have the actual fact." However he adds in imagination, or takes away, something is sure to be still wrong. The picture is out of harmony.

235. It will happen, however, much more frequently, that you have to darken the whole system of colours, than to make them paler. You remember, in your first studies of colour from Nature,[1] you were to leave the passages of light which were too bright to be imitated, as white paper. But, in completing the picture, it becomes necessary to put colour into them; and then the other colours must be made darker, in some fixed relation to them. If you deepen all proportionately, though the whole scene is darker than reality, it is only as if you were looking at the reality in a lower light: but if, while you darken some of the tints, you leave others undarkened, the picture is out of harmony, and will not give the impression of truth.

236. It is not, indeed, possible to deepen *all* the colours so much as to relieve the lights in their natural degree, you would merely sink most of your colours, if you tried to do so, into a broad mass of blackness: but it is quite possible to lower them harmoniously, and yet more in some parts of the picture than in others, so as to allow you to show the light you want in a visible relief. In well-harmonised pictures this is done by gradually deepening the tone of the picture towards the lighter parts of it, without materially lowering it in the very dark parts; the tendency in such pictures being, of course, to include large masses of middle tints. But the principal point to be observed in doing this, is to deepen the individual tints without dirtying or obscuring them. It is easy to lower the tone of the picture by washing it over with grey or brown; and easy to see the effect of the landscape, when its colours are thus universally polluted with black, by using the black convex mirror, one of the most pestilent inventions for falsifying Nature and degrading art which ever was put into

[1] [Above, p. 145.]

an artist's hand.* For the thing required is not to darken
pale yellow by mixing grey with it, but to deepen the pure
yellow; not to darken crimson by mixing black with it,
but by making it deeper and richer crimson: and thus the
required effect could only be seen in Nature, if you had
pieces of glass of the colour of every object in your land-
scape, and of every minor hue that made up those colours,
and then could see the real landscape through this deep
gorgeousness of the varied glass. You cannot do this with
glass, but you can do it for yourself as you work; that is
to say, you can put deep blue for pale blue, deep gold for
pale gold, and so on, in the proportion you need; and then
you may paint as forcibly as you choose, but your work
will still be in the manner of Titian, not of Caravaggio or
Spagnoletto,[1] or any other of the black slaves of painting.†

. 237. Supposing those scales of colour, which I told you
to prepare in order to show you the relations of colour to
grey, were quite accurately made, and numerous enough,
you would have nothing more to do, in order to obtain a
deeper tone in any given mass of colour, than to substitute
for each of its hues the hue as many degrees deeper in the
scale as you wanted, that is to say, if you wanted to
deepen the whole two degrees, substituting for the yellow
No. 5 the yellow No. 7, and for the red No. 9 the red
No. 11, and so on: but the hues of any object in Nature
are far too numerous, and their degrees too subtle, to
admit of so mechanical a process. Still, you may see the
principle of the whole matter clearly by taking a group of

* I fully believe that the strange grey gloom, accompanied by consider-
able power of effect, which prevails in modern French art, must be owing
to the use of this mischievous instrument; the French landscape always
gives me the idea of Nature seen carelessly in the dark mirror, and painted
coarsely, but scientifically, through the veil of its perversion.

† Various other parts of this subject are entered into, especially in their
bearing on the ideal of painting, in *Modern Painters*, vol. iv. chap. iii.

[1] [For other references in a similar sense to Caravaggio, see Vol. X. p. 223; to
Spagnoletto, Vol. IV. p. 137.]

colours out of your scale, arranging them prettily, and then washing them all over with grey: that represents the treatment of Nature by the black mirror. Then arrange the same group of colours, with the tints five or six degrees deeper in the scale; and that will represent the treatment of Nature by Titian.

238. You can only, however, feel your way fully to the right of the thing by working from Nature.

The best subject on which to begin a piece of study of this kind is a good thick tree trunk, seen against blue sky with some white clouds in it. Paint the clouds in true and tenderly gradated white; then give the sky a bold full blue, bringing them well out; then paint the trunk and leaves grandly dark against all, but in such glowing dark green and brown as you see they will bear. Afterwards proceed to more complicated studies, matching the colours carefully first by your old method; then deepening each colour with its own tint, and being careful, above all things, to keep truth of equal change when the colours are connected with each other, as in dark and light sides of the same object. Much more aspect and sense of harmony are gained by the precision with which you observe the relation of colours in dark sides and light sides, and the influence of modifying reflections, than by mere accuracy of added depth in independent colours.

239. This harmony of tone, as it is generally called, is the most important of those which the artist has to regard. But there are all kinds of harmonies in a picture, according to its mode of production. There is even a harmony of touch. If you paint one part of it very rapidly and forcibly, and another part slowly and delicately, each division of the picture may be right separately, but they will not agree together: the whole will be effectless and valueless, out of harmony. Similarly, if you paint one part of it by a yellow light in a warm day, and another by a grey light in a cold day, though both may have been sunlight, and both may be well toned, and have their relative

shadows truly cast, neither will look like light; they will destroy each other's power, by being out of harmony. These are only broad and definable instances of discordance; but there is an extent of harmony in all good work much too subtle for definition; depending on the draughtsman's carrying everything he draws up to just the balancing and harmonious point, in finish, and colour, and depth of tone, and intensity of moral feeling, and style of touch, all considered at once; and never allowing himself to lean too emphatically on detached parts, or exalt one thing at the expense of another, or feel acutely in one place and coldly in another. If you have got some of Cruikshank's etchings, you will be able, I think, to feel the nature of harmonious treatment in a simple kind, by comparing them with any of Richter's illustrations to the numerous German story-books lately published at Christmas,[1] with all the German stories spoiled. Cruikshank's work is often incomplete in character and poor in incident, but, as drawing, it is *perfect* in harmony. The pure and simple effects of daylight which he gets by his thorough mastery of treatment in this respect, are quite unrivalled, as far as I know, by any other work executed with so few touches. His vignettes to Grimm's German stories, already recommended,[2] are the most remarkable in this quality. Richter's illustrations, on the contrary, are of a very high stamp as respects understanding of human character, with infinite playfulness and tenderness of fancy; but, as drawings, they are almost unendurably out of harmony, violent blacks in one place being continually opposed to trenchant white in another; and, as is almost sure to be the case with bad harmonists, the local colour hardly felt anywhere. All German work is apt to be out of harmony, in consequence of its too frequent conditions of affectation, and its wilful refusals of fact; as well as by reason of a feverish kind of excitement, which dwells violently on particular points, and

[1] [For Richter, see below, p. 224; for Cruikshank, p. 222.]
[2] [See above, p. 79.]

makes all the lines of thought in the picture to stand on end, as it were, like a cat's fur electrified; while good work is always as quiet as a couchant leopard, and as strong.

240. I have now stated to you all the laws of composition which occur to me as capable of being illustrated or defined; but there are multitudes of others which, in the present state of my knowledge, I cannot define, and others which I never hope to define; and these the most important, and connected with the deepest powers of the art. I hope, when I have thought of them more, to be able to explain some of the laws which relate to nobleness and ignobleness; that ignobleness especially which we commonly call "vulgarity," and which, in its essence, is one of the most curious subjects of inquiry connected with human feeling.[1] Others I never hope to explain, laws of expression, bearing simply on simple matters; but, for that very reason, more influential than any others. These are, from the first, as inexplicable as our bodily sensations are; it being just as impossible, I think, to show, finally, why one succession of musical notes * shall be lofty and pathetic, and such as might have been sung by Casella to Dante,[2] and why another succession is base and ridiculous, and would be fit only for the reasonably good ear of Bottom,[3] as to explain why we like sweetness, and dislike bitterness. The best part of every great work is always

* In all the best arrangements of colour, the delight occasioned by their mode of succession is entirely inexplicable, nor can it be reasoned about; we like it just as we like an air in music, but cannot reason any refractory person into liking it, if they do not: and yet there is distinctly a right and a wrong in it, and a good taste and bad taste respecting it, as also in music.

[1] [Ruskin returned to the subject in *Modern Painters*, vol. v. pt. ix. ch. vii. ("Of Vulgarity"), and compare Vol. XIV. p. 243.]
[2] [See *Purgatorio*, ii. 107 *seq.*, and Milton's "Sonnet to Henry Lawes":—

"Dante shall give fame leave to set thee higher
Than his Casella, whom he wooed to sing,
Met in the milder shades of Purgatory."]

[3] [*Midsummer Night's Dream*, iv. i. 31.]

inexplicable : it is good because it is good ; and innocently gracious, opening as the green of the earth, or falling as the dew of heaven.

241. But though you cannot explain them, you may always render yourself more and more sensitive to these higher qualities by the discipline which you generally give to your character, and this especially with regard to the choice of incidents ; a kind of composition in some sort easier than the artistical arrangements of lines and colours, but in every sort nobler, because addressed to deeper feelings.

242. For instance, in the "Datur Hora Quieti," the last vignette to Rogers's *Poems*, the plough in the foreground has three purposes.[1] The first purpose is to meet the stream of sunlight on the river, and make it brighter by opposition ; but any dark object whatever would have done this. Its second purpose is, by its two arms, to repeat the cadence of the group of the two ships, and thus give a greater expression of repose ; but two sitting figures would have done this. Its third and chief, or pathetic, purpose is, as it lies abandoned in the furrow (the vessels also being moored, and having their sails down), to be a type of human labour closed with the close of day. The parts of it on which the hand leans are brought most clearly into sight ; and they are the chief dark of the picture, because the tillage of the ground is required of man as a punishment : but they make the soft light of the setting sun brighter, because rest is sweetest after toil. These thoughts may never occur to us as we glance carelessly at the design ; and yet their undercurrent assuredly affects the feelings, and increases, as the painter meant it should, the impression of melancholy, and of peace.

243. Again, in the "Lancaster Sands," which is one of the plates I have marked as most desirable for your possession,[2] the stream of light which falls from the setting sun on the advancing tide stands similarly in need of some force

[1] [Compare *Modern Painters*, vol. i. (Vol. III. p. 265), and vol. v. pt. viii. ch. ii. § 5.]
[2] [See above, p. 75 n. For another reference to the plate, see Vol. XIII. p. 495.]

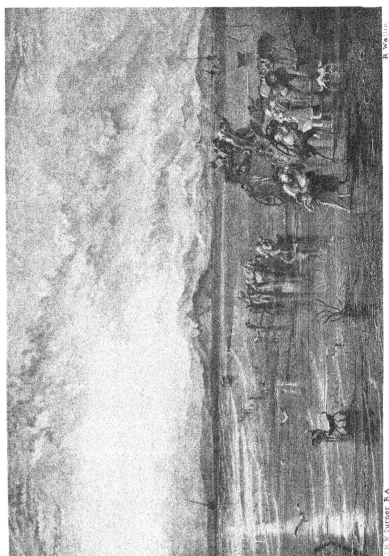

of near object to relieve its brightness. But the incident which Turner has here adopted is the swoop of an angry sea-gull at a dog, who yelps at it, drawing back as the wave rises over his feet, and the bird shrieks within a foot of his face. Its unexpected boldness is a type of the anger of its ocean element, and warns us of the sea's advance just as surely as the abandoned plough told us of the ceased labour of the day.

244. It is not, however, so much in the selection of single incidents of this kind, as in the feeling which regulates the arrangement of the whole subject, that the mind of a great composer is known. A single incident may be suggested by a felicitous chance, as a pretty motto might be for the heading of a chapter. But the great composers so arrange *all* their designs that one incident illustrates another, just as one colour relieves another. Perhaps the " Heysham," of the Yorkshire series,[1] which, as to its locality, may be considered a companion to the last drawing we have spoken of, the " Lancaster Sands," presents as interesting an example as we could find of Turner's feeling in this respect. The subject is a simple north-country village, on the shore of Morecambe Bay; not in the common sense a picturesque village; there are no pretty bow-windows, or red roofs, or rocky steps of entrance to the rustic doors, or quaint gables; nothing but a single street of thatched and chiefly clay-built cottages, ranged in a somewhat monotonous line, the roofs so green with moss that at first we hardly discern the houses from the fields and trees. The village street is closed at the end by a wooden gate, indicating the little traffic there is on the road through it, and giving it something the look of a large farmstead, in which a right of way lies through the yard. The road which leads to this gate is full of ruts, and winds down a bad bit of hill between two broken banks of moor ground, succeeding immediately to the few enclosures which surround the village; they can

[1] [Published in vol. ii. of Whitaker's *Richmondshire*. The drawing was in Ruskin's collection : see *Notes on his Drawings by Turner*, No. 25 (Vol. XIII. p. 429).]

hardly be called gardens: but a decayed fragment or two of fencing fill the gaps in the bank; a clothes-line, with some clothes on it, striped blue and red, and a smock-frock, is stretched between the trunks of some stunted willows; a *very* small haystack and pig-stye being seen at the back of the cottage beyond. An empty, two-wheeled, lumbering cart, drawn by a pair of horses with huge wooden collars, the driver sitting lazily in the sun, sideways on the leader, is going slowly home along the rough road, it being about country dinner-time. At the end of the village there is a better house, with three chimneys and a dormer window in its roof, and the roof is of stone shingle instead of thatch, but very rough. This house is no doubt the clergyman's: there is some smoke from one of its chimneys, none from any other in the village; this smoke is from the lowest chimney at the back, evidently that of the kitchen, and it is rather thick, the fire not having been long lighted. A few hundred yards from the clergyman's house, nearer the shore, is the church, discernible from the cottages only by its low two-arched belfry, a little neater than one would expect in such a village; perhaps lately built by the Puseyite incumbent:* and beyond the church, close to the sea, are two fragments of a border war-tower, standing on their circular mound, worn on its brow deep into edges and furrows by the feet of the village children. On the bank of moor, which forms the foreground, are a few cows, the carter's dog barking at a vixenish one: the milkmaid is feeding another, a gentle white one, which turns its head to her, expectant of a handful of fresh hay, which she has brought for it in her blue apron, fastened up round her waist; she stands with her pail on her head, evidently the

* "Puseyism" was unknown in the days when this drawing was made; but the kindly and helpful influences of what may be called ecclesiastical sentiment, which, in a morbidly exaggerated condition, forms one of the principal elements of "Puseyism,"—I use this word regretfully, no other existing which will serve for it,—had been known and felt in our wild northern districts long before.[1]

[1] [For Ruskin's dislike of Puseyism, see Vol. XII. pp. 533, 550.]

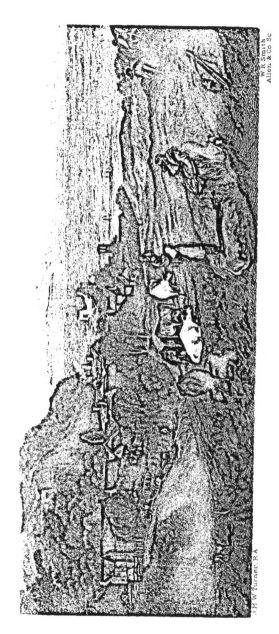

J.M.W.Turner. R.A.

W.R.Smith
Allen & Co Sc

Heysham

village coquette, for she has a neat bodice, and pretty striped petticoat under the blue apron, and red stockings. Nearer us, the cowherd, barefooted, stands on a piece of the limestone rock (for the ground is thistly and not pleasurable to bare feet);—whether boy or girl we are not sure: it may be a boy, with a girl's worn-out bonnet on, or a girl with a pair of ragged trowsers on; probably the first, as the old bonnet is evidently useful to keep the sun out of our eyes when we are looking for strayed cows among the moorland hollows, and helps us at present to watch (holding the bonnet's edge down) the quarrel of the vixenish cow with the dog, which, leaning on our long stick, we allow to proceed without any interference. A little to the right the hay is being got in, of which the milkmaid has just taken her apronful to the white cow; but the hay is very thin, and cannot well be raked up because of the rocks; we must glean it like corn, hence the smallness of our stack behind the willows; and a woman is pressing a bundle of it hard together, kneeling against the rock's edge, to carry it safely to the hay-cart without dropping any. Beyond the village is a rocky hill, deep set with brushwood, a square crag or two of limestone emerging here and there, with pleasant turf on their brows, heaved in russet and mossy mounds against the sky, which, clear and calm, and as golden as the moss, stretches down behind it towards the sea. A single cottage just shows its roof over the edge of the hill, looking seawards: perhaps one of the village shepherds is a sea captain now, and may have built it there, that his mother may first see the sails of his ship whenever it runs into the bay. Then under the hill, and beyond the border tower, is the blue sea itself, the waves flowing in over the sand in long curved lines slowly; shadows of cloud, and gleams of shallow water on white sand alternating—miles away; but no sail is visible, not one fisher-boat on the beach, not one dark speck on the quiet horizon. Beyond all are the Cumberland mountains, clear in the sun, with rosy light on all their crags.

245. I should think the reader cannot but feel the kind of harmony there is in this composition; the entire purpose of the painter to give us the impression of wild, yet gentle, country life, monotonous as the succession of the noiseless waves, patient and enduring as the rocks; but peaceful, and full of health and quiet hope, and sanctified by the pure mountain air and baptismal dew of heaven, falling softly between days of toil and nights of innocence.

246. All noble composition of this kind can be reached only by instinct; you cannot set yourself to arrange such a subject; you may see it, and seize it, at all times, but never laboriously invent it. And your power of discerning what is best in expression, among natural subjects, depends wholly on the temper in which you keep your own mind; above all, on your living so much alone as to allow it to become acutely sensitive in its own stillness. The noisy life of modern days is wholly incompatible with any true perception of natural beauty. If you go down into Cumberland by the railroad, live in some frequented hotel, and explore the hills with merry companions, however much you may enjoy your tour or their conversation, depend upon it you will never choose so much as one pictorial subject rightly; you will not see into the depth of any. But take knapsack and stick, walk towards the hills by short day's journeys,—ten or twelve miles a day—taking a week from some starting-place sixty or seventy miles away: sleep at the pretty little wayside inns, or the rough village ones; then take the hills as they tempt you, following glen or shore as your eye glances or your heart guides, wholly scornful of local fame or fashion, and of everything which it is the ordinary traveller's duty to see, or pride to do. Never force yourself to admire anything when you are not in the humour; but never force yourself away from what you feel to be lovely, in search of anything better; and gradually the deeper scenes of the natural world will unfold themselves to you in still increasing fulness of passionate power; and your difficulty will be no more to seek

or to compose subjects, but only to choose one from among the multitude of melodious thoughts with which you will be haunted, thoughts which will of course be noble or original in proportion to your own depth of character and general power of mind; for it is not so much by the consideration you give to any single drawing, as by the previous discipline of your powers of thought, that the character of your composition will be determined. Simplicity of life will make you sensitive to the refinement and modesty of scenery, just as inordinate excitement and pomp of daily life will make you enjoy coarse colours and affected forms. Habits of patient comparison and accurate judgment will make your art precious, as they will make your actions wise; and every increase of noble enthusiasm in your living spirit will be measured by the reflection of its light upon the works of your hands.—Faithfully yours,

J. RUSKIN.

APPENDIX

ILLUSTRATIVE NOTES

NOTE 1, p. 69.—"PRINCIPLE OF THE STEREOSCOPE."

247. I 'AM sorry to find a notion current among artists, that they can, in some degree, imitate in a picture the effect of the stereoscope, by confusion of lines. There are indeed one or two artifices by which, as stated in the text, an appearance of retirement or projection may be obtained, so that they partly supply the place of the stereoscopic effect, but they do not imitate that effect. The principle of the human sight is simply this:—by means of our two eyes we literally see everything from two places at once; and, by calculated combination, in the brain, of the facts of form so seen, we arrive at conclusions respecting the distance and shape of the object, which we could not otherwise have reached. But it is just as vain to hope to paint at once the two views of the object as seen from these two places, though only an inch and a half distant from each other, as it would be if they were a mile and a half distant from each other. With the right eye you see one view of a given object, relieved against one part of the distance; with the left eye you see another view of it, relieved against another part of the distance. You may paint whichever of those views you please; you cannot paint both. Hold your finger upright, between you and this page of the book, about six inches from your eyes, and three from the book; shut the right eye, and hide the words "inches from," in the second line above this, with your finger; you will then see "six" on one side of it, and "your," on the other. Now shut the left eye and open the right without moving your finger, and you will see "inches," but not "six." You may paint the finger with "inches" beyond it, or with "six" beyond it, but not with both. And this principle holds for any object and any distance. You might just as well try to paint St. Paul's at once from both ends of London Bridge as to realise any stereoscopic effect in a picture.

NOTE 2, p. 84.—"DARK LINES TURNED TO THE LIGHT."

248. It ought to have been farther observed, that the enclosure of the light by future shadow is by no means the only reason for the dark lines which great masters often thus introduce. It constantly happens that a local colour will show its own darkness most on the light side, by projecting

into and against masses of light in that direction; and then the painter will indicate this future force of the mass by his dark touch. Both the monk's head in Fig. 11 and dog in Fig. 20 are dark towards the light for this reason.

Note 3, p. 124.—"Softness of Reflections."

249. I have not quite insisted enough on the extreme care which is necessary in giving the tender evanescence of the edges of the reflections, when the water is in the least agitated; nor on the decision with which you may reverse the object, when the water is quite calm. Most drawing of reflections is at once confused and hard; but Nature's is at once intelligible and tender. Generally, at the edge of the water, you ought not to see where reality ceases and reflection begins; as the image loses itself you ought to keep all its subtle and varied veracities, with the most exquisite softening of its edge. Practise as much as you can from the reflections of ships in calm water, following out all the reversed rigging, and taking, if anything, more pains with the reflection than with the ship.

Note 4, p. 126.—"Where the Reflection is Darkest, you will see through the Water Best."

250. For this reason it often happens that if the water be shallow, and you are looking steeply down into it, the reflection of objects on the bank will consist simply of pieces of the bottom seen clearly through the water, and relieved by flashes of light, which are the reflection of the sky. Thus you may have to draw the reflected dark shape of a bush: but, inside of that shape, you must not draw the leaves of the bush, but the stones under the water; and, outside of this dark reflection, the blue or white of the sky, with no stones visible.

Note 5, p. 127.—"Approach Streams with Reverence."

251. I have hardly said anything about waves of torrents or waterfalls, as I do not consider them subjects for beginners to practise upon; but, as many of our younger artists are almost breaking their hearts over them, it may be well to state at once that it is physically impossible to draw a running torrent quite rightly, the lustre of its currents and whiteness of its foam being dependent on intensities of light which art has not at its command. This also is to be observed, that most young painters make their defeat certain by attempting to draw running water, which is a lustrous object in rapid motion, without ever trying their strength on a lustrous object standing still. Let them break a coarse green-glass bottle into a great many bits, and try to paint those, with all their undulations and edges of fracture, as they lie still on the table; if they cannot, of course they need not try the rushing crystal and foaming fracture of the stream. If they can manage the glass bottle, let them next buy a fragment or two of yellow fire-opal; it is quite a common and cheap mineral, and presents, as closely as anything can, the milky bloom

and colour of a torrent wave: and if they can conquer the opal, they may at last have some chance with the stream, as far as the stream is in any wise possible. But, as I have just said, the bright parts of it are *not* possible, and ought, as much as may be, to be avoided in choosing subjects. A great deal more may, however, be done than any artist has done yet, in painting the gradual disappearance and lovely colouring of stones seen through clear and calm water.

Students living in towns may make great progress in rock-drawing by frequently and faithfully drawing broken edges of common roofing-slates, of their real size.

NOTE 6, p. 153.—"NATURE'S ECONOMY OF COLOUR."

252. I heard it wisely objected to this statement, the other day, by a young lady, that it was not through economy that Nature did not colour deep down in the flower bells, but because "she had not light enough there to see to paint with." This may be true; but it is certainly not for want of light that, when she is laying the dark spots on a foxglove, she will not use any more purple than she has got already on the bell, but takes out the colour all round the spot, and concentrates it in the middle.

NOTE 7, p. 168.—"THE LAW OF REPETITION."

253. The reader may perhaps recollect a very beautiful picture of Vandyck's, in the Manchester Exhibition,[1] representing three children in court dresses of rich black and red. The law in question was amusingly illustrated, in the lower corner of that picture, by the introduction of two crows, in a similar colour of court dress, having jet black feathers and bright red beaks.

254. Since the first edition of this work was published, I have ascertained that there are two series of engravings from the Bible drawings mentioned in the list at p. 76. One of these is inferior to the other, and in many respects false to the drawings; the "Jericho," for instance, in the false series, has common bushes instead of palm trees in the middle distance. The original plates may be had at almost any respectable printseller's; and ordinary impressions, whether of these or any other plates mentioned in the list at p. 75, will be quite as useful as proofs; but, in buying Liber Studiorum, it is always well to get the best impressions that can be had, and if possible impressions of the original plates, published by Turner. In case these are not to be had, the copies which are in course of publication by Mr. Lupton[2] (4 Keppel Street, Russell Square) are good and serviceable; but no others are of any use.[3]

[1] [No. 660 in the catalogue: "'Three Children,' lent by Earl de Grey."]
[2] [For whom, see Vol. IX. p. 15 n. Lupton dedicated the copies to Ruskin.]
[3] [Note added in ed. 2, 1857.]

I have placed in the hands of Mr. Ward (Working Men's College) some photographs from the etchings made by Turner for the Liber; the original etchings being now unobtainable, except by fortunate accident. I have selected the subjects carefully from my own collection of the etchings; and though some of the more subtle qualities of line are lost in the photographs, the student will find these proofs the best lessons in pen-drawing accessible to him.[1]

[1] [The last seven lines of this note were added in ed. 3, 1859. Mr. William Ward, now of 2 Church Terrace, Richmond, Surrey, still supplies prints and photographs after Turner, etc., to illustrate Ruskin's works and teaching.]

THINGS TO BE STUDIED

255. The worst danger by far, to which a solitary student is exposed, is that of liking things that he should not. It is not so much his difficulties, as his tastes, which he must set himself to conquer: and although, under the guidance of a master, many works of art may be made instructive, which are only of partial excellence (the good and bad of them being duly distinguished), his safeguard, as long as he studies alone, will be in allowing himself to possess only things, in their way, so free from faults, that nothing he copies in them can seriously mislead him, and to contemplate only those works of art which he knows to be either perfect or noble in their errors. I will therefore set down, in clear order, the names of the masters whom you may safely admire, and a few of the books which you may safely possess. In these days of cheap illustration, the danger is always rather of your possessing too much than too little. It may admit of some question, how far the looking at bad art may set off and illustrate the characters of the good; but, on the whole, I believe it is best to live always on quite wholesome food, and that our enjoyment of it will never be made more acute by feeding[1] on ashes; though it may be well sometimes to taste the ashes, in order to know the bitterness of them. Of course the works of the great masters can only be serviceable to the student after he has made considerable progress himself. It only wastes the time and dulls the feelings of young persons, to drag them through picture galleries; at least, unless they themselves wish to look at particular pictures. Generally, young people only care to enter a picture gallery when there is a chance of getting leave to run a race to the other end of it; and they had better do that in the garden below. If, however, they have any real enjoyment of pictures, and want to look at this one or that, the principal point is never to disturb them in looking at what interests them, and never to make them look at what does not. Nothing is of the least use to young people (nor, by the way, of much use to old ones), but what interests them; and therefore, though it is of great importance to put nothing but good art into their possession, yet, when they are passing through great houses or galleries, they should be allowed to look precisely at what pleases them: if it is not useful to them as art, it will be in some other way; and the healthiest way in

[1] [Ed. 1 reads:
"... by feeding, however temporarily, on ashes. Of course the works ..."]

which art can interest them is when they look at it, not as art, but because it represents something they like in Nature. If a boy has had his heart filled by the life of some great man, and goes up thirstily to a Vandyck portrait of him, to see what he was like, that is the wholesomest way in which he can begin the study of portraiture; if he loves mountains, and dwells on a Turner drawing because he sees in it a likeness to a Yorkshire scar or an Alpine pass, that is the wholesomest way in which he can begin the study of landscape; and if a girl's mind is filled with dreams of angels and saints, and she pauses before an Angelico because she thinks it must surely be like heaven, that is the right way for her to begin the study of religious art.

256. When, however, the student has made some definite progress, and every picture becomes really a guide to him, false or true, in his own work, it is of great importance that he should never look, with even partial admiration, at bad art; and then, if the reader is willing to trust me in the matter, the following advice will be useful to him. In which, with his permission, I will quit the indirect and return to the epistolary address, as being the more convenient.

First, in Galleries of Pictures:

1. You may look, with trust in their being always right, at Titian, Veronese, Tintoret,[1] Giorgione, John Bellini, and Velasquez; the authenticity of the picture being of course established for you by proper authority.

2. You may look with admiration, admitting, however, question of right and wrong,* at Van Eyck, Holbein, Perugino, Francia, Angelico, Leonardo da Vinci, Correggio, Vandyck, Rembrandt, Reynolds, Gainsborough, Turner, and the modern Pre-Raphaelites.† You had better look at no other painters than these, for you run a chance, otherwise, of being led far off the road, or into grievous faults, by some of the other great ones, as Michael Angelo, Raphael, and Rubens; and of being, besides, corrupted in taste by the base ones, as Murillo, Salvator, Claude, Gaspar Poussin, Teniers, and such others. You may look, however, for examples of evil, with safe universality of reprobation, being sure that everything you see is bad, at Domenichino, the Carracci, Bronzino, and the figure pieces of Salvator.[2]

Among those named for study under question, you cannot look too much at, nor grow too enthusiastically fond of, Angelico, Correggio, Reynolds, Turner, and the Pre-Raphaelites; but, if you find yourself getting especially fond of any of the others, leave off looking at them, for

* I do not mean necessarily to imply inferiority of rank in saying that this second class of painters have questionable qualities. The greatest men have often many faults, and sometimes their faults are a part of their greatness; but such men are not, of course, to be looked upon by the student with absolute implicitness of faith.

† Including, under this term, John Lewis, and William Hunt of the Old Water-colour, who, take him all in all, is the best painter of still life, I believe, that ever existed.

[1] [But see *Two Paths*, § 69, and Appendix i., where some qualification is made of the inclusion of Tintoret here.]

[2] [For Ruskin's other references to these painters, see General Index; while the list here may be compared with his classification given in Vol. IV. pp. xxxiv.–xxxv.]

you must be going wrong some way or other. If, for instance, you begin to like Rembrandt or Leonardo especially, you are losing your feeling for colour; if you like Van Eyck or Perugino especially, you must be getting too fond of rigid detail; and if you like Vandyck or Gainsborough especially, you must be too much attracted by gentlemanly flimsiness.

257. Secondly, of published, or otherwise multiplied, art, such as you may be able to get yourself, or to see at private houses or in shops, the works of the following masters are the most desirable, after the Turners, Rembrandts, and Dürers, which I have asked you to get first:

1. SAMUEL PROUT.*

All his published lithographic sketches are of the greatest value,[1] wholly unrivalled in power of composition, and in love and feeling of architectural subject. His somewhat mannered linear execution, though not to be imitated in your own sketches from Nature, may be occasionally copied, for discipline's sake, with great advantage: it will give you a peculiar steadiness of hand, not quickly attainable in any other way; and there is no fear of your getting into any faultful mannerism as long as you carry out the different modes of more delicate study above recommended.

If you are interested in architecture, and wish to make it your chief study, you should draw much from photographs of it; and then from the architecture itself, with the same completion of detail and gradation, only keeping the shadows of due paleness,—in photographs they are always about four times as dark as they ought to be,—and treat buildings with as much care and love as artists do their rock foregrounds, drawing all the moss, and weeds, and stains upon them. But if, without caring to understand architecture, you merely want the picturesque character of it, and to be able to sketch it fast, you cannot do better than take Prout for your exclusive master; only do not think that you are copying Prout by drawing straight lines with dots at the end of them. Get first his *Rhine*,[2] and draw the subjects that have most hills, and least architecture

* The order in which I place these masters does not in the least imply superiority or inferiority. I wrote their names down as they occurred to me; putting Rossetti's last because what I had to say of him was connected with other subjects; and one or another will appear to you great, or be found by you useful, according to the kind of subjects you are studying.

[1] [For a summary of Ruskin's references to Prout, see Introduction to the volume containing *Notes on Prout and Hunt* (Vol. XIV. pp. xxxiv.–xxxv.]

[2] [This was the first series of Prout's foreign drawings. It consisted of twenty-four (increased in a later edition to thirty) lithographs, published in oblong quarto in 1824 by Ackermann, with the title *Illustrations of the Rhine drawn from Nature and on Stone by S. Prout*. For the *Sketches in Flanders and Germany* (about 1833), see Vol. I. p. xxix.; Vol. III. p. 217; Vol. XIV. p. 433; and for the *Sketches in France, Switzerland, and Italy* (about 1839), Vol. III. p. 217 *n*. The full title of the other work referred to in the text is *Prout's Microcosm: The Artistic Sketch-book of Groups and Figures, Shipping and other Picturesque Objects. By Samuel Prout, F.S.A.* It contains twenty-four lithographs, and was published in 1841 (large quarto).]

in them, with chalk on smooth paper, till you can lay on his broad flat tints, and get his gradations of light, which are very wonderful; then take up the architectural subjects in the *Rhine*, and draw again and again the groups of figures, etc., in his *Microcosm*, and *Lessons on Light and Shadow*. After that, proceed to copy the grand subjects in the *Sketches in Flanders and Germany*; or in *Switzerland and Italy*, if you cannot get the Flanders; but the Switzerland is very far inferior. Then work from Nature, not trying to Proutise Nature, by breaking smooth buildings into rough ones, but only drawing *what you see*, with Prout's simple method and firm lines. Don't copy his coloured works. They are good, but not at all equal to his chalk and pencil drawings; and you will become a mere imitator, and a very feeble imitator, if you use colour at all in Prout's method. I have not space to explain why this is so, it would take a long piece of reasoning; trust me for the statement.

2. John Lewis.

His sketches in ¦Spain, lithographed by himself, are very valuable. Get them, if you can, and also some engravings (about eight or ten, I think, altogether) of wild beasts, executed by his own hand a long time ago; they are very precious in every way. The series of the "Alhambra" is rather slight, and few of the subjects are lithographed by himself; still it is well worth having.[1]

But let *no* lithographic work come into the house, if you can help it, nor even look at any, except Prout's, and those sketches of Lewis's.

3. George Cruikshank.

If you ever happen to meet with the two volumes of *Grimm's German Stories*, which were illustrated by him long ago,[2] pounce upon them instantly; the etchings in them are the finest things, next to Rembrandt's, that, as far as I know, have been done since etching was invented. You cannot look at them too much, nor copy them too often.

All his works are very valuable, though disagreeable when they touch on the worst vulgarities of modern life; and often much spoiled by a curiously mistaken type of face, divided so as to give too much to the mouth and eyes and leave too little for forehead, the eyes being set about two thirds up,

[1] [For another reference to Lewis's *Studies of Wild Animals*, see Vol. XII. p. 363. The other publications here referred to are: Lewis's *Sketches and Drawings of the Alhambra, made during a residence in Granada in 1833–1834*, drawn on stone by J. D. Harding . . . and J. F. L.: 1835, fol.; and Lewis's *Sketches of Spain and Spanish Character, made during his tour in that country in 1833–1834*, drawn on stone, from his original sketches, by himself: 1836. For Ruskin's other references to Lewis, see General Index.]

[2] [Published in 1826; for another reference to it, see Vol. V. p. xxiii., and for Cruikshank generally, see also Vol. II. p. xxxiii. and Vol. VI. p. 471. His *Cinderella, Jack and the Beanstalk*, and *Hop o' my Thumb* (for which Ruskin by a slip of the pen wrote "*Tom Thumb*") were published in separate parts of *George Cruikshank's Fairy Library* (about 1854).]

instead of at half the height of the head. But his manner of work is always right; and his tragic power, though rarely developed, and warped by habits of caricature, is, in reality, as great as his grotesque power.

There is no fear of his hurting your taste, as long as your principal work lies among art of so totally different a character as most of that which I have recommended to you; and you may, therefore, get great good by copying almost anything of his that may come in your way; except only his illustrations, lately published, to *Cinderella*, and *Jack and the Bean-stalk*, and *Hop o' my Thumb*, which are much over-laboured, and confused in line. You should get them, but do not copy them.

4. ALFRED RETHEL.[1]

I only know two publications by him; one, the "Dance of Death," with text by Reinick, published in Leipsic, but to be had now of any London bookseller for the sum, I believe, of eighteen pence, and containing six plates full of instructive character; the other, of two plates only, "Death the Avenger," and "Death the Friend." These two are far superior to the "Todtentanz," and, if you can get them, will be enough in themselves to show all that Rethel can teach you. If you dislike ghastly subjects, get "Death the Friend" only.

5. BEWICK.

The execution of the plumage in Bewick's birds is the most masterly thing ever yet done in woodcutting; it is worked just as Paul Veronese would have worked in wood, had he taken to it. His vignettes, though too coarse in execution, and vulgar in types of form, to be good copies, show, nevertheless, intellectual power of the highest order; and there are pieces of sentiment in them, either pathetic or satirical,[2] which have never since been equalled in illustrations of this simple kind; the bitter intensity of the feeling being just like that which characterises some of the leading Pre-Raphaelites. Bewick is the Burns of painting.

6. BLAKE.[3]

The *Book of Job*, engraved by himself, is of the highest rank in certain characters of imagination and expression; in the mode of obtaining certain effects of light it will also be a very useful example to you. In expressing conditions of glaring and flickering light, Blake is greater than Rembrandt.

[1] [For a note on Rethel and his drawings for "The Dance of Death," see Vol. XII. p. 489; and for an account of the "two plates," *ibid.*, pp. 507, 508.]

[2] [As, for instance, in the case mentioned in Vol. XIII. p. 435, where, in the note, other references by Ruskin to Bewick are given.]

[3] [For Ruskin's other references to Blake, see Vol. V. p. 138; Vol. VIII. p. 256 *n.*; Vol. XIV. p. 354. *His Illustrations of the Book of Job* were engraved and published by him in 1825; a facsimile edition was published by J. M. Dent in 1902.]

7. RICHTER.

I have already told you what to guard against in looking at his works.[1]
I am a little doubtful whether I have done well in including them in this
catalogue at all; but the imaginations in them are so lovely and numberless,
that I must risk, for their sake, the chance of hurting you a little in judgment
of style. If you want to make presents of story-books to children, his are
the best you can now get; but his most beautiful work, as far as I know, is
his series of Illustrations to the Lord's Prayer.[2]

8. ROSSETTI.

An edition of Tennyson, lately published, contains woodcuts from drawings
by Rossetti and other chief Pre-Raphaelite masters.[3] They are terribly spoiled
in the cutting, and generally the best part, the expression of feature, *entirely*
lost;[*] still they are full of instruction, and cannot be studied too closely.
But observe, respecting these woodcuts, that if you have been in the habit
of looking at much spurious work, in which sentiment, action, and style are
borrowed or artificial, you will assuredly be offended at first by all genuine
work, which is intense in feeling. Genuine art, which is merely art, such
as Veronese's or Titian's, may not offend you, though the chances are that
you will not care about it; but genuine works of feeling, such as *Maud*
or *Aurora Leigh* in poetry,[4] or the grand Pre-Raphaelite designs in paint-
ing, are sure to offend you: and if you cease to work hard, and persist in
looking at vicious and false art, they will continue to offend you. It will

[*] This is especially the case in the St. Cecily, Rossetti's first illustration to the
Palace of Art, which would have been the best in the book had it been well
engraved. The whole work should be taken up again, and done by line engraving,
perfectly; and wholly from Pre-Raphaelite designs, with which no other modern
work can bear the least comparison.

[1] [See above, p. 204. Adrian Ludwig Richter, painter and engraver (1803–1884),
for many years Professor at the Dresden Academy. His illustrations to the Lord's
Prayer were published in 1856 ("*Vater Unser*" in *Bildern von Ludwig Richter. In
Holzschnitt ausgeführt von August Gaber: Dresden*), and in the same year, with English
Text ("*The Lord's Prayer, with Illustrations by Ludwig Richter. Engraved on wood by
A. Gaber, Dresden: Published by Gaber and Richter*"). Story-books illustrated by him
are very numerous; for a complete bibliography see *Adrian Ludwig Richter: Maler
und Radirer* (a Catalogue of his works by Johann Friedrich Hoff, Dresden: 1877).]

[2] [Ed. 1 reads: ". . . this catalogue at all; but the fancies in them are so pretty
and numberless . . ."; and omits, at the end of the paragraph, the words "but his
most beautiful work . . . Lord's Prayer."]

[3] [This was an edition of the *Poems* (the 1842 volume) with illustrations by
Thomas Creswick, John Everett Millais, William Holman Hunt, William Mulready,
John Callcott, Horsley, Dante Gabriel Rossetti, Clarkson Stanfield, and Daniel Maclise,
published by Moxon in 1857. It was reprinted by Messrs. Macmillan in 1893, and
by Freemantle & Co. in 1901 (with an introduction by Holman Hunt). The volume
is the subject of a monograph by G. S. Layard, entitled *Tennyson and his Pre-Raphaelite
Illustrators*: 1894.]

[4] [For Ruskin's appreciation of *Maud*, see Vol. V. p. 219 *n*. *Aurora Leigh* had
just been published (1856) when this book appeared.]

be well, therefore, to have one type of entirely false art, in order to know what to guard against. Flaxman's outlines to Dante [1] contain, I think, examples of almost every kind of falsehood and feebleness which it is possible for a trained artist, not base in thought, to commit or admit, both in design and execution. Base or degraded choice of subject, such as you will constantly find in Teniers and others of the Dutch painters, I need not, I hope, warn you against; you will simply turn away from it in disgust; while mere bad or feeble drawing, which makes mistakes in every direction at once, cannot teach you the particular sort of educated fallacy in question. But, in these designs of Flaxman's, you have gentlemanly feeling, and fair knowledge of anatomy, and firm setting down of lines, all applied, in the foolishest and worst possible way; you cannot have a more finished example of learned error, amiable want of meaning, and bad drawing with a steady hand.* Retzsch's [2] outlines have more real material in them than Flaxman's, occasionally showing true fancy and power; in artistic principle they are nearly as bad, and in taste, worse. All outlines from statuary, as given in works on classical art, will be very hurtful to you if you in the least like them; and *nearly* all finished line engravings. Some particular prints I could name which possess instructive qualities, but it would take too long to distinguish them, and the best way is to avoid line engravings of figures altogether.†

* The praise I have given incidentally to Flaxman's sculpture in the *Seven Lamps*, and elsewhere,[3] refers wholly to his studies from Nature, and simple groups in marble, which were always good and interesting. Still, I have overrated him, even in this respect; and it is generally to be remembered that, in speaking of artists whose works I cannot be supposed to have specially studied, the errors I fall into will always be on the side of praise. For, of course, praise is most likely to be given when the thing praised is above one's knowledge; and, therefore, as our knowledge increases, such things may be found less praiseworthy than we thought. But blame can only be justly given when the thing blamed is below one's level of sight; and, practically, I never do blame anything until I have got well past it, and am certain that there is demonstrable falsehood in it. I believe, therefore, all my blame to be wholly trustworthy,[4] having never yet had occasion to repent of one depreciatory word that I have ever written, while I have often found that, with respect to things I had not time to study closely, I was led too far by sudden admiration, helped, perhaps, by peculiar associations, or other deceptive accidents; and this the more, because I never care to check an expression of delight, thinking the chances are, that, even if mistaken, it will do more good than harm; but I weigh every word of blame with scrupulous caution. I have sometimes erased a strong passage of blame from second editions of my books;[5] but this was only when I found it offended the reader without convincing him, never because I repented of it myself.

† Large line engravings, I mean, in which the lines, as such, are conspicuous. Small vignettes in line are often beautiful in figures no less than landscape; as, for instance, those from Stothard's drawings in Rogers's *Italy*;[6] and, therefore, I have just recommended the vignettes to Tennyson to be done by line engraving.

[1] [See the examples given in Vol. VI. pp. 371–373.]
[2] [For the works of Retzsch, see Vol. IV. pp. 259, 371, and Vol. XIII. p. 275.]
[3] [Vol. VIII. p. 44; and *Stones of Venice*, vol. i. (Vol. IX. p. 289 n.).]
[4] [Compare *The Two Paths*, Appendix i. (Vol. XVI.), and a passage in a letter on George Eliot given in a later volume: "I have always praised the living, and judged —the dead."]
[5] [See, for instance, Vol. III. pp. 529, 619.]
[6] [For other references to Stothard, see Vol. IV. p. 194 n.]

XV.

If you happen to be a rich person, possessing quantities of them, and if you are fond of the large finished prints from Raphael, Correggio, etc., it is wholly impossible that you can make any progress in knowledge of real art till you have sold them all,—or burnt them, which would be a greater benefit to the world. I hope that, some day, true and noble engravings will be made from the few pictures of the great schools, which the restorations undertaken by the modern managers of foreign galleries may leave us; but the existing engravings have nothing whatever in common with the good in the works they profess to represent, and, if you like them, you like in the originals of them hardly anything but their errors.

258. Finally, your judgment will be, of course, much affected by your taste in literature. Indeed, I know many persons who have the purest taste in literature, and yet false taste in art, and it is a phenomenon which puzzles me not a little; but I have never known any one with false taste in books, and true taste in pictures. It is also of the greatest importance to you, not only for art's sake, but for all kinds of sake, in these days of book deluge, to keep out of the salt swamps of literature, and live on a little rocky island of your own, with a spring and a lake in it, pure and good. I cannot, of course, suggest the choice of your library to you: every several mind needs different books; but there are some books which we all need, and assuredly, if you read Homer,* Plato, Æschylus, Herodotus, Dante,† Shakspeare, and Spenser, as much as you ought, you will not require wide enlargement of shelves to right and left of them for purposes of perpetual study. Among modern books avoid generally magazine and review literature. Sometimes it may contain a useful abridgment or a wholesome piece of criticism; but the chances are ten to one it will either waste your time or mislead you. If you want to understand any subject whatever, read the best book upon it you can hear of: not a review of the book. If you don't like the first book you try, seek for another; but do not hope ever to understand the subject without pains, by a reviewer's help. Avoid especially that class of literature which has a knowing tone; it is the most poisonous of all. Every good book, or piece of book, is full of admiration and awe; it may contain firm assertion or stern satire, but it never sneers coldly, nor asserts haughtily, and it always leads you to reverence or love something with your whole heart. It is not always easy to distinguish the satire of the venomous race of books from the satire of the noble and pure ones; but in general you may notice that the cold-blooded, Crustacean and Batrachian books will sneer at sentiment; and the warm-blooded, human books, at sin. Then, in general, the more you can

* Chapman's, if not the original.[1]

† Cary's or Cayley's, if not the original. I do not know which are the best translations of Plato.[2] Herodotus and Æschylus can only be read in the original. It may seem strange that I name books like these for "beginners": but all the greatest books contain food for all ages; and an intelligent and rightly bred youth or girl ought to enjoy much, even in Plato, by the time they are fifteen or sixteen.

[1] [For Ruskin's appreciation of Chapman's Homer, see *Proserpina*, ch. v. ("Papaver Rhoeas"), and *Storm-Cloud of the Nineteenth Century*, Lecture ii.]

[2] [This was in 1857, and Jowett's translation of Plato, which Ruskin sometimes used (see *Fors Clavigera*, Letter 37), was not published till 1871. For his own exercises in translating Plato, see Vol. I. p. 494 n.]

restrain your serious reading to reflective or lyric poetry, history, and natural history, avoiding fiction and the drama, the healthier your mind will become. Of modern poetry, keep to Scott, Wordsworth, Keats, Crabbe, Tennyson, the two Brownings, Thomas Hood,[1] Lowell, Longfellow, and Coventry Patmore, whose *Angel in the House* is a most finished piece of writing, and the sweetest analysis we possess of quiet modern domestic feeling; while Mrs. Browning's *Aurora Leigh* is, as far as I know, the greatest poem which the century has produced in any language. Cast Coleridge at once aside, as sickly and useless; and Shelley, as shallow and verbose; Byron, until your taste is fully formed, and you are able to discern the magnificence in him from the wrong.[2] Never read bad or common poetry, nor write any poetry yourself; there is, perhaps, rather too much than too little in the world already.

259. Of reflective prose, read chiefly Bacon, Johnson, and Helps.[3] Carlyle is hardly to be named as a writer for "beginners," because his teaching, though to some of us vitally necessary, may to others be hurtful. If you understand and like him, read him; if he offends you, you are not yet ready for him, and perhaps may never be so; at all events, give him up, as you would sea-bathing if you found it hurt you, till you are stronger. Of fiction, read *Sir Charles Grandison*, Scott's novels, Miss Edgeworth's, and, if you are a young lady, Madame de Genlis', the French Miss Edgeworth;[4] making

[1] ["Thomas Hood" was first inserted here in ed. 3 (1859).]

[2] [In the General Index all Ruskin's references to, or citations from, the poets named above are given. A summary statement is here added. For Scott, Ruskin's admiration never wavered. His early admiration of Wordsworth is sufficiently shown by the numerous quotations in *Modern Painters;* the qualifications which he afterwards made were set out in the papers on *Fiction, Fair and Foul.* In the same papers he emphasised "the magnificence" in Byron, whom, it may be added, Ruskin himself had read from very early years (*Præterita,* i. ch. viii. § 163). Ruskin's admiration of Keats is indicated in many quotations in *Modern Painters,* and very strongly expressed in vol. v. pt. vi. ch. ix. § 9 *n.*; his changing attitude towards Shelley has already been noted (Vol. I. pp. 253–254 *n.*) For other references to Crabbe, see Vol. VI. p. 71, Vol. X. p. 231; to Tennyson, see (among many other passages) *Two Paths,* Appendix i.; to Mrs. Browning, *Stones of Venice,* vol. i. (Vol. IX. p. 228 *n.*); to Robert Browning, Vol. VI. p. 449; to Thomas Hood, Vol. VI. p. 471 *n.* To Lowell, Ruskin refers as his "dear friend and teacher" in *Modern Painters,* vol. v. pt. ix. ch. xii. § 10 (see also *ibid.,* ch. viii. § 15 *n.*); for his admiration of Longfellow, see *Modern Painters,* vol. iii. (Vol. V. p. 229), vol. iv. (Vol. VI. p. 446), Vol. XII. p. 485. Ruskin's admiration of Coventry Patmore's work is fully shown in his letters to the poet, contained in a later volume of this edition; see also *Sesame and Lilies,* § 65 and *n.* For a discussion of Coleridge, see Vol. IV. pp. 391, 392.]

[3] [Here, again, see the General Index for a list of Ruskin's references to the authors cited. His characterisation of Bacon is given in Vol. VI. p. 439; his debt to Johnson is explained in *Præterita,* i. ch. xii. §§ 251, 252; for the high place assigned to Helps, see Vol. V. p. 334, Vol. XI. p. 153 *n.* Among those to whom Carlyle was "vitally necessary" was Ruskin himself. For his admiration of Richardson, and especially of *Sir Charles Grandison,* see *Præterita,* ii. ch. iv. § 70. The same book contains repeated tributes of admiration to Miss Edgeworth; Ruskin was especially fond of her *Absentee* and *Helen,* which books he would often read aloud to his guests at Brantwood.]

[4] [For Madame de Genlis, see Vol. VI. p. 298. Ruskin was much interested in her books and in her life. In 1781 she had been appointed "gouverneur" in the household of the Duke of Orleans, and in 1793 she took refuge with her pupil,

these, I mean, your constant companions. Of course you must, or will, read other books for amusement once or twice; but you will find that these have an element of perpetuity in them, existing in nothing else of their kind; while their peculiar quietness and repose of manner will also be of the greatest value in teaching you to feel the same characters in art. Read little at a time, trying to feel interest in little things, and reading not so much for the sake of the story as to get acquainted with the pleasant people into whose company these writers bring you. A common book will often give you much amusement, but it is only a noble book which will give you dear friends.[1] Remember, also, that it is of less importance to you in your earlier years, that the books you read should be clever than that they should be right. I do not mean oppressively or repulsively instructive; but that the thoughts they express should be just, and the feelings they excite generous. It is not necessary for you to read the wittiest or the most suggestive books: it is better, in general, to hear what is already known, and may be simply said. Much of the literature of the present day, though good to be read by persons of ripe age, has a tendency to agitate rather than confirm, and leaves its readers too frequently in a helpless or hopeless indignation, the worst possible state into which the mind of youth can be thrown. It may, indeed, become necessary for you, as you advance in life, to set your hand to things that need to be altered in the world, or apply your heart chiefly to what must be pitied in it, or condemned; but, for a young person, the safest temper is one of reverence, and the safest place one of obscurity. Certainly at present, and perhaps through all your life, your teachers are wisest when they make you content in quiet virtue, and that literature and art are best for you which point out, in common life, and in familiar things, the objects for hopeful labour, and for humble love.

Mademoiselle d'Orleans, in Switzerland. At Bremgarten, in 1858, Ruskin came across some memorials of her, as thus described in a letter to his father :
"*30th May, Sunday* [1858].— . . . Here it was that Madame de Genlis lived with her pupil and her daughter in the Convent for two years before their final separation. The landlord of the inn, now deserted or nearly so, is the son of one of their servants, and has still three drawings of flowers which he showed me, signed in their pretty little courtly hands—now almost invisible from the fading of the ink—'Louise Adèle,' 'Stephanie' (Madame de Genlis), and 'Henriette' (Madame de Genlis' daughter). They were beautifully done in a quaint old way, founded on the Dutch flower painting, but precise, complete, and delicate. The Princess's, besides the flowers, had four shells ranged symmetrically underneath, prettily rounded and spotted; Madame de Genlis' was of a white and purple tulip, with guelder roses. They were nearly all equally well done, the two girls seeming to have entirely reached, without trying to improve upon it, the manner of their mother and tutress."]
[1] [Compare *Sesame and Lilies*, § 6, and *Eagle's Nest*, § 206.]

II

THE ELEMENTS OF PERSPECTIVE

(1859)

THE

ELEMENTS OF PERSPECTIVE

ARRANGED FOR THE USE OF SCHOOLS

AND INTENDED TO BE READ IN CONNEXION WITH
THE FIRST THREE BOOKS OF EUCLID

By JOHN RUSKIN, M.A

AUTHOR OF

"MODERN PAINTERS," "SEVEN LAMPS OF ARCHITECTURE,"
"STONES OF VENICE," "LECTURES ON ARCHITECTURE AND PAINTING,"
"ELEMENTS OF DRAWING," ETC.

LONDON:

SMITH, ELDER & CO., 65 CORNHILL

1859.

[*Bibliographical Note.*—Of this book there has only been one English edition, issued in 1859. The title-page was as on the preceding page. Crown 8vo, pp. xiv. + 144. Half-title, pp. i.–ii. ; Preface (here pp. 235, 236), pp. v.–viii. ; Contents (here pp. 237–239), pp. ix.–xii. ;' Fly-title, "The Elements," pp. xiii.–xiv. ; Introduction, pp. 1–17 ; Text, pp. 18–94; Fly-title to Appendix, pp. 95–96 ; Text of Appendix, pp. 97–144. Imprint (on the reverse of the half-title and at the foot of the last page)—"London : Printed by Spottiswoode and Co., New Street Square." A Catalogue of 24 numbered pages, of works published by Smith, Elder & Co., is inserted at the end (pp. 7, 8 being occupied by Ruskin's Works). Issued in green cloth on November 17, 1859 ; price 3s. 6d. Lettered across the back : "The | Elements | of | Perspective | Ruskin." The earlier copies have also at the foot "London | Smith, Elder and Co." ; copies, cased at a later date, omit these words.

An unauthorised *American Edition* was issued in various forms.

Reviewed in the *Leader*, December 3, 1859 ; the *Daily News*, January 6, 1860 ; *Athenæum*, January 14, 1860 ; the *Guardian*, January 25 ; the *Builder*, January 28, 1860 ; the *Morning Herald*, May 28, 1860.

Variæ Lectiones.—In this edition several differences in the text are introduced, for the most part in accordance with the author's intended revision (see above, p. xxvi.). These differences are :—

Introduction. Heading to Fig. 1 : in ed. 1 "station-line" and "station-point" were transposed.

Page 245, lines 1–15 (of this edition) : see p. 245 n.

Page 246, line 8, the word "theoretically" is here inserted ; lines 20–28, ed. 1 reads "generally" before "advisable," "about" for "at least," and "more rather than less" for "somewhat more." It does not italicise the words "all the dimensions . . likewise," and reads "and for this reason" for "for this following reason."

Page 248, lines 23–28 (after Fig. 3), ed. 1 reads "many" before "perspective problems," and "the single oblique measurement E T" for "the oblique measurement E T with that of the angle S T S'" (?).

Page 249, line 17, ed. 1 does not italicise "if."

Problem I., Fig. 4 (p. 251), ed. 1 gave the lower P as "P" instead of "P'."

Problem II., Corollary I. (p. 255, author's note), ed. 1 misprinted "B T."

Corollary III. (p. 257, author's note), ed. 1 omits the words "prolonged" and "agitated."

Problem III., Corollary III., line 4 (p. 261), ed. 1 misprinted "R" for "R'."

Problem V., Corollary I. (p. 266, line 3), ed. 1 misprinted "c M'" for "c' M."

Problem IX., Fig. 24 (p. 274), ed. 1 wrongly put "*b*" instead of "*h*" at the head of the figure ; and in line 9, transposed "*b g*" and "*c f.*" The footnote to this problem is added from Ruskin's revise. Corollary, line 2, ed. 1 misprinted "*a e f c* and *a e g b*" for "A E F C and A E G B."

Problem X., note (p. 276), ed. 1 reads "p. 106" (a wrong reference corrected by Ruskin to "108," *i.e.*, p. 314 in this edition).

Problem XI., Fig. 29 (p. 279), ed. 1 placed the letter "*f*" where "*e*" is now, and gave no letter at the point where "*f*" is now.

Corollary, page 280, line 18, ed. 1 transposed "*x*" and "P" and "*y*" and "O."

Problem XII., page 282, line 7, ed. 1 omits "in both directions," and in Fig. 32 omits the letter "R." In the Corollary, line 1, ed. 1 misprints "R" for "R'."

Problem XIV., Fig. 38 (p. 288), ed. 1 misprinted the letter "*b*" for "h ;" and in the note *, ed. 1 transposed "*e c.*"

Problem XV., page 291, line 6, ed. 1 misprinted "Problem I.," and in the next line, "A C" for "*a c.*"

Problem XVI., page 293, lines 21, 22, ed. 1 transposed "Y C ; " in the note the page reference was added by Ruskin in revision, and similarly in line 29 of the text of the problem.

Problem XVII., page 295, line 4, the reference to Problem IV. was added by Ruskin in revision ; and in the note the page reference was corrected from "138" to "140" (p. 329 in this edition) ; page 296, line 5, ed. 1 reads "E" for "F."

Problem XX. (p. 300), the note was added by Ruskin on revision. In Fig. 50 the letter "B" was not apparent in ed. 1.

Appendix I. Problem I., Fig. 51 (p. 309), in ed. 1 the letter "A" was at the bottom instead of at the top. In Fig. 52 (p. 310), the letter "Q" was omitted, and "I" printed for "D." On page 311, fifth line from bottom, ed. 1 read "*c* D" for "C D," and in the last line did not give the page reference.

Problem IX., Fig. 55 (p. 314), ed. 1 omits the letter "*h.*"

Problem X., line 6, ed. 1 reads "H'" for "H" ; on page 317, line 9, reads "D V" for "G V" ; and at the end omits the page reference.

In Fig. 65 ed. 1 omits the letters "A" and "E," and on page 320, line 5, reads "then" for "these." In Fig. 68 it omits the letter "D," and in Fig. 70 the letter "E" ; in the fourth line from the end of Problem XV. ed. 1 omits the words "as seen below the eye."

In Fig. 72 there was a mistake in the diagram ; instead of the straight line Y to V, there was a dotted line part of the way. This error Ruskin appears to have noted as the book was passing through the press, for he added a footnote in ed. 1, thus : "The diagram is inaccurately cut. Y V should be a right line."

Appendix II. Page 328, under "III." ed. 1 reads "Problem XV." for "Problem XVI." In line 4, below Fig. 76, ed. 1 reads "T P V" for "T V P." In line 3, below Fig. 78, ed. 1 reads "given in page 32" ; the reference should have been "pages 33 and 137" (in this edition pp. 261, 328). In Fig. 80, ed. 1 gave the letter "Q" at the top, instead of "Q'" ; and in line 22 of page 331, read "Q' P'" for "Q' P."]

PREFACE

For some time back I have felt the want, among Students
of Drawing, of a written code of accurate Perspective Law;
the modes of construction in common use being various,
and, for some problems, insufficient. It would have been
desirable to draw up such a code in popular language, so
as to do away with the most repulsive difficulties of the
subject; but finding this popularization would be impossible,
without elaborate figures and long explanations, such as I
had no leisure to prepare, I have arranged the necessary
rules in a short mathematical form, which any schoolboy
may read through in a few days,[1] after he has mastered
the first three and the sixth books of Euclid.

Some awkward compromises have been admitted between
the first-attempted popular explanation, and the severer
arrangement, involving irregular lettering and redundant
phraseology; but I cannot for the present do more, and
leave the book therefore to its trial, hoping that, if it be
found by masters of schools to answer its purpose, I may
hereafter bring it into better form.*

* Some irregularities of arrangement have been admitted merely for the
sake of convenient reference; the eighth problem, for instance, ought to have
been given as a case of the seventh, but is separately enunciated on account of
its importance.

Several constructions, which ought to have been given as problems, are on
the contrary given as corollaries, in order to keep the more directly connected
problems in closer sequence; thus the construction of rectangles and polygons
in vertical planes would appear by the Table of Contents to have been omitted,
being given in the corollary to Problem IX.

[1] [Compare *Stones of Venice*, vol. iii. (Vol. XI. p. 71).]

An account of practical methods, sufficient for general purposes of sketching, might indeed have been set down in much less space; but if the student reads the following pages carefully, he will not only find himself able, on occasion, to solve perspective problems of a complexity greater than the ordinary rules will reach, but obtain a clue to many important laws of pictorial effect, no less than of outline. The subject thus examined becomes, at least to my mind, very curious and interesting; but, for students who are unable or unwilling to take it up in this abstract form, I believe good help will be soon furnished, in a series of illustrations of practical perspective now in preparation by Mr. Le Vengeur. I have not seen this essay in an advanced state, but the illustrations shown to me were very clear and good; and as the author has devoted much thought to their arrangement, I hope that his work will be precisely what is wanted by the general learner.[1]

Students wishing to pursue the subject into its more extended branches will find, I believe, Cloquet's treatise the best hitherto published.*

 * *Nouveau Traité Élémentaire de Perspective.* Bachelier, 1823.[2]

 [1] [Ruskin on his side sent the proof-sheets of his book to Mr. Le Vengeur, and in writing to his father (from Winnington, November 1, 1859) says :—

"Mr. Le Vengeur on seeing my book thinks he must remodel his own and make it simpler, and I mean to give him the best advice I can, so as to make it a quite popular and serviceable book, founded on my principles; the two will then form a really valuable manual."
The editors cannot trace any publication on the subject by the author named.]

 [2] [J. B. Cloquet: 2 vols, 4to, an atlas of eighty-four plates, with text.]

CONTENTS

CONTENTS

INTRODUCTION

WHEN you begin to read this book, sit down very near the window, and shut the window. I hope the view out of it is pretty; but, whatever the view may be, we shall find enough in it for an illustration of the first principles of perspective (or, literally, of "looking through").

Every pane of your window may be considered, if you choose, as a glass picture; and what you see through it, as painted on its surface.

And if, holding your head still, you extend your hand to the glass, you may, with a brush full of any thick colour, trace, roughly, the lines of the landscape on the glass.

But, to do this, you must hold your head very still. Not only you must not move it sideways, nor up and down, but it must not even move backwards or forwards; for, if you move your head forwards, you will see *more* of the landscape through the pane; and, if you move it backwards, you will see *less*: or considering the pane of glass as a picture, when you hold your head near it, the objects are painted small, and a great many of them go into a little space; but, when you hold your head some distance back, the objects are painted larger upon the pane, and fewer of them go into the field of it.

But, besides holding your head still, you must, when you try to trace the picture on the glass, shut one of your eyes. If you do not, the point of the brush appears double; and, on farther experiment, you will observe that each of your eyes sees the object in a different place on the glass, so that the tracing which is true to the sight of the right eye is a couple of inches (or more, according to

your distance from the pane), to the left of that which is true to the sight of the left.

Thus, it is only possible to draw what you see through the window rightly on the surface of the glass, by fixing one eye at a given point, and neither moving it to the right nor left nor up nor down, nor backwards nor forwards. Every picture drawn in true perspective may be considered as an upright piece of glass,* on which the objects seen through it have been thus drawn. Perspective can, therefore, only be quite right, by being calculated for one fixed position of the eye of the observer; nor will it ever appear *deceptively* right unless seen precisely from the point it is calculated for. Custom, however, enables us to feel the rightness of the work on using both our eyes, and to be satisfied with it, even when we stand at some distance from the point it is designed for.

Supposing that, instead of a window, an unbroken plate of crystal extended itself to the right and left of you, and high in front, and that you had a brush as long as you wanted (a mile long, suppose), and could paint with such a brush, then the clouds high up, nearly over your head, and the landscape far away to the right and left, might be traced, and painted, on this enormous crystal field.† But if the field were so vast (suppose a mile high and a mile wide), certainly, after the picture was done, you would not stand as near to it, to see it, as you are now sitting near to your window. In order to trace the upper clouds through your great glass, you would have had to stretch your neck quite back, and nobody likes to bend their neck back to see the top of a picture. So you would walk a long way back to see the great picture—a quarter of a mile, perhaps,—and then all the perspective would be wrong,

* If the glass were not upright, but sloping, the objects might still be drawn through it, but their perspective would then be different. Perspective, as commonly taught, is always calculated for a vertical plane of picture.

† Supposing it to have no thickness; otherwise the images would be distorted by refraction.

and would look quite distorted, and you would discover that you ought to have painted it from the greater distance, if you meant to look at it from that distance. Thus, the distance at which you intend the observer to stand from a picture, and for which you calculate the perspective, ought to regulate to a certain degree the size of the picture. If you place the point of observation near the canvass, you should not make the picture very large: *vice versâ*, if you place the point of observation far from the canvass, you should not make it very small; the fixing, therefore, of this point of observation determines, as a matter of convenience, within certain limits, the size of your picture. But it does not determine this size by any perspective law; and it is a mistake made by many writers on perspective, to connect some of their rules definitely with the size of the picture. For, suppose that you had what you now see through your window painted actually upon its surface, it would be quite optional to cut out any piece you chose, with the piece of the landscape that was painted on it. You might have only half a pane, with a single tree; or a whole pane, with two trees and a cottage; or two panes, with the whole farmyard and pond; or four panes, with farmyard, pond, and foreground. And any of these pieces, if the landscape upon them were, as a scene, pleasantly composed, would be agreeable pictures, though of quite different sizes; and yet they would be all calculated for the same distance of observation.

In the following treatise, therefore, I keep the size of the picture entirely undetermined. I consider the field of canvass as wholly unlimited, and on that condition determine the perspective laws. After we know how to apply those laws without limitation, we shall see what limitations of the size of the picture their results may render advisable.

But although the size of the *picture* is thus independent of the observer's distance, the size of the *object represented* in the picture is not. On the contrary, that size is fixed by absolute mathematical law; that is to say, supposing you

have to draw a tower a hundred feet high, and a quarter of a mile distant from you, the height which you ought to give that tower on your paper depends, with mathematical precision, on the distance at which you intend your paper to be placed. So, also, do all the rules for drawing the form of the tower, whatever it may be.

Hence, the first thing to be done in beginning a drawing is to fix, at your choice, this distance of observation, or the distance at which you mean to stand from your paper. After that is determined, all is determined, except only the ultimate size of your picture, which you may make greater, or less, not by altering the size of the things represented, but by *taking in more, or fewer* of them. So, then, before proceeding to apply any practical perspective rule, we must always have our distance of observation marked, and the most convenient way of marking it is the following.

PLACING OF THE SIGHT-POINT, SIGHT-LINE, STATION-LINE, AND STATION-POINT

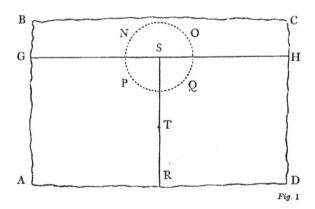

Fig. 1

I. THE SIGHT-POINT.—Let A B C D, Fig. 1, be your sheet of paper, the larger the better, though perhaps we may cut out of it at last only a small piece for our picture, such as the dotted circle N O P Q. This circle is not

intended to limit either the size or shape of our picture: you may ultimately have it round or oval, horizontal or upright, small or large, as you choose. I only dot the line to give you an idea of whereabouts you will probably like to have it; and, as the operations of perspective are more conveniently performed upon paper underneath the picture than above it, I put this conjectural circle at the top of the paper, about the middle of it, leaving plenty of paper on both sides and at the bottom. Now, as an observer generally stands near the middle of a picture to look at it, we had better at first, and for simplicity's sake, fix the point of observation opposite the middle of our conjectural picture. So take the point s, the centre of the circle N O P Q;—or, which will be simpler for you in your own work, take[1] the point s at random near the top of your paper, and strike the circle N O P Q round it, any size you like. Then the point S is to represent the point *opposite* which you wish the observer of your picture to place his 'eye, in looking at it. Call this point the "Sight-Point."

II. THE SIGHT-LINE.—Through the Sight-point, s, draw a horizontal line, G H, right across your paper from side to side, and call this line the "Sight-Line."

This line is of great practical use, representing the level of the eye of the observer all through the picture. You will find hereafter that if there is a horizon to be represented in your picture, as of distant sea or plain, this line defines it.

III. THE STATION-LINE.—From s let fall a perpendicular line, s R, to the bottom of the paper, and call this line the "Station-Line."

[1] [In his copy for revision, Ruskin struck out the passage "This circle is not intended . . . simpler for you in your own work," and revised the following words, thus:—
 " . . . the dotted circle N O P Q. Take any point s near the top of your paper, and towards the middle of it—laterally, and strike the circle N O P Q round it . . ."]

This represents the line on which the observer stands, at a greater or less distance from the picture; and it ought to be *imagined* as drawn right out from the paper at the point s. Hold your paper upright in front of you, and hold your pencil horizontally, with its point against the point s, as if you wanted to run it through the paper there, and the pencil will represent the direction in which the line s R ought theoretically to be drawn. But as all the measurements which we have to set upon this line, and operations which we have to perform with it, are just the same when it is drawn on the paper itself, below s, as they would be if it were represented by a wire in the position of the levelled pencil, and as they are much more easily performed when it is drawn on the paper, it is always in practice so drawn.

IV. THE STATION-POINT.—On this line, mark the distance s T at your pleasure, for the distance at which you wish your picture to be seen, and call the point T the " Station-Point."

In practice, it is advisable to make the distance s T at least as great as the diameter of your intended picture; and it should, for the most part, be somewhat more; but, as I have just stated, this is quite arbitrary. However, in this figure, as an approximation to a generally advisable distance, I make the distance s T equal to the diameter of the circle N O P Q. Now, having fixed this distance, s T, *all the dimensions of the objects in our picture are fixed likewise*, for this following reason :—

Let the upright line A B, Fig. 2, represent a pane of glass placed where our picture is to be placed; but seen at the side of it, edgeways; let s be the Sight-point; s T the Station-line, which, in this figure, observe, is in its true position, drawn out from the paper, not down upon it; and T the Station-point.

Suppose the Station-line s T to be continued, or in

mathematical language "produced," through s, far beyond
the pane of glass, and let P Q be a tower or other up-
right object situated on or above this line.

Now the *apparent* height of the tower P Q is measured
by the angle T P Q between the rays of light which
come from the top and bottom of it to the eye of the
observer. But the *actual* height of the *image* of the
tower on the pane of glass A B, between us and it, is the
distance P′ Q′, between the points where the rays traverse
the glass.

Evidently, the farther from the point T we place the
glass, making s T longer, the larger will be the image;

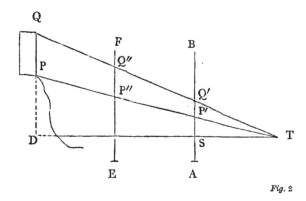

Fig. 2

and the nearer we place it to T, the smaller the image,
and that in a fixed ratio. Let the distance D T be the
direct distance from the Station-point to the foot of the
object. Then, if we place the glass A B at one third of
that whole distance, P′ Q′ will be one third of the real
height of the object; if we place the glass at two thirds
of the distance, as at E F, P″ Q″ (the height of the image
of that point) will be two thirds the height * of the object,
and so on. Therefore the mathematical law is that P′ Q′

* I say "height" instead of "magnitude," for a reason stated in Appendix
309], to which you will soon be referred. Read on here at present.

will be to P Q as S T to D T. I put this ratio clearly by
itself that you may remember it:

$$\text{P}'\ \text{Q}' : \text{P Q} :: \text{S T} : \text{D T}$$

or in words:

P dash Q dash is to P Q as S T to D T

In which formula, recollect that P' Q' is the height of the
appearance of the object on the picture; P Q the height of
the object itself; S the Sight-point; T the Station-point; D
a point at the direct distance of the object; though the
object is seldom placed actually on the line T S produced,
and may be far to the right or left of it, the formula is
still the same.

For let S, Fig. 3, be the Sight-point, and A B the
glass—here seen looking *down* on its *upper edge,* not side-
ways;—then if the tower (repre-
sented now, as on a map, by the dark
square), instead of being at D on the
line S T produced, be at E, to the
right (or left) of the spectator, still
the apparent height of the tower on
A B will be as S' T to E T, which is
the same ratio as that of S T to D T.

Now in perspective problems, the
position of an object is more con-
veniently expressed by the two mea-
surements D T and D E, than by the
oblique measurement E T with that of

Fig. 3

the angle S T S'.

I shall call D T the " direct distance " of the object at
E, and D E its " lateral distance." It is rather a license to
call D T its " direct " distance, for E T is the more direct of
the two; but there is .no other term which would not cause
confusion.

Lastly, in order to complete our knowledge of the
position of an object, the vertical height of some point in

it, above or below the eye, must be given; that is to say,
either D P or D Q in Fig. 2:* this I shall call the "vertical
distance" of the point given. In all perspective problems
these three distances, and the dimensions of the object,
must be stated, otherwise the problem is imperfectly given.
It ought not to be required of us merely to draw *a* room
or *a* church in perspective; but to draw *this* room from
this corner, and *that* church on *that* spot, in perspective.
For want of knowing how to base their drawings on the
measurement and place of the object, I have known
practised students represent a parish church, certainly in
true perspective, but with a nave about two miles and a
half long.

It is true that in drawing landscapes from nature the
sizes and distances of the objects cannot be accurately
known. When, however, we know how to draw them
rightly, *if* their size were given, we have only to *assume
a rational approximation* to their size, and the resulting
drawing will be true enough for all intents and purposes.
It does not in the least matter that we represent a distant
cottage as eighteen feet long when it is in reality only
seventeen; but it matters much that we do not represent
it as eighty feet long, as we easily might if we had not
been accustomed to draw from measurement. Therefore,
in all the following problems the measurement of the
object is given.

The student must observe, however, that in order to
bring the diagrams into convenient compass, the measure-
ments assumed are generally very different from any likely
to occur in practice. Thus, in Fig. 3, the distance D S
would be probably in practice half a mile or a mile, and
the distance T S, from the eye of the observer to the
paper, only two or three feet. The mathematical law is
however precisely the same, whatever the proportions; and

* P and Q being points indicative of the place of the tower's base and top.
In this figure both are above the sight-line; if the tower were below the
spectator both would be below it, and therefore measured below D.

I use such proportions as are best calculated to make the diagram clear.

Now, therefore, the conditions of a perspective problem are the following:

> The Sight-line G H given, Fig. 1 ;
> The Sight-point s given ;
> The Station-point T given ; and
> The three distances of the object,* direct, lateral, and vertical, with its dimensions, given.

The size of the picture, conjecturally limited by the dotted circle, is to be determined afterwards at our pleasure. On these conditions I proceed at once to construction.

* More accurately, "the three distances of any point, either in the object itself, or indicative of its distance."

PROBLEM I

TO FIX THE POSITION OF A GIVEN POINT*

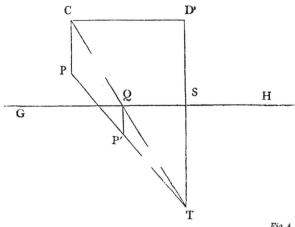

Fig. 4

LET P, Fig. 4, be the given point.

Let its direct distance be D T; its lateral distance to the left, D C; and vertical distance *beneath* the eye of the observer, C P.

(Let G H be the Sight-line, S the Sight-point, and T the Station-point.) †

It is required to fix on the plane of the picture the position of the point P.

Arrange the three distances of the object on your paper, as in Fig. 4.*

Join c t, cutting g h in q.
From q let fall the vertical line q p'.
Join p t, cutting q p in p'
p' is the point required.

If the point p is *above* the eye of the observer instead

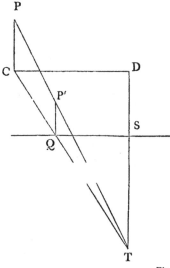

Fig. 5

of below it, c p is to be measured upwards from c, and q p' drawn upwards from q. The construction will be as in Fig. 5.

And if the point p is to the right instead of the left

* In order to be able to do this, you must assume the distances to be small; as in the case of some object on the table: how large distances are to be treated you will see presently; the mathematical principle, being the same for all, is best illustrated first on a small scale. Suppose, for instance, p to be the corner of a book on the table, seven inches below the eye, five inches to the left of it, and a foot and a half in advance of it, and that you mean to hold your finished drawing at six inches from the eye; then t s will be six inches, t d a foot and a half, d c five inches, and c p seven.

of the observer, D C is to be measured to the right instead of the left.

The figures 4 and 5, looked at in a mirror, will show the construction of each, on that supposition.

Now read very carefully the examples and notes to this problem in Appendix I. (page 309). I have put them in the Appendix in order to keep the sequence of following problems more clearly traceable here in the text; but you must read the first Appendix before going on.

PROBLEM II

TO DRAW A RIGHT LINE BETWEEN TWO GIVEN POINTS

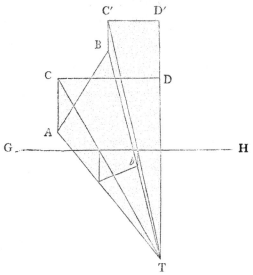

Fig. 6

LET A B, Fig. 6, be the given right line, joining the given points A and B.

Let the direct, lateral, and vertical distances of the point A be T D, D C, and C A.

Let the direct, lateral, and vertical distances of the point B be T D', D C', and C' B.

Then, by Problem I., the position of the point A on the plane of the picture is *a*.

And similarly, the position of the point B on the plane of the picture is *b*.

Join *a b*.

Then *a b* is the line required.

254

COROLLARY I

If the line A B is in a plane parallel to that of the pic-
ture, one end of the line A B must be at the same direct
distance from the eye of the observer as the other.

Therefore, in that case, D T is equal to D′ T.

Then the construction will be as in Fig. 7; and the

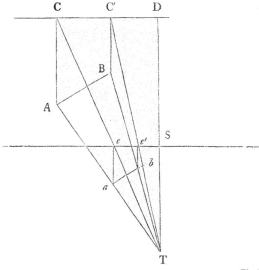

Fig. 7

student will find experimentally that *a b* is now parallel
to A B.*

And that *a b* is to A B as T S is to T D.

Therefore, to draw any line in a plane parallel to that
of the picture, we have only to fix the position of one of
its extremities, *a* or *b*, and then to draw from *a* or *b* a line
parallel to the given line, bearing the proportion to it that
T S bears to T D.

* For by the construction A T : *a* T :: B T : *b* T; and therefore the
two triangles A B T, *a b* T, (having a common angle A T B,) are similar.

COROLLARY II

If the line A B is in a horizontal plane, the vertical distance of one of its extremities must be the same as that of the other.

Therefore, in that case, A c equals B c′ (Fig. 6).

And the construction is as in Fig. 8.

In Fig. 8 produce *a b* to the sight-line, cutting the

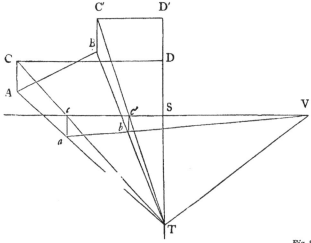

Fig. 8

sight-line in v; the point v, thus determined, is called the VANISHING-POINT of the line A B.

Join T v. Then the student will find experimentally that T v is parallel to A B.*

COROLLARY III

If the line A B produced would pass through some point beneath or above the station-point, C D is to D T as c′ D′ is to D′ T; in which case the point *c* coincides with the point c′, and the line *a b* is vertical.

* The demonstration is in Appendix II. Article I. [p. 327].

Therefore every vertical line in a picture is, or may be, the perspective representation of a horizontal one which, produced, would pass beneath the feet or above the head of the spectator.*

* The prolonged reflection in agitated water of any luminous point or isolated object (such as the sun or moon) is therefore, in perspective, a vertical line; since such reflection, if produced, would pass under the feet of the spectator. Many artists (Claude among the rest) knowing something of optics, but nothing of perspective, have been led occasionally to draw such reflections towards a point at the centre of the base of the picture.[1]

[1] [See further on this practice of Claude's, *Modern Painters*, vol. i. (Vol. III. p. 511).]

PROBLEM III

TO FIND THE VANISHING-POINT OF A GIVEN HORIZONTAL LINE

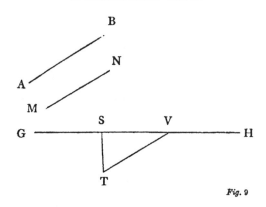

Fig. 9

LET A B, Fig. 9, be the given line.

From T, the station-point, draw T V parallel to A B, cutting the sight-line in V.

V is the Vanishing-point required.*

* The student will observe, in practice, that, his paper lying flat on the table, he has only to draw the line T V on its horizontal surface, parallel to the given horizontal line A B. In theory, the paper should be vertical, but the station-line S T horizontal (see its definition above, page 246); in which case T V, being drawn parallel to A B, will be horizontal also, and still cut the sight-line in V.

The construction will be seen to be founded on the second Corollary of the preceding problem.

It is evident that if any other line, as M N in Fig. 9, parallel to A B, occurs in the picture, the line T V, drawn from T, parallel to M N, to find the vanishing-point of M N, will coincide with the line drawn from T, parallel to A B, to find the vanishing-point of A B.

Therefore A B and M N will have the same vanishing-point.

Therefore all parallel horizontal lines have the same vanishing-point.

It will be shown hereafter that all parallel *inclined* lines also have

258

COROLLARY I

As, if the point *b* is first found, v may be determined by it, so, if the point v is first found, *b* may be determined by it. For let A B, Fig. 10, be the given line, constructed

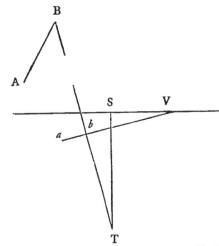

Fig. 10

upon the paper as in Fig. 8; and let it be required to draw the line *a b* without using the point *c'*.

Find the position of the point A in *a*. (Problem I.)

Find the vanishing-point of A B in v. (Problem III.)

Join *a* v.

Join B T, cutting *a* v in *b*.

Then *a b* is the line required.*

the same vanishing-point; the student may here accept the general conclusion—"*All parallel lines have the same vanishing-point.*"

It is also evident that if A B is parallel to the plane of the picture, T v must be drawn parallel to G H, and will therefore never cut G H. The line A B has in that case no vanishing-point: it is to be drawn by the construction given in Fig. 7.

It is also evident that if A B is at right angles with the plane of the picture, T v will coincide with T s, and the vanishing-point of A B will be the sight-point.

* I spare the student the formality of the *reductio ad absurdum*, which would be necessary to prove this.

COROLLARY H

We have hitherto proceeded on the supposition that the given line was small enough, and near enough, to be actually drawn on our paper of its real size; as in the example given in Appendix I. [p. 309]. We may, however, now deduce a construction available under all circumstances, whatever may be the distance and length of the line given.

From Fig. 8 remove, for the sake of clearness, the lines

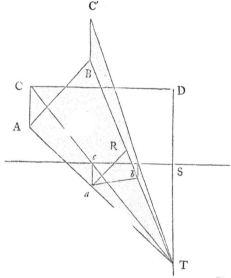

Fig. 11

c' D', b v, and T v; and, taking the figure as here in Fig. 11, draw from a, the line a R parallel to A B, cutting B T in R.

Then a R is to A B as a T is to A T.

— — as c T is to C T.

— — as T S is to T D.

That is to say, a R is the sight-magnitude of A B.*

* For definition of Sight-Magnitude, see Appendix I. [p. 310]. It ought to have been read before the student comes to this problem; but I refer to it in case it has not.

Therefore, when the position of the point A is fixed in
a, as in Fig. 12, and *a* v is drawn to the vanishing-point;
if we draw a line *a* R from *a*, parallel to A B, and make
a R equal to the sight-magnitude of A B, and then join R T,
the line R T will cut *a* v in *b*.

So that, in order to determine the length of *a b*, we
need not draw the long and distant line A B, but only *a* R

Fig. 12

parallel to it, and of its sight-magnitude; which is a great
gain, for the line A B may be two miles long, and the line
a R perhaps only two inches.

COROLLARY III

In Fig. 12, altering its proportions a little for the sake of
clearness, and putting it as here in Fig. 13, draw a hori-
zontal line *a* R′ and make *a* R′ equal to *a* R.

Through the points R′ and *b* draw R′ M, cutting the sight-
line in M. Join T V. Now the reader will find experi-
mentally that v M is equal to v T.*

* The demonstration is in Appendix II. Article II. p. 328.

Hence it follows that, if from the vanishing-point ᐯ we lay off on the sight-line a distance, ᴠ ᴍ, equal to ᴠ ᴛ; then draw through *a* a horizontal line *a* ʀ′, make *a* ʀ′ equal to

Fig. 13

the sight-magnitude of ᴀ ʙ, and join ʀ′ ᴍ; the line ʀ′ ᴍ will cut *a* ᴠ in *b*. And this is in practice generally the most convenient way of obtaining the length of *a b*.

COROLLARY IV

Removing from the preceding figure the unnecessary lines, and retaining only ʀ′ ᴍ and *a* ᴠ, as in Fig. 14, produce

Fig. 14

the line *a* ʀ′ to the other side of *a*, and make *a* x equal to *a* ʀ′.

Join x *b*, and produce x *b* to cut the line of sight in ɴ.

Then as x ʀ' is parallel to M N, and a ʀ' is equal to a x, v N must, by similar triangles, be equal to v M (equal to v T in Fig. 13).

Therefore, on whichever side of v we measure the distance v T, so as to obtain either the point M, or the point N, if we measure the sight-magnitude a ʀ' or a x on the opposite side of the line a v, the line joining ʀ' M or x N will equally cut a v in b.

The points M and N are called the "DIVIDING-POINTS" of the original line A B (Fig. 12), and we resume the results of these corollaries in the following three problems.

PROBLEM IV

TO FIND THE DIVIDING-POINTS OF A GIVEN HORIZONTAL LINE

Fig. 15

LET the horizontal line A B (Fig. 15) be given in position and magnitude It is required to find its dividing-points.

Find the vanishing-point v of the line A B.

With centre v and distance v T, describe circle cutting the sight-line in M and N.

Then M and N are the dividing-points required.

In general, only one dividing-point is needed for use with any vanishing-point, namely, the one nearest s (in this case the point M). But its opposite N, or both, may be needed under certain circumstances.

PROBLEM V

TO DRAW A HORIZONTAL LINE, GIVEN IN POSITION AND MAGNITUDE, BY MEANS OF ITS SIGHT-MAGNITUDE AND DIVIDING-POINTS

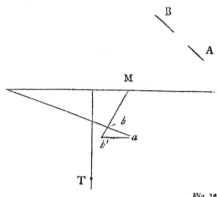

Fig. 16

LET A B (Fig 16) be the given line.

Find the position of the point A in *a*.

Find the vanishing-point v, and most convenient dividing-point M, of the line A B.

Join *a* v.

Through *a* draw a horizontal line *a b'* and make *a b'* equal to the sight-magnitude of A B. Join *b'* M, cutting *a* v in *b*.

Then *a b* is the line required.

COROLLARY I

Supposing it were now required to draw a line A C (Fig. 17) twice as long as A B, it is evident that the sight-magnitude *a c'* must be twice as long as the

sight-magnitude $a\ b'$; we have, therefore, merely to con-
tinue the horizontal line $a\ b'$, make $b'\ c'$ equal to $a\ b'$, join
c' M, cutting a v in c, and $a\ c$ will be the line required.
Similarly, if we have to draw a line A D, three times the
length of A B, $a\ d'$ must be three times the length of $a\ b'$,
and, joining d' M, $a\ d$ will be the line required.

The student will observe that the nearer the portions
cut off, $b\ c$, $c\ d$, &c., approach the point v, the smaller

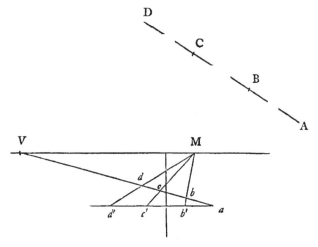

Fig. 17

they become; and, whatever lengths may be added to the
line A D, and successively cut off from a v, the line a v
will never be cut off entirely, but the portions cut off will
become infinitely small, and apparently " vanish " as they
approach the point v : hence this point is called the " vanish-
ing " point.

COROLLARY II

It is evident that if the line A D had been given ori-
ginally, and we had been required to draw it, and divide it
into three equal parts, we should have had only to divide
its sight-magnitude, $a\ d'$, into the three equal parts, $a\ b'$,

b' c', and c' d', and then, drawing to M from b' and c', the line a d would have been divided as required in b and c. And supposing the original line A D be divided *irregularly into any number* of parts, if the line a d' be divided into a similar number in the same proportions (by the construction given in Appendix I.[1]), and, from these points of division, lines are drawn to M, they will divide the line a d in true perspective into a similar number of proportionate parts.

The horizontal line drawn through a, on which the sight-magnitudes are measured, is called the " MEASURING-LINE."

And the line a d, when properly divided in b and c, or any other required points, is said to be divided "IN PERSPECTIVE RATIO" to the divisions of the original line A D.

If the line a v is above the sight-line instead of beneath it, the measuring-line is to be drawn above also: and the lines b' M, c' M, etc., drawn *down* to the dividing-point. Turn Fig. 17 upside down, and it will show the construction.

[1] [See below, Fig. 53, p. 311.]

PROBLEM VI

TO DRAW ANY TRIANGLE, GIVEN IN POSITION AND MAGNITUDE, IN A HORIZONTAL PLANE

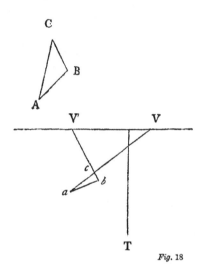

Fig. 18

LET A B C (Fig. 18) be the triangle.

As it is given in position and magnitude, one of its sides, at least, must be given in position and magnitude, and the directions of the two other sides.

Let A B be the side given in position and magnitude.

Then A B is a horizontal line, in a given position, and of a given length.

Draw the line A B. (Problem V.)

Let *a b* be the line so drawn.

Find v and v′, the vanishing-points respectively of the lines A C and B C. (Problem III.)

From a draw a v, and from b, draw b v' cutting each other in c.

Then $a\ b\ c$ is the triangle required.

If A C is the line originally given, $a\ c$ is the line which must be first drawn, and the line v' b must be drawn from v' to c and produced to cut $a\ b$ in b. Similarly, if B C is given, v c must be drawn to c and produced, and $a\ b$ from its vanishing-point to b, and produced to cut $a\ c$ in a

PROBLEM VII

TO DRAW ANY RECTILINEAR QUADRILATERAL FIGURE, GIVEN IN POSITION AND MAGNITUDE, IN A HORIZONTAL PLANE

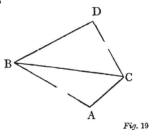

Fig. 19

LET A B C D (Fig 19) be the given figure.

Join any two of its opposite angles by the line B C.

Draw first the triangle A B C. (Problem VI.)

And then, from the base B C, the two lines B D, C D, to their vanishing-points, which will complete the figure. It is unnecessary to give a diagram of the construction, which is merely that of Fig. 18 duplicated; another triangle being drawn on the line A C or B C.

COROLLARY

It is evident that by this application of Problem VI. any given rectilinear figure whatever in a horizontal plane may be drawn, since any such figure may be divided into a number of triangles, and the triangles then drawn in succession.

More convenient methods may, however, be generally found, according to the form of the figure required, by the use of succeeding problems; and for the quadrilateral figure which occurs most frequently in practice, namely, the square, the following construction is more convenient than that used in the present problem.

PROBLEM VIII

TO DRAW A SQUARE, GIVEN IN POSITION AND MAGNITUDE, IN A HORIZONTAL PLANE

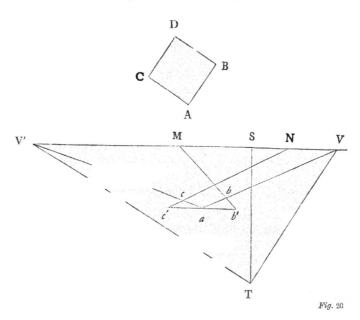

Fig. 20

LET A B C D (Fig. 20) be the square.

As it is given in position and magnitude, the position and magnitude of all its sides are given.

Fix the position of the point A in *a*.

Find v, the vanishing-point of A B; and M, the dividing-point of A B, nearest s.

Find v′, the vanishing-point of A C; and N, the dividing-point of A C, nearest s.

Draw the measuring-line through *a*, and make *a b′*, *a c′*, each equal to the sight-magnitude of A B.

271

(For since A B C D is a square, A C is equal to A B.)

Draw *a* v′ and *c′* N, cutting each other in *c*.

Draw *a* v, and *b′* M, cutting each other in *b*.

Then *a c*, *a b*, are the two nearest sides of the square.

Now, clearing the figure of superfluous lines, we have *a b*, *a c*, drawn in position, as in Fig. 21.

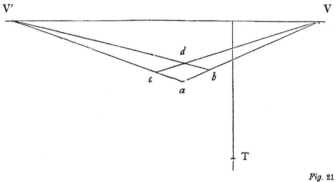

Fig. 21

And because A B C D is a square, C D (Fig. 20) is parallel to A B.

And all parallel lines have the same vanishing-point. (Note to Problem III.)

Therefore, v is the vanishing-point of C D.

Similarly, v′ is the vanishing-point of B D.

Therefore, from *b* and *c* (Fig. 22) draw *b* v′, *c* v, cutting each other in *d*.

Then *a b c d* is the square required.

COROLLARY I

It is obvious that any rectangle in a horizontal plane may be drawn by this problem, merely making *a b′*, on the measuring-line, Fig. 20, equal to the sight-magnitude of one of its sides, and *a c′* the sight-magnitude of the other.

COROLLARY H

Let *a b c d*, Fig. 22, be any square drawn in perspective. Draw the diagonals *a d* and *b c*, cutting each other in c. Then c is the centre of the square. Through c, draw *e f* to

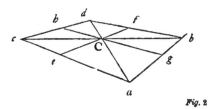

Fig. 2

the vanishing-point of *a b*, and *g h* to the vanishing-point of *a c*, and these lines will bisect the sides of the square, so that *a g* is the perspective representation of half the side *a b; a e* is half *a c; c h* is half *c d;* and *b f* is half *b d.*

COROLLARY III

Since A B C D, Fig. 20, is a square, B A C is a right angle; and as T V is parallel to A B, and T v' to A C, v' T V must be a right angle also.

As the ground plan of most buildings is rectangular, it constantly happens in practice that their angles (as the corners of ordinary houses) throw the lines to the vanishing-points thus at right angles; and so that this law is observed, and V T v' is kept a right angle, it does not matter in general practice whether the vanishing-points are thrown a little more or a little less to the right or left of s; but it matters much that the relation of the vanishing-points should be accurate. Their position with respect to s merely causes the spectator to see a little more or less on one side or other of the house, which may be a matter of chance or choice; but their rectangular relation determines the rectangular shape of the building, which is an essential point.

xv.

PROBLEM IX

TO DRAW A SQUARE PILLAR, GIVEN IN POSITION AND
MAGNITUDE, ITS BASE AND TOP BEING IN HORI-
ZONTAL PLANES

LET A H, Fig. 23, be the square pillar.

Then, as it is given in position and magnitude, the posi-
tion and magnitude of the square it stands upon must be

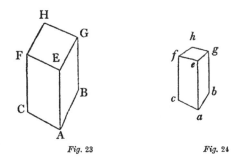

Fig. 23 Fig. 24

given (that is, the line A B or A C in position), and the height
of its side A E.

Find the sight-magnitudes of A B and A E. Draw the
two sides a b, a c, of the square of the base, by Problem
VIII., as in Fig. 24. From the points a, b, and c, raise
vertical lines a e, b g, c f.

Make a e equal to the sight-magnitude of A E.

Now because the top and base of the pillar are in hori-
zontal planes, the square of its top, F G, is parallel to the
square of its base, B C.

Therefore the line E F is parallel to A C, and E G to A B.

Therefore E F has the same vanishing-point as A C, and
E G the same vanishing-point as A B.

274

From *e* draw *e f* to the vanishing-point of *a c*, cutting *c f* in *f*.

Similarly draw *e g* to the vanishing-point of *a b*, cutting *b g* in *g*.

Complete the square *g f* in *h*, drawing *g h* to the vanishing-point of *e f*, and *f h* to the vanishing-point of *e g*, cutting each other in *h*. Then *a g h f* is the square pillar required.*

COROLLARY

It is obvious that if A E is equal to A C, the whole figure will be a cube, and each side, A E F C and A E G B, will be a square in a given vertical plane. And by making A B or A C longer or shorter in any given proportion, any form of rectangle may be given to either of the sides of the pillar. No other rule is therefore needed for drawing squares or rectangles in vertical planes.

Also any triangle may be thus drawn in a vertical plane, by enclosing it in a rectangle and determining, in perspective ratio, on the sides of the rectangle, the points of their contact with the angles of the triangle.

And if any triangle, then any polygon.

A less complicated construction will, however, be given hereafter.†

* See application of this problem in Appendix, p. 312 (App. i. Prob. ix.).
† See p. 325 (note), after you have read Problem XVI.

PROBLEM X

TO DRAW A PYRAMID, GIVEN IN POSITION AND MAG-
NITUDE, ON A SQUARE BASE IN A HORIZONTAL
PLANE

Fig. 25

LET A B, Fig. 25 be the four-sided pyramid. As it is given in position and magnitude, the square base on which it stands must be given in position and magnitude, and its vertical height, C D.*

Draw a square pillar, A B G E, Fig. 26, on the square

Fig. 26 *Fig.* 27

base of the pyramid, and make the height of the pillar A F equal to the vertical height of the pyramid C D (Problem

* If, instead of the vertical height, the length of A D is given, the vertical must be deduced from it. See the Exercises on this Problem in the Appendix, pp. 314–318.

IX.). Draw the diagonals G F, H I, on the top of the square pillar, cutting each other in C. Therefore C is the centre of the square F G H I. (Prob. VIII. Cor. II.)

Join C E, C A, C B.

Then A B C E is the pyramid required. If the base of the pyramid is above the eye, as when a square spire is seen on the top of a church-tower, the construction will be as in Fig. 27.

PROBLEM XI

TO DRAW ANY CURVE IN A HORIZONTAL OR VERTICAL PLANE

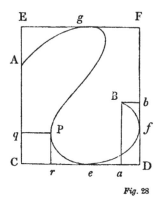

Fig. 28

LET A B, Fig. 28, be the curve.

Enclose it in a rectangle, C D E F.

Fix the position of the point C or D, and draw the rectangle. (Problem VIII. Coroll. I.)*

Let C D E F, Fig. 29, be the rectangle so drawn.

If an extremity of the curve, as A, is in a side of the rectangle, divide the side C E, Fig. 29, so that A C shall be (in perspective ratio) to A E as A C is to A E in Fig. 28. (Prob. V. Cor. II.)

Similarly determine the points of contact of the curve and rectangle, *e, f, g.*

If an extremity of the curve, as B, is not in a side of the rectangle, let fall the perpendiculars B *a,* B *b* on the

* Or if the curve is in a vertical plane, Coroll. to Problem IX. As a rectangle may be drawn in any position round any given curve, its position with respect to the curve will in either case be regulated by convenience. See the Exercises on this Problem in the Appendix, p. 318.

rectangle sides. Determine the correspondent points *a* and *b* in Fig. 29, as you have already determined A, B, *e*, and *f.*

From *b*, Fig. 29, draw *b* B parallel to C D,* and from *a* draw A B to the vanishing-point of D F, cutting each other in B. Then B is the extremity of the curve.

Fig. 29

Determine any other important point in the curve, as P, in the same way, by letting fall P *q* and P *r* on the rect-angle's sides.

Any number of points in the curve may be thus determined, and the curve drawn through the series; in most cases, three or four will be enough. Practically, complicated curves may be better drawn in perspective by an experienced eye than by rule, as the fixing of the various points in haste involves too many chances of error; but it is well to draw a good many by rule first, in order to give the eye its experience.†

<p align="center">COROLLARY</p>

If the curve required be a circle, Fig. 30, the rectangle which encloses it will become a square, and the curve will have four points of contact, A B C D, in the middle of the sides of the square.

Draw the square, and as a square may be drawn about a circle in any position, draw it with its nearest side, E G, parallel to the sight-line.

Let E F, Fig. 31, be the square so drawn.

Draw its diagonals E F, G H; and through the centre of the square (determined by their intersection) draw A B to the vanishing-point of G F, and C D parallel to E G. Then

* Or to its vanishing-point, if C D has one.

† Of course, by dividing the original rectangle into any number of equal rectangles, and dividing the perspective rectangle similarly, the curve may be approximately drawn without any trouble; but, when accuracy is required, the points should be fixed, as in the problem.

the points A B C D are the four points of the circle's contact.

On E G describe a half square, E L; draw the semicircle K A L; and from its centre, R, the diagonals R E, R G, cutting the circle in x, y.

From the points x y, where the circle cuts the diagonals, raise perpendiculars, x P, y Q, to E G.

From P and Q draw P P′, Q Q′, to the vanishing-point of G F, cutting the diagonals in m, n, and o, p.

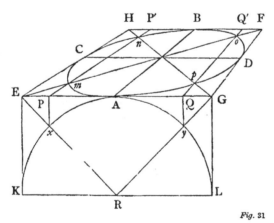

Fig. 30

Then m, n, o, p are four other points in the circle.

Through these eight points the circle may be drawn by the hand accurately enough for general purposes; but any number of points required may, of course, be determined, as in Problem XI.

The distance E P is approximately one seventh of E G, and may be assumed to be so in quick practice, as the error involved is not greater than would be

Fig. 31

incurred in the hasty operation of drawing the circle and diagonals.

It may frequently happen that, in consequence of associated

constructions, it may be inconvenient to draw E G parallel to the sight-line, the square being perhaps first constructed in some oblique direction. In such cases, Q G and E P must be determined in perspective ratio by the dividing-point, the line E G being used as a measuring-line.

(*Obs.* In drawing Fig. 31, the station-point has been taken much nearer the paper than is usually advisable, in order to show the character of the curve in a very distinct form.

If the student turns the book so that E G may be vertical, Fig. 31 will represent the construction for drawing a circle in a vertical plane, the sight-line being then of course parallel to G L; and the semicircles A D B, A C B, on each side of the diameter A B, will represent ordinary semi-circular arches seen in perspective. In that case, if the book be held so that the line E H is the top of the square, the upper semicircle will repre-sent a semicircular arch, *above* the eye, drawn in perspective. But if the book be held so that the line G F is the top of the square, the upper

perspective.

If the book be turned upside down, the figure will represent a circle drawn on the ceiling, or any other horizontal plane above the eye; and the construction is, of course, accurate in every case.)·

PROBLEM XII

TO DIVIDE A CIRCLE DRAWN IN PERSPECTIVE INTO ANY GIVEN NUMBER OF EQUAL PARTS

LET A B, Fig. 32, be the circle drawn in perspective. It is required to divide it into a given number of equal parts; in this case, 20.

Let K A L be the semicircle used in the construction. Divide the semicircle K A L into half the number of parts required; in this case, 10.

Produce the line E G laterally in both directions, as far as may be necessary.

From o, the centre of the semicircle K A L, draw radii through the points of division of the semicircle, *p*, *q*, *r*, etc., and produce them to cut the line E G in P, Q, R, etc.

From the points P Q R draw the lines P P′, Q Q′, R R′, etc., through the centre of the circle A B, each cutting the circle in two points of its circumference.

Then these points divide the perspective circle as required.

If from each of the points *p*, *q*, *r*, a vertical were raised to the line E G, as in Fig. 31, and from the point where it cut E G a line were drawn to the vanishing-point, as Q Q′ in Fig. 31, this line would also determine two of the points of division.

If it is required to divide a circle into any number of given *un*equal parts (as in the points A, B, and C, Fig. 33), the shortest way is thus to raise vertical lines from A and B to the side of the perspective square X Y, and then draw to the vanishing-point, cutting the perspective circle in *a* and *b*, the points required. Only notice that if any point,

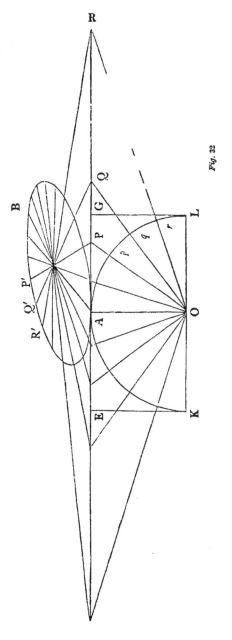

Fig. 32

as A, is on the nearer side of the circle A B C, its representative point, a, must be on the nearer side of the circle $a\ b\ c$; and if the point B is on the farther side of the circle A B C, b must be on the farther side of $a\ b\ c$. If any point, as C,

Fig. 33

is so much in the lateral arc of the circle as not to be easily determinable by the vertical line, draw the horizontal c P, find the correspondent p in the side of the perspective square, and draw $p\ c$ parallel to x y, cutting the perspective circle in c.

COROLLARY

It is obvious that if the points P′, Q′, R′, etc., by which the circle is divided in Fig. 32, be joined by right lines, the resulting figure will be a regular equilateral figure of twenty sides inscribed in the circle. And if the circle be divided into given unequal parts, and the points of division joined by right lines, the resulting figure will be an irregular polygon inscribed in the circle with sides of given length.

Thus any polygon, regular or irregular, inscribed in a circle, may be inscribed in position in a perspective circle.

PROBLEM XIII

TO DRAW A SQUARE, GIVEN IN MAGNITUDE, WITHIN A LARGER SQUARE, GIVEN IN POSITION AND MAGNITUDE; THE SIDES OF THE TWO SQUARES BEING PARALLEL

Fig. 34

LET A B, Fig. 34, be the sight-magnitude of the side of the smaller square, and A C that of the side of the larger square.

Draw the larger square. Let D E F G be the square so drawn.

Join E G and D F.

On either D E or D G set off, in perspective ratio, D H equal to one half of B C. Through H draw H K to the vanishing-point of D E, cutting D F in I and E G in K. Through I and K draw I M, K L, to vanishing-point of D G, cutting D F in L and E G in M. Join L M.

Then I K L M is the smaller square, inscribed as required.*

* If either of the sides of the greater square is parallel to the plane

Fig. 35

of the picture, as D G in Fig. 35, D G of course must be equal to A C, and D H equal to $\frac{B C}{2}$, and the construction is as in Fig 35.

285

COROLLARY

If, instead of one square within another, it be required to draw one circle within another, the dimensions of both

Fig. 36

being given, enclose each circle in a square. Draw the squares first, and then the circles within, as in Fig. 36.

PROBLEM XIV

TO DRAW A TRUNCATED CIRCULAR CONE, GIVEN IN POSITION
AND MAGNITUDE, THE TRUNCATIONS BEING IN HORI-
ZONTAL PLANES, AND THE AXIS OF THE CONE VERTICAL[1]

LET A B C D, Fig. 37, be the portion of the cone required.
As it is given in magnitude, its diameters must be

Fig. 37

given at the base and summit, A B and C D; and its
vertical height, C E.*

And as it is given in position, the centre of its base
must be given.

Draw in position about this centre,† the square pillar
a f d, Fig. 38, making its height, *b g*, equal to C E;
and its side, *a b*, equal to A B.

In the square of its base, *a b c d*, inscribe a circle,

* Or if the length of its side, A c, is given instead, take *a e*, Fig.
37, equal to half the excess of A B over C D; from the point *e* raise the
perpendicular *e c*. With centre *a*, and distance A c, describe a circle
cutting *e c* in *c*. Then *c e* is the vertical height of the portion of cone
required, or C E.

† The direction of the side of the square will of course be regulated
by convenience.

[1] [For exercises on this Problem, see Appendix, p. 319.]

which therefore is of the diameter of the base of the cone, A B.

In the square of its top, *e f g h*, inscribe concentri-

Fig. 38

cally a circle whose diameter shall equal c D. (Coroll. Prob. XIII.)

Join the extremities of the circles by the right lines *k l, n m.*

Then *k l n m* is the portion of cone required.

COROLLARY I

If similar polygons be inscribed in similar positions in the circles *k n* and *l m* (Coroll. Prob. XII.), and the corresponding angles of the polygons joined by right lines, the resulting figure will be a portion of a polygonal pyramid. (The dotted lines in Fig. 38, connecting the extremities of two diameters and one diagonal in the respective circles, occupy the position of the three nearest angles of a regular octagonal pyramid, having its angles set on the diagonals and diameters of the square *a d*, enclosing its base.)

If the cone or polygonal pyramid is not truncated, its apex will be the centre of the upper square, as in Fig. 26.

COROLLARY II

If equal circles, or equal and similar polygons, be inscribed in the upper and lower squares in Fig. 38, the resulting figure will be a vertical cylinder, or a vertical polygonal pillar, of given height. and diameter, drawn in position.

COROLLARY III

If the circles in Fig. 38, instead of being inscribed in the squares $b\,c$ and $f\,g$, be inscribed in the sides of the solid figure $b\,e$ and $d\,f$, those sides being made square, and the line $b\,d$ of any given length, the resulting figure will be, according to the constructions employed, a cone, polygonal pyramid, cylinder, or polygonal pillar, drawn in position about a horizontal axis parallel to $b\,d$.

Similarly, if the circles are drawn in the sides $g\,d$ and $e\,c$, the resulting figures will be described about a horizontal axis parallel to $a\,b$.

PROBLEM XV

TO DRAW AN INCLINED LINE, GIVEN IN POSITION
AND MAGNITUDE

WE have hitherto been examining the conditions of horizontal and vertical lines only, or of curves enclosed in rectangles.

We must, in conclusion, investigate the perspective of inclined lines, beginning with a single one given in position. For the sake of completeness of system, I give in

Fig. 39

Fig. 40

Appendix II., Article III., the development of this problem from the second. But, in practice, the position of an inclined line may be most conveniently defined by considering it as the diagonal of a rectangle, as A B in Fig. 39, and I shall therefore, though at some sacrifice of system, examine it here under that condition.

If the sides of the rectangle A C and A D are given, the slope of the line A B is determined; and then its position will depend on that of the rectangle. If, as in Fig. 39, the rectangle is parallel to the picture plane, the line A B must be so also. If, as in Fig. 40, the rectangle is inclined to the picture plane, the line A B will be so also. So that,

to fix the position of A B, the line A C must be given in position and magnitude, and the height A D.

If these are given, and it is only required to draw the single line A B in perspective, the construction is entirely simple; thus :—

Draw the line A C by Problem II.

Let *a c*, Fig. 41, be the line so drawn. From *a* and *c* raise the vertical lines *a d, c b*. Make *a d* equal to the

Fig. 41

Fig. 42

sight-magnitude of A D. From *d* draw *d b* to the vanishing-point of *a c*, cutting *b c* in *b*.

Join *a b*. Then *a b* is the inclined line required.

If the line is inclined in the opposite direction, as D C in Fig. 42, we have only to join *d c* instead of *a b* in Fig. 41, and *d c* will be the line required.

I shall hereafter call the line A C, when used to define the position of an inclined line A B (Fig. 40), the "relative horizontal" of the line A B.

OBSERVATION.

In general, inclined lines are most needed for gable roofs, in which, when the conditions are properly stated, the vertical height of the gable, X Y, Fig. 43, is given, and the base line, A C, in position. When these are given, draw A C; raise vertical A D; make A D equal to sight-magnitude of X Y; complete the perspective-rectangle A D B C; join A B and D C (as by dotted lines in figure); and through the intersection of the dotted lines draw vertical X Y, cutting D B in Y. Join A Y, C Y; and these lines are the sides of

the gable. If the length of the roof A A′ is also given, draw in perspective the complete parallelopiped *A′ D′ B C, and from Y draw Y Y′ to the vanishing-point of A A′, cutting

Fig. 43

Fig. 44

D′ B′ in Y′. Join A′ Y, and you have the slope of the farther side of the roof.

The construction above the eye is as in Fig. 44; the roof is reversed in direction merely to familiarise the student with the different aspects of its lines.

PROBLEM XVI

TO FIND THE VANISHING-POINT OF A GIVEN INCLINED LINE [1]

IF, in Fig. 43 or Fig. 44, the lines A Y and A' Y' be produced, the student will find that they meet.

Let P, Fig. 45, be the point at which they meet.

From P let fall the vertical P v on the sight-line, cutting the sight-line in v.

Then the student will find experimentally that v is the vanishing-point of the line A C.*

Complete the rectangle of the base A C', by drawing A' C' to v, and c C' to the vanishing-point of A A'.

Join Y' C'.

Now if Y C and Y' C' be produced downwards, the student will find that they meet.

Let them be produced, and meet in P'.

Produce P v, and it will be found to pass through the point P'.

Therefore if A Y (or C Y), Fig. 45, be any inclined line drawn in perspective by Problem XV., and A C the relative horizontal (A C in Figs. 39, 40), also drawn in perspective.

Through v, the vanishing-point of A C, draw the vertical P P' upwards and downwards.

Produce A Y (or Y C), cutting P P' in P (or P').

Then P is the vanishing-point of A Y (or P' of Y C).

The student will observe that, in order to find the point P by this method, it is necessary first to draw a portion of the given inclined line by Problem XV. Practically, it is

* The demonstration is in Appendix II. Article III., p. 328.

[1] [For remarks on this Problem, see Appendix I., p. 323; and for analysis of it, Appendix II., pp. 328-331.]

always necessary to do so, and, therefore, I give the problem
in this form.

Theoretically, as will be shown in the analysis of the
problem [p. 329], the point P should be found by drawing a
line from the station-point parallel to the given inclined line;
but there is no practical means of drawing such a line; so
that in whatever terms the problem may be given, a portion
of the inclined line (A Y or C Y) must always be drawn in
perspective before P can be found.

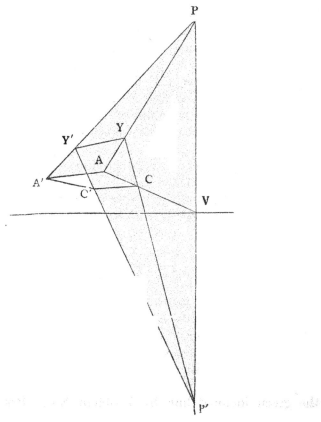

Fig. 45

PROBLEM XVII

TO FIND THE DIVIDING-POINTS OF A GIVEN INCLINED LINE

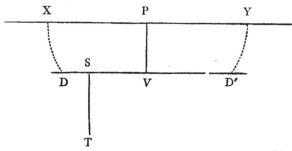

Fig. 46 :

LET P, Fig. 46, be the vanishing-point of the inclined line and v the vanishing-point of the relative horizontal.

Find the dividing-points of the relative horizontal, D and D'. (Problem IV.)

Through P draw the horizontal line x y.

With centre P and distance D P describe the two arcs D x and D' y, cutting the line x y in x and y.

Then x and y are the dividing-points of the inclined line.*

Obs. The dividing-points found by the above rule, used with the ordinary measuring-line, will lay off distances on the retiring inclined line, as the ordinary dividing-points lay them off on the retiring horizontal line.

Another dividing-point, peculiar in its application, is sometimes useful, and is to be found as follows:

Let A B, Fig. 47, be the given inclined line drawn in perspective, and A c the relative horizontal.

* The demonstration is in Appendix II., p. 329

Find the vanishing-points, v and E, of A *c* and A B; D, the dividing-point of A *c;* and the sight-magnitude of A *c* on the measuring-line, or A C.

From D erect the perpendicular D F.

Join C B, and produce it to cut D F in F. Join E F.

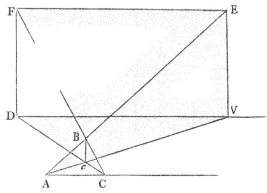

Fig. 47

Then, by similar triangles, D F is equal to E V, and E F is parallel to D V.

Hence it follows that if from D, the dividing-point of A *c*, we raise a perpendicular and make D F equal to E V, a line C F, drawn from any point C on the measuring-line to F, will mark the distance A B on the inclined line, A B being the portion of the given inclined line which forms the diagonal of the vertical rectangle of which A C is the base.

PROBLEM XVIII

TO FIND THE SIGHT-LINE OF AN INCLINED PLANE IN WHICH TWO LINES ARE GIVEN IN POSITION *

As in order to fix the position of a line two points in it

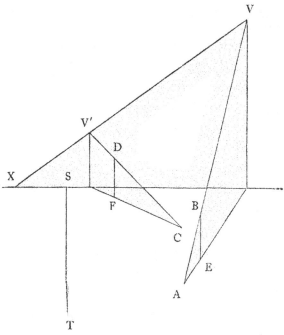

Fig. 48

must be given, so in order to fix the position of a plane, two lines in it must be given.

Let the two lines be A B and C D, Fig. 48.

* Read the Article on this problem in the Appendix, p. 325, before investigating the problem itself.

As they are given in position, the relative horizontals A E and C F must be° given.

Then by Problem XVI. the vanishing-point of A B is v, and of C D, v′.

Join v v′ and produce it to cut the sight-line in x.

Then v x is the sight-line of the inclined plane.

Like the horizontal sight-line, it is of indefinite length and may be produced in either direction as occasion requires, crossing the horizontal line of sight, if the plane continues downward in that direction.

x is the vanishing-point of all horizontal lines in the inclined plane.

PROBLEM XIX

TO FIND THE VANISHING-POINT OF STEEPEST LINES IN AN INCLINED PLANE WHOSE SIGHT-LINE IS GIVEN

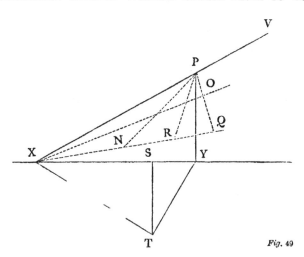

Fig. 49

LET v x, Fig. 49, be the given sight-line.

Produce it to cut the horizontal sight-line in x

Therefore x is the vanishing-point of horizontal lines in the given inclined plane. (Problem XVIII.)

Join T x, and draw T Y at right angles to T x.

Therefore Y is the rectangular vanishing-point corre sponding to x.*

From Y erect the vertical Y P, cutting the sight-line of the inclined plane in P.

Then P is the vanishing-point of steepest lines in the plane.

All lines drawn to it, as Q P, R P, N P, etc., are the steepest possible in the plane; and all lines drawn to x, as Q x, O x, etc., are horizontal, and at right angles to the lines P Q, P R, etc.

* That is to say, the vanishing-point of horizontal lines drawn at right angles to the lines whose vanishing-point is x.

299

PROBLEM XX

TO FIND THE VANISHING-POINT OF LINES PERPEN-
DICULAR TO THE SURFACE OF A GIVEN INCLINED
PLANE

As the inclined plane is given, one of its steepest lines *
must be given, or may be ascertained.

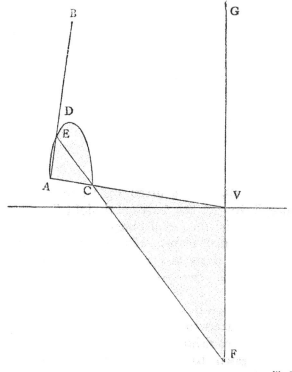

Fig. 50

 Let A B, Fig. 50, be a portion of a steepest line in
the given plane, and v the vanishing-point of its relative
horizontal.

 * See explanation of "steepest lines" on p. 326.

Through v draw the vertical G F upwards and downwards.

From A set off any portion of the relative horizontal A C, and on A C describe a semicircle in a vertical plane, A D C, cutting A B in E.

Join E C, and produce it to cut G F in F.

Then F is the vanishing-point required.

For, because A E C is an angle in a semicircle, it is a right angle; and therefore the line E F is at right angles to the line A B; and similarly all lines drawn to F, and therefore parallel to E F, are at right angles with any line which cuts them, drawn to the vanishing-point of A B.

And because the semicircle A D C is in a vertical plane, and its diameter A C is at right angles to the horizontal lines traversing the surface of the inclined plane, the line E C, being in this semicircle, is also at right angles to such traversing lines. And therefore the line E C, being at right angles to the steepest lines in the plane, and to the horizontal lines in it, is perpendicular to its surface.

THE preceding series of constructions, with the examples in the first Article of the Appendix, put it in the power of the student to draw any form, however complicated,* which does not involve intersection of curved surfaces. I shall not proceed to the analysis of any of these more complex problems, as they are entirely useless in the ordinary practice of artists. For a few words only I must ask the reader's further patience, respecting the general placing and scale of the picture.[1]

As the horizontal sight-line is drawn through the sight-point, and the sight-point is opposite the eye, the sight-line is always on a level with the eye. Above and below the sight-line, the eye comprehends, as it is raised or depressed while the head is held upright, about an equal space; and, on each side of the sight-point, about the same space is easily seen without turning the head; so that if a picture represented the true field of easy vision, it ought to be circular, and have the sight-point in its centre. But because some parts of any given view are usually more interesting than others, either the uninteresting parts are left out, or somewhat more than would generally be seen of the interesting parts is included, by moving the field of the picture a little upwards or downwards, so as to throw the sight-point low or high. The operation will be understood in a moment by cutting an aperture in a piece of pasteboard, and moving it up and down in front of the eye, without moving the eye. It will be seen to embrace sometimes the low, sometimes the high objects, without altering their perspective, only the eye will be opposite the lower

* As in algebraic science, much depends, in complicated perspective on the student's ready invention of expedients, and on his quick sight of the shortest way in which the solution may be accomplished, when there are several ways.

[1] [On this subject compare Ruskin's early paper given in Vol. I. pp. 235-245.]

part of the aperture when it sees the higher objects, and *vice versâ.*

There is no reason, in the laws of perspective, why the picture should not be moved to the right or left of the sight-point, as well as up or down. But there is this practical reason. The moment the spectator sees the horizon in a picture high, he tries to hold his head high, that is, in its right place. When he sees the horizon in a picture low, he similarly tries to put his head low. But, if the sight-point is thrown to the left hand or right hand, he does not understand that he is to step a little to the right or left; and if he places himself, as usual, in the middle, all the perspective is distorted. Hence it is generally unadvisable to remove the sight-point laterally, from the centre of the picture. The Dutch painters, however, fearlessly take the license of placing it to the right or left; and often with good effect.

The rectilinear limitation of the sides, top, and base of the picture is of course quite arbitrary, as the space of a landscape would be which was seen through a window; less or more being seen at the spectator's pleasure, as he retires or advances.

The distance of the station-point is not so arbitrary. In ordinary cases it should not be less than the intended greatest dimension (height or breadth) of the picture. In most works by the great masters it is more; they not only calculate on their pictures being seen at considerable distances, but they like breadth of mass in buildings, and dislike the sharp angles which always result from station-points at short distances.*

Whenever perspective, done by true rule, looks wrong, it is always because the station-point is too near. Determine, in the outset, at what distance the spectator is likely

* The greatest masters are also fond of parallel perspective, that is to say, of having one side of their buildings fronting them full, and therefore parallel to the picture plane, while the other side vanishes to the sight-point. This is almost always done in figure back-grounds securing simple and balanced lines.

to examine the work, and never use a station-point within a less distance.

There is yet another and a very important reason, not only for care in placing the station-point, but for that accurate calculation of distance and observance of measurement which have been insisted on throughout this work. All drawings of objects on a reduced scale are, if rightly executed, drawings of the appearance of the object at the distance which in true perspective reduces it to that scale. They are not *small* drawings of the object seen near, but drawings the *real size* of the object seen far off. Thus if you draw a mountain in a landscape, three inches high, you do not reduce all the features of the near mountain so as to come into three inches of paper. You could not do that. All that you can do is to give the appearance of the mountain, when it is so far off that three inches of paper would really hide it from you. It is precisely the same in drawing any other object. A face can no more be reduced in scale than a mountain can. It is infinitely delicate already ; it can only be quite rightly rendered on its own scale, or at least on the slightly diminished scale which would be fixed by placing the plate of glass, supposed to represent the field of the picture, close to the figures. Correggio and Raphael were both fond of this slightly subdued magnitude of figure. Colossal painting, in which Correggio excelled all others,[1] is usually the enlargement of a small picture (as a colossal sculpture is of a small statue), in order to permit the subject of it to be discerned at a distance. The treatment of colossal (as distinguished from ordinary) paintings will depend therefore, in general, on the principles of optics more than on those of perspective, though, occasionally, portions may be represented as if they were the projection of near objects on a plane behind them. In all points the subject is one of great difficulty and subtlety ; and its examination does not fall within the compass of this essay.

[1] [For other references to Correggio, see Vol. IV. p. 197 *n*.]

Lastly, it will follow from these considerations, and the conclusion is one of great practical importance, that, though pictures may be enlarged, they cannot be reduced, in copying them. All attempts to engrave pictures completely on a reduced scale are, for this reason, nugatory.[1] The best that can be done is to give the aspect of the picture at the distance which reduces it in perspective to the size required; or, in other words, to make a drawing of the distant effect of the picture. Good painting, like nature's own work, is infinite, and unreduceable.

I wish this book had less tendency towards the infinite and unreduceable. It has so far exceeded the limits I hoped to give it, that I doubt not the reader will pardon an abruptness of conclusion, and be thankful, as I am myself, to get to an end on any terms.

[1] [Compare Vol. VI. p. 4.]

XV.

APPENDIX

PRACTICE AND OBSERVATIONS ON
THE PRECEDING PROBLEMS

PROBLEM I [p. 251]

AN example will be necessary to make this problem clear to the general student.

The nearest corner of a piece of pattern on the carpet is $4\frac{1}{2}$ feet beneath the eye, 2 feet to our right and $3\frac{1}{2}$ feet in direct distance from us. We intend to make a drawing of the pattern which shall be seen properly when held $1\frac{1}{2}$ foot from the eye. It is required to fix the position of the corner of the piece of pattern.

Let A B, Fig. 51, be our sheet of paper, some 3 feet wide. Make s T equal to $1\frac{1}{2}$ foot. Draw the line of sight through s. Produce T s, and make D s equal to 2 feet, therefore T D equal to $3\frac{1}{2}$ feet. Draw D c, equal to 2 feet; c P, equal to 4 feet. Join T c (cutting the sight-line in Q) and T P.

Let fall the vertical Q P', then P' is the point required.

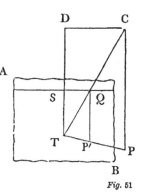

Fig. 51

If the lines, as in the figure, fall outside of your sheet of paper, in order to draw them, it is necessary to attach other sheets of paper to its edges. This is inconvenient, but must be done at first that you may see your way clearly; and sometimes afterwards, though there are expedients for doing without such extension in fast sketching.

It is evident, however, that no extension of surface could be of any use to us, if the distance T D, instead of being $3\frac{1}{2}$ feet, were 100 feet, or a mile, as it might easily be in a landscape.

It is necessary, therefore, to obtain some other means of construction; to do which we must examine the principle of the problem.

In the analysis of Fig. 2, in the introductory remarks [p. 247], I used the word "height" only of the tower, Q P, because it was only to its vertical height that the law deduced from the figure could be applied. For suppose it had

309

been a pyramid, as o q p, Fig. 52, then the image of its side, q p, being, like every other magnitude, limited on the glass a b by the lines coming from its extremities, would appear only of the length q' s; and it is not true that q' s is to q p as t s is to t p. But if we let fall a vertical q d from q, so as to get the vertical height of the pyramid, then it is true that q' s is to q d as t s is to t d.

Supposing this figure represented, not a pyramid, but a triangle on the ground, and that q d and q p are horizontal lines, expressing lateral distance from the line t d, still the rule would be false for q p and true for q d. And, similarly, it is true for all lines which are parallel, like q d, to

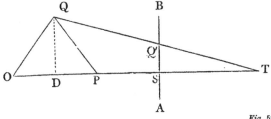

Fig. 52

the plane of the picture a b, and false for all lines which are inclined to it at an angle.

Hence generally. Let p q (Fig. 2 in Introduction, p. 247) be any magnitude *parallel to the plane of the picture;* and p' q' its image on the picture.

Then always the formula is true which you learned in the Introduction: p' q' is to p q as s t is to d t.

Now the magnitude p dash q dash in this formula I call the "sight-magnitude" of the line p q. The student must fix this term, and the meaning of it, well in his mind. The "sight-magnitude" of a line is the magnitude which bears to the real line the same proportion that the distance of the picture bears to the distance of the object. Thus, if a tower be a hundred feet high, and a hundred yards off; and the picture, or piece of glass, is one yard from the spectator, between him and the tower; the distance of picture being then to distance of tower as 1 to 100, the sight-magnitude of the tower's height will be as 1 to 100; that is to say, one foot. If the tower is two hundred yards distant, the sight-magnitude of its height will be half a foot, and so on.

But farther. It is constantly necessary, in perspective operations, to measure the other dimensions of objects by the sight-magnitude of their vertical lines. Thus, if the tower, which is a hundred feet high, is square, and twenty-five feet broad on each side; if the sight-magnitude of the height is one foot, the measurement of the side, reduced to the same scale, will be the hundredth part of twenty-five feet, or three inches: and accordingly, I use in this treatise the term "sight-magnitude" indiscriminately for all lines reduced in the same proportion as the vertical lines of the object. If I tell you to find the "sight-magnitude" of any line, I mean, always, find the magnitude which bears to that line the proportion

of s t to d t; or, in simpler terms, reduce the line to the scale which you have fixed by the first determination of the length s t.

Therefore, you must learn to draw quickly to scale before you do any-thing else; for all the measurements of your object must be reduced to the scale fixed by s t before you can use them in your diagram. If the object is fifty feet from you, and your paper one foot, all the lines of the object must be reduced to a scale of one fiftieth before you can use them; if the object is two thousand feet from you, and your paper one foot, all your lines must be reduced to the scale of one two-thousandth before you can use them, and so on. Only in ultimate practice, the reduction never need be tiresome, for, in the case of large distances, accuracy is never re-quired. If a building is three or four miles distant, a hairbreadth of acci-dental variation in a touch makes a difference of ten or twenty feet in height or breadth, if estimated by ac-curate perspective law. Hence it is never attempted to apply measurements with precision at such distances. Measure-ments are only required within distances of, at the most, two or three hundred feet. Thus, it may be necessary to re-present a cathedral nave precisely as seen from a spot seventy feet in front of a given pillar; but we shall hardly be re-quired to draw a cathedral three miles distant precisely as seen from seventy feet in advance of a given milestone. Of course, if such a thing be required, it can be done; only the reductions are somewhat long and complicated: in ordi-nary cases it is easy to assume the distance s t so as to get at the reduced dimensions in a moment. Thus, let the pillar of the nave, in the case supposed, be 42 feet high, and we are required to stand 70 feet from it: assume s t to be equal to 5 feet. Then, as 5 is to 70 so will the sight-magnitude required be to 42; that is to say, the sight-magnitude of the pillar's height will be 3 feet. If we make s t equal to 2½ feet, the pillar's height will be 1½ foot, and so on.

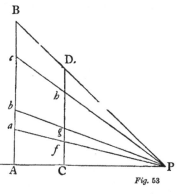

Fig. 53

And for fine divisions into irregular parts which cannot be measured, the ninth and tenth problems of the sixth book of Euclid will serve you: the following construction is, however, I think, more practically convenient:—

The line a b (Fig. 53) is divided by given points, *a*, *b*, *c*, into a given number of irregularly unequal parts: it is required to divide any other line, c d, into an equal number of parts, bearing to each other the same propor-tions as the parts of a b, and arranged in the same order.

Draw the two lines parallel to each other, as in the figure.

Join a c and b d, and produce the lines a c, b d, till they meet in p.

Join *a* p, *b* p, *c* p, cutting c d in *f*, *g*, *h*.

Then the line c d is divided as required, in *f*, *g*, *h*.

In the figure the lines a b and c d are accidentally perpendicular to a p. There is no need for their being so.

Now, to return to our first problem (p. 251).

The construction given in the figure is only the quickest mathematical way of obtaining, on the picture, the sight-magnitudes of D C and P C, which are both magnitudes parallel with the picture plane. But if these magnitudes are too great to be thus put on the paper, you have only to obtain the reduction by scale. Thus, if T S be one foot, T D eighty feet, D C forty feet, and C P ninety feet, the distance Q S must be made equal to one eighteenth of D C, or half a foot; and the distance Q P', one eighteenth of C P, or one eighteenth of ninety feet; that is to say, nine eighths of a foot, or thirteen and a half inches. The lines C T and P T are thus *practically* useless, it being only necessary to measure Q S and Q P, on your paper, of the due sight-magnitudes. But the mathematical construction, given in Problem I., is the basis of all succeeding problems, and, if it is once thoroughly understood and practised (it can only be thoroughly understood by practice), all the other problems will follow easily.

Lastly. Observe that any perspective operation whatever may be performed with reduced dimensions of every line employed, so as to bring it conveniently within the limits of your paper. When the required figure is thus constructed on a small scale, you have only to enlarge it accurately in the same proportion in which you reduced the lines of construction, and you will have the figure constructed in perspective on the scale required for use.

PROBLEM IX [p. 275]

The drawing of most buildings occurring in ordinary practice will resolve itself into applications of this problem. In general, any house, or block of houses, presents itself under the main conditions assumed here in Fig. 54. There will be an angle or corner somewhere near the spectator, as A B; and the level of the eye will usually be above the base of the building, of which, therefore, the horizontal upper lines will slope down to the vanishing-points, and the base lines rise to them. The following practical directions will, however, meet nearly all cases:—

Let A B, Fig. 54, be any important vertical line in the block of buildings; if it is the side of a street, you may fix upon such a line at the division between two houses. If its real height, distance, etc., are given, you will proceed with the accurate construction of the problem; but usually you will neither know, nor care, exactly how high the building is, or how far off. In such case draw the line A B, as nearly as you can guess, about the part of the picture it ought to occupy, and on such a scale as you choose. Divide it into any convenient number of equal parts, according to the height you presume it to be. If you suppose it to be twenty feet high, you may divide it into twenty parts, and let each part stand for a foot; if thirty feet high, you may divide it into ten parts, and let each part stand for three feet; if seventy feet high, into fourteen parts, and let each part stand for five feet; and so on, avoiding thus very minute divisions till you come to details. Then observe how high your eye reaches upon this vertical line; suppose, for instance, that it is thirty feet high and divided into ten parts, and you are standing so as to raise your head to about six feet above its base, then the sight-line may be drawn, as in the figure, through the second

division from the ground. If you are standing above the house, draw the sight-line above B; if below the house, below A; at such height or depth as you suppose may be accurate (a yard or two more or less matters little at ordinary distances, while at great distances perspective rules become nearly useless, the eye serving you better than the necessarily imperfect calculation). Then fix your sight-point and station-point, the latter with proper reference to the scale of the line A B. As you cannot, in all probability, ascertain the exact direction of the line A V or B V, draw the slope B V as it appears to you, cutting the sight-line in V. Thus having fixed one vanishing-point, the other, and the dividing-points, must be accurately found by rule; for, as before stated, whether your entire group

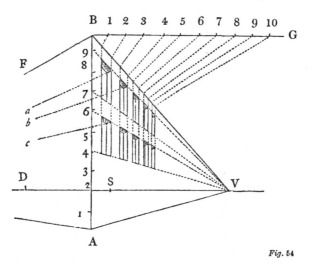

Fig. 54

of points (vanishing and dividing) falls a little more or less to the right or left of s does not signify, but the relation of the points to each other *does* signify. Then draw the measuring-line B G, either through A or B, choosing always the steeper slope of the two; divide the measuring-line into parts of the same length as those used on A B, and let them stand for the same magnitudes. Thus, suppose there are two rows of windows in the house front, each window six feet high by three wide, and separated by intervals of three feet, both between window and window and between tier and tier; each of the divisions here standing for three feet, the lines drawn from B G to the dividing-point D fix the lateral dimensions, and the divisions on A B the vertical ones. For other magnitudes it would be necessary to subdivide the parts on the measuring-line, or on A B, as required. The lines which regulate the inner sides or returns of the windows (*a, b, c,* etc.) of course are drawn to the vanishing-point of B F (the other side of the house), if F B V represents a right angle; if not, their own vanishing-point must be found separately for these returns. But see Practice on Problem XI. [p. 318].

Interior angles, such as E B C, Fig. 55 (suppose the corner of a room), are to be treated in the same way, each side of the room having its measurements separately carried to it from the measuring-line. It may sometimes happen in such cases that we have to carry the measurement *up* from the corner B, and that the sight-magnitudes are given us from the length of the line A B. For instance, suppose the room is eighteen

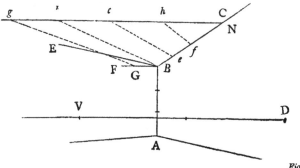

Fig. 55

feet high, and therefore A B is eighteen feet; and we have to lay off lengths of six feet on the top of the room-wall, B C. Find D, the dividing-point of B C. Draw a measuring-line, B F, from B; and another, *g* C, anywhere above. On B F lay off B G equal to one third of A B, or six feet; and draw from D, through G and B, the lines G *g*, B *b*, to the upper measuring-line. Then *g b* is six feet on that measuring-line. Make *b c*, *c h*, etc., equal to *b g*; and draw *c e*, *h f*, etc., to D, cutting B C in *e* and *f*, which mark the required lengths of six feet each at the top of the wall.

PROBLEM X [p. 276]

This is one of the most important foundational problems in perspective, and it is necessary that the student should entirely familiarize himself with its conditions.

In order to do so, he must first observe these general relations of magnitude in any pyramid on a square base.

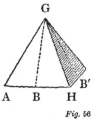

Fig. 56

Let A G H, Fig. 56, be any pyramid on a square base.

The best terms in which its magnitude can be given, are the length of one side of its base, A H, and its vertical altitude (C D in Fig. 25); for, knowing these, we know all the other magnitudes. But these are not the terms in which its size will be usually ascertainable. Generally, we shall have given us, and be able to ascertain by measurement, one side of its base A H, and either A G the length of one of the lines of its angles, or B G (or B' G) the length of a line drawn from its vertex, G, to the middle of the side of its base. In measuring a real pyramid, A G will usually be

the line most easily found; but in many architectural problems B G is given, or is most easily ascertainable.

Observe therefore this general construction.

Let A B D E, Fig. 57, be the square base of any pyramid.

Draw its diagonals, A E, B D, cutting each other in its centre, C.

Bisect any side, A B, in F.

From F erect vertical F G.

Produce F B to H, and make F H equal to A C.

Now if the vertical altitude of the pyramid (C D in Fig. 25) be given, make F G equal to this vertical altitude.

Join G B and G H.

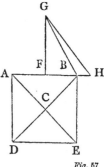

Fig. 57

Then G B and G H are the true magnitudes of G B and G H in Figure 56.

If G B is given, and not the vertical altitude, with centre B, and distance G B, describe circle cutting F G in G, and F G is the vertical altitude.

If G H is given, describe the circle from H, with distance G H, and it will similarly cut P G in G.

It is especially necessary for the student to examine this construction thoroughly, because in many complicated forms of ornaments, capitals of columns, etc., the lines B G and G H become the limits or bases of curves, which are elongated on the longer (or angle) profile G H, and shortened

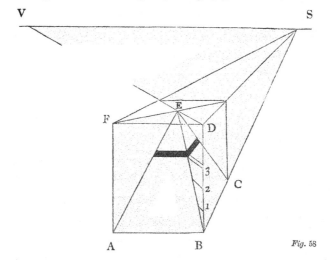

Fig. 58

on the shorter (or lateral) profile B G. We will take a simple instance, but must previously note another construction.

It is often necessary, when pyramids are the roots of some ornamental form, to divide them horizontally at a given vertical height. The shortest way of doing so is in general the following.

Let A E c, Fig. 58, be any pyramid on a square base A B c, and A D c the square pillar used in its construction.

Then by construction (Problem X.) B D and A F are both of the vertical height of the pyramid.

Of the diagonals, F E, D E, choose the shortest (in this case D E), and produce it to cut the sight-line in v.

Therefore v is the vanishing-point of D E.

Divide D B, as may be required, into the sight-magnitudes of the given vertical heights at which the pyramid is to be divided.

From the points of division, 1, 2, 3, etc., draw to the vanishing-point v. The lines so drawn cut the angle line of the pyramid, B E, at the required elevations. Thus, in the figure, it is required to draw a horizontal black band on the pyramid at three fifths of its height, and in breadth one twentieth of its height. The line B D is divided into five parts, of which

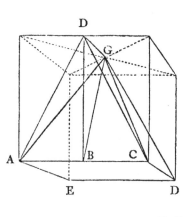

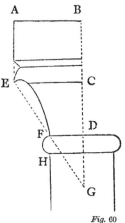

Fig. 59 Fig. 60

three are counted from B upwards. Then the line drawn to v marks the base of the black band. Then one fourth of one of the five parts is measured, which similarly gives the breadth of the band. The terminal lines of the band are then drawn on the sides of the pyramid parallel to A B (or to its vanishing-point if it has one), and to the vanishing-point of B c.

If it happens that the vanishing-points of the diagonals are awkwardly placed for use, bisect the nearest base line of the pyramid in B, as in Fig. 59.

Erect the vertical D B and join G B and D G (G being the apex of pyramid).

Find the vanishing-point of D G, and use D B for division, carrying the measurements to the line G B.

In Fig. 59, if we join A D and D c, A D c is the vertical profile of the whole pyramid, and B D c of the half pyramid, corresponding to F G B in Fig. 57.

We may now proceed to an architectural example.

Let A H, Fig. 60, be the vertical profile of the capital of a pillar, A B the semi-diameter of its head or abacus, and F D the semi-diameter of its shaft.

Let the shaft be circular, and the abacus square, down to the level E. Join B D, E F, and produce them to meet in G.

Therefore E C G is the semi-profile of a reversed pyramid containing the capital.

Construct this pyramid, with the square of the abacus, in the required

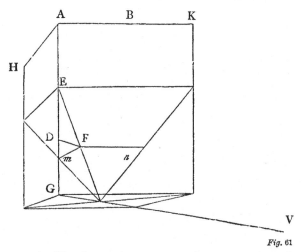

Fig. 61

perspective, as in Fig. 61 ; making A E equal to A E in Fig. 60, and A K, the side of the square, equal to twice A B in Fig. 60. Make E G equal to C G, and E D equal to C D. Draw D F to the vanishing-point of the diagonal G V (the figure is too small to include this vanishing-point), and F is the level of the point P in Fig. 60, on the side of the pyramid.

Draw F *m*, F *n*, to the vanishing-points of A H and A K. Then F *n* and F *m* are horizontal lines across the pyramid at the level F, forming at that level two sides of a square.

Complete the square, and within it inscribe a circle, as in Fig. 62, which is left unlettered that its construction may be clear. At the extremities of this draw vertical lines, which will be the sides of the shaft in its right place. It will be found to be somewhat smaller in diameter than the entire shaft in Fig. 60, because at the centre of the square it is more distant than the nearest edge of the square abacus. The curves of the capital may

Fig. 62

then be drawn approximately by the eye. They are not quite accurate in Fig. 62, there being a subtlety in their junction with the shaft which could

not be shown on so small a scale without confusing the student; the curve on the left springing from a point a little way round the circle behind the shaft, and that on the right from a point on this side of the circle a little way within the edge of the shaft. But for their more accurate construction see Notes on Problem XIV.

PROBLEM XI [p. 278]

It is seldom that any complicated curve, except occasionally a spiral, needs to be drawn in perspective; but the student will do well to practise for some time any fantastic shapes which he can find drawn on flat surfaces, as on wall-papers, carpets, etc., in order to accustom himself to the strange and great changes which perspective causes in them.

Fig 63

The curves most required in architectural drawing, after the circle, are those of pointed arches; in which, however, all that will be generally needed is to fix the apex, and two points in the sides. Thus if we have to draw a range of pointed arches, such as A P B, Fig. 63, draw the measured arch to its sight-magnitude first neatly in a rectangle, A B C D; then draw the diagonals A D and B C;

where they cut the curve draw a horizontal line (as at the level E in the figure), and carry it along the range to the vanishing-point, fixing the points where the arches cut their diagonals all along. If the arch is cusped, a line should be drawn at F to mark the height of the cusps, and verticals raised at G and H, to determine the interval between them. Any other points may be similarly determined, but these will usually be enough. Figure 63 shows the perspective construction of a square niche of good Veronese Gothic, with an uncusped arch of similar size and curve beyond.

In Fig. 64 the more distant arch only is lettered, as the construction of the nearest explains itself more clearly to the eye without letters. The more dis-

Fig. 64

tant arch shows the general construction for all arches seen underneath, as of bridges, cathedral aisles, etc. The rectangle A B C D is first drawn to contain the outside arch; then the depth of the arch, A *a*, is determined

by the measuring-line, and the rectangle, *a b c d*, drawn for the inner arch.

A *a*, B, *b*, etc., go to one vanishing-point; A B, *a b*, etc., to the opposite one.

In the nearer arch another narrow rectangle is drawn to determine the cusp. The parts which would actually come into sight are slightly shaded.

PROBLEM XIV [p. 287]

Several exercises will be required on this important problem.

I. It is required to draw a circular flat-bottomed dish narrower at the bottom than the top; the vertical depth being given, and the diameter at the top and bottom.

Let *a b*, Fig. 65, be the diameter of the bottom, *a c* the diameter of the top, and *a d* its vertical depth.

Fig. 65

Take A D in position equal to *a c.*

On A D draw the square A B C D, and inscribe in it a circle.

Therefore, the circle so inscribed has the diameter of the top of the dish.

From A and D let fall verticals, A E, D H, each equal to *a d.*

Join E H, and describe square E F G H, which accordingly will be equal to the square A B C D, and be at the depth *a d* beneath it.

Within the square E F G H describe a square I K, whose diameter shall be equal to *a b.*

Describe a circle within the square I K. Therefore the circle so inscribed has its diameter equal to *a b ;* and it is in the centre of the square E F G H, which is vertically beneath the square A B C D.

Therefore the circle in the square I K represents the bottom of the dish.

Now the two circles thus drawn will either intersect one another, or they will not.

If they intersect one another, as in the figure, and they are below the eye, part of the bottom of the dish is seen within it.

To avoid confusion, let us take these two intersecting circles without the enclosing squares, as in Fig. 66.

Draw right lines, *a b, c d,* touching both circles externally. Then

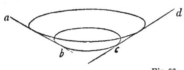

Fig. 66

the parts of these lines which connect the circles are the sides of the dish. They are drawn in Fig. 65 without any prolongations, but the best way to construct them is as in Fig. 66.

If the circles do not intersect each other, the smaller must either be within the larger or not within it.

If within the larger, the whole of the bottom of the dish is seen from above, Fig. 67 *a.*

If the smaller circle is not within the larger, none of the bottom is seen inside the dish, *b.*

If the circles are above instead of beneath the eye, the bottom of the dish is seen beneath it, *c.*

If one circle is above and another beneath the eye, neither the bottom nor top of the dish is seen, *d.* Unless the object be very large, the circles in this case will have little apparent curvature.

II. The preceding problem is simple, because the lines of the profile of the object (*a b* and *c d,* Fig. 66) are straight. But if these lines of profile are curved, the problem becomes much more complex: once mastered, however, it leaves no farther difficulty in perspective.

Let it be required to draw a flattish circular cup or vase, with a given curve of profile.

The basis of construction is given in Fig. 68, half of it only being drawn, in order that the eye may seize its lines easily.

Two squares (of the required size) are first drawn, one above the other, with a given vertical interval, A c, between them, and each is divided into eight parts by its diameters and diagonals. In these squares two circles are drawn; which are, therefore, of equal size, and one above the other. Two smaller circles, also of equal size, are drawn within these larger

Fig. 67

circles in the construction of the present problem; more may be necessary in some, none at all in others.

It will be seen that the portions of the diagonals and diameters of squares which are cut off between the circles represent radiating planes, occupying the position of the spokes of a wheel.

Now let the line A E B, Fig. 69, be the profile of the vase or cup to be drawn.

Enclose it in the rectangle c D, and if any portion of it is not curved, as A E, cut off the curved portion by the vertical line E F, so as to include it in the smaller rectangle F D.

Draw the rectangle A c B D in position, and upon it construct two squares

as they are constructed on the rectangle A C D in Fig. 68; and complete the construction of Fig. 68, making the radius of its large outer circles equal to A D, and of its small inner circles equal to A E.

The planes which occupy the position of the wheel-spokes will then each

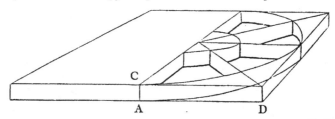

Fig. 68

represent a rectangle of the size of F D. The construction is shown by the dotted lines in Fig. 69; c being the centre of the uppermost circle.

Within each of the smaller rectangles between the circles, draw the curve E B in perspective, as in Fig. 69.

Draw the curve $x\,y$, touching and enclosing the curves in the rectangles, and meeting the upper circle at y.*

Then $x\,y$ is the contour of the surface of the cup, and the upper circle is its lip.

If the line $x\ y$ is long, it may be necessary to draw other rectangles between the eight principal ones; and, if the curve of profile A B is complex or retorted, there may be several lines corresponding to $x\ y$, enclosing the successive waves of the profile; and the outer curve will then be an undulating or broken one.

III. All branched ornamentation, forms of flowers, capitals of columns, machicolations of round towers, and other such arrangements of radiating curve, are resolvable by this problem, using more or fewer interior circles according to the conditions of the curves. Fig. 70 is an example of the construction of a circular group of eight trefoils with curved stems. One outer or limiting circle is drawn within the square E D C F, and the extremities of the

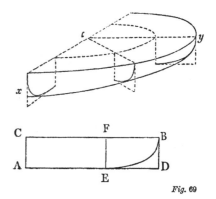

Fig. 69

trefoils touch it at the extremities of its diagonals and diameters. A smaller circle is at the vertical distance B C below the larger, and A is the angle of the square within which the smaller circle is drawn; but the square is not given, to avoid confusion. The stems of the trefoils form drooping curves,

* This point coincides in the figure with the extremity of the horizontal diameter, but only accidentally.

XV.

arranged on the diagonals and diameters of the smaller circle, which are dotted. But no perspective laws will do work of this intricate kind so well as the hand and eye of a painter.

IV. There is one common construction, however, in which, singularly, the

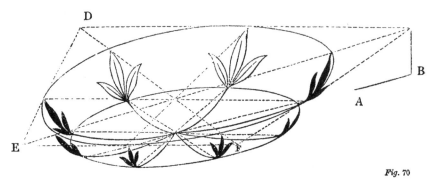

Fig. 70

hand and eye of the painter almost always fail, and that is the fillet of any ordinary capital or base of a circular pillar (or any similar form). It is rarely necessary in practice to draw such minor details in perspective ; yet the per-

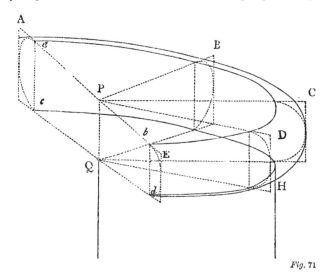

Fig. 71

spective laws which regulate them should be understood, else the eye does not see their contours rightly until it is very highly cultivated.

Fig. 71 will show the law with sufficient clearness ; it represents the perspective construction of a fillet whose profile is a semicircle, such as F H in

Fig. 60, seen above the eye. Only half the pillar with half the fillet is drawn, to avoid confusion.

Q is the centre of the shaft.

P Q the thickness of the fillet, sight-magnitude at the shaft's centre.

Round P a horizontal semicircle is drawn on the diameter of the shaft *a b*.

Round Q another horizontal semicircle is drawn on diameter *c d*.

These two semicircles are the upper and lower edges of the fillet.

Then diagonals and diameters are drawn as in Fig. 68, and at their extremities, semicircles in perspective, as in Fig. 69.

The letters A, B, C, D, and E, indicate the upper and exterior angles of the rectangles in which these semicircles are to be drawn; but the inner vertical line is not dotted in the rectangle at C, as it would have confused itself with other lines.

Then the visible contour of the fillet is the line which encloses and touches * all the semicircles. It disappears behind the shaft at the point H, but I have drawn it through to the opposite extremity of the diameter at *d*.

Turned upside down the figure shows the construction of a basic fillet as seen below the eye.

The capital of a Greek Doric pillar should be drawn frequently for exercise on this fourteenth problem, the curve of its echinus being exquisitely subtle, while the general contour is simple.

PROBLEM XVI [p. 293]

It is often possible to shorten other perspective operations considerably, by finding the vanishing-points of the inclined lines of the object. Thus, in drawing the gabled roof in Fig. 43, if the gable A Y C be drawn in perspective, and the vanishing-point of A Y determined, it is not necessary to draw the two sides of the rectangle, A' D' and D' B', in order to determine the point Y'; but merely to draw Y Y' to the vanishing-point of A A' and A' Y' to the vanishing-point of A Y, meeting in Y', the point required.

Again, if there be a series of gables, or other figures produced by parallel inclined lines, and retiring to the point V, as in Fig. 72, it is not necessary to draw each separately, but merely to determine their breadths on the line A V, and draw the slopes of each to their vanishing-points, as shown in Fig. 72. Or if the gables are equal in height, and a line be drawn from Y to V, the construction resolves itself into a zigzag drawn alternately to P and Q, between the lines Y V and A V.

The student must be very cautious, in finding the vanishing-points of inclined lines, to notice their relations to the horizontals beneath them, else he may easily mistake the horizontal to which they belong.

* The engraving is a little inaccurate; the enclosing line should semicircles at A and B. The student should draw it on a large scale.

Thus, let A B C D, Fig. 73, be a rectangular inclined plane, and let it be required to find the vanishing-point of its diagonal B D.

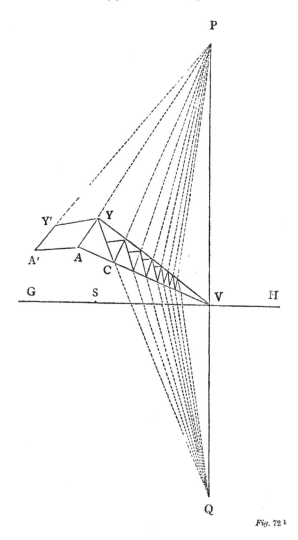

Fig. 72 [1]

Find v, the vanishing-point of A D and B C.

[1] [Ruskin in his copy for revision notes that he intended to complete the figure— *i.e.*, by carrying on the diminishing triangles.]

Draw A E to the opposite vanishing-point, so that D A E may represent a right angle.

Let fall from B the vertical B E, cutting A E in E.

Join E D, and produce it to cut the sight-line in v'.

Then, since the point E is vertically under the point B, the horizontal line E D is vertically under the inclined line B D. So that if we now let

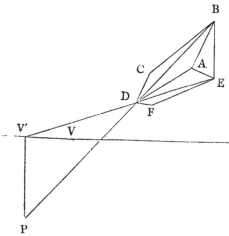

Fig. 73

fall the vertical v' P from v', and produce B D to cut v' P in P, the point P will be the vanishing-point of B D, and of all lines parallel to it.*

PROBLEM XVIII [p. 297]

Before examining the last three problems it is necessary that you should understand accurately what is meant by the position of an inclined plane.

Cut a piece of strong white pasteboard into any irregular shape, and

* The student may perhaps understand this construction better by completing the rectangle A D F E, drawing D F to the vanishing-point of A E, and E F to v. The whole figure, B F, may then be conceived as representing half the gable roof of a house, A F the rectangle of its base, and A C the rectangle of its sloping side.

In nearly all picturesque buildings, especially on the Continent, the slopes of gables are much varied (frequently unequal on the two sides), and the vanishing-points of their inclined lines become very important, if accuracy is required in the inter-sections of tiling, sides of dormer windows, etc.

Obviously, also, irregular triangles and polygons in vertical planes may be more easily constructed by finding the vanishing-points of their sides, than by the con-struction given in the corollary to Problem IX. [p. 275]; and if such triangles or polygons have others concentrically inscribed within them, as often in Byzantine mosaics, etc., the use of the vanishing-points will become essential.

dip it in a sloped position into water. However you hold it, the edge of the water, of course, will always draw a horizontal line across its surface. The direction of this horizontal line is the direction of the inclined plane. (In beds of rock geologists call it their "strike.")

Next, draw a semicircle on the piece of pasteboard; draw its diameter, A B, Fig. 74, and a vertical line from its centre, C D; and draw some other lines, C E, C F, etc., from the centre to any points in the circumference.

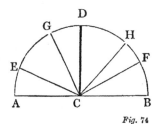

Fig. 74

Now dip the piece of pasteboard again into water, and holding it at any inclination and in any direction you choose, bring the surface of the water to the line A B. Then the line C D will be the most steeply inclined of all the lines drawn to the circumference of the circle; G c and H c will be less steep; and E c and F c less steep still. The nearer the lines to C D, the steeper they will be; and the nearer to A B, the more nearly horizontal.

When, therefore, the line A B is horizontal (or marks the water surface), its direction is the direction of the inclined plane, and the inclination of the line D c is the inclination of the inclined plane. In beds of rock geologists call the inclination of the line D c their "dip."

To fix the position of an inclined plane, therefore, is to determine the direction of any two lines in the plane, A B and C D, of which one shall be horizontal and the other at right angles to it. Then any lines drawn in the inclined plane, parallel to A B, will be horizontal; and lines drawn parallel to C D will be as steep as C D, and are spoken of in the text [p. 300] as the "steepest lines" in the plane.

But farther, whatever the direction of a plane may be, if it be extended indefinitely, it will be terminated, to the eye of the observer, by a boundary line, which, in a horizontal plane, is horizontal (coinciding nearly with the visible horizon);—in a vertical plane, is vertical;—and, in an inclined plane, is inclined.

This line is properly, in each case, called the "sight-line" of such plane; but it is only properly called the "horizon" in the case of a horizontal plane: and I have preferred using always the term "sight-line," not only because more comprehensive, but more accurate; for though the curvature of the earth's surface is so slight that practically its visible limit always coincides with the sight-line of a horizontal plane, it does not mathematically coincide with it, and the two lines ought not to be considered as theoretically identical, though they are so in practice.

It is evident that all vanishing-points of lines in any plane must be found on its sight-line, and, therefore, that the sight-line of any plane may be found by joining any two of such vanishing-points. Hence the construction of Problem XVIII. [p. 297].

DEMONSTRATIONS WHICH COULD NOT CON VENIENTLY BE INCLUDED IN THE TEXT

I

THE SECOND COROLLARY, PROBLEM II [p. 256]

IN Fig. ⌒ omit the lines C D, C′ D′, and D S; and, as here in Fig. 75, from

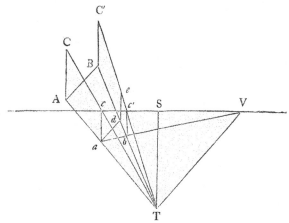

Fig. 75

a draw $a\,d$ parallel to A B, cutting B T in d; and from d draw $d\,e$ parallel to B C.

Now as $a\,d$ is parallel to A B—

$$\text{A C}: a\,c :: \text{B C}: d\,e;$$

but A C is equal to B $c′$—

$$a\,c = d$$

Now because the triangles $a\,c$ V, $b\,c′$ V, are similar—

$$a\,c : b\,c′ :: a\,\text{V} : b\,\text{V};$$

and because the triangles $d\,e$ T, $b\,c′$ T are similar—

$$d\,e : b\,c′ :: d\,\text{T} : b\,\text{T}.$$

327

But $a\ c$ is equal to $d\ e$—

$$\therefore\ a\ \text{v} : b\ \text{v} :: d\ \text{T} : b\ \text{T};$$

the two triangles $a\ b\ d$, $b\ \text{T}\ \text{v}$, are similar, and their angles are alternate ;

$$\therefore\ \text{T}\ \text{v is parallel to } a\ d.$$

But $a\ d$ is parallel to A B—

$$\therefore\ \text{T}\ \text{v is parallel to A B.}$$

II

THE THIRD COROLLARY, PROBLEM III [p. 261]

In Fig. 13, since a R is by construction parallel to A B in Fig. 12, and T v is by construction in Problem III. also parallel to A B

$$\therefore\ a\ \text{R is parallel to T v,}$$

$$\therefore\ a\ b\ \text{R and T } b\ \text{v are alternate triangles,}$$

$$\therefore\ a\ \text{R} : \text{T v} :: a\ b : b\ \text{v.}$$

Again, by the construction of Fig. 13, a R′ is parallel to M v—

$$\therefore\ a\ b\ \text{R′ and M } b\ \text{v are alternate triangles,}$$

$$\therefore\ a\ \text{R′} : \text{M v} :: a\ b : b\ \text{v.}$$

And it has just been shown that also

$$a\ \text{R} : \text{T v} :: a\ b : b\ \text{v}$$

$$a\ \text{R′} : \text{M v} :: a\ \text{R} : \text{T v.}$$

But by construction, a R′ $= a$ R—

$$\therefore\ \text{M v} = \text{T v.}$$

III

ANALYSIS OF PROBLEM XVI [p. 293]

We proceed to take up the general condition of the second problem, before left unexamined, namely, that in which the vertical distances B c′ and A c (Fig. 6, page 254), as well as the direct distances T D and T D′ are unequal.

In Fig. 6, here repeated (Fig. 76), produce c′ B downwards, and make c′ E equal to c A.

Join A E.

Then, by the second Corollary of Problem II., A E is a horizontal line.

Draw T v parallel to A E, cutting the sight-line in v.

v is the vanishing-point of A E.

Complete the constructions of Problem II. and its second Corollary.

Then by Problem II. $a\ b$ is the line A B drawn in perspective; and by its Corollary $a\ e$ is the line A E drawn in perspective.

From v erect perpendicular v P, and produce *a b* to cut it in P.
Join T P, and from *e* draw *e f* parallel to A E, and cutting A T in *f*.
Now in triangles E B T and A E T, as *e b* is parallel to E B and *e f* to A E ;—
e b : *e f* :: E B : A E.
But T v is also parallel to A E and P v to *e b*.

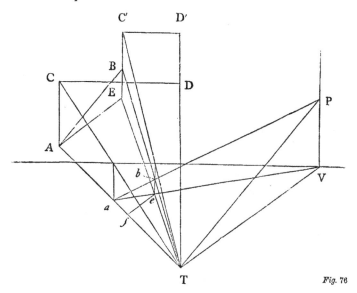

T *Fig. 76*

Therefore also in the triangles *a* P v and *a* v T,

$$e\ b : e\ f :: P\ V : V\ T.$$

Therefore P V : V T :: E B : A E.
And, by construction, angle T v P = ∠ A E B.
Therefore the triangles T v P, A E B, are similar ; and T P is parallel to A B.

Now the construction in this problem is entirely general for any inclined line A B, and a horizontal line A E in the same vertical plane with it.

So that if we find the vanishing-point of A E in v, and from v erect a vertical v P, and from T draw T P parallel to A B, cutting v P in P, P will be the vanishing-point of A B, and (by the same proof as that given at page 258) of all lines parallel to it.

Next, to find the dividing-point of the inclined line [p. 295].
I remove some unnecessary lines from the last figure and repeat it here, Fig. 77, adding the measuring-line *a* M, that the student may observe its position with respect to the other lines before I remove any more of them.

Now if the line A B in this diagram represented the length of the line A B in reality (as A B *does* in Figs. 10 and 11), we should only have to proceed to modify Corollary III. of Problem II. to this new construction. We shall see presently that A B does not represent the actual length of the inclined line

A B in nature, nevertheless we shall first proceed as if it did, and modify our result afterwards.

In Fig. 77 draw a d parallel to A B, cutting B T in d.

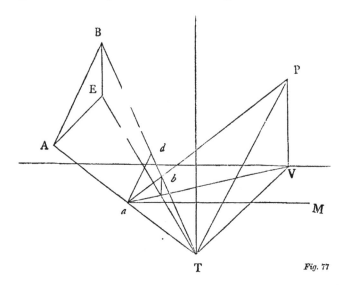

Fig. 77

Therefore a d is the sight-magnitude of A B, as a R is of A B in Fig. 11.

Remove again from the figure all lines except P V, V T, P T, a b, a d, and the measuring-line.

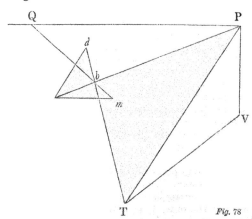

Fig. 78

Set off on the measuring-line a m equal to a d.

Draw P Q parallel to a m, and through b draw m Q, cutting P Q in

Then, by the proof already given in pages 261 and 328, P Q = P T.

Therefore if P is the vanishing-point of an inclined line A B, and Q P is a horizontal line drawn through it, make P Q equal to P T, and *a m* on the measuring-line equal to the sight-magnitude of the line A B *in the diagram,* and the line joining *m* Q will cut *a* P in *b*.

We have now, therefore, to consider what relation the length of the line A B in this diagram, Fig. 77, has to the length of the line A B in reality.

Now the line A E in Fig. 77 represents the length of A E in reality.

But the angle A E B, Fig. 77, and the corresponding angle in all the constructions of the earlier problems, is in reality a right angle, though in the diagram necessarily represented as obtuse.

Therefore, if from E we draw E C, as in Fig. 79, at right angles to A E, make E C = E B, and join A C, A C will be the real length of the line A B.

Fig. 79

Now, therefore, if instead of *a m* in Fig. 78, we take the real length of A B, that real length will be to *a m* as A C to A B in Fig. 79.

And then, if the line drawn to the measuring-line P Q is still to cut *a* P in *b*, it is evident that the line P Q must be shortened in the same ratio that *a m* was shortened, and the true dividing-point will be Q′ in Fig. 80, fixed so that Q′ P shall be to Q P as *a m′* is to *a m : a m′* representing the real length of A D.

Fig. 80

But *a m′* is therefore to *a m* as A C is to A B in Fig. 79.

Therefore P Q′ must be to P Q as A C is to A B.

But P Q equals P T (Fig. 78); and P V is to V T (in Fig. 78) as B E is to A E (Fig. 79).

Hence we have only to substitute P V for E C, and V T for A E, in Fig. 79, and the resulting diagonal A C will be the required length of P Q′.

It will be seen that the construction given in the text (Fig. 46) is the simplest means of obtaining this magnitude, for V D in Fig. 46 (or V M in Fig. 15) = V T by construction in Problem IV. It should, however, be observed, that the distance P Q′ or P X, in Fig. 46, may be laid on the sight-line of the inclined plane itself, if the measuring-line be drawn parallel to that sight-line. And thus any form may be drawn on an inclined plane as conveniently as on a horizontal one, with the single exception of the radiation of the verticals, which have a vanishing-point, as shown in Problem XX. [p. 300].

III

THE LAWS OF FÉSOLE

(1877–1878)

THE LAWS OF FÉSOLE.

A FAMILIAR TREATISE

ON THE ELEMENTARY PRINCIPLES AND PRACTICE

OF

DRAWING AND PAINTING.

AS DETERMINED BY THE TUSCAN MASTERS.

ARRANGED FOR THE USE OF SCHOOLS.

BY

JOHN RUSKIN, LL.D.,

HONORARY STUDENT OF CHRIST CHURCH, AND SLADE PROFESSOR OF FINE ARTS.

VOLUME I.

GEORGE ALLEN,
SUNNYSIDE, ORPINGTON, KENT.
1879.

[*Bibliographical Note.*—This work originally came out in four parts, which were afterwards collected into "Volume I." No further parts were published; there is, therefore, no "Volume II."

First Edition. In Parts (1877–1878).—Each of these was furnished with a title-page, similar to that given here (on the preceding page), except that "Part I.," etc., took the place of "Volume I.," and that the date was "1877" in the case of Part I., and "1878" in the others. Part I. contained pp. 1–48 (*i.e.*, down to the end of ch. v. § 7); Part II., pp. 49–96 (ch. v. § 8 to ch. vii. § 9, "Be sure that you are always ready"); Part III., pp. 97–144 (to ch. ix. § 7, "the Devon line. Its"); and Part IV., pp. 145–208 (containing the remainder of the volume).

The parts were issued in pale buff-coloured wrappers, with the title-page (enclosed in a double-ruled frame) reproduced upon the front, and the addition of the Rose above the publisher's imprint, and "Price Half-a-Crown" below the frame.

A slip was inserted at the commencement of each Part as follows :—

"NOTICE.—Extra copies (on larger paper) of the plates used in the 'Laws of Fésole' can be had for copying purposes, in sets as published in each Part, at the rate of sixpence per plate, post free, on application to Mr. Allen."

Such copies are no longer supplied.

Part I. was issued on September 21, 1877. A second edition of it appeared in 1879 ; and a third in 1885. One thousand copies were printed of each issue.

Part II. was issued in July 1878 ; a second edition in 1880 ; a third in 1889 (650 copies).

Part III. was issued in October 1878 ; a second edition in 1881 ; a third in 1889 (600 copies).

Part IV. was issued in March 1879 ; a second edition in 1882 ; a third (400 copies) in 1891.

The later issues of the several parts all bear the words "Second" (or "Third") "Thousand" (or "Edition") upon both title-page and wrapper. The first editions bore the imprint of Hazell, Watson, and Viney : the later, of the Chiswick Press.

With Part IV. were issued the Title-page and Contents to Vol. I., and Part I. had been preceded by a half-title. The First Edition of the book was issued in these Parts only. The title-page was as given here (on the preceding page). The collation of the book is :—

Octavo, pp. xvi.+208. "Contents of Vol. I.," pp. iii., iv. (here pp. 349, 350); Preface, pp. v.–xvi. (here pp. 341–347); Text, pp. 1–208. The headlines

were as given in this edition. The imprint (at the foot of the reverse of the title-page) was "Hazell, Watson & Viney, Printers, London and Aylesbury."

Second Edition (1882).—By this time all the Parts were in their second edition. The title-page varies from that of the preceding issue, reading thus after the author's name : "Honorary Student of Christ Church, and Honorary Fellow of Corpus | Christi College, Oxford. | Volume I. | Second Thousand. | George Allen, | Sunnyside, Orpington, Kent. | 1882." The imprint was also different, thus : "Chiswick Press :—C. Whittingham and Co., Took's Court, | Chancery Lane." Issued in mottled-grey paper boards, with a white paper back label which reads : "Ruskin. | Laws of | Fésole. | Vol. I." Price 10s.

Third Edition (1890).—The title-page follows that of the Second Issue, except for the substitution of "Third Edition" for "Second Thousand," and that the publisher's imprint reads after "Kent,"—"and | 8, Bell Yard, Temple Bar, London. | 1890." The imprint now reverted to "Hazell, Watson and Viney." In April 1893, the price of the separate Parts was reduced to 2s. each, and of the collected volume to 8s.

No *Reviews* of the work appeared ; Ruskin's publications at this time were not sent to the press.

———————

There are few *variations in the text* of the work in any of the editions above described, except alterations in references to the author's books, and the correction of a transliteration ("contemplatde") in ed. 1 in the author's footnote to ch. viii. § 10.

In the present edition the author's revisions are incorporated (see above, p. xxix.), and a few misprints, etc., have been corrected. These alterations are as follow :—

Preface, § 9, line 18, "82" has been altered to "32" ; § 10, last line but one, all previous editions misprint "effect" for "effort."

Ch. i. § 6, line 20, "expressing the pleasure of a loving heart" is the author's revision of "speaking the pleasure of a great heart" ; so in § 11, last line, "in his compartment" is his revision for "within his compass" ; and § 12, last line, "as subjects" for "for subjects."

Ch. ii., the numbering of the paragraphs was incorrect in all previous editions, there being no § 4 or § 6.

Ch. iii. § 2, line 10, "squares" is the author's correction of "square."

Ch. iv. § 3 n., "Julien" is here corrected to "Jullien."

Ch. v. § 17, in the quotation from Humboldt "a" has hitherto been omitted before "fear," and "Lataniers" misprinted "Latainers."

Ch. vi. § 2 n., the author's reference "*Pursuivant of Arms,* p. 48" has here been amplified in an editorial note in accordance with a pencilled revision by the author ; § 6, the words "imbricated," "form," and "colour" were italicised by the author in revision ; so also "re-weaves" in § 10 ; and in § 11, line 3, "now" was inserted.

Ch. vii. § 17, line 14, "Verd" is here corrected to "Vert" ; § 20,

line 8, "165" here corrected to "163"; § 29, line 21, "ophryds" to "ophrys"; § 31, line 10, ed. 3 supplemented in the text the author's reference to *Eagle's Nest*; the reference is now given in a footnote.

Ch. ix. § 20, previous editions contained the following author's footnote :—

> "By a mistake of the engraver, the small letters, though all printed by myself in Roman form, have been changed, throughout the figures in this chapter, into italics. But in copying them, let them all be carefully printed in Roman type."

In this edition the letters have been corrected in accordance with this note; the figures thus altered are 19, 20, 23, 24, 25, 26, 27, 28, 29.

Ch. x. § 1, line 5, the reference to *Proserpina* has been altered to suit the present edition; § 19, last line, "piece" in former editions is here corrected to "peace"; § 24 *n.*, ed. 1 reads "4·03" for "14·03"; § 37, line 19, "nine" in previous editions (an obvious slip of the pen) is here corrected to "ten."

In this volume omissions are made in two places, where the passages in question have already been printed in this edition : see below, pp. 432, 439.

The numbering of the paragraphs in the *Preface* is here introduced.]

PREFACE

1. THE publication of this book has been delayed by what seemed to me vexatious accident, or (on my own part) unaccountable slowness in work: but the delay thus enforced has enabled me to bring the whole into a form which I do not think there will be any reason afterwards to modify in any important particular, containing a system of instruction in art generally applicable in the education of gentlemen; and securely elementary in that of professional artists. It has been made as simple as I can in expression, and is specially addressed, in the main teaching of it, to young people, (extending the range of that term to include students in our universities;) and it will be so addressed to them, that if they have not the advantage of being near a master, they may teach themselves, by careful reading, what is essential to their progress. But I have added always to such initial principles, those which it is desirable to state for the guidance of advanced scholars, or the explanation of the practice of exemplary masters.

2. The exercises given in this book, when their series is completed, will form a code of practice which may advisedly be rendered imperative on the youth of both sexes who show disposition for drawing. In general, youths and girls who do not wish to draw should not be compelled to draw;[1] but when natural disposition exists, strong enough to render wholesome discipline endurable with patience, every well-trained youth and girl ought to be taught the elements of drawing, as of music, early, and accurately.

To teach them inaccurately is indeed, strictly speaking,

[1] [Compare preface to *Elements of Drawing*, § 2, above, p. 11.]

not to teach them at all; or worse than that, to prevent the possibility of their ever being taught. The ordinary methods of water-colour sketching, chalk drawing, and the like, now so widely taught by second-rate masters, simply prevent the pupil from ever understanding the qualities of great art, through the whole of his after-life.

3. It will be found also that the system of practice here proposed differs in many points, and in some is directly adverse, to that which has been for some years instituted in our public schools of art. It might be supposed that this contrariety was capricious or presumptuous, unless I gave my reasons for it, by specifying the errors of the existing popular system.

The first error in that system is the forbidding accuracy of measurement,[1] and enforcing the practice of guessing at the size of objects. Now it is indeed often well to outline at first by the eye, and afterwards to correct the drawing by measurement; but under the present method, the student finishes his inaccurate drawing to the end, and his mind is thus, during the whole progress of his work, accustomed to falseness in every contour. Such a practice is not to be characterized as merely harmful,—it is ruinous. No student who has sustained the injury of being thus accustomed to false contours, can ever recover precision of sight. Nor is this all: he cannot so much as attain to the first conditions of art-judgment. For a fine work of art differs from a vulgar one by subtleties of line which the most perfect measurement is not, alone, delicate enough to detect; but to which precision of attempted measurement directs the attention; while the security of boundaries, within which maximum error *must* be restrained, enables the hand gradually to approach the perfectness which instruments cannot. Gradually, the mind then becomes conscious of the beauty which, even after this honest effort, remains inimitable; and the faculty of discrimination increases alike through failure and success. But when the

[1] [Compare on this subject, *Lectures on Art*, § 142, and Leonardo's *Treatise*, § 1.]

true contours are voluntarily and habitually departed from, the essential qualities of every beautiful form are necessarily lost, and the student remains for ever unaware of their existence.

4. The second error in the existing system is the enforcement of the execution of finished drawings in light and shade, before the student has acquired delicacy of sight enough to observe their gradations. It requires the most careful and patient teaching to develop this faculty; and it can only be developed at all by *rapid* and *various* practice from natural objects, during which the attention of the student must be directed only to the facts of the shadows themselves, and not at all arrested on methods of producing them. He may even be allowed to produce them as he likes, or as he can; the thing required of him being only that the shade be of the right darkness, of the right shape, and in the right relation to other shades round it; and not at all that it shall be prettily cross-hatched, or deceptively transparent. But at present, the only virtues required in shadow are that it shall be pretty in texture and picturesquely effective; and it is not thought of the smallest consequence that it should be in the right place, or of the right depth. And the consequence is that the student remains, when he becomes a painter, a mere manufacturer of conventional shadows of agreeable texture, and to the end of his life incapable of perceiving the conditions of the simplest natural passage of chiaroscuro.

5. The third error in the existing code, and, in ultimately destructive power, the worst, is the construction of entirely symmetrical or balanced forms for exercises in ornamental design; whereas every beautiful form in this world, is varied in the minutiæ of the balanced sides. Place the most beautiful of human forms in exact symmetry of position, and curl the hair into equal curls on both sides, and it will become ridiculous, or monstrous. Nor can any law of beauty be nobly observed without occasional wilfulness of violation.

The moral effect of these monstrous conditions of orna-
ment on the mind of the modern designer is very singular.
I have found, in past experience in the Working Men's
College, ` and recently at Oxford, that the English student
must at present of necessity be inclined to one of two
opposite errors, equally fatal. Either he will draw things
mechanically and symmetrically altogether, and represent
the two sides of a leaf, or of a plant, as if he had cut
them in one profile out of a doubled piece of paper; or he
will dash and scrabble for effect, without obedience to law
of any kind : and I find the greatest difficulty, on the one
hand, in making ornamental draughtsmen draw a leaf of
any shape which it could possibly have lived in;[1] and, on
the other, in making landscape draughtsmen draw a leaf
of any shape at all. So that the process by which great
work is achieved, and by which only it can be achieved,
is in both directions antagonistic to the present English
mind. Real artists are absolutely submissive to law, and
absolutely at ease in fancy; while we are at once wilful
and dull; resolved to have our own way, but when we
have got it, we cannot walk two yards without holding by
a railing.

6. The tap-root of all this mischief is in the endeavour
to produce some ability in the student to make money by
designing for manufacture. No student who makes this his
primary object will ever be able to design at all; and the
very words "School of Design" involve the profoundest of
Art fallacies. Drawing may be taught by tutors: but
Design only by Heaven;[2] and to every scholar who thinks
to sell his inspiration, Heaven refuses its help.

7. To what kind of scholar, and on what conditions,
that help has been given hitherto, and may yet be hoped
for, is written with unevadeable clearness in the history of
the Arts of the Past. And this book is called *The Laws
of Fésole* because the entire system of possible Christian

[1] [Compare the experience recorded by Ruskin in Vol. XII. p. 89 n.]
[2] [Compare the preface to *Elements of Drawing*, § 6.]

Art is founded on the principles established by Giotto in Florence, he receiving them from the Attic Greeks through Cimabue, the last of their disciples, and engrafting them on the existing art of the Etruscans, the race from which both his master and he were descended.[1]

In the centre of Florence, the last great work of native Etruscan architecture,[2] her Baptistery, and the most perfect work of Christian architecture, her Campanile, stand within a hundred paces of each other: and from the foot of that Campanile, the last conditions of design which preceded the close of Christian art are seen in the dome of Brunelleschi. Under the term "laws of Fésole," therefore, may be most strictly and accurately arranged every principle of art, practised at its purest source, from the twelfth to the fifteenth century inclusive. And the purpose of this book is to teach our English students of art the elements of these Christian laws, as distinguished from the Infidel laws of the spuriously classic school, under which, of late, our students have been exclusively trained.

8. Nevertheless, in this book the art of Giotto and Angelico[3] is not taught because it is Christian, but because it is absolutely true and good: neither is the Infidel art of Palladio and Giulio Romano[4] forbidden because it is Pagan; but because it is false and bad; and has entirely destroyed

[1] [Ruskin in his copy for revision has marked § 7 as "questionable." He was, however, at the time when he wrote this book much impressed by the apparent connexion between Greek and Etruscan art: see his preface to "The Economist of Xenophon" in vol. i. of *Bibliotheca Pastorum.* Compare also Vol. IX. p. 36 *n.* So also Ruskin often insisted on the continuity of Etruscan influence in the Florentine art of the Middle Ages. See, for instance, his comparison in certain details between the "Cervetri Sarcophagus," in the British Museum, and a Madonna by Lippi (*Fors Clavigera,* Letters 66 and 71). See also *Ariadne Florentina,* § 69, for the influence of Etruscan metal work. The Etruscan Fæsulæ is described in vol. ii. (ch. xli.) of Dennis's *Cities and Cemeteries of Etruria.*]

[2] [Compare *Seven Lamps,* Vol. VIII. p. 187.]

[3] [Ruskin's "conclusive lessons" with regard to the laws of line and colour were given him, he says, not by Venetians, but the three Florentines, Botticelli, Giotto, and Angelico ; so that he was forced to call his lesson-book *The Laws of Fésole* (see Vol. XIII. p. 525). For Angelico as the standard in colour, see below, ch. vii. p. 420 *n.*]

[4] [For other references to Palladio and Giulio Romano as typifying the architecture and painting of the infidel Renaissance, see Vol. V. p. 93 ; Vol. VI. p. 447 ; Vol. IX. p. 46.]

not only our English schools of art, but all others in which it has ever been taught, or trusted in.

Whereas the methods of draughtsmanship established by the Florentines, in true fulfilment of Etruscan and Greek tradition, are insuperable in execution, and eternal in principle; and all that I shall have occasion here to add to them will be only such methods of their application to landscape as were not needed in the day of their first invention; and such explanation of their elementary practice as, in old time, was given orally by the master.

9. It will not be possible to give a sufficient number of examples for advanced students (or on the scale necessary for some purposes) within the compass of this handbook; and I shall publish therefore together with it, as I can prepare them, engravings or lithographs of the examples in my Oxford schools, on folio sheets, sold separately.[1] But this handbook will contain all that was permanently valuable in my former *Elements of Drawing*, together with such further guidance as my observance of the result of those lessons has shown me to be necessary. The work will be completed in twelve numbers, each containing at least two engravings, the whole forming, when completed, two volumes of the ordinary size of my published works;[2] the first, treating mostly of drawing, for beginners; and the second, of colour, for advanced pupils. I hope also that I may prevail on the author of the excellent little treatise on Mathematical Instruments (Weale's Rudimentary Series, No. 32), to publish a lesson-book with about one-fourth of the contents of that formidably comprehensive volume,[3] and in larger print, for the use of students of art;

[1] [Here, again, see the Introduction, p. xxviii.]

[2] [As actually published, four "parts" were issued, subsequently bound up as Volume I., although no second volume was published. For an account of MS. material for further parts, see below, Appendix, pp. 495–501.]

[3] [*A Treatise on Mathematical Instruments*, by J. F. Heather, being No. 32 in "Weale's Rudimentary Series," afterwards transferred to Messrs. Virtue. The treatise ran through several editions, the fourteenth (1888) being revised with additions by A. T. Walmisley (Crosby Lockwood & Son), but the curtailment suggested by Ruskin was not adopted.]

omitting therefrom the descriptions of instruments useful only to engineers, and without forty-eight pages of advertisements at the end of it. Which, if I succeed in persuading him to do, I shall be able to make permanent reference to his pages for elementary lessons on construction.

10. Many other things I meant to say, and advise, in this Preface; but find that were I to fulfil such intentions, my Preface would become a separate book, and had better therefore end itself forthwith, only desiring the reader to observe, in sum, that the degree of success, and of pleasure, which he will finally achieve, in these or any other art-exercises on a sound foundation, will virtually depend on the degree in which he desires to understand the merit of others, and to make his own talents permanently useful. The folly of most amateur work is chiefly in its selfishness, and self-contemplation; it is far better not to be able to draw at all, than to waste life in the admiration of one's own littlenesses;—or, worse, to withdraw, by merely amusing dexterities, the attention of other persons from noble art. It is impossible that the performance of an amateur can ever be otherwise than feeble in itself; and the virtue of it consists only in having enabled the student, by the effort of its production, to form true principles of judgment, and direct his limited powers to useful purposes.

BRANTWOOD, *31st July*, 1877.

CONTENTS

THE LAWS OF FÉSOLE

CHAPTER I

ALL GREAT ART IS PRAISE

1. THE art of man is the expression of his rational and disciplined delight in the forms and laws of the Creation of which he forms a part.[1]

2. In all first definitions of very great things, there must be some obscurity and want of strictness; the attempt to make them too strict will only end in wider obscurity. We may indeed express to our friend the rational and disciplined pleasure we have in a landscape, yet not be artists: but it is true, nevertheless, that all art is the skilful expression of such pleasure; not always, it may be, in a thing seen, but only in a law felt; yet still, examined accurately, always in the Creation, of which the creature forms a part; and not in itself merely. Thus a lamb at play, rejoicing in its own life only, is not an artist;—but the lamb's shepherd, carving the piece of timber which he lays for his door-lintel into beads, is expressing, however unconsciously, his pleasure in the laws of time, measure, and order, by which the earth moves, and the sun abides in heaven.

3. So far as reason governs, or discipline restrains, the art even of animals, it becomes human, in those virtues; but never, I believe, perfectly human, because it never, so

[1] [In his copy for revision Ruskin notes this aphorism as "too subtle," and adds to it that art must also be "subordinate to use," referring to the beginning of ch. ix. (p. 440).]

far as I have seen, expresses even an unconscious delight in divine laws. A nightingale's song is indeed exquisitely divided; but only, it seems to me, as the ripples of a stream, by a law of which the waters and the bird are alike unconscious. The bird is conscious indeed of joy and love, which the waters are not;—but, (thanks be to God,) joy and love are not Arts; nor are they limited to Humanity. But the love-*song* becomes Art, when, by reason and discipline, the singer has become conscious of the ravishment of its divisions to the lute.

4. Farther to complete the range of our definition, it is to be remembered that we express our delight in a beautiful or lovely thing no less by lament for its loss, than gladness in its presence, much art is therefore tragic or pensive; but all true art is praise.*

5. There is no exception to this great law, for even caricature is only artistic in conception of the beauty of

* As soon as the artist forgets his function of praise in that of imitation, his art is lost.[1] His business is to give, by any means, however imperfect, the idea of a beautiful thing; not, by any means, however perfect, the realization of an ugly one. In the early and vigorous days of Art, she endeavoured to praise the saints, though she made but awkward figures of them. Gradually becoming able to represent the human body with accuracy, she pleased herself greatly at first in this new power, and for about a century decorated all her buildings with human bodies in different positions. But there was nothing to be praised in persons who had no other virtue than that of possessing bodies, and no other means of expression than unexpected manners of crossing their legs. Surprises of this nature necessarily have their limits, and the Arts founded on Anatomy expired when the changes of posture were exhausted.[2]

[1] [To this definition Ruskin often recurred, generally citing it as "All great art is praise." See Vol. IV. p. 153 n.; Vol. VIII. p. 11 n.; *The Art of England*, § 58; and *Fiction, Fair and Foul*, § 42, in which latter place he adds that "the contrary is also true, all foul or miscreant art is accusation." Other definitions of great art, or aphoristic sayings, will be found in *Stones of Venice*, vol. iii. (Vol. XI. p. 201): "art is valuable or otherwise, only as it expresses . . . a good and great human soul"; *Modern Painters*, vol. iii. (Vol. V. p. 44): "great art is that which represents what is beautiful and good"; *ibid.*, p. 189: "greatness in art is the expression of a mind of a God-made great man"; *Two Paths*, § 45: "great art is nothing else than the type of strong and noble life"; *ibid.*, § 54: "Fine Art is that in which the hand, the head, and the *heart* of man go together."]

[2] [For a summary of Ruskin's references to the subject of anatomy, see Vol. IV. p. 155 n.]

which it exaggerates the absence. Caricature by persons who cannot conceive beauty, is monstrous in proportion to that dulness; and, even to the best artists, perseverance in the habit of it is fatal.[1]

6. Fix, then, this in your mind as the guiding principle of all right practical labour, and source of all healthful life energy,—that your art is to be the praise of something that you love.[2] It may be only the praise of a shell[3] or a stone; it may be the praise of a hero; it may be the praise of God:—your rank as a living creature is determined by the height and breadth of your love; but, be you small or great, what healthy art is possible to you must be the expression of your true delight in a real thing, better than the art. You may think, perhaps, that a bird's nest by William Hunt is better than a real bird's nest. We indeed pay a large sum for the one, and scarcely care to look for, or save, the other. But it would be better for us that all the pictures in the world perished, than that the birds should cease to build nests.

And it is precisely in its expression of this inferiority, that the drawing itself becomes valuable. It is because a photograph cannot condemn itself, that it is worthless. The glory of a great picture is in its shame; and the charm of it, in expressing the pleasure of a loving heart, that there is something better than picture. Also it speaks with the voices of many: the efforts of thousands dead, and their passions, are in the pictures of their children to-day. Not with the skill of an hour, nor of a life, nor of a century, but with the help of numberless souls, a beautiful thing must be done.[4] And the obedience, and the understanding, and the pure natural passion, and the perseverance, *in secula*

[1] [On the subject of caricature, compare Appendix i. in vol. iv. of *Modern Painters*, (Vol. VI. p. 470), and Vol. XIV. p. 490.]

[2] [In his copy for revision Ruskin notes that this principle is expanded below, in ch. viii. § 16 (p. 438).]

[3] [As, for instance, in Rembrandt's etching of a spotted shell, praised in Vol. IV. p. 303.]

[4] [So in the preface to *St. Mark's Rest* it is said that the art of a nation can be mighty "only by the general gifts and common sympathies of the race."]

XV.

seculorum, as they must be given to produce a picture, so they must be recognized, that we may perceive one.

7. This is the main lesson I have been teaching, so far as I have been able, through my whole life,—Only that picture is noble, which is painted in love of the reality.[1] It is a law which embraces the highest scope of Art; it is one also which guides in security the first steps of it. If you desire to draw, that you may represent something that you care for, you will advance swiftly and safely. If you desire to draw, that you may make a beautiful drawing, you will never make one.

8. And this simplicity of purpose is farther useful in closing all discussions of the respective grace or admirableness of method. The best painting is that which most completely represents what it undertakes to represent, as the best language is that which most clearly says what it undertakes to say.

9. Given the materials, the limits of time, and the conditions of place, there is only one proper method of painting.* And since, if painting is to be entirely good, the materials of it must be the best possible, and the conditions of time and place entirely favourable, there is only one manner of entirely good painting. The so-called "styles" of artists are either adaptations to imperfections of material, or indications of imperfection in their own power, or the knowledge of their day. The great painters are like each other in their strength, and diverse only in weakness.[2]

10. The last aphorism is true even with respect to the

* In sculpture, the materials are necessarily so varied, and the circumstances of place so complex, that it would seem like an affected stretching of principle to say there is only one proper method of sculpture: yet this is also true, and any handling of marble differing from that of Greek workmen is inferior by such difference.

[1] [So in the *Notes on Prout and Hunt* (Vol. XIV. p 444), Ruskin says of Hunt's inscription, "Love what you study, study what you love," that it is "all *Modern Painters* in a nutshell."]

[2] [With this passage, compare—for fuller explanations—*Modern Painters*, vol. i. (Vol. III. pp. 193–194).]

dispositions which induce the preference of particular characters in the subject. Perfect art perceives and reflects the whole of nature: imperfect art is fastidious, and impertinently prefers and rejects. The foible of Correggio is grace, and of Mantegna, precision: Veronese is narrow in his gaiety, Tintoret in his gloom, and Turner in his light.

11. But, if we *know* our weakness, it becomes our strength; and the joy of every painter, by which he is made narrow, is also the gift by which he is made delightful, so long as he is modest in the thought of his distinction from others, and no less severe in the indulgence, than careful in the cultivation, of his proper instincts. Recognizing his place, as but one quaintly-veined pebble in the various pavement,—one richly-fused fragment, in the vitrail of life,—he will find, in his distinctness, his glory and his use; but destroys himself in demanding that all men should stand in his compartment, or see through his colour.

12. The differences in style instinctively caused by personal character are however of little practical moment, compared to those which are rationally adopted, in adaptation to circumstance.

Of these variously conventional and inferior modes of work, we will examine such as deserve note in their proper place. But we must begin by learning the manner of work which, from the elements of it to the end, is completely right, and common to all the masters of consummate schools. In whom these two great conditions of excellence are always discernible,—that they conceive more beautiful things than they can paint, and desire only to be praised in so far as they can represent these, as subjects of higher praising.

CHAPTER II

THE THREE DIVISIONS OF THE ART OF PAINTING

1. In order to produce a completely representative picture of any object on a flat surface, we must outline it, colour it, and shade it. Accordingly, in order to become a complete artist, you must learn these three following modes of skill completely. First, how to outline spaces with accurate and delicate lines. Secondly, how to fill the outlined spaces with accurate, and delicately laid, colour. Thirdly, how to gradate the coloured spaces, so as to express, accurately and delicately, relations of light and shade.

2. By the word "accurate" in these sentences, I mean nearly the same thing as if I had written "true"; but yet I mean a little more than verbal truth: for, in many cases, it is possible to give the strictest truth in words without any painful care; but it is not possible to be true in lines, without constant care, or "*accuracy.*" We may say, for instance, without laborious attention, that the tower of Garisenda[1] is a hundred and sixty feet high, and leans nine feet out of the perpendicular. But we could not draw the line representing this relation of nine feet horizontal to a hundred and sixty vertical, without extreme care.

3. In other cases, even by the strictest attention, it is not possible to give complete or strict truth in words. We could not, by any number of words, describe the colour of a riband so as to enable a mercer to match it without seeing it. But an "accurate" colourist can convey the required intelligence at once, with a tint on paper. Neither would it be possible, in language, to explain the difference in gradations of shade which the eye perceives between a beautifully

[1] [At Bologna, built by the brothers Filippo and Oddo Garisenda, in 1110.]

rounded and dimpled chin, and a more or less determinedly
angular one. But on the artist's "accuracy" in distinguishing
and representing their relative depths, not in one feature
only, but in the harmony of all, depend his powers of
expressing the charm of beauty, or the force of character;
and his means of enabling us to know Joan of Arc from
Fair Rosamond.

4. Of these three tasks, outline, colour, and shade, out-
line, in perfection, is the most difficult; but students must
begin with that task, and are masters when they can see
to the end of it, though they never reach it.

To colour is easy if you can see colour; and impossible
if you cannot.*

To shade is very difficult; and the perfections of light
and shadow have been rendered by few masters; but in the
degree sufficient for good work, it is within the reach of
every student of fair capacity who takes pains.

5. The order in which students usually learn these three
processes of art is in the inverse ratio of their difficulty.
They begin with outline, proceed to shade, and conclude
in colour. While, naturally, any clever house decorator can
colour, and any patient Academy pupil shade; but Raphael
at his full strength is plagued with his outline, and tries
half a dozen backwards and forwards before he pricks his
chosen one down.†

6. Nevertheless, both the other exercises should be
practised with this of outline, from the beginning. We
must outline the space which is to be filled with colour, or
explained by shade; but we cannot handle the brush too
soon, nor too long continue the exercises of the lead‡ point.

* A great many people do not know green from red; and such kind of
persons are apt to feel it their duty to write scientific treatises on colour,
edifying to the art-world.[1]

† Beautiful and true shade can be produced by a machine fitted to the
surface, but no machine can outline.

‡ See explanation of term, p. 369.

[1] [Compare Ruskin's letter on a paper by Dr. Liebreich in Vol. X. p. 458, and *Art
of England*, § 182.]

Every system is imperfect which pays more than a balanced and equitable attention to any one of the three skills, for all are necessary in equal perfection to the completeness of power. There will indeed be found great differences between the faculties of different pupils to express themselves by one or other of these methods; and the natural disposition to give character by delineation, charm by colour, or force by shade, may be discreetly encouraged by the master, after moderate skill has been attained in the collateral exercises. But the first condition of steady progress for every pupil,—no matter what their gifts, or genius,—is that they should be taught to draw a calm and true outline, entirely decisive, and admitting no error avoidable by patience and attention.

Fig. 1

7. We will begin therefore with the simplest conceivable practice of this skill, taking for subject the two elementary forms which the shepherd of Fésole gives us, (Fig. 1,) supporting the desk of the master of Geometry.

You will find the original bas-relief represented very sufficiently in the nineteenth of the series of photographs from the Tower of Giotto,[1] and may thus for yourself ascertain the accuracy of this outline, which otherwise you might suppose careless, in that the suggested square is not a true one, having two acute and two obtuse angles; nor is it set upright, but with the angle on your right hand higher than the opposite one, so as partly to comply with the slope of the desk. But this is one of the first signs that the sculpture is by a master's hand. And the first

[1] [*The Shepherd's Tower. A Series of Photographs of the Sculptures of Giotto's Tower. To illustrate Part vi. of Mornings in Florence* (1881): reprinted in a later volume of this edition. See the reference to this figure ("the type of mensuration, circle in square") in *Mornings in Florence,* § 138.]

thing a modern restorer would do, would be to "correct the mistake," and give you, instead, the, to him, more satisfactory arrangement. (Fig. 2.)

8. We must not, however, permit ourselves, in the beginning of days, to draw inaccurate squares; such liberty is only the final reward of obedience, and the generous breaking of law, only to be allowed to the loyal.

Take your compasses, therefore, and your ruler, and smooth paper over which your pen will glide unchecked. And take above all things store of patience ; and then,—but for what is to be done then, the directions had best be reserved to a fresh chapter, which,

Fig. 2

as it will begin a group of exercises of which you will not at once perceive the intention, had better, I think, be preceded by this following series of general aphorisms, which I wrote for a young Italian painter, as containing what was likely to be most useful to him in briefest form; and which for the same reason I here give, before entering on specific practice.

APHORISMS

I.

The greatest art represents everything with absolute sincerity, as far as it is able. But it chooses the best things to represent, and it places them in the best order in which they can be seen. You can only judge of what is *best*, in process of time, by the bettering of your own character. What is *true*, you can learn now, if you will.

II.

Make your studies always of the real size of things. A man is to be drawn the size of a man; and a cherry the size of a cherry.

"But I cannot draw an elephant his real size"?

There is no occasion for you to draw an elephant.

"But nobody can draw Mont Blanc his real size"?

No. Therefore nobody can draw Mont Blanc at all; but only a distant view of Mont Blanc. You may also draw a distant view of a man, and of an elephant, if you like; but you must take care that it is seen to be so, and not mistaken for a drawing of a pigmy, or a mouse, near.

"But there is a great deal of good miniature painting"?

Yes, and a great deal of fine cameo-cutting. But I am going to teach you to be a painter, not a locket-decorator, or medallist.

III.

Direct all your first efforts to acquire the power of drawing an absolutely accurate outline of any object, of its real size, as it appears at a distance of not less than twelve feet from the eye. All greatest art represents objects at not less than this distance; because you cannot see the full stature and action of a man if you go nearer him. The difference between the appearance of anything—say a bird, fruit, or leaf—at a distance of twelve feet or more, and its appearance looked at closely, is the first difference also between Titian's painting of it, and a Dutchman's.

IV.

Do not think, by learning the nature or structure of a thing, that you can learn to draw it. Anatomy is necessary in the education of surgeons; botany in that of apothecaries; and geology in that of miners. But none of the three will enable you to draw a man, a flower, or a mountain. You can learn to do that only by looking at them; not by cutting them to pieces. And don't think you can paint a peach, because you know there's a stone inside; nor a face, because you know a skull is.

V.

Next to outlining things accurately, of their true form you must learn to colour them delicately, of their true colour.

VI.

If you can match a colour accurately, and lay it delicately, you are a painter; as, if you can strike a note surely, and deliver it clearly, you are a singer. You may then choose what you will paint, or what you will sing.

VII.

A pea is green, a cherry red, and a blackberry black, all round.

VIII.

Every light is a shade, compared to higher lights, till you come to the sun; and every shade is a light, compared to deeper shades, till you come to the night. When, therefore, you have outlined any space, you have no reason to ask whether it is in light or shade, but only, of what colour it is, and to what depth of that colour.

IX.

You will be told that shadow is grey. But Correggio, when he has to shade with one colour, takes red chalk.

X.

You will be told that blue is a retiring colour,[1] because distant mountains are blue. The sun setting behind them is nevertheless farther off, and you must paint it with red or yellow.

[1] [See on this subject, Vol. XIII. p. 218, and above, p. 157.]

XI.

"Please paint me my white cat," said little Imelda. "Child," answered the Bolognese Professor, "in the grand school, all cats are grey."

XII.

Fine weather is pleasant; but if your picture is beautiful, people will not ask whether the sun is out or in.

XIII.

When you speak to your friend in the street, you take him into the shade. When you wish to think you can speak to him in your picture, do the same.

XIV.

Be economical in everything, but especially in candles. When it is time to light them, go to bed. But the worst waste of them is drawing by them.

XV.

Never, if you can help it, miss seeing the sunset and the dawn.[1] And never, if you can help it, see anything but dreams between them.

XVI.

"A fine picture, you say?" "The finest possible; St. Jerome, and his lion, and his arm-chair. St. Jerome was painted by a saint, and the Lion by a hunter, and the chair by an upholsterer."

My compliments. It must be very fine; but I do not care to see it.

[1] [Compare Vol. III. p. 286, and below, p. 418.]

XVII.

"Three pictures, you say? and by Carpaccio!" "Yes—
St. Jerome, and his lion, and his arm-chair. Which will you
see?" "What does it matter? The one I can see soonest."[1]

XVIII.

Great painters defeat Death;—the vile, adorn him, and
adore.[2]

XIX.

If the picture is beautiful, copy it as it is; if ugly, let
it alone. Only Heaven, and Death, know what it *was*.

XX.

"The King has presented an Etruscan vase, the most
beautiful in the world, to the Museum of Naples. What
a pity I cannot draw it!"
In the meantime, the housemaid has broken a kitchen
teacup; let me see if you can draw one of the pieces.

XXI.

When you would do your best, stop, the moment you
begin to feel difficulty. Your drawing will be the best you
can do; but you will not be able to do another so good
to-morrow.

XXII.

When you would do *better* than your best, put your
full strength out, the moment you feel a difficulty. You
will spoil your drawing to-day; but you will do better than
your to-day's best, to-morrow.

[1] [For Ruskin's account of these pictures at Venice, see *St. Mark's Rest*, "The
Shrine of the Slaves."]
[2] [For the love of death and horror in morbid art compare Vol. VI. pp. 397–399,
and *Lectures on Art*, §§ 15, 56.]

XXIII.

"The enemy is too strong for me to-day," said the wise young general. I won't **fight him**; but I won't lose sight of him."

XXIV.

"I can do what I like with my colours, now," said the proud young scholar. "So could I, at your age," answered the master; "but now, I can only do what other people like."

SCHOOLS OF S^T GEORGE

Elementary Drawing. Plate I

THE TWO SHIELDS

CHAPTER III

FIRST EXERCISE IN RIGHT LINES, THE QUARTERING OF ST. GEORGE'S SHIELD

1. TAKE your compasses,* and measuring an inch on your ivory rule,[1] mark that dimension by the two dots at B and C, (see the uppermost figure on the left in Plate I.) and with your black ruler draw a straight line between them, with a fine steel pen and common ink.† Then measure the same length, of an inch, down from B, as nearly perpendicular as you can, and mark the point A ; and divide the height A B into four equal parts with the compasses, and mark them with dots, drawing every dot as a neatly circular point, clearly visible. This last finesse will be an essential part of your drawing practice; it is very irksome to draw such dots patiently, and very difficult to draw them well.

Then mark, not now by measure, but by eye, the remaining corner of the square, D, and divide the opposite side C D, by dots, opposite the others as nearly as you can guess. Then draw four level lines without a ruler, and without raising your pen, or stopping, slowly, from dot to dot, across the square. The four lines altogether should not take less,—but not much more,—than a quarter of a minute in the drawing, or about four seconds each. Repeat this practice now and then, at leisure minutes, until you have got an approximately well-drawn group of five lines; the point D being successfully put in accurate corner of the

* I have not been able yet to devise a quite simple and sufficient case of drawing instruments for my schools. But, at all events, the complete instrument-case must include the ivory scale, the black parallel rule, a divided quadrant (which I will give a drawing of when it is wanted), one pair of simple compasses, and one fitted with pen and pencil.

† Any dark colour that will wash off their fingers may be prepared for children.

[1] [Compare above, p. 33.]

square. Then similarly divide the lines A D and B C, by the eye, into four parts, and complete the figure as on the right hand at the top of Plate 1, and test it by drawing diagonals across it through the corners of the squares, till you can draw it true.

2. Contenting yourself for some time with this square of sixteen quarters for *hand* practice, draw also, with extremest accuracy of measurement possible to you, and finely ruled lines such as those in the plate, the inch square, with its side sometimes divided into three parts, sometimes into five, and sometimes into six, completing the interior nine, twenty-five, and thirty-six squares with utmost precision; and do not be satisfied with these till diagonals afterwards drawn, as in the figure, pass precisely through the angles of the squares.

Then, as soon as you can attain moderate precision in instrumental drawing, construct the central figure in the plate, drawing, first, the square; then, the lines of the horizontal bar, from the midmost division of the side divided into five. Then draw the curves of the shield, from the uppermost corners of the cross-bar, for centres; then the vertical bar, also one-fifth of the square in breadth; lastly, find the centre of the square, and draw the enclosing circle, to test the precision of all. More advanced pupils may draw the inner line to mark thickness of shield; and lightly tint the cross with rose-colour.

In the lower part of the plate is a first study of a feather, for exercise later on; it is to be copied with a fine steel pen and common ink, having been so drawn with decisive and visible lines, to form steadiness of hand.*

* The original drawings for all these plates will be put in the Sheffield Museum;[1] but if health remains to me, I will prepare others of the same kind, only of different subjects, for the other schools of St. George. The engravings, by Mr. Allen's good skill, will, I doubt not, be better than the originals for all practical purposes; especially as my hand now shakes more than his, in small work.

[1] [This intention was not, however, fulfilled; the Museum possesses only the original drawing of Plate V.]

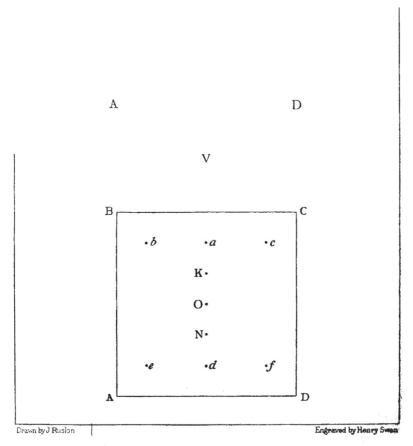

SCHOOLS OF ST GEORGE

Elementary Drawing. Plate II.

CONSTRUCTION FOR PLACING THE HONOUR-POINTS.

3. The feather is one of the smallest from the upper edge of a hen's wing; the pattern is obscure, and not so well adapted for practice as others to be given subsequently, but I like best to begin with this, under St. George's shield; and whether you can copy it or not, if you have any natural feeling for beauty of line, you will see, by comparing the two, that the shield form, mechanically constructed, is meagre and stiff; and also that it would be totally impos‑sible to draw the curves which terminate the feather below by any mechanical law; much less the various curves of its filaments. Nor can we draw even so simple a form as that of a shield beautifully, by instruments. But we may come nearer, by a more complex construction, to beautiful form; and define at the same time the heraldic limits of the bearings. This finer method is given in Plate II., on a scale twice as large, the shield being here two inches wide. And it is to be constructed as follows.

4. Draw the square A B C D, two inches on the side, with its diagonals A C, B D, and the vertical P Q through its centre O; and observe that, henceforward, I shall always use the word " vertical" for " perpendicular," and "level" for "horizontal," being shorter, and no less accurate.

Divide O Q, O P, each into three equal parts by the points, K, a; N, d.

Through a and d draw the level lines, cutting the diago‑nals in b, c, e, and f; and produce b c, cutting the sides of the square in m and n, as far towards x and y as you see will be necessary.

With centres m and n, and the equal radii m a, n a, describe semicircles, cutting x y in x and y. With centres x and y, and the equal radii x n, y m, describe arcs, m V n V, cutting each other and the line Q P, produced, in V.

The precision of their concurrence will test your accuracy of construction.

5. The form of shield B C V, thus obtained, is not a perfect one, because no perfect form (in the artist's sense

of the word "perfectness") can be drawn geometrically; but it approximately represents the central type of English shield.

It is necessary for you at once to learn the names of the nine points thus obtained, called "honour-points," by which the arrangement and measures of bearings are determined.

All shields are considered heraldically to be square in the field, so that they can be divided accurately into quarters.

I am not aware of any formerly recognized geometrical method of placing the honour-points in this field: — that which I have here given will be found convenient for strict measurement of the proportions of bearings.

6. Considering the square A B C D as the field, and removing from it the lines of construction, the honour-points are seen in their proper places, in the lower part of the plate.

These are their names,—

a Middle Chief	
b Dexter Chief	
c Sinister Chief	
K Honour	
O Fesse	} point.
N Numbril	
d Middle Base	
e Dexter Base	
f Sinister Base	

I have placed these letters, with some trouble as I think best for help of your memory.

The a, b, c; d, e, f, are, I think, most conveniently placed in upper and under series: I could not, therefore, put f for the Fesse point, but the O will remind you of it as the sign for a belt or girdle. Then K will stand for knighthood, or the honour-point, and putting N for

the numbril, which is otherwise difficult to remember, we have, reading down, the syllable KON, the Teutonic beginning of KONIG or King, all which may be easily remembered.

And now look at the first plate of the large Oxford series.* It is engraved from my free-hand drawing in the Oxford schools; and is to be copied, as that drawing is executed, with pencil and colour.

In which sentence I find myself face to face with a difficulty of expression which has long teazed me, and which I must now conclusively, with the reader's good help, overcome.

7. In all classical English writing on art, the word " pencil,"—in all classical French writing, the word " pinceau,"—and in all classical Italian writing, the word " pennello," means the painter's instrument, the brush.†

It is entirely desirable to return, in England, to this classical use with constant accuracy, and resolutely to call the black-lead pencil, the " lead-crayon "; or, for shortness, simply " the lead." In this book I shall generally so call it, saying, for instance, in the case of this diagram, " draw it first with the lead." " Crayon," from " craie," chalk, I shall use instead of " chalk "; meaning when I say black crayon, common black chalk; and when I say white crayon, common white chalk; while I shall use indifferently the word " pencil " for the instrument whether of water-colour or oil painting.

8. Construct then the whole of this drawing, Plate 1,

* See notice of this series in Preface.[1]
† The Latin " penicillum " originally meant a " little tail," as of the ermine. My friend Mr. Alfred Tylor[2] informs me that Newton was the first to apply the word to light, meaning a pointed group of rays.

[1] [See above, p. 346 n. The plate in question was engraved but not published. It is a repetition of the upper figure in Plate II. here (p. 367), on a larger scale and with the letters omitted. In the original drawing (No. 6 in the Rudimentary Series of the Oxford Drawing School) the lines and points are drawn in carmine.]
[2] [For Mr. Tylor, see Vol. IV. p. 107 n. ; Deucalion, ii. ch. i. (" Living Waves "), and Fors Clavigera, Letter 82.]

Oxford series, first with a light lead line; then take an ordinary* camel's hair pencil, and with free hand follow the lead lines in colour. Indian red is the colour generally to be used for practice, being cheap and sufficiently dark, but lake or carmine work more pleasantly for a difficult exercise like this.

9. In laying the colour lines, you may go over and over again, to join them and make them even, as often as you like, but must not thicken the thin ones; nor interrupt the thickness of the stronger outline so as to confuse them at all with each other. Giotto, Dürer, or Mantegna, would draw them at once without pause or visible error, as far as the colour in the pencil lasted. Only two or three years ago I could nearly have done so myself, but my hand now shakes a little; the drawing in the Oxford schools is however very little retouched over the first line.

10. We will at this point leave our heraldry,† because

* That is to say, not a particularly small one; but let it be of good quality. Under the conditions of overflowing wealth which reward our national manufacturing industry, I find a curious tendency in my pupils to study economy especially in colours and brushes. Every now and then I find a student using a brush which bends up when it touches the paper, and remains in the form of a fish-hook. If I advise purchase of a better, he—or she—says to me, "Can't I do something with this?" "Yes,—something, certainly. Perhaps you may paste with it; but you can't draw. Suppose I was a fencing-master, and you told me you couldn't afford to buy a foil,—would you expect me to teach you to fence with a poker?"

† Under the general influence of Mr. Gradgrind, there has been lately published a book of *Heraldry founded on facts* (*The Pursuivant of Arms*, —Chatto and Windus)[1] which is worth buying, for two reasons: the first, that its "facts" are entirely trustworthy and useful; (well illustrated in minor woodcut also, and, many, very curious and new,) — the second that the writer's total ignorance of art, and his education among vulgar modernisms, have caused him to give figure-illustrations, wherever he draws either man or beast, as at pages 62 and 106, whose horrible vulgarity will be of good future service as a type to us of the maximum in that particular. But the curves of shields are, throughout, admirably chosen and drawn, to the point mechanically possible.

[1] [*The Pursuivant of Arms; or, Heraldry Founded upon Facts.* By J. R. Planché, Esq., F.S.A., Somerset Herald (3rd edition), Chatto & Windus (1874). The woodcut on p. 62 is of "Simon de Montfort, from the windows of the Cathedral of

we cannot better the form of our shield until we can draw
lines of more perfect, that is to say, more varied and
interesting, curvature, for its sides. And in order to do this
we must learn how to construct and draw curves which can-
not be drawn with any mathematical instrument, and yet
whose course is perfectly determined.

Chartres"; that on p. 106, "Arms of Henry III., from Westminster Abbey." For
another reference to the book, see below, ch. vi. § 2. *Hard Times* (which opens with
Mr. Gradgrind's saying, "Now, what I want is, Facts") was in Ruskin's opinion one
of Dickens's greatest works (see *Unto This Last*, § 10 *n.*).]

CHAPTER IV

FIRST EXERCISE IN CURVES. THE CIRCLE

1. AMONG the objects familiarly visible to us, and usually regarded with sentiments of admiration, few are more classically representative of Giotto's second figure, inscribed in his square,[1] than that by common consent given by civilized nations to their pieces of money. We may, I hope, under fortunate augury, limit ourselves at first to the outline (as, in music, young students usually begin with the song), of Sixpence.

2. Supposing you fortunate enough to possess the coin, may I ask you to lay it before you on a stiff card. Do you think it looks round? It does not, unless you look exactly down on it. But let us suppose you do so, and have to draw its outline under that simple condition.

Take your pen, and do it then, beside the sixpence.

"You cannot?"

Neither can I. Giotto could,[2] and perhaps after working due time under the laws of Fésole, you may be able to do it, too, approximately. If I were as young as you, I should at least encourage that hope. In the meantime you must do it ignominiously, with compasses. Take your pen-compasses, and draw with them a circle the size of a sixpence.*

* Not all young students can even manage their compasses; and it is well to get over this difficulty with deliberate and immediate effort. Hold your compasses upright, and lightly, by the joint at the top; fix one point quite firm, and carry the other round it any quantity of times without touching the paper, as if you were spinning a top without quitting hold of it. The fingers have to shift as the compasses revolve; and, when well

[1] [See above, p. 358.]
[2] [For the reference here, see above, p. 39.]

3. When it is done, you will not, I hope, be satisfied with it as the outline of a sixpence.* For, in the first place, it might just as well stand for the outline of the moon; and in the second, though it is true, or accurate, in the mere quality of being a circle, either the space enclosed by the inner side of the black line must be smaller, or that enclosed by the outside larger, than the area of a sixpence. So the closer you can screw the compass-point, the better you will be pleased with your line: only it must always happen even with the most delicate line, so long as it has thickness at all, that its inner edge is too small, or its outer too large. It is best, therefore, that the error should be divided between these two excesses, and that the centre of the line should coincide with the contour of the object. In advanced practice, however, outline is properly to be defined as the narrowest portion which can be conveniently laid of a dark background round an object which is to be relieved in light, or of a light background round an object to be relieved in shade. The Venetians often leave their first bright outlines gleaming round their dark figures, after the rest of the background has been added

practised, should do so without stopping, checking, or accelerating the motion of the point. Practise for five minutes at a time till you get skilful in this action, considering it equally disgraceful that the fixed point of the compasses should slip, or that it should bore a hole in the paper. After you are enough accustomed to the simple mechanism of the revolution, depress the second point, and draw any quantity of circles with it, large and small, till you can draw them throughout, continuously, with perfect ease.

* If any student object to the continued contemplation of so vulgar an object, I must pray him to observe that, vulgar as it may be, the idea of it is contentedly allowed to mingle with our most romantic ideals. I find this entry in my diary for 26th January, 1876:—"To Crystal Palace, through squalor and rags of declining Dulwich: very awful. In palace afterwards, with organ playing above its rows of ghastly cream-coloured amphitheatre seats, with 'SIXPENCE' in letters as large as the organist,—occupying the full field of sight below him. Of course, the names of Mendelssohn, Orpheus, Apollo, Jullien, and other great composers, were painted somewhere in the panelling above. But the real inscription—meant to be practically, and therefore divinely, instructive—was 'SIXPENCE.'"

4. The *perfect* virtue of an outline, therefore, is to be absolutely accurate with its inner edge, the outer edge being of no consequence. Thus the figures relieved in light on black Greek vases are first enclosed with a line of thick black paint about the eighth of an inch broad, afterwards melted into the added background.

In dark outline on white ground, however, it is often necessary to draw the extremities of delicate forms with lines which give the limit with their outer instead of their inner edge; else the features would become too large. Beautiful examples of this kind of work are to be seen in face-drawing, especially of children, by Leech, and Du Maurier, in *Punch*.[1]

Loose lines, doubled or trebled, are sometimes found in work by great, never by the greatest, masters; but these are only tentative; processes of experiment as to the direction in which the real outline is to be finally laid.

5. The fineness of an outline is of course to be estimated in relation to the size of the object it defines.[2] A chalk sketch on the wall may be a very subtle outline of a large picture; though Holbein or Bewick would be able to draw a complete figure within the width of one of its lines. And, for your own practice, the simplest instrument is the best; and the line drawn by any moderately well-cut quill pen, not crow quill, but sacred goose, is the means of all art which you have first to master; and you may be sure that, in the end, your progress in all this highest skill of art will be swift in proportion to the patience with which in the outset you persist in exercises which will finally enable you to draw with ease the outline of any object of a moderate size, (plainly visible, be it

[1] [For Leech and Du Maurier, see *Art of England*, Lecture v.; and for Leech, see also Vol. XIV. p. 332.]

[2] [On this subject, compare *Modern Painters*, vol. iv., where Ruskin further distinguishes between "the mere fineness of instrument in the artist's hand, and the precision of the line he draws" (Vol. VI. p. 247 *n.*).]

understood, and firmly terminated,)* with an unerring and continuous pen line.

6. And observe, once for all, there is never to be any scrawling, blotting, or splashing, in your work, with pen or anything else. But especially with the pen, you are to avoid rapid motion, because you will be easily tempted to it. Remember, therefore, that no line is well drawn unless you can stop your hand at any point of it you choose. On the other hand, the motion must be consistent and continuous, otherwise the line will not be even.

7. It is not indeed possible to say with precision how fast the point may move, while yet the eye and fingers retain perfect attention and directing power over it. I have seen a great master's hand flying over the paper as fast as gnats over a pool; and the ink left by the light grazing of it, so pale, that it gathered into shade like grey lead;—and yet the contours, and fine notes of character, seized with the accuracy of Holbein. But gift of this kind is a sign of the rarest artistic faculty and tact: you need not attempt to gain it, for if it is in you, and you work continually, the power will come of itself; and if it is not in you, will never come; nor, even if you could win it, is the attainment wholly desirable. Drawings thus executed are always imperfect, however beautiful: they are out of harmony with the general manner and scheme of serviceable art; and always, so far as I have observed, the sign of some deficiency of earnestness in the worker. Whatever your faculty may be, deliberate exercise will strengthen and confirm the good of it; while, even if your natural gift for drawing be small, such exercise will at least enable you to understand and admire, both in art and nature, much that was before totally profitless or sealed to you.

8. We return, then, to our coin study. Now, if we are ever to draw a sixpence in a real picture, we need not

* By "firmly terminated," I mean having an outline which *can* be drawn, as that of your sixpence, or a book, or a table. You can't outline a bit of cotton wool, or the flame of a candle.

think that it can always be done by looking down at it like a hawk, or a miser, about to pounce. We must be able to draw it lying anywhere, and seen from any distance.

So now raise the card, with the coin on it, slowly to the level of the eye, so as at last to look straight over its surface. As you do so, gradually the circular outline of it becomes compressed; and between the position in which you look down on it, seeing its outline as a circle, and the position in which you look across it, seeing nothing but its edge, there are thus developed an infinite series of intermediate outlines, which, as they approach the circle, resemble that of an egg, and as they approach the straight line, that of a rolling-pin; but which are all accurately drawn curves, called by mathematicians "ellipses," or curves that "leave out" something; in this first practice you see they leave out some space of the circle they are derived from.

9. Now, as you can draw the circle with compasses, so you can draw any ellipse with a bit of thread and two pins.* But as you cannot stick your picture over with pins, nor find out, for any given ellipse, without a long mathematical operation, where the pins should go, or how long the thread should be, there is now no escape for you from the necessity of drawing the flattened shape of the sixpence with free hand.

10. And, therefore, that we may have a little more freedom for it, we will take a larger, more generally attainable, and more reverendly classic coin; namely, the "Soldo," or solid thing, from whose Italian name, heroes who fight for pay were first called Soldiers, or, in English, Pennyworthmeu.[1] Curiously, on taking one by chance out of my pocket,

* No method of drawing it by points will give a finely continuous line, until the hand is free in passing through the points.

[1] [For these derivations, see *Fors Clavigera*, Letters 15, 37.]

it proves to be a Double Obolus, (Charon's fare l[1]—and back again, let us hope,) or Ten Mites, of which two make a Five-thing.[2] Inscribed to that effect on one side—

<div align="center">

ΔΙΩΒΟΛΟΝ

ΙΟ

ΛΕΠΤΑ

</div>

while the other bears an effigy not quite so curly in the hair as an ancient Herakles, written around thus,—

<div align="center">

ΓΕΩΡΓΙΟΣ Α

ΒΑΣΙΛΕΥΣ ΤΩΝ ΕΛΛΗΝΩΝ

</div>

I lay this on a sheet of white paper on the table; and, the image and superscription[3] being, for our perspective purposes, just now indifferent, I will suppose you have similarly placed a penny before you for contemplation.

11. Take next a sheet of moderately thick note-paper, and folding down a piece of it sharply, cut out of the folded edge a small flat arch, which, when you open the sheet, will give you an oval aperture, somewhat smaller than the penny.

Holding the paper with this opening in it upright, adjust the opening to some given point of sight, so that you see the penny exactly through it. You can trim the cut edge till it fits exactly, and you will then see the penny apparently painted on the paper between you and it, on a smaller scale.

If you make the opening no larger than a grain of oats and hold the paper near you, and the penny two or three feet back, you will get a charming little image of it, very pretty and quaint to behold; and by cutting apertures of different sizes, you will convince yourself that you don't

[1] [For the ferryman's fee for conveying the dead across the Styx, see *A Joy for Ever*, § 3 (Vol. XVI. p. 16), and *The Tortoise of Ægina*, § 10.]

[2] [Mark xii. 42: "two mites which make a farthing."]

[3] [Matthew xxii. 20.]

see the penny of any given size, but that you judge of its
actual size by guessing at its distance, the real image on
the retina of the eye being far smaller than the smallest
hole you can cut in the paper.

12. Now if, supposing you already have some skill in
painting, you try to produce an image of the penny which
shall look exactly like it, seen through any of these open-
ings, beside the opening, you will soon feel how absurd it
is to make the opening small, since it is impossible to
draw with fineness enough quite to imitate the image seen
through any of these diminished apertures. But if you
cut the opening only a hair's-breadth less wide than the
coin, you may arrange the paper close to it by putting
the card and penny on the edge of a book, and then paint
the simple image of what you see (penny only, mind, not
the cast shadow of it), so that you can't tell the one from
the other; and that will be right, if your only object is to
paint the penny. It will be right also for a flower, or a
fruit, or a feather, or aught else which you are observing
simply for its own sake.

13. But it will be *natural-history* painting, not great
painter's painting. A great painter cares only to paint his
penny while the steward gives it to the labourer, or his
twopence while the Good Samaritan gives it to the host.[1]
And then it must be so painted as you would see it at the
distance where you can also see the Samaritan.

14. *Perfectly*, however, at that distance. Not sketched
or slurred, in order to bring out the solid Samaritan in
relief from the aerial twopence.

And by being "perfectly" painted at that distance, I
mean, as it would be seen by the human eye in the perfect
power of youth. That for ever indescribable instrument, aid-
less, is the proper means of sight, and test of all laws of
work which bear upon aspects of things, for human beings.[2]

[1] [Matthew xx. 9 (the parable from which Ruskin took the title of his book *Unto
this Last*); Luke x. 35. Mrs. Jameson has collected instances of the treatment in art
of both parables (see her *History of our Lord*, vol. i. pp. 394, 388).]
[2] [On this text much of Ruskin's discourses entitled *The Eagle's Nest* was based.]

15. Having got thus much of general principle defined, we return to our own immediate business, now simplified by having ascertained that our elliptic outline is to be of the width of the penny proper, within a hair's-breadth, so that, practically, we may take accurate measure of the diameter, and on that diameter practise drawing ellipses of different degrees of fatness. If you have a master to help you, and see that they are well drawn, I need not give you farther direction at this stage; but if not, and we are to go on by ourselves, we must have some more compass work; which reserving for next chapter, I will conclude this one with a few words to more advanced students on the use of outline in study from nature.

16. I. Lead, or silver point, outline.

It is the only one capable of perfection, and the best of all means for gaining intellectual knowledge of form. Of the degrees in which shade may be wisely united with it, the drawings of the figure in the early Florentine schools give every possible example: but the severe method of engraved outline used on Etruscan metal-work is the standard appointed by the laws of Fésole. The finest application of such method may be seen in the Florentine engravings, of which more or less perfect facsimiles are given in my *Ariadne Florentina*. Raphael's silver point outline, for the figure, and Turner's lead outline in landscape, are beyond all rivalry in abstract of graceful and essential fact. Of Turner's lead outlines, examples enough exist in the National Gallery to supply all the schools in England, when they are properly distributed.*

17. II. Pen, or woodcut, outline. The best means of primal study of composition, and for giving vigorous impression to simple spectators. The woodcuts of almost any

* My kind friend Mr. Burton, is now so fast bringing all things under his control into good working order at the National Gallery, that I have good hope, by the help of his influence with the Trustees, such distribution may be soon effected.[1]

--

[1] [See on this subject, Vol. XIII. p. 608.]

Italian books towards 1500, most of Dürer's (*a*),—all Holbein's; but especially those of the "Dance of Death" (*b*), and the etchings by Turner himself in the "Liber Studiorum," are standards of it (*c*). With a light wash of thin colour above, it is the noblest method of intellectual study of composition; so employed by all the great Florentine draughtsmen, and by Mantegna (*d*). Holbein and Turner carry the method forward into full chiaroscuro; so also Sir Joshua in his first sketches of pictures (*e*).

18. III. Outline with the pencil. Much as I have worked on illuminated manuscripts, I have never yet been able to distinguish, clearly, pencilled outlines from the penned rubrics. But I shall gradually give large examples from thirteenth century work which will be for beginners

(*a*) I have put the complete series of the life of the Virgin in the St. George's Museum, Sheffield.

(*b*) First edition, also in Sheffield Museum.

(*c*) "Æsacus and Hesperic," and "The Falls of the Reuss," in Sheffield Museum.

(*d*) "The Triumph of Joseph." Florentine drawing in Sheffield Museum.

(*e*) Two, in Sheffield Museum.[1]

[1] [The series of the Life of the Virgin is not in the Museum, though there are several other examples of Dürer. The first edition (1538) of the "Dance of Death" (a rare perfect copy) is in the Library of the Museum. "Æsacus and Hesperie" and "The Falls of the Reuss" (*i.e.*, the Little Devil's Bridge over the Reuss) are included in the Museum's set of the *Liber Studiorum*. The examples of (1) Holbein and (2) Reynolds are: (1) A pencil study by Miss Ethel Webling of John Fisher, Bishop of Rochester, from the drawing by Holbein, in the Print Room of the British Museum. (2) A photograph of the first sketch of a picture by Sir Joshua Reynolds (of a child in winter attire, accompanied by a small terrier).

The Florentine drawing (or rather drawings, for there were two in the Museum) of "The Triumph of Joseph" has an interesting history. In about the year 1874 Ruskin had bought for £1000 a unique volume of Italian drawings (see *The Storm-Cloud of the Nineteenth Century*, Lecture ii.). The drawings are ninety-nine in number, executed in pen-and-bistre and bistre-wash, "with an extraordinary richness (says Mr. Colvin) and fancifulness of invention in matters of costume, ornament, and decoration. They are unique in character and subject, representing the personages and events of sacred and profane history from the creation of man to the foundation of Florence by Julius Cæsar." Two of the drawings were placed by Ruskin in his Museum at Sheffield. But in 1888 he agreed to sell the collection to the British Museum (at the price he had given for it), and the two drawings of "The Triumph of Joseph" were removed from Sheffield to complete the set. The drawings are ascribed by Mr. Colvin to the goldsmith, engraver, and draughtsman, Maso Finiguerra (1426–1464). They have been published, with letterpress by Mr. Colvin, under the title *A Florentine Picture-Chronicle* (Quaritch, 1898).]

to copy with the pen, and for advanced pupils to follow with the pencil.[1]

19. The following notes, from the close of one of my Oxford lectures on landscape,[2] contain the greater part of what it is necessary farther to say to advanced students * on this subject.

When forms, as of trees or mountain edges, are so complex that you cannot follow them in detail, you are to enclose them with a careful outside limit, taking in their main masses. Suppose you have a map to draw on a small scale, the kind of outline which a good geographical draughtsman gives to the generalized capes and bays of a country, is that by which you are to define too complex masses in landscapes.

An outline thus perfectly made, with absolute decision, and with a wash of one colour above it, is the most masterly of all methods of light and shade study, with limited time, when the forms of the objects to be drawn are clear and unaffected by mist.

But without any wash of colour, such an outline is the most valuable of all means of obtaining such memoranda of any scene as may explain to another person, or record for yourself, what is most important in its features; only when it is thus used, some modification is admitted in its treatment, and always some slight addition of shade becomes

* I find this book terribly difficult to arrange; for if I did it quite rightly, I should make the exercises and instructions progressive and consecutive; but then, nobody would see the reason for them till we came to the end; and I am so encumbered with other work that I think it best now to get this done in the way likeliest to make each part immediately useful. Otherwise, this chapter should have been all about right lines only, and then we should have had one on the arrangement of right lines, followed by curves, and arrangement of curves.

[1] [No such large examples were, however, issued.]
[2] [A lecture given to his pupils (not a public lecture) on January 20, 1871; published in 1897 as Lecture i. in *Lectures on Landscape*. The passage here—"An outline thus perfectly made . . . most important in its features"—occurs there word for word (§ 26). The rest of the passage here does not; it must therefore come from an undelivered draft which has not been found among Ruskin's MSS.]

necessary in order that the outline may contain the utmost information possible. Into this question of added shade I shall proceed hereafter.[1]

20. For the sum of present conclusions: observe that in all drawings in which flat washes of colour are associated with outline, the first great point is entirely to suppress the influences of impatience and affectation, so that if you fail, you may know exactly in what the failure consists. Be sure that you spread your colour as steadily as if you were painting a house wall, filling in every spot of white to the extremest corner, and removing every grain of superfluous colour in nooks and along edges. Then when the tint is dry, you will be able to say that it is either too warm or cold, paler or darker than you meant it to be. It cannot possibly come quite right till you have long experience; only, let there be no doubt in your mind as to the point in which it is wrong; and next time you will do better.

21. I cannot too strongly, or too often, warn you against the perils of affectation. Sometimes colour lightly broken, or boldly dashed, will produce a far better instant effect than a quietly laid tint;—and it looks so dextrous, or so powerful, or so fortunate, that you are sure to find everybody liking your work better for its insolence. But never allow yourself in such things. Efface at once a happy accident—let nothing divert you from the purpose you began with—nothing divert or confuse you in the course of its attainment; let the utmost strength of your work be in its continence, and the crowning grace of it in serenity.

And even when you know that time will not permit you to finish, do a little piece of your drawing rightly, rather than the whole falsely: and let the non-completion consist either in that part of the paper is left white, or that only a foundation has been laid up to a certain point, and the second colours have not gone on. Let your work be a good outline—or part of one; a good first tint—or part of

[1] [In the second of the *Lectures on Landscape*.]

one; but not, in any sense, a sketch; in no point, or measure, fluttered, neglected, or experimental. In this manner you will never be in a state of weak exultation at an undeserved triumph; neither will you be mortified by an inexplicable failure. From the beginning you will know that more than moderate success is impossible, and that when you fall short of that due degree, the reason may be ascertained, and a lesson learnt. As far as my own experience reaches, the greater part of the fatigue of drawing consists in doubt or disappointment, not in actual effort or reasonable application of thought; and the best counsels I have to give you may be summed in these,—to be constant to your first purpose, content with the skill you are sure of commanding, and desirous only of the praises which belong to patience and discretion.

CHAPTER V

OF ELEMENTARY FORM

1. In the 15th paragraph of the preceding chapter, we were obliged to leave the drawing of our ellipse till we had done some more compass work. For, indeed, all curves of subtle nature must be at first drawn through such a series of points as may accurately define them; and afterwards without points, by the free hand.

And it is better in first practice to make these points for definition very distinct and large; and even sometimes to consider them rather as beads strung upon the line, as if it were a thread, than as mere points through which it passes.

2. It is wise to do this, not only in order that the points themselves may be easily and unmistakably set, but because all beautiful lines are beautiful, or delightful to sight, in *showing the directions in which material things may be wisely arranged, or may serviceably move.* Thus, in Plate 1, the curve which terminates the hen's feather pleases me, and ought to please *you*, better than the point of the shield, partly because it expresses such relation between the lengths of the filaments of the plume as may fit the feather to act best upon the air, for flight; or, in unison with other such softly inlaid armour, for covering.

3. The first order of arrangement in substance is that of coherence into a globe; as in a drop of water, in rain, and dew,—or, hollow, in a bubble: and this same kind of coherence takes place gradually in solid matter, forming spherical knots, or crystallizations. Whether in dew, foam, or any other minutely beaded structure, the simple form is always

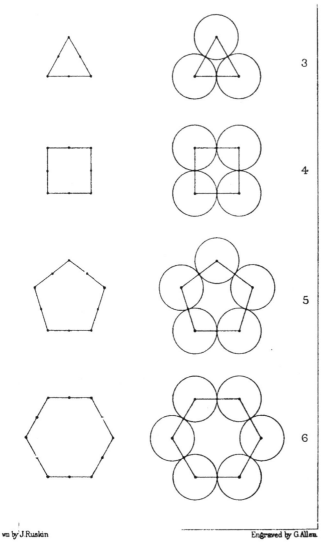

SCHOOLS OF ST GEORGE

Elementary Drawing, Plate III

PRIMAL GROUPS OF THE CIRCLE.

pleasant to the human mind; and the "pearl"—to which the most precious object of human pursuit is likened by its wisest guide,[1]—derives its delightfulness merely from its being of this perfect form, constructed of a substance of lovely colour.

4. Then the second orders of arrangement are those in which several beads or globes are associated in groups under definite laws, of which of course the simplest is that they should set themselves together as close as possible.

Take, therefore, eight marbles or beads* about three-quarters of an inch in diameter; and place successively two, three, four, etc., as near as they will go. You can but let the first two touch, but the three will form a triangular group, the four a square one, and so on, up to the octagon. These are the first general types of all crystalline or inorganic grouping: you must know their properties well; and therefore you must draw them neatly.

5. Draw first the line an inch long, which you have already practised,[2] and set upon it five dots, two large and three small, dividing it into quarter inches,—A B, Plate III. Then from the large dots as centres, through the small ones, draw the two circles touching each other, as at C.

The triangle, equal-sided, each side half an inch, and the square, in the same dimensions, with their dots, and their groups of circles, are given in succession in the plate; and you will proceed to draw the pentagon, hexagon, heptagon, and octagon group, in the same manner, all of them half an inch in the side. All to be done with the lead, free hand, corrected by test of compasses till you get them moderately right, and finally drawn over the lead with common steel pen and ink.

* In St. George's schools, they are to be of pale rose-coloured or amber-coloured quartz, with the prettiest veins I can find it bearing: there are any quantity of tons of rich stone ready for us, waste on our beaches.

[1] [Matthew xiv. 45, 46.]
[2] [In Plate I. B–C.]

The degree of patience with which you repeat, to per-fection, this very tedious exercise, will be a wholesome measure of your resolution and general moral temper, and the exercise itself a discipline at once of temper and hand. On the other hand, to do it hurriedly or inattentively is of no use whatever, either to mind or hand.

6. While you are persevering in this exercise, you must also construct the same figures with your instruments, as delicately as you can; but complete them, as in Plate IV., by drawing semicircles on the sides of each rectilinear figure; and, with the same radius, the portions of circles which will include the angles of the same figures, placed in a parallel series, enclosing each figure finally in a circle.

7. You have thus the first two leading groups of what architects call Foils;[1]—*i.e.*, trefoils, quatrefoils, cinquefoils, etc.,—their French names indicating the original dominance of French design in their architectural use.

The entire figures may be best called "Roses," the word rose, or rose window, being applied by the French to the richest groups of them. And you are to call the point which is the centre of each entire figure, the "Rose-centre." The arcs, you are to call "foils"; the centres of the arcs, "foil-centres"; and the small points where the arcs meet, "cusps," from cuspis, Latin for a point.

8. From the group of circle-segments thus constructed, we might at once deduce the higher forms of symmetrical (or equally measured *) architecture, and of symmetrical flowers, such as the rose, or daisy. But it will be better first, with only our simple groups of circles themselves, to examine the laws which regulate forms *not* equally measured in every direction.

In this inquiry, however, we should find our marbles

* As distinguished from the studiously varied design, executed in all its curves with the free hand, characteristic of less educated but more living schools. The south end of the western aisle of Bolton Abbey is an exquisite example of Early English of this kind.

[1] [For this term, see *Seven Lamps* (Vol. VIII. pp. 119, 126).]

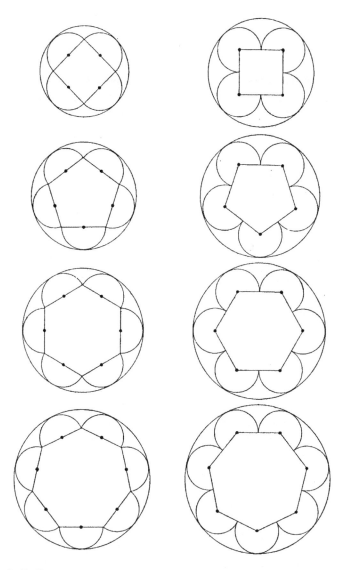

Drawn by J Ruskin.　　　　　　　　　　　　　　　　　Engraved by G.Allen

SCHOOLS OF St GEORGE

Elementary Drawing. Plate IV.

PRIMAL GROUPS OF FOILS WITH ARC-CENTRES

rún inconveniently about the table: we will therefore take to our coins again: they will serve admirably, as long as we keep clear of light and shade. We will at first omit

the dual and triune groups, being too simple for interesting experiment; and begin with Figure 4, Plate III.

9. Take, accordingly, four six-pences, and lay them on a sheet of paper in this arrangement (Fig. 3), as evenly square as you can.

Now, lift one up out of its place, thus (Fig. 4), but still keeping it in contact with its next neighbour.*

Fig. 3

You don't like that arrangement so well, do you? You ought not to like it so well. It is suggestive of one of the sixpences having got "liberty and independence." It is a form of dissolution.

Fig. 4

Fig. 5

Next push up one of the coins below, so as to touch the one already raised, as in Figure 5.

* If you have the book, compare the exercises in *Ethics of the Dust*, page 67.[1]

[1] [In all previous editions, the pagination being uniform in them. The section (§) is 39.]

You dislike this group even more than the last, I should think. *Two* of the sixpences have got liberty and independence now! Two, if referred to the first quatrefoil; or, if the three upper ones are considered as a staggering trefoil, three.

Push the lower one up to join them, then; Figure 6.

That is a little more comfortable, but the whole figure seems squinting or tumbling. You can't let it stay so!

Put it upright, then; Figure 7.

And now you like it as well as the original group, or,

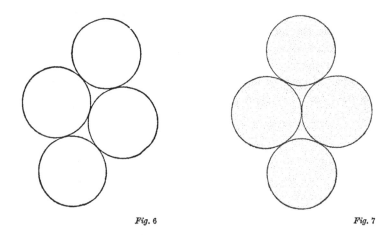

Fig. 6 Fig. 7

it may be, even better. You ought to like it better, for it is not only as completely under law as the original group, but it is under *two* laws instead of one, variously determining its height and width. The more laws any thing, or any creature, interprets, and obeys, the more beautiful it is (cæteris paribus).

10. You find then, for first conclusion, that you naturally like things to be under law; and, secondly, that your feeling of the pleasantness in a group of separate (and not living) objects, like this, involves some reference to the great law of gravity, which makes you feel it desirable

that things should stand upright, unless they have clearly some reason for stooping.

It will, however, I should think, be nearly indifferent to you whether you look at Figure 7 as I have placed it, or from the side of the page. Whether it is broad or high will not matter, so long as it is balanced. But you see the charm of it is increased, in either case, by *in*equality of dimension, in one direction or another; by the intro-

Fig. 8 *Fig.* 9

duction, that is to say, of another law, modifying the first.

11. Next, let us take *five* sixpences, which we see will at once fall into the pleasant equal arrangement, Figure 5, Plate III.; but we will now break up that, by putting four together, as in our first quatrefoil here; and the fifth on the top (Figure 8).

But you feel this new arrangement awkward. The uppermost circle has no intelligible connection with the group below, which, as a foundation, would be needlessly large for it. If you turn the figure upside-down, however,

I think you will like it better; for the lowest circle now seems a little related to the others, like a pendant. But the form is still unsatisfactory.

Take the group in Figure 7, above, then, and add the fifth sixpence to the top of that (Fig. 9).

Are you not better pleased? There seems now a unity of vertical position in three circles, and of level position in two: and you get also some suggestion of a pendant, or if you turn the page upside-down, of a statant,* cross.

Fig. 10

If, however, you now raise the two level circles, and the lowest, so as to get the arrangement in Figure 10, the result is a quite balanced group; more pleasing, if I mistake not, than any we have arrived at yet, because we have here perfect order, with an unequal succession of magnitudes in mass and interval, between the outer circles.

12. By now gradually increasing the number of coins, we can deduce a large variety of groups more or less pleasing, which you will find, on the whole, throw themselves either into *garlanded* shapes,—seven, eight, and so on, in a circle, with differences in the intervals;—or into *stellar*

* Clearly, this Latin derivative is needed in English, besides our own "standing"; to distinguish, on occasion, a permanently fixed "state" of anything, from a temporary pause. Stant, (as in extant,) would be merely the translation of "standing"; so I assume a participle of the obsolete "statare" to connect the adopted word with Statina (the goddess), Statue, and State.[1]

[1] [Statina is mentioned by Tertullian (*Anim.* 39) as the goddess who helps children to stand. "The obsolete 'statare'" seems to be rather a coinage of Ruskin's. The words are derived either from *sto*, or (when transitive in sense) from *sisto* (*statum*).]

shapes, of which the simplest is the cross, and the more complex will be composed of five, six, seven, or more rays, of various length. Then farther, successive garlands may be added to the garlands, or crossing rays, producing chequers, if we have unlimited command of sixpences. But by no artifice of arrangement shall we be able to produce any perfectly interesting or beautiful form, as long as our coins *remain of the same size.*

13. But now take some fourpenny and threepenny pieces also; and, beginning with the cross, of five orbs (Fig. 10), try first a sixpence in the middle, with four fourpenny pieces round it; and then a fourpenny piece in the middle, with four sixpences round it. Either group will be more pleasing to you than the original one: and by varying the intervals, and removing the surrounding coins to greater or less distances, you may pleasantly vary even this single group to a curious extent; while if you increase the number of coins, and farther vary their sizes, adding shillings and half-crowns to your original resources, you will find the producible variety of pleasant figures quite infinite.

14. But, supposing your natural taste and feeling moderately good, you will always feel some of the forms you arrive at to be pleasanter than others; for no explicable reason, but that there is relation between their sizes and distances which satisfies you as being under some harmonious law. Up to a certain point, I could perhaps show you logical cause for these preferences; but the moment the groups become really interesting, their relations will be found far too complex for definition, and our choice of one or another can no more be directed by rule, or explained by reason, than the degrees of enjoyment can be dictated, or the reasons for admiration demonstrated, as we look from Cassiopeia to Orion, or from the Pleiades[1] to Arcturus with his sons.

[1] [For these constellations, see also *Queen of the Air*, §§ 26, 38; *Eagle's Nest*, §§ 28, 124.]

15. Three principles only you will find certain:

A. That perfect dependence of everything on everything else, is necessary for pleasantness;

B. That such dependence can only become perfect by means of differences in magnitude (or other qualities, of course, when others are introduced).

C. That some kind of balance, or "equity," is necessary for our satisfaction in arrangements which are clearly *subjected to human interference.*

You will be perhaps surprised, when you think of it, to find that this last condition—human interference,—is very greatly involved in the principles of contemplative pleasure; and that your eyes are both metaphysical, and moral, in their approval and blame.

Thus you have probably been fastidious, and found it necessary to be so, before you could please yourself with enough precision in balance of coin against coin, and of one division of each coin-group against its fellow. But you would not, I think, desire to arrange any of the constellations I have just named, in two parallel parts; or to make the rock-forms on one side of a mountain valley, merely the reversed images of those upon the other?

16. Yet, even among these, you are sensible of a kind of order, and rejoice in it; nay, you find a higher pleasure in the mystery of it. You would not desire to see Orion and the Pleiades broken up, and scattered over the sky in a shower of equal-sized stars, among which you could no more trace group, or line, or pre-eminence. Still less would you desire to see the stars, though of different magnitudes, arrested on the vault of heaven in a chequer-pattern, with the largest stars at the angles, or appointed to rise and set in erected ranks, the same at zenith and horizon; never bowed, and never supine.

17. The beautiful passage in Humboldt's *Personal Narrative*[1] in which he describes the effect on his mind of the

[1] [The passage quoted below will be found most readily in vol. i. pp. 134, 135 of *Personal Narrative of Travels to the Equinoctial Regions of America, during the years*

first sight of the Southern Cross, may most fitly close, con-
firm, and illumine, a chapter too wearisome; by which,
however, I trust that you will be led into happier trust
in the natural likings and dislikings which are the proper
groundwork of taste in all things, finding that in things
directly prepared for the service of men, a quite palpable
order and symmetry are felt by him to be beautiful; but in
the things which involve interest wider than his own, the
mystery of a less comprehensible order becomes necessary
for their sublimity, as, for instance, the forms of mountains,
or balances of stars, expressing their birth in epochs of
creation during which man had no existence, and their
functions in preparing for a future state of the world, over
which he has no control.

"We saw distinctly for the first time the Cross of the
South only, in the night of the 4th and 5th of July, in the
sixteenth degree of latitude; it was strongly inclined, and
appeared from time to time between the clouds, the centre
of which, furrowed by uncondensed lightnings, reflected a
silver light.

"*If a traveller may be permitted to speak of his personal
emotions*,* I shall add, that in this night I saw one of the
reveries of my earliest youth accomplished.

"At a period when I studied the heavens, *not with the
intention of devoting myself to astronomy*, but only to ac-
quire *a knowledge of the stars*,† I was agitated by a fear

* I italicise, because the reserve of the *Personal Narrative*, in this respect,
is almost majestic; and entirely exemplary as compared with the explosive
egotism of the modern tourist.[1]

† Again note the difference between modestly useful, and vainly ambitious,
study.

1799-1804, by Alexander von Humboldt : translated and edited by Thomasina Ross,
3 vols., 1852 (Behn's edition). Ruskin, however, quotes from the translation of Helen
Maria Williams, 1814, 7 vols. (vol. ii. pp. 20-22).]

[1] [In his copy for revision Ruskin notes here, "Add the beautiful letters of
Humboldt to Agassiz" (for which see *Louis Agassiz ; his Life and Correspondence*, edited
by Elizabeth Cary Agassiz, 2 vols. Boston, 1885).]

unknown to those who love a sedentary life. It seemed painful to me to renounce the hope of beholding those beautiful constellations which border the southern pole. Impatient to rove in the equinoctial regions, I could not raise my eyes toward the starry vault without thinking of the Cross of the South, and without recalling the sublime passage of Dante, which the most celebrated commentators have applied to this constellation:

> "Io mi volsi a man destra, e posi mente
> All' altro polo, e vidi quattro stelle
> Non viste mai, fuor ch' alla prima gente.
> Goder paresa, 'l ciel di lor fiammelle.
> O settentrional vedovo sito,
> Poi che privato se' di mirar quelle!" [1]

"The two great stars which mark the summit and the foot of the Cross having nearly the same right ascension, it follows hence that the constellation is almost perpendicular at the moment when it passes the meridian. This circumstance is known to every nation that lives beyond the tropics or in the southern hemisphere. It has been observed at what hour of the night, in different seasons, the Cross of the South is erect, or inclined. It is a timepiece that advances very regularly near four minutes a day; and no other group of stars exhibits, to the naked eye, an observation of time so easily made. How often have we heard our guides exclaim, in the savannahs of the Venezuela, or in the desert extending from Lima to Truxillo, 'Midnight is past, the Cross begins to bend!' How often those words reminded us of that affecting scene where Paul and Virginia, seated near the source of the river of Lataniers, conversed together for the last time, and where the old man, at the sight of the Southern Cross, warns them that it is time to separate!" [2]

[1] [*Purgatorio*, i. 23–28.]
[2] [See p. 156 of the illustrated edition, published by Curmer, 1838.]

CHAPTER VI

OF ELEMENTARY ORGANIC STRUCTURE

1. Among the various arrangements made of the coins in our last experiment, it appeared that those were on the whole pleasantest which fell into some crosslet or stellar disposition, referred to a centre. The reader might perhaps suppose that, in making him feel this, I was preparing the way for assertion of the form of the cross, as a beautiful one, for religious reasons. But this is not so. I have given the St. George's cross for first practice, that our artwork might be thus early associated with the other studies of our schools; but not as in any wise a dominant or especially beautiful form. On the contrary, if we reduce it into perfectly simple lines, the pure cross (a stellar group of four lines at right angles) will be found to look meagre when compared with the stellar groups of five, six, or seven rays; and, in fact, its chief use, when employed as a decoration, is not in its possession of any symbolic or abstract charm, but as the simplest expression of accurate, and easy, mathematical division of space. It is thus of great value in the decoration of severe architecture, where it is definitely associated with square masonry: but nothing could be more painful than its substitution, in the form of tracery bars, for the stellar tracery of any fine rose window; though, in such a position, its symbolic office would be perfect. The most imaginative and religious symbolist will, I think, be surprised to find, if he thus tries it fairly, how little symbolism can please, if physical beauty be refused.

2. Nor do I doubt that the author of the book on

heraldry above referred to,[1] is right in tracing some of the earliest forms of the heraldic cross itself "to the metal clamps or braces required to strengthen and protect the long kite-shaped shield of the eleventh and twelfth centuries." The quartering of the field, which afterwards became the foundation of the arrangement of bearings, was thus naturally suggested by the laws of first construction. But the "Somerset Herald" pushes his modern mechanics too far, when he confuses the Cross Fleury with an "ornamental clamp"! (p. 49). It is directly traceable to the Byzantine Fleur-de-lys, and that to Homer's Iris.[2]

3. So also with respect to the primary forms of crystals, the pleasure of the eye in perceiving that the several lines of a group may be traced to some common centre is partly referable to our mere joy in orderly construction: but, in our general judgment of design, it is founded on our sense of the nature of radiant light and heat as the strength of all organic life, together with our interest in noticing either growth from a common root in plants, or dependence on a nervous or otherwise vital centre in animal organism, indicating not merely order of construction, but process or sequence of animation.[3]

4. The smallest number of lines which can completely express this law of radiation * is five; or if a completely opposite symmetry is required, six; and the families of all the beautiful flowers prepared for the direct service and delight of man are constructed on these two primary

* The groups of three, though often very lovely, do not clearly express radiation, but simply cohesion; because by merely crowding three globes close to each other, you at once get a perfect triune form; but to put them in a circle of five or more, at equal distances from a centre, requires an ordering and proportionate force.

[1] [See above, p. 370. The first passage here quoted is at p. 47 of *The Pursuivant of Arms*.]

[2] [For the Fleur-de-lys, see also *Queen of the Air*, § 82; and *Val d'Arno*, §§ 251–252.]

[3] [Compare sec. i. ch. xii. in the second volume of *Modern Painters* ("Of Vital Beauty").]

schemes,—the rose representing the cinqfold radiation, and the lily the sixfold, (produced by the two triangles of the sepals and petals, crossed, in the figure called by the Arabs "Solomon's Seal"); while the fourfold, or cruciform, are on the whole restricted to more servile utility. One plant only, that I know of, in the Rose family,—the tormentilla,[1] —subdues itself to the cruciform type with a grace in its simplicity which makes it, in mountain pastures, the fitting companion of the heathbell and thyme.

5. I shall have occasion enough, during the flower study carried on in *Proserpina*, to analyse the laws of stellar grouping in flowers. In this book I shall go on at once to the more complex forms produced by radiation under some continually altering force, either of growth from a root, or of motion from some given point under given law.

We will therefore return to our feather from the hen's wing, and try to find out, by close examination, why we think it, and other feathers, pretty.

6. You must observe first that the feathers of all birds fall into three great classes:[2]

(1) The Feathers for Clothing.
(2) The Feathers for Action.
(3) The Feathers for Ornament.

(1) Feathers for clothing are again necessarily divided into (ᴀ) those which clothe for warmth, (down,) which are the birds' blankets and flannel; and (ʙ) those which clothe it for defence against weather or violence; these last bearing a beautiful resemblance partly to the tiles of a house, partly to a knight's armour. They are *imbricated* against rain and wind, like tiles; but they play and move over each other like mail, actually becoming effective armour to many of the warrior birds; as in the partial protection of others from impact of driven boughs, or hail, or even shot.

[1] [See *Proserpina*, ch. vi.]
[2] [Compare *Love's Meinie*, §§ 28 *seq.*]

(2) Feathers for action. These are essentially, again,
either (A) feathers of force, in the wing, or (B) of guidance,
in the tail, and are the noblest in structure which the bird
possesses.

(3) Feathers for ornament. These are, again, to be
divided into (A), those which modify the bird's *form* (being
then mostly imposed as a crest on the head, or expanded
as a fan at the tail, or floating as a train of ethereal soft-
ness); and (B) those which modify its *colour;* these last
being, for the most part, only finer conditions of the armour
feathers on the neck, breast, and back, while the force-
feathers usually are reserved and quiet in colour though
more or less mottled, clouded, or barred.

7. Before proceeding to any closer observation of these
three classes of feathers, the student must observe generally
how they must *all* be modified according to the bird's size.
Chiefly, of course, the feathers of action, since these are
strictly under physical laws determining the scale of organic
strength. It is just as impossible for a large bird to move
its wings with a rapid stroke, as for the sail of a windmill,
or of a ship, to vibrate like a lady's fan. Therefore none
but small birds can give a vibratory, (or insect-like,) motion
to their wings. On the other hand, none but large birds
can *sail* without stroke, because small wings cannot rest on
a space of air large enough to sustain the body.

8. Therefore, broadly, first of all, birds range—with re-
lation to their flight—into three great classes : (A) the *sail-
ing* birds, who, having given themselves once a forward
impulse, can rest, merely with their wings open, on the
winds and clouds; (B) the properly so called *flying* birds,
who must *strike* with their wings, no less to sustain them-
selves than to advance; and, lastly, (C) the *fluttering* birds,
who can keep their wings quivering like those of a fly, and
therefore pause at will, in one spot in the air, over a flower,
or over their nest. And of these three classes, the first
are necessarily large birds (frigate-bird, albatross, condor,
and the like); the second, of average bird-size, falling

chiefly between the limiting proportions of the swallow and seagull; for a smaller bird than the swift has not power enough over the air, and a larger one than the seagull has not power enough over its wings, to be a perfect flyer.

Finally, the birds of vibratory wing are all necessarily minute, represented chiefly by the humming - birds; but sufficiently even by our own smaller and sprightlier pets: the robin's quiver of his wing in leaping, for instance, is far too swift to be distinctly seen.

9. These are the three main divisions of the birds for whom the function of the wing is mainly *flight*.

But to us, human creatures, there is a class of birds more pathetically interesting—those in whom the function of the wing is essentially, not flight, but the protection of their young.

Of these, the two most familiar to us are the domestic fowl and the partridge; and there is nothing in arrangement of plumage approaching the exquisiteness of that in the vaulted roofs of their expanded *covering* wings; nor does anything I know in decoration rival the consummate art of the minute cirrus-clouding of the partridge's breast.

10. But before we can understand either the structure of the striking plumes, or the tincture of the decorative ones, we must learn the manner in which all plumes whatsoever are primarily made.

Any feather—(as you know, but had better nevertheless take the first you can find in your hand to look at, as you read on)—is composed of a central quill, like the central rib of a leaf, with fine rays branching from it on each side, united, if the feather be a strong one, into a more or less silky tissue or "web," as it has hitherto been called by naturalists.* Not unreasonably, in some respects; for truly

* So far as one can make out what they call anything! The following lucid passage is all that in the seven hundred closely printed pages of Mr. Swainson's popular ornithology,[1] the innocent reader will find vouchsafed

¹ [*On the Natural History and Classification of Birds*, by William Swainson, 2 vols., 1836 (published in " Lardner's Cabinet Cyclopædia").]

it is a woven thing, with a warp and woof, beautiful as
Penelope's or Arachne's tapestry; but with this of marvel
beyond beauty in it, that it is a web which *re-weaves* itself
when you tear it! Closes itself as perfectly as a sea-wave
torn by the winds, being indeed nothing else than a wave
of silken sea, which the winds trouble enough; and fret
along the edge of it, like fretful Benacus[1] at its shore; but
which, tear it as they will, closes into its unruffled strength
again in an instant.

11. *There* is a problem for you, and your engines,—
good my Manchester friends! What with Thirlmere[2] to

to him in description of feathers (§ 71, p. 77, vol. 1):—"The regular
external feathers of the body, like those of the wings and tail, are very
differently constructed from such as are called the down; they are ex-
ternally composed of three parts or substances: 1. The down; 2. The
laminæ, *or webs* (1); and, 3. The shaft, or quill, on the sides of which the
two former are arranged. The downy laminæ, or webs of these feathers,
are very different from the substance we have just described, since they
not only have a distinct shaft of their own, but the laminæ which spring
from both sides of it are perceptibly and regularly arranged, although,
from being devoid of all elasticity, (!) like true down, they do not unite
and repose parallel to each other. The soft downy laminæ are always
situated close to the insertion of the quill into the skin; and although, for
obvious reasons, they are more developed on those feathers which cover
the body, they likewise exist on such as are employed in flight, as shown
in the quill of a goose; and as they are always concealed from sight when
the plumage is uninjured, and are not exposed to the action of the air, so
they are always colourless. The third part of a feather consists in the true
external laminæ, which are arranged in two series, one on each side the
shaft; and these sides are called the *external* and the *internal* (1!) webs.
To outward appearance, the form of the laminæ which compose these webs
appears to be much the same as that of down, which has been just de-
scribed, with this difference only, that the laminæ are stronger and elastic,
and seem to stick together, and form a parallel series, which the downy
laminæ do not. Now, this singular adhesiveness is seen by the microscope
to be occasioned by the filaments on each side of these laminæ being hooked
into those of the next laminæ; so that one supports the other in the same
position; while their elasticity (!) makes them return to their proper place
in the series, if by any accident they are discomposed. This will be suffi-
cient to give the reader a correct idea of the general construction of a
feather, without going into further details on the microscopic appearance of
the parts."

[1] ["Fluctibus et fremitu adsurgens Benace marino": Virgil, *Georgics*, ii. 160, of the
Lago di Garda.]
[2] [See Vol. XIII. p. 517 *n*.]

fill your boilers, and cotton grown now by free niggers, surely the forces of the ,universe must be favourable to you,—and, indeed, wholly at your disposal. Yet of late I have heard that your various tissues tear too easily ;—how if you could produce them such as that they could mend themselves again without help from a sewing-machine! (for I find my glove-fingers, sewn up the seam by that great economist of labour, split down all at once like walnut-shells). But even that Arabian web which could be *packed* in a walnut-shell would have no chance of rivalling with yours if· you could match the delicate spirit that weaves—a sparrow's wing. (I suppose you have no other birds to look at now—within fifty miles.)

However, from the bodies of birds, plucked for eating —or the skins of them, stuffed for wearing, I do not doubt but the reader, though inhabitant of modern English towns, may still possess himself, or herself, of a feather large enough to be easily studied;* nay, I believe British Law still indites itself with the legitimate goose-feather. If that be attainable, with grateful reverence to law, in general, and to real Scripture, which is only possible with quill or reed; and to real music, of Doric eagerness, touched of old for the oaks and rills, while the still morn went out with sandals grey,[1]—we will therewith begin our inquiry into the weaving of plumes.

12. And now, for convenience of description, observe, that as all feathers lie backwards from the bird's head towards its tail, when we hold one in our hand by the point of the quill so as to look at its upper surface, we are virtually looking from the bird's head towards the tail of it: therefore, unless with warning of the contrary, I

* My ingenious friend, Mr. W. E. Dawes,[2] of 72, Denmark Hill, will attend scrupulously, to a feather, to any orders sent him from *Fésole.*

[1] [*Lycidas*, 187.]
[2] [The late Mr. Dawes was a naturalist, long in business at the address given.]

shall always describe the feathers which belong to the bird's right side, which, when we look down on its back and wing, with the head towards us, curve for the most part with the convex edge to our own left; and when we look down on its throat and breast, with the head towards us, curve for the most part with the convex edge to our right.

13. Choosing, therefore, a goose feather from the bird's right wing, and holding it with the upper surface upwards, you see it curves to your own right, with convex edge to the left; and that it is composed mainly of the rapidly tapering quill, with its two so-called "webs," one on each side, meeting in a more or less blunt point at the top, like that of a kitchen carving-knife.

14. But I do not like the word "web" for these tissues of the feather, for two reasons: the first, that it would get confused with the word we *must* use for the membrane of the foot; and the second, that feathers of force continually resemble swords or scimitars, striking both with flat and edge; and one cannot rightly talk of striking with a web! And I have been a long time (this number of *Fésole* having, indeed, been materially hindered by this hesitation) in deciding upon any name likely to be acceptable to my readers for these all-important parts of the plume structure. The one I have at last fixed upon, "Fret,"* will not on the instant approve itself to them; but they will be content with it, I believe, in use. I take it from the constant fretting or rippling of the surface of the tissue, even when it is not torn along its edge,† and one can fancy a sword "fretted" at its edge, easily enough.

15. The two frets are composed, you see, each of—

* "Vane" is used in the English translation of Cuvier; but would be too apt to suggest rotation in the quill, as in a weathercock.
† See *Love's Meinie*, Lecture I., page 33.[1]

[1] [Of the first edition; § 32.]

(I was going to write, innumerable; but they are quite numerable, though many,)—smaller feathers; for they are nothing less, each of them, than a perfect little feather in its own way. You will find it convenient to call these the "rays." In a goose's feather there are from thirty to forty in an inch of the fret; three or four hundred, that is to say, on each side of the quill. You see—and much more, may feel—how firmly these plumelets fasten themselves together to form the continuous strength of silken tissue of the fret.

16. Pull one away from the rest, and you find it composed of a white piece of the substance of the quill, extended into a long, slightly hollowed strip, something like the awn of a grain of oats—each edge of this narrow white strip being fringed with an exquisitely minute series of minor points, or teeth, like the teeth of a comb, becoming softer and longer towards the end of the ray, where also the flat chaff-like strip of quill becomes little more than a fine rod.

Again, for names clear and short enough to be pleasantly useful, I was here much at a loss, and cannot more satisfactorily extricate myself than by calling the awnlike shaft simply the "Shaft"; and the fine points of its serrated edges, (and whatever, in other feathers, these become,) " Barbs."

17. If, with a sharp pair of scissors, you cut the two frets away from the quill, down the whole length of it, you will find the fret still hold together, inlaid, woven together by their barbs into a white soft riband,—feeling just like satin to the finger, and looking like it on the under surface, which is exquisitely lustrous and smooth. And it needs a lens of some power to show clearly the texture of the fine barbs that weave the web, as it used to be called, of the whole.

Nevertheless, in the goose feather, the rays terminate somewhat irregularly and raggedly; and it will be better now to take for further examination the plume of a more

strongly flying bird. I take that of the common seagull,*
where, in exquisite grey and dark-brown, the first elements
of variegation are also shown at the extremity of the
plume.

18. And here the edge of the fret is rippled indeed, but
not torn; the quill tapers with exquisite subtlety; and
another important part of plumage occurs at the root of it.
There the shafts of the rays lose their stiffness and breadth;
they become mere threads, on which the barbs become long
and fine like hairs; and the whole plumelet becomes a wavy,
wild-wandering thing, each at last entangled with its flutter-
ing neighbours, and forming what we call the "down" of
the feather, where the bird needs to be kept warm.

19. When the shafts change into these wandering threads,
they will be called filaments; and the barbs, when they be-
come , fine detached hairs, will be called cilia. I am very
sorry to have all this nomenclature to inflict at once; but
it is absolutely needful, all of it; nor difficult to learn, if
you will only keep a feather in your hand as you learn it.
A feather always consists of the quill and its rays; a ray,
of the shaft and its barbs. Flexible shafts are filaments;
and flexible barbs, cilia.

20. In none of the works which I at present possess on
ornithology, is any account given of the general form or
nature of any of these parts of a plume; although of all
subjects for scientific investigation, supremely serviceable to
youth, this is, one should have thought, the nearest and
most tempting, to any person of frank heart. To begin
with it, we must think of all feathers first as exactly inter-
mediate between the fur of animals and scales of fish. They
are fur, made strong, and arranged in scales or plates, partly
defensive armour, partly active instruments of motion or
action.† And there are definitely three textures of this

* Larus Canus, (Linnæus,) "White Seamew." St. George's English name
for it.

† Compare *Love's Meinie*, Lecture I., pp. 28, 29 [§§ 27, 28]; but I find
myself now compelled to give more definite analysis of structure by the

strengthened fur, variously pleasurable to the eye : the first, a dead texture like that of simple silk in its cocoon, or wool; receptant of pattern colours in definite stain, as in the thrush or partridge; secondly, a texture like that of lustrous shot silk, soft, but reflecting different colours in different lights, as in the dove, pheasant, and peacock; thirdly, a quite brilliant texture, flaming like metal,—nay, sometimes more brightly than any polished armour: and this also reflective of different colours in different lights, as in the humming-bird. Between these three typical kinds of lustre, there is every gradation; the tender lustre of the dove's plumage being intermediate between the bloomy softness of the part-ridge, and the more than rainbow iridescence of the pea-cock; while the semi-metallic, unctuous, or pitchy lustre of the raven, is midway between the silken and metallic groups.

21. These different modes of lustre and colour depend entirely on the structure of the barbs and cilia. I do not often invite my readers to use a microscope; but for once and for a little while, we will take the tormenting aid of it.

In all feathers used for flight, the barbs are many and minute, for the purpose of locking the shafts well together. But in covering and decorative plumes, they themselves be-come principal, and the shafts subordinate. And, since of flying plumes we have first taken the seagull's wing feather, of covering plumes we will first take one from the seagull's breast.

22. I take one, therefore, from quite the middle of a seamew's breast, where the frets are equal in breadth on each side. You see, first, that the whole plume is bent almost into the shape of a cup; and that the soft white lustre plays variously on its rounded surface as you turn it more or less to the light. This is the first

entirely inconceivable, (till one discovers it,) absence of any such analysis in books on birds. Their writers all go straight at the bones, like hungry dogs; and spit out the feathers as if they were choked by them.

condition of all beautiful forms. Until you can express this rounded surface, you need not think you can draw them at all.

23. But for the present, I only want you to notice the structure and order of its rays. Any single shaft with its lateral barbs, towards the top of the feather, you will find approximately of the form Fig. 11, the central shaft being

Fig. 11

so fine that towards the extremity it is quite lost sight of; and the end of the rays being not formed by the extremity of the shaft, with barbs tapering to it, but by the forked separation, like the notch of an arrow, of the two ultimate barbs.

Which, please, observe to be indeed the normal form of all feathers, as opposed to that of leaves; so that the end of a feather, however finely disguised, is normally as at A, Fig. 12; but of a leaf, as at B; the arrow-like form of the feather being developed into the most lovely duplicated symmetries of outline and pattern, by which, throughout, the colour designs of feathers, and of floral petals, (which are the sign of the dual or married life in the flower, raising it towards the rank of animal nature,) are distinguished from the colour designs in minerals, and in merely wood-forming, as opposed to floral, or seed-forming, leaves.

A　　　　B

Fig. 12

24. You will observe also, in the detached ray, that the barbs lengthen downwards, and most distinctly from the middle downwards; and now taking up the wing-feather again, you will see that its frets being constructed by the imbrication, or laying over each other like the tiles of a

house, of the edges of the successive rays,—on the upper
or outer surface of the plume, the edges are overlaid *to-wards* the plume-*point*, like breaking waves over each other
towards shore; and of course, on the
under surface, reversed, and overlaid to-
wards the root of the quill. You may
understand this in a moment by cutting
out roughly three little bits of card-
board, of this shape (Fig. 13), and draw-
ing the directions of the barbs on them:
I cut their ends square because they are
too short to represent the lengths of real

Fig. 13

rays, but are quite long enough to illustrate their imbrica-
tion. Lay first the three of them in this position, (Fig. 14,
A,) with their points towards you, one above the other;
then put the edge of the lowest *over* the edge of that
above it, and the edge of that over the third, so as just
to show the central shaft, and you will get three edges,

A B

Fig. 14

with their barbs all vertical, or nearly so: that is the struc
ture of the plume's *upper* surface. Then put the edges of
the farther off ones over the nearer, and you get three
edges with their barbs all transverse, (Fig. 14, B,) which is
the structure of the plume's *lower* surface. There are, of
course, endless subtleties and changes of adjustment, but
that is the first general law to be understood.

25. It follows, as a necessary consequence of this arrangement, that we may generally speak of the barbs which form the upper surface of the feather as the upper, or longitudinal, barbs, meaning those which lie parallel to the quill, pointing to the end of the feather; and of those which form the under surface of the feather as the lower, or transverse, barbs,—lying, that is to say, nearly transversely across the feather, at right angles to the quill. And farther, as you see that the quill shows itself clearly projecting from the under surface of the plume, so the shafts show themselves clearly projecting, in a corduroy fashion, on the under surface of the fret, the transverse barbs being seen only in the furrows between them.

26. Now, I should think, in looking carefully at this close structure of quill and shaft, you will be more and more struck by their resemblance to the beams and tiles of a roof. The feather is, in fact, a finely raftered and tiled roof to throw off wind and rain; and in a large family of birds the wing has indeed chiefly a roof's office, and is not only raftered and tiled, but *vaulted*, for the roof of the nursery. Of which hereafter;[1] in the meantime, get this clearly into your head, that on the upper surface of the plume the tiles are overlaid from the bird's head backward —so as to have their edges *away* from the wind, that it may slide over them as the bird flies;—and the furrows formed by the barbs lie parallel with the quill, so as to give the least possible friction. The under side of the plume, you may then always no less easily remember, has the *transverse* barbs; and tile-edges towards the bird's head. The beauty and colour of the plume, therefore, depend mainly on the formation of the longitudinal barbs, as long as the fret is close and firm. But it is kept close and firm throughout only in the wing feathers; expanding in the decorative ones, under entirely different conditions.

27. Looking more closely at your seamew's breast-feather, you will see that the rays lock themselves close

[1] [The subject was not, however, resumed in the book as published.]

only in the middle of it; and that this close-locked space is limited by a quite definite line, outside of which the rays contract their barbs into a thick and close thread, each such thread detached from its neighbours, and forming a snowy fringe of pure white, while the close-locked part is toned, by the shades which show you its structure, into a silver grey.

Finally, at the root of the feather, not only do its own rays change into down, but underneath, you find a supplementary plume attached, composed of nothing else but down.

28. I find no account, in any of my books on birds, of the range of these supplementary under-plumes,—the bird's body-clothing. I find the seagull has them nearly all over its body, neck, breast, and back alike; the small feathers on the head are nothing else than down. But besides these, or in the place of these, some birds have down covering the skin itself; with which, however, the painter has nothing to do, nor even with the supplementary plumes: and already indeed I have allowed the pupil, in using the microscope at all, to go beyond the proper limits of artistic investigation. Yet, while we have the lens in our hand, put on for once its full power to look at the separate cilia of the down. They are all jointed like canes; and have, doubtless, mechanism at the joints which no eye nor lens can trace. The same structure, modified, increases the lustre of the true barbs in coloured plumes.

One of the simplest of these I will now take, from the back of the peacock, for a first study of plume-radiation.

29. Its general outline is that of the Norman shield P A V B, Fig. 15; but within this outline, the frets are close-woven only within the battledore-shaped space P a v b; and between A a, and b B, they expand their shafts into filaments, and their barbs into cilia, and become " down."

We are only able to determine the arrangement of the shafts within this closely-woven space P a v b, which you will find to be typically thus. The shafts remaining

parallel most of the way up, towards the top of the plume, gradually throw themselves forward so as to get round without gap. But as, while they are thus getting round, they are not fastened on a central pivot like the rays of a fan, but have still to take, each its *ascending* place on the sides of the quill, we get a method of radiation which you will find convenient henceforward to call "plume-radiation," (Fig. 16, B,) which is precisely intermediate between two other great modes of structure—shell-radiation, A, and frond-radiation, C.

Fig. 15

30. You may perhaps have thought yourself very hardly treated in being obliged to begin your natural history drawing with so delicate a thing as a feather. But you should rather be very grateful to me, for not having given you, instead, a bit of moss, or a cockle-shell! The last, which you might perhaps fancy the easiest of the three, is in reality quite hopelessly difficult, and in its ultimate condition, inimitable by art. Bewick can engrave feathers to the point of decep-

A B C

Fig. 16

tive similitude; and Hunt can paint a bird's-nest built of feathers, lichen, and moss.[1] But neither the one nor the other ever attempted to render the diverging lines which have their origin in the hinge of the commonest bivalve shell.

[1] [On Bewick's feathers, see *Love's Meinie*, § 100, and *Art of England*, § 135. On him generally, see above, p. 223. On Hunt's bird's-nests, see Vol. X. p. 455, and Vol. XIV. p. 446 and Plate xxvi.]

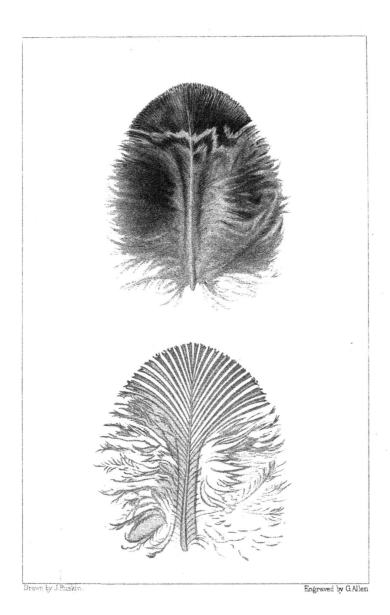

Drawn by J.Ruskin.

Engraved by G.Allen

SCHOOLS OF S^T GEORGE

Elementary Drawing, Plate V.

DECORATIVE PLUMAGE. 1 PEACOCK

31. These exactly reverse the condition of frond radiation; in that, while the frond-branch is thick at the origin, and diminishes to the extremity, the shell flutings, infinitely minute at the origin, expand into vigorous undulation at the edge. But the essential point you have now to observe is, that the shell radiation is from a central *point*, and has no supporting or continuous stem; that the plume radiation is a combination of stem and centre; and that the frond radiation has a stem throughout, all the way up. It is to be called frond, not tree, radiation, because trees in great part of their structure are like plumage, whereas the fern-frond is entirely and accurately distinct in its structure.

32. And now, at last, I draw the entire feather as well as I can in lampblack, for an exercise to you *in that material; putting a copy of the first stage of the work below it, Plate V. This lower figure may be with advantage copied by beginners; with the pencil and rather dry lampblack, over slight lead outline; the upper one is for advanced practice, though such minute drawing, where the pattern is wrought out with separate lines, is of course only introductory to true painter's work. But it is the best possible introduction, being exactly intermediate between such execution as Dürer's, of the wing in the greater Fortune,[1] and Turner's or Holbein's with the broad pencil, —of which in due time.[2]

33. Respecting the two exercises in Plate V., observe, the lower figure is not an outline of the feather, to be filled up: it is the first stage of the drawing completed above it. In order to draw the curves of the shafts harmoniously, you must first put in a smaller number of guiding lines, and then fill in between. But in this primary state, the radiant lines cannot but remind you, if you are at all familiar with architecture, of a Greek "honeysuckle"

[1] [For the "greater Fortune," see *Ariadne Florentina*, § 169. For another example of Dürer's wing drawing, see Fig. 49 in vol. iv. of *Modern Painters* (Vol. VI. p. 247).]
[2] [Not discussed in detail. See below, pp. 467–468, for the only subsequent mention of Turner and Holbein in the book.]

ornament,[1] the fact being that the said ornament has nothing at all to do with honeysuckles; but is a general expression of the radiate organic power of natural forms, evermore delightful to human eyes; and the beauty of it depends on just as subtle care in bringing the curves into harmonious flow, as you will have to use in drawing this plume.

34. Nevertheless, that students possessing some already practised power may not be left without field for its exercise, I have given in Plate VI. an example of the use of ink and lampblack with the common pen and broad wash. The outline is to be made with common ink in any ordinary pen—steel or quill does not matter, if not too fine—and, after it is thoroughly dry, the shade put on with a single wash, adding the necessary darks, or taking out light with the dry brush, as the tint dries, but allowing no retouch after it is once dry. The reason of this law is, first, to concentrate the attention on the fullest possible expression of forms by the tint first laid, which is always the pleasantest that *can* be laid, and, secondly, that the shades may be all necessarily gradated by running into the wet tint, and no edge left to be modified afterwards. The outline, that it may be indelible, is made with common ink; its slight softening by the subsequent wash being properly calculated on; but it must not be washed twice over.

35. The exercise in the lower figure of Plate I. is an example of Dürer's manner; but I do not care to compel the pupil to go through much of this, because it is always unsatisfactory at its finest. Dürer himself has to indicate the sweep of his plume with a current external line; and even Bewick could not have done plume patterns in line, unless he had had the advantage of being able to cut out his white; but with the pencil, and due patience in the use of it, everything linear in plumes may be rightly indicated, and the pattern followed all the time.

The minute moss-like *fringe* at the edge of the feather

[1] [See also below, p. 501; and *Modern Painters*, vol. v. pt. vi. ch. iv. § 8; while for a different view of this ornament, see Vol. IX. pp. 287, 368, 369, and 408 n.]

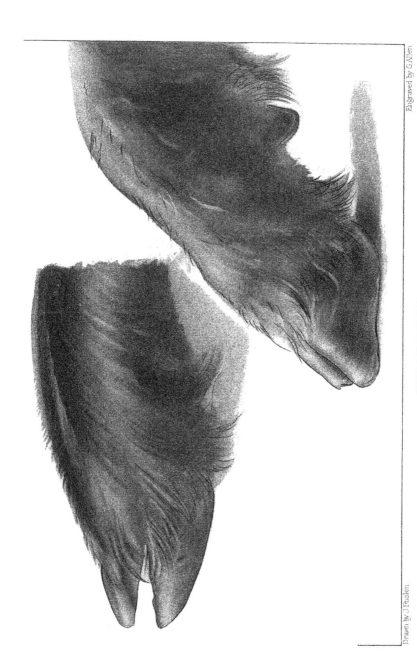

SCHOOLS OF St GEORGE

Elementary Drawing. Plate VI.

BLACK SHEEP'S TROTTERS. PEN OUTLINE WITH

in Plate V. introduces us, however, to another condition of decorative plumage, which, though not bearing on our immediate subject of radiation, we may as well notice at once.

If you examine a fine tail-feather of the peacock, above the eye of it, you will find a transparent space formed by the *cessation* of the barbs along a certain portion of the shaft. On the most scintillant of the rays, which have green and golden barbs, and in the lovely blue rays of the breast-plumes, these cessations of the barbs become alternate cuts or jags; while at the end of the long brown wing-feathers, they *comply* with the coloured pattern: so that, at the end of the clouded plume, its pattern, instead of being constructed of brown and *white* barbs, is constructed of brown —and *no* barbs,—but vacant spaces. The decorative use of this transparency consists in letting the colour of one plume *through* that of the other, so that not only every possible artifice is employed to obtain the most lovely play of colour on the plume itself; but, with mystery through mystery, the one glows and flushes through the other, like cloud seen through cloud. But now, before we can learn how either glow, or flush, or bloom is to be painted, we must learn our alphabet of colour itself.

CHAPTER VII

OF THE TWELVE ZODIACAL COLOURS

I. In my introductory Oxford lectures you will find it stated (§ 130) that "*all objects appear to the eye merely as masses of colour*";[1] and (§§ 134, 175) that shadows are as full in colour as lights are, every possible shade being a light to the shades below it, and every possible light, a shade to the lights above it. till you come to absolute darkness on one side, and to the sun on the other. Therefore, you are to consider all the various pieces either of shaded or lighted colour, out of which any scene whatsoever is composed, simply as the patches of a Harlequin's jacket—of which some are black, some red, some blue, some golden; but of which you are to imitate every one, *by the same methods.*

2. It is of great importance that you should understand how much this statement implies. In almost all the received codes of art-instruction, you will be told that shadows should be transparent, and lights solid.[2] You will find also, when you begin drawing yourselves, that your shadows, whether laid with lead, chalk, or pencil, will for the most part really look like dirt or blotches on the paper, till you cross-hatch or stipple them, so as to give them a look of net-work; upon which they instantly become more or less like shade; or, as it is called, "transparent." And you will find a most powerful and attractive school of art founded on the general principle of laying a literally transparent brown all over the picture, for the shade; and striking the lights upon it with opaque white.

[1] [And see also p. 27, above.]
[2] [Here, again, see *Lectures on Art*, § 164.]

3. Now the statement I have just made to you (in § 1) implies the falseness of all such theories and methods.* And I mean to assert that falsity in the most positive manner. Shadows are not more transparent than lights, nor lights than shadows; both are transparent, when they express space; both are opaque, when they express substance; and both are to be imitated in precisely the same manner, and with the same quality, of pigment. The only technical law which is indeed constant, and which requires to be observed with strictness, is precisely that the method *shall be* uniform. You may take a white ground, and lay darks on it, leaving the white for lights; or you may take a dark ground, and lay lights on it, leaving the dark for darks: in either case you must go on as you begin, and not introduce the other method where it suits you. A glass painter must make his *whole* picture transparent;[1] and a fresco painter, his whole picture opaque.

4. Get, then, this plain principle well infixed in your minds. Here is a crocus—there is the sun—here a piece of coal—there, the hollow of the coal-scuttle it came out of. They are every one but patches of colour,—some yellow, some black; and must be painted in the same manner, with whatever yellow or black paint is handy.

5. Suppose it, however, admitted that lights and shades are to be produced in the same manner; we have farther to ask, what that manner may best be?

You will continually hear artists disputing about grounds, glazings, vehicles, varnishes, transparencies, opacities, oleaginousnesses. All that talk is as idle as the east wind.[2] Get

* Essentially, the use of transparent brown by Rubens, (followed by Sir Joshua with asphaltum,) ruined the Netherland schools of colour,[3] and has rendered a school of colour in England hitherto impossible.

[1] [On transparency as the essence of coloured glass, see Vol. X. p. 456, and *Lectures on Art*, § 186.]

[2] [See Job xv. 2.]

[3] [See the discussion of this matter in the review of Eastlake's *History of Oil-Painting*, §§ 29, 30 (Vol. XII. pp. 286–287), and compare Vol. V. p. 299.]

a flat surface that won't crack,—some coloured substance
that will stick upon it, and remain always of the colour
it was when you put it on,—and a pig's bristle or two,
wedged in a stick; and if you can't paint, you are no painter;
and had better not talk about the art.

The one thing you have to learn—the one power truly
called that of "painting"—is to lay on any coloured sub-
stance, whatever its consistence may be, (from mortar to
ether,) *at once*, of the exact tint you want, in the exact
form you want, and in the exact quantity you want. *That*
is painting.

6. Now, you are well aware that to play on the violin
well, requires some practice. Painting is playing on a
colour-violin, seventy-times-seven stringed, and inventing
your tune as you play it! That is the easy, simple, straight-
forward business you have to learn. Here is your catgut
and your mahogany,—better or worse quality of both of
course there may be,—Cremona tone, and so on, to be
discussed with due care, in due time;—you cannot paint
miniature on the sail of a fishing-boat, nor do the fine work
with hog's bristles that you can with camel's hair:—all these
catgut and bristle questions shall have their place; but, the
primary question of all is—*can* you *play?*

7. Perfectly, you never can, but by birth-gift. The
entirely first-rate musicians and painters are born, like
Mercury;—their words are music, and their touch is gold:
sound and colour wait on them from their youth; and no
practice will ever enable other human creatures to do any-
thing like them. The most favourable conditions, the most
docile and apt temper, and the unwearied practice of life,
will never enable any painter of merely average human
capacity to lay a single touch like Gainsborough, Velasquez,
Tintoret, or Luini. But to understand that the matter must
still depend on practice *as well* as on genius,—that painting
is not one, whit less, but more, difficult than playing on an
instrument,—and that your care as a student, on the whole,
is not to be given to the quality of your piano, but of

your touch,—this is the great fact which I have to teach you respecting colour; this is the root of all excellent doing and perceiving.

And you will be utterly amazed, when once you begin to feel what colour means, to find how many qualities which appear to result from peculiar method and material do indeed depend only on loveliness of execution; and how divine the law of nature is, which has so connected the immortality of beauty with patience of industry, that by precision and rightness of laborious art you may at last literally command the rainbow to stay, and forbid the sun to set.

8. To-day, then, you are to begin to learn your notes— to hammer out, steadily, your first five-finger exercises; and as in music you have first to play in true time, with stubborn firmness, so in colour the first thing you have to learn is to lay it flat, and well within limits. You shall have it first within linear limits of extreme simplicity, and you must be content to fill spaces so enclosed, again and again and again, till you are perfectly sure of your skill up to that elementary point.

9. So far, then, of the manner in which you are to lay your colour;—next comes the more debatable question yet, what kind of colour you are thus to lay,—sober, or bright. For you are likely often to have heard it said that people of taste like subdued or dull colours, and that only vulgar persons like bright ones.[1]

But I believe you will find the standard of colour I am going to give you, an extremely safe one—the morning sky. Love *that* rightly with all your heart, and soul, and eyes; and you are established in foundation-laws of colour. The white, blue, purple, gold, scarlet, and ruby of morning clouds, are meant to be entirely delightful to the human creatures whom the "clouds and light"[2] sustain. Be sure

[1] [See Vol. X. p. 109.]

[2] [These words are the title of a small devotional book, in prose and verse, by Rose La Touche (Nisbet, 1870), for whom see *Præterita*, iii. §§ 51 *seq.* On the title-page are the following passages from the Book of Job (xxxvii. 11, 15, 21): " He wearieth the thick cloud ; he scattereth his bright cloud. And caused the light of his cloud to shine. Men see not the bright light which is in the clouds."]

you are always ready to see *them,* the moment they are painted by God for you.[1]

But you must not rest in these. It is possible to love them intensely, and yet to have no understanding of the modesty or tenderness of colour.

Therefore, next to the crystalline firmament over you, the crystalline earth beneath your feet is to be your standard.

Flint, reduced to a natural glass containing about ten per cent. of water, forms the opal; which gives every lower hue of the prism in as true perfection as the clouds; but not the scarlet or gold, both which are crude and vulgar in opal. Its perfect hues are the green, blue, and purple. Emerald and lapis-lazuli give central green and blue in fulness; and the natural hues of all true gems, and of the marbles, jaspers, and chalcedonies, are types of intermediate tint: the oxides of iron, especially, of reds. All these earth-colours are curiously prepared for right standards: there is no misleading in them.

10. Not so when we come to the colours of flowers and animals. Some of these are entirely pure and heavenly; the dove can contend with the opal, the rose with the clouds, and the gentian with the sky; but many animals and flowers are stained with vulgar, vicious, or discordant colours. But all those intended for the service and companionship of man are typically fair in colour; and therefore especially the fruits and flowers of temperate climates;— the purple of the grape and plum; the red of the currant and strawberry, and of the expressed juices of these,—the wine that "giveth his colour in the cup,"[2] and the "lucent syrup tinct with cinnamon."[3] With these, in various subordination, are associated the infinitudes of quiet and harmonized colour on which the eye is intended to repose; the softer duns and browns of birds and animals, made quaint

[1] [Compare, above, p. 362.]
[2] [Proverbs xxiii. 31.]
[3] [Keats: *The Eve of St. Agnes.*]

by figured patterns; and the tender green and grey of vegetation and rock.

11. No science, but only innocence, gaiety of heart, and ordinary health and common sense, are needed, to enable us to enjoy all these natural colours rightly. But the more grave hues, which, in the system of nature, are associated with danger or death, have become, during the later practice of art, pleasing in a mysterious way to the most accomplished artists: so that the greatest masters of the sixteenth century may be recognized chiefly by their power of producing beauty with subdued colours. I cannot enter here into the most subtle and vital question of the difference between the subdued colours of Velasquez or Tintoret, and the daubed grey and black[1] of the modern French school:* still less into any analysis of the grotesque inconsistency

* One great cause of the delay which has taken place in the publication of this book has been my doubt of the proper time and degree in which study in subdued colour should be undertaken. For though, on the one hand, the entirely barbarous glare of modern coloured illustration would induce me to order practice in subdued colour merely for antidote to it; on the other, the affection,—or morbid reality,—of delight in subdued colour, are among the fatallest errors of semi-artists. The attacks on Turner in his greatest time were grounded in real feeling, on the part of his adversaries, of the solemnity in the subdued tones of the schools of classic landscape.

To a certain extent, therefore, the manner of study in colour required of any student must be left to the discretion of the master, who alone can determine what qualities of colour the pupil is least sensible to; and set before him examples of brightness, if he has become affectedly grave,—and of subdued harmony, if he errs by crudeness and discord. But the general law must be to practise first in pure colour, and then, as our sense of what is grave and noble in life and conduct increases, to express what feeling we have of such things in the hues belonging to them, remembering, however, always, that the instinct for grave colour is not at all an index of a grave mind. I have had curious proof of this in my own experience. When I was an entirely frivolous and giddy boy, I was fondest of what seemed to me "sublime" in gloomy art, just in proportion as I was insensible to crudeness and glare in the bright colours which I enjoyed for their own sake: and the first old picture I ever tried to copy was the small Rembrandt in the Louvre, of the Supper at Emmaus.[2] But now, when my inner mind is as sad as it is well possible for any man's to be, and my thoughts are for the most part occupied in very

[1] [Compare Vol. XIV. p. 141, and see the references there noted.]
[2] [See *Præterita*, i. ch. iv. § 94.]

which makes the foreign modern schools, generally, re-paint all sober and tender pictures with glaring colours, and yet reduce the pure colours of landscape to drab and brown. In order to explain any of these phenomena, I should have first to dwell on the moral sense which has induced us, in ordinary language, to use the metaphor of " chastity " for the virtue of beautifully subdued colour ; and then to explain how the chastity of Britomart or Perdita[1] differs from the vileness of souls that despise love. But no subtle inquiries or demonstrations can be admitted in writing primal laws ; nor will they ever be needed, by those who obey them. The things which are naturally pleasant to innocence and youth, will be for ever pleasant to us, both in this life and in that which is to come ; and the same law which makes the babe delight in its coral, and the girl in the cornelian pebble she gathers from the wet and shining beach, will still rule their joy within the walls whose light shall be " like a stone most precious, even like a jasper stone, clear as crystal."[2]

12. These things, then, above named, without any de-bate, are to be received by you as *standards* of colour : by admiration of which you may irrefragably test the rightness

earnest manner, and with very grave subjects, my ideal of colour is that which I now assign for the standard of St. George's schools,—the colour of sunrise, and of Angelico.

Why not, then, of the rainbow, simply ?

Practically, I *must* use those of the rainbow to begin with. But, for stand-ards, I give the sunrise and Angelico, because the sun and he both use gold for yellow. Which is indeed an infinite gain ; if poor Turner had only been able to use gold for yellow too, we had never heard any vulgar jests about him.[3] But, in cloud-painting, nobody can use gold except the sun himself,—while, on angel's wings, it can but barely be managed, if you have old Etrus-can blood in your fingers,—not here, by English ones, cramped in their clutch of Indian or Californian gold.

[1] [For the chastity of Britomart, see Vol. X. pp. 383, 408 ; for Perdita, Vol. XIV. p. 243 *n.*]

[2] [Revelation xxi. 11.]

[3] [For Turner's fondness for yellow, see *Modern Painters*, vol. i. (Vol. III. pp. 284, 296) ; for one reason why his system of colouring exposed him to "laughter," see *ibid.*, vol. iv. (Vol. VI. pp. 55–56). Many of the jests which used to be made at the expense of his brilliant colouring may be found in Thornbury's *Life*.]

of your sense, and by imitation* of which you can form
and order all the principles of your practice. The morning
sky, primarily, I repeat; and then from the dawn onwards.
There are no greys nor violets which can come near
the perfectness of a pure dawn; no gradations of other
shade can be compared with the tenderness of its transi-
tions. Dawn, with the waning moon, (it is always best
so, because the keen gleam of the thin crescent shows the
full depth of the relative grey,) determines for you all that
is lovely in subdued hue and subdued light. Then the
passages into sunrise determine for you all that is best
in the utmost glory of colour. Next to these, having
constant office in the pleasures of the day, come the colours
of the earth, and her fruits and flowers; the iron ochres[1]
being the standards of homely and comfortable red, always
ruling the pictures of the greatest masters at Venice, as
opposed to the vulgar vermilion of the Dutch; hence
they have taken the general name of *Venetian* red: then,
gold itself, for standard of lustrous yellow, tempered so
wisely with grey in the shades; silver, of lustrous white,
tempered in like manner; marble and snow, of white pure,
glowing into various amber and rose under sunlight: then
the useful blossoms and fruits;—peach and almond blossom,
with the wild rose, of the paler reds; the clarissas, of full
reds, etc.; and the fruits, of such hues modified by texture
or bloom. Once learn to paint a peach, an apricot, and a
greengage, and you have nothing more to know in the

* "Imitation"—I use the word advisedly. The last and best lesson I
ever had in colour was a vain endeavour to estimate the time which Angelico
must have taken to paint a small amethyst on the breast of his St. Laurence.[2]

[1] [Compare in *Two Paths* (Vol. XVI.) Lecture v., "The Work of Iron in Nature,
Art, and Policy").]

[2] [In one of the frescoes in the Cappella di Niccolò V. in the Vatican. Ruskin
was at work in the Vatican, for some weeks in 1874. For other references to
Angelico's painting of jewelled robes, see *Eagle's Nest*, § 218, and *Giotto and his Works
in Padua*, § 23. At an earlier date Ruskin had noted Angelico's work in this sort
rather for its generic, than its specific, character: see *Modern Painters*, vol. ii. (Vol. IV.
p. 324).]

modes of colour enhanced by texture. Corn is the standard of brown,—moss of green; and in general, whatever is good for human life is also made beautiful to human sight, not by "association of ideas,"[1] but by appointment of God that in the bread we rightly break for our lips, we shall best see the power and grace of the Light He gave for our eyes.

13. The perfect order of the colours in this gentle glory is, of course, normal in the rainbow,—namely, counting from outside to inside, red, yellow, and blue, with their combinations,*—namely, scarlet, formed by yellow with red; green, formed by blue with yellow; and purple, formed by red with blue.

14. But neither in rainbow prism, nor opal, are any of these tints seen in separation. They pass into each other by imperceptible gradation, nor can any entirely beautiful colour exist without this quality. Between each secondary, therefore, and the primaries of which it is composed, there are an infinite series of tints; inclining on one side to one primary, on the other to the other; thus green passes into blue through a series of bluish greens, which are of great importance in the painting of sea and sky;—and it passes into yellow through a series of golden greens, which are of no less importance in painting earth and flowers. Now it is very tiresome to have to mix names as well as colours, and always say "bluish green," or "reddish purple," instead of having proper special names for these intermediate tints. Practically we have such names for several of them; "orange," for instance, is the intermediate between scarlet

* Strictly speaking, the rainbow is *all* combination; the primary colours being only lines of transition, and the bands consisting of scarlet, green, and purple; the scarlet being not an especially pure or agreeable one in its general resultant hue on cloud-grey. The green and violet are very lovely when seen over white cloud.

[1] [For Ruskin's criticism "Of the False Opinion that Beauty depends on the Association of Ideas," see *Modern Painters,* vol. ii. (Vol. IV. p. 70). See also Vol. XII. p. 28.]

and yellow; "lilac" one of the paler tints between purple and red; and "violet" that between purple and blue. But we must now have our code of names complete; and that we may manage this more easily, we will put the colours first in their places.

15. Take your sixpence again;[1] and, with that simple mathematical instrument, draw twelve circles of its size, or at least as closely by its edge as you can,* on a piece of Bristol board, so that you may be able to cut them out, and place them variously. Then take carmine, cobalt, gamboge, orange vermilion, and emerald green; and, marking the circles with the twelve first letters of the alphabet, colour "a" with pure gamboge, "b" with mixed gamboge and emerald green, "c" with emerald green, "d" with emerald green and cobalt, "e" with cobalt pure, "f" with two-thirds cobalt and one-third carmine, "g" with equally mixed cobalt and carmine, "h" with two-thirds carmine and one-third cobalt, "i" with carmine pure, "j" with carmine and vermilion, "k" with vermilion, "l" with vermilion and gamboge.[2]

16. But how is all this to be done smoothly and rightly, and how are the thirds to be measured?† Well,—for the

* It is really in practice better to do this than to take compasses, which are nearly sure to slip or get pinched closer, in a beginner's hands, before the twelve circles are all done. But if you like to do it accurately, see Figure 17, p. 428.

† I have vainly endeavoured to persuade Messrs. Winsor and Newton to prepare for me powder-colours, of which I could direct half or a quarter grain to be mixed with a measured quantity of water; but I have not given up the notion. In the meantime, the firm have arranged at my request a beginner's box of drawing materials,—namely, colours, brushes, ruler, and compasses fitted with pencil-point.[3] (As this note may be read by many persons, hurriedly, who have not had time to look at the first number, I allow once more, but for the last time in this book, the vulgar use of the words "pencil" and "brush.") The working pencil and penknife should be always in the pocket, with a small sketch-book, which a student of drawing should consider just as necessary a

[1] [See above, p. 373.]
[2] [With this arrangement of colours, compare *Elements of Drawing*, above, p. 142.]
[3] [This box is no longer sold by the firm.]

doing of it, I must assume, that in the present artistic and communicative phase of society, the pupil can, at some chance opportunity, see the ordinary process of washing with water-colour; or that the child in more happy circumstances may be allowed so to play with "paints" from its earliest years, as to be under no particular difficulty in producing a uniform stain on a piece of pasteboard. The quantity of pigment to be used cannot be yet defined;— the publication of these opening numbers of *Fésole* has already been so long delayed that I want now to place them in the student's hand, with what easily explicable details I can give, as soon as possible; and the plates requiring care in colouring by hand, which will finally be given as examples,[1] are deferred until I can give my readers some general idea of the system to be adopted. But, for the present need, I can explain all that is wanted without the help of plates, by reference to flower-tints; not that the student is to be vexed by any comparisons of his work with *these*, either in respect of brilliancy or texture: if he can bring his sixpenny circles to an approximate resemblance of as many old-fashioned wafers, it is all that is required of him. He will not be able to do this with one coat of colour; and had better allow himself three or four than permit the tints to be uneven.

17. The first tint, pure gamboge, should be brought, as near as may be, up to that of the yellow daffodil,—the

part of his daily equipment as his watch or purse. Then the colour-box, thus composed, gives him all he wants more. For the advanced student, I add the palette, with all needful mathematical instruments and useful colours. I give *him* colours, of finest quality,—being content, for beginners, with what I find one of the best practical colourists in England, my very dear friend Professor Westwood,[2] has found serviceable all his life,—children's colours.

[1] [These, however, were never executed.]

[2] [John Obadiah Westwood (1805–1893), entomologist and palæographer; Hope Professor of Zoology at Oxford (1861–1893); and author (among other palæographical works) of *Palæographia Sacra* (1843–1845) and *Pictorial Facsimiles of Miniatures and Ornaments of Anglo-Saxon and Irish Manuscripts* (1868). The former work is referred to by Ruskin in *Two Paths*, § 28. For other references to Westwood, see *Pleasures of England*, §§ 53, 102–103.]

buttercup is a little too deep. In fine illumination, and in the best decorative fresco painting, this colour is almost exclusively represented by gold, and the student is to give it, habitually, its heraldic name of "Or."

The second tint, golden-green, which is continually seen in the most beautiful skies of twilight, and in sun-lighted trees and grass, is yet unrepresented by any flower in its fulness; but an extremely pale hue of it, in the primrose, forms the most exquisite opposition, in spring, to the blue of the wood-hyacinth; and we will therefore keep the name, "Primrose," for the hue itself.

The third tint, pure green, is, in heraldry, "Vert" on the shields of commoners, and "Emerald" on those of nobles.[1] We will take for St. George's schools the higher nomenclature, which is also the most intelligible and convenient; and as we complete our colour zodiac, we shall thus have the primary and secondary colours named from gems, and the tertiary from flowers.

18. The next following colour, however, the tertiary between green and blue, is again not represented distinctly by any flower; but the blue of the Gentiana Verna[2] is so associated with the pure green of Alpine pasture, and the colour of Alpine lakes, which is precisely the hue we now want a name for, that I will call this beautiful tertiary "Lucia"; (that being the name given in *Proserpina*[3] to the entire tribe of the gentians,) and especially true to our general conception of luminous power or transparency in this colour, which the Greeks gave to the eyes of Athena.

19. The fifth colour, the primary blue, heraldic "azure," or "sapphire," we shall always call "Sapphire"; though, in truth, the sapphire itself never reaches anything like the intensity of this colour, as used by the Venetian painters,

[1] [This distinction between "Vert" and "Emerald" is one used by English heralds.]

[2] [For the colour of this gentian, see Vol. XIII. p. 117 and *n*.]

[3] [See chs. vi. and xi.; aud for the colour of the eyes of Athena, *Queen of the Air*, §§ 15, 91; and *Deucalion*, ch. vii. § 32.]

who took for its representative pure ultramarine. But it is only seen in perfect beauty in some gradations of the blue glass of the twelfth century. For ordinary purposes, cobalt represents it with sufficient accuracy.

20. The sixth colour, the tertiary between sapphire and purple, is exactly the hue of the Greek sea, and of the small Greek iris, Homer's ἴον, commonly translated "violet."[1] We will call it "Violet"; our own flower of that name being more or less of the same hue, though paler. I do not know what the "syrup of violets" was, with which Humboldt stained his test-paper, (*Personal Narrative*, i., p. 163,)[2] but I am under the impression that an extract of violets may be obtained which will represent this colour beautifully and permanently. Smalt is one of its approximate hues.

21. The seventh colour, the secondary purple, is the deepest of all the pure colours; it is the heraldic "purpure," and "jacinth"; by us always to be called "Jacinth." It is best given by the dark pansy; see the notes on that flower in the seventh number of *Proserpina*, which will I hope soon be extant.[3]

22. The eighth colour, the tertiary between purple and red, corresponds accurately to the general hue and tone of bell-heather, and will be called by us therefore "Heath." In various depths and modifications, of which the original tint cannot be known with exactness, it forms the purple ground of the most stately missals between the seventh and twelfth century, such as the Psalter of Boulogne.[4] It was always, however, in these books, I doubt not, a true heath-purple, not a violet.

23. The ninth colour, the primary red, heraldic "gules"

[1] [See *The Queen of the Air*, § 84.]
[2] [For note on this book, see above, p. 392. The passage here referred to is: "A short time before the great eruption of Mount Vesuvius, in 1805, M. Gay-Lussac and myself had observed that water, under the form of vapor, in the interior of the crater, did not redden paper dipped in sirup of violets."]
[3] [Now ch. i. (§ 11) of vol. ii. of that work.]
[4] [In the Public Library of that town.]

and "ruby," will be called by us always "Ruby." It is not represented accurately by any stable pigment; but crimson lake, or better, carmine, may be used for it in exercises; and rose madder in real painting.

24. The tenth colour, the tertiary between red and scarlet, corresponds to the most beautiful dyes of the carnation, and other deeper-stained varieties of the great tribe of the pinks. The mountain pink, indeed, from which they all are in justice named, is of an exquisitely rich, though pale, ruby: but the intense glow of the flower leans towards fiery scarlet in its crimson; and I shall therefore call this tertiary "Clarissa," the name of the pink tribe in *Proserpina.*[1]

25. The eleventh colour, the secondary scarlet heraldic "tenny" and "jasper," is accurately represented by the aluminous silicas, coloured scarlet by iron, and will be by us always called "Jasper."

26. The twelfth colour, the tertiary between scarlet and gold, is most beautifully represented by the golden crocus, —being the colour of the peplus of Athena.[2] We shall call it "Crocus"; thus naming the group of the most luminous colours from the two chief families of spring flowers, with gold (for the sun) between them.

This, being the brightest, had better be placed uppermost in our circle, and then, taking the rest in the order I have named them, we shall have our complete zodiac thus arranged. (Fig. 17.*)

* If you choose to construct this figure accurately, draw first the circle x y, of the size of a sixpence, and from its diameter x y, take the angles m a x, n a y, each = the sixth of the quadrant, or fifteen degrees. Draw the lines a b, a l, each equal to x y. and l and b are the centres of the next circles. Then the perpendiculars from m and n will cut the perpendicular from a in the centre of the large circle. And if you get it all to come right, I wish you joy of it.

[1] [Ch. viii. § 21. In *Fors Clavigera*, however (Letter 74, dated January 2, 1877), he proposed to change the name from "Clarissa" to "Clara."]

[2] [See *The Queen of the Air*, § 84.]

27. However rudely the young student may have
coloured his pieces of cardboard, when he has placed them
in contact with each other in this circular order, he will
at once see that they form a luminous gradation, in which

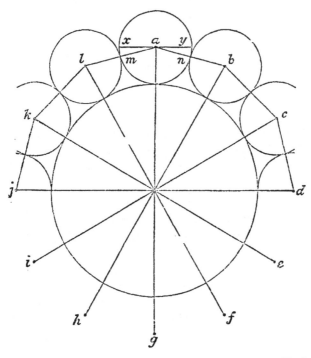

Fig. 17

the uppermost, Or, is the lightest, and the lowest, Jacinth,
the darkest hue.

Every one of the twelve zodiacal colours has thus a
pitch of intensity at which its special hue becomes clearly
manifest, and above which, or below which, it is not clearly
recognized, and may, even in ordinary language, be often
spoken of as another colour. Crimson, for instance, and

pink, are only the dark and light powers of the central Clarissa, and "rose" the pale power of the central Ruby. A pale jacinth is scarcely ever, in ordinary terms, called purple, but "lilac."

28. Nevertheless, in strictness, each colour is to be held as extending in unbroken gradation from white to black, through a series of tints, in some cases recognizable throughout for the same colour; but in all the darker tones of Jasper, Crocus and Or, becoming what we call "brown"; and in the darker tints of Lucia and Primrose passing into greens, to which artists have long given special titles of "Sap," "Olive," "Prussian," and the like.

29. After we have studied the modifications of shade itself, in neutral grey, we will take up the gradated scales of each colour; dividing them always into a hundred degrees, between white and black; of which the typical or representative hue will be, in every one of the zodiacal colours, at a different height in the scale—the representative power of Or being approximately 20; of Jasper, 30; of Ruby, 50; and of Jacinth, 70. But, for the present, we must be content with much less precise ideas of hue; and begin our practice with little more than the hope of arriving at some effective skill in producing the tints we want, and securing some general conclusions about their effects in companionship with, or opposition to, each other; the principal use of their zodiacal arrangement, above given, being that each colour is placed over against its proper opponent;—Jacinth being the hue which most perfectly relieves Or, and Primrose the most lovely opponent to Heath. The stamens and petals of the sweet-william present the loveliest possible type of the opposition of a subtle and subdued Lucia to dark Clarissa. In central spring on the higher Alps, the pansy, (or, where it is wanting, the purple ophrys,[1]) with the bell gentian, and pale yellow furred anemone, complete the entire chord from Or to Jacinth in embroideries as

[1] [For this plant, and its name, see *Proserpina*, i. ch. xi. § 7.]

rich as those of an Eastern piece of precious needlework on green silk.* The chord used in the best examples of glass and illumination is Jasper, Jacinth, and Sapphire, on ground of Or: being the scarlet, purple, and blue of the Jewish Tabernacle, with its clasps and furniture of Gold.

30. The best Rubrics of ecclesiastical literature are founded on the opposition of Jasper to Sapphire, which was the principal one in the minds of the illuminators of the thirteenth century. I do not know if this choice was instinctive, or scientific; many far more beautiful might have been adopted; and I continually, and extremely, regret the stern limitation of the lovely penmanship of all minor lettering, for at least a hundred years through the whole of literary Europe, to these two alternating colours. But the fact is that these do quite centrally and accurately express the main opposition of what artists call, and most people feel to be truly called, *warm* colours as opposed to cold; pure blue being the coldest, and pure scarlet the warmest, of abstract hues.

31. Into the mystery of Heat, however, as affecting colour-sensation, I must not permit myself yet to enter, though I believe the student of illumination will be enabled at once, by the system given in this chapter, to bring his work under more consistent and helpful law than he has hitherto found written for his use. My students of drawing will find the subject carried on as far as they need follow, in tracing the symbolic meanings of the colours, from the 28th to the 40th paragraph of the seventh chapter of *Deucalion;* (compare also *Eagle's Nest*, § 226) and, without requiring, in practice, the adoption of any nomenclature merely fanciful, it may yet be found useful, as an aid to memory for young people, to associate in their minds the order of the zodiacal colours with that of the zodiacal signs. Taking Jacinth for Aries, Or will very fitly be the colour

* Conf. Lane's *Arabian Nights*, vol. i., p. 480, and vol. ii., p. 395.

of Libra, and blue of Aquarius; other associations by a little graceful and careful thought, may be easily instituted between each colour and its constellation; and the motion of the Source of Light through the heavens, registered to the imagination by the beautiful chord of his own divided rays.

CHAPTER VIII

OF THE RELATION OF COLOUR TO OUTLINE

1 4.

5. Thus far I have repeated, with modification of two sentences only, the words of my old *Elements of Drawing;*—words which I could not change to any good purpose, so far as they are addressed to the modern amateur, whose mind has been relaxed, as in these days of licentious pursuit of pleasurable excitement, all our minds must be, more or less, to the point of not being able to endure the stress of wholesome and errorless labour,—(errorless, I mean, of course, only as far as care can prevent fault). But the *Laws of Fésole* address themselves to no persons of such temper; they are written only for students who have the fortitude to do their best; and I am not minded, any more, as will be seen in next chapter, while they have any store of round sixpences in their pockets, to allow them to draw their Sun, Earth, and Moon like crooked ones.

6. Yet the foregoing paragraphs are to be understood also in a nobler sense. They are right, and for evermore right, in their clear enunciation of the necessity of being true in colour, as in music, note to note; and therefore also in their implied assertion of the existence of Colour-Law, recognizable by all colourists, as harmony is by all musicians; and capable of being so unanimously ascertained by accurate obedience to it, that an ill-coloured picture could be no more admitted into the gallery of any rightly

¹ [§§ 1–4 of this chapter, dwelling on the extreme difficulty of right colouring, consisted of §§ 152–154 of *The Elements of Drawing;* see above, pp. 133–136, where the notes and modifications added in *The Laws of Fésole* are given.]

constituted Academy, or Society of Painters, than a howling dog into a concert.

7. I say, observe, that Colour-Law may be ascertained by accurate *obedience* to it; not by theories concerning it. No musical philosophy will ever teach a girl to sing, or a master to compose; and no colour-philosophy will ever teach a man of science to enjoy a picture, or a dull painter to invent one. Nor is it prudent, in early practice, even to allow the mind to be influenced by its preferences and fancies in colour, however delicate. The first thing the student has to do, is to enable himself to match *any* colour when he sees it; and the effort which he must make constantly, for many a day, is simply to match the colour of natural objects as nearly as he can.

And since the mightiest masters in the world cannot match these *quite*, nor any *but* the mightiest match them, even nearly; the young student must be content, for many and many a day, to endure his own deficiencies with resolute patience, and lose no time in hopeless efforts to rival what is admirable in art, or copy what is inimitable in nature.

8. And especially, he must for a long time abstain from attaching too much importance to the beautiful mystery by which the blended colours of objects seen at some distance charm the eye inexplicably. The day before yesterday, as I was resting in the garden, the declining sunshine touched just the points of the withered snapdragons on its wall. They never had been anything very brilliant in the way of snapdragons, and were, when one looked at them close, only wasted and much pitiable ruins of snapdragons; but this Enid-like tenderness of their fading grey,[1] mixed with what remnant of glow they could yet raise into the rosy sunbeams, made them, at a little distance, beautiful beyond all that pencil could ever follow. But you are not

[1] [See "The Marriage of Geraint" in *Idylls of the King*: "Then she bethought her of a faded silk," etc.]

to concern yourself with such snapdragons yet, nor for a long while yet.

Attempt at first to colour nothing but what is well within sight, and approximately copiable;—but take a *group* of objects always, not a single one; outline them with the utmost possible accuracy, with the lead; and then paint each of its own colour, with such light and shade as you can see in it, and produce, in the first wash, as the light and shade is produced in Plate VI., never retouching. This law will compel you to look well what the colour is, before you stain the paper with any: it will lead you, through that attention, daily into more precision of eye, and make all your experience gainful and definite.

9. Unless you are very sure that the shadow is indeed of some different colour from the light, shade simply with a deeper, and if you already know what the word means, a warmer, tone of the colour you are using. Darken, for instance, or with crocus, ruby with clarissa, heath with ruby; and, generally, any colour whatever with the one next to it, between it and the jasper. And in all mixed colours, make the shade of them slightly more vivid in hue than the light, unless you assuredly see it in nature to be less so. But for a long time, do not trouble yourself much with these more subtle matters; and attend only to the three vital businesses;—approximate matching of the main colour in the light,—perfect limitation of it by the outline, and flat, flawless, laying of it over all the space within.

10. For instance, I have opposite me, by chance, at this moment, a pale brown cane-bottomed chair, set against a pale greenish wall-paper.[1] The front legs of the chair are round; the back ones, something between round and square; and the cross-bar of the back, flat in its own section, but bent into a curve.

[1] [Ruskin must have been writing away from Brantwood, where the study paper was (and is) of a white ground with a gold and coloured design, copied from a pictured embroidery in Marco Marziale's "Circumcision" at the National Gallery (No. 803); see *Letters to Ward*, vol. ii. p. 24, privately issued in 1893 and reprinted in a later volume of this edition.]

To represent these roundings, squarings, and flattenings completely, with all the tints of brown and grey involved in them, would take a forenoon's work, to little profit. But to outline the entire chair with extreme precision, and then tint it with two well-chosen colours, one for the brown wood, the other for the yellow cane, completing it, part by part, with gradation such as could be commanded in the wet colour; and then to lay the green of the wall behind, into the spaces left, fitting edge to edge without a flaw or an overlapping, would be progressive exercise of the best possible kind.

Again, on another chair beside me there is a heap of books, as the maid has chanced to leave them, lifting them off the table when she brought my breakfast. It is not by any means a pretty or picturesque group; but there are no railroad-stall bindings in it,—there are one or two of old vellum, and some sober browns and greens, and a bit of red; and, altogether, much more variety of colour than anybody but an old Venetian could paint rightly. But if you see * any day such a pleasantly inconsiderate heap of old books, then outline them with perfect precision, and then paint each of its own colour at once, to the best of your power, completely finishing that particular book, as far as you mean to finish it,† before you touch the white paper with the slightest tint of the next,—you will have gone much farther than at present you can fancy any idea, towards gaining the power of painting a Lombard tower, or a Savoyard precipice, in the right way also,—that is to say, joint by joint, and tier by tier.

11. One great advantage of such practice is in the necessity of getting the colour quite even, that it may fit with precision, and yet without any hard line, to the piece

* You had better "see" or find, than construct them;—else they will always have a constructed look, somehow.

† The drawing of the lines that show the edges of the leaves, or, in the last example, of the interlacing in the cane of the chair, is entirely a subsequent process, not here contemplated.

next laid on. If there has been the least too much in the brush, it of course clogs and curdles at the edge, whereas it ought to be at the edge just what it is at the middle, and to end there, whatever its outline may be, as——Well, as you see it *does* end, if you look, in the thing you are painting. Hardness, so called, and myriads of other nameless faults, all are traceable, ultimately, to mere want of power or attention in keeping tints quiet at their boundary.

12. Quiet—and therefore keen; for with this boundary of them, ultimately, you are to draw, and not with a black-lead outline; so that the power of the crags on the far-away mountain crest, and the beauty of the fairest saint that stoops from heaven, will depend, for true image of them, utterly on the last line that your pencil traces with the edge of its colour, true as an arrow, and light as the air. In the meantime, trust me, everything depends on the lead outline's being clear and sufficient. After my own forty years' experience, I find nearly all difficulties resolve themselves at last into the want of more perfect outline: so that I say to myself—before any beautiful scene,—Alas, if only I had the outline of that, what a lovely thing I would make of it in an hour or two! But then the outline would take, for the sort of things I want to draw, not an hour, but a year, or two!

13. Yet you need not fear getting yourself into a like discomfort by taking my counsel. This sorrow of mine is because I want to paint Rouen Cathedral, or St. Mark's, or a whole German town with all the tiles on the roofs, that one might know against what kind of multitude Luther threw his defiance. If you will be moderate in your desires as to subject, you need not fear the oppressiveness of the method;—fear it, however, as you may, I tell you positively it is the only method by which you can ever force the Fates to grant you good success.

14. The opposite plate, VII., will give you an idea of the average quantity of lines which Turner used in any landscape sketch in his great middle time, whether he

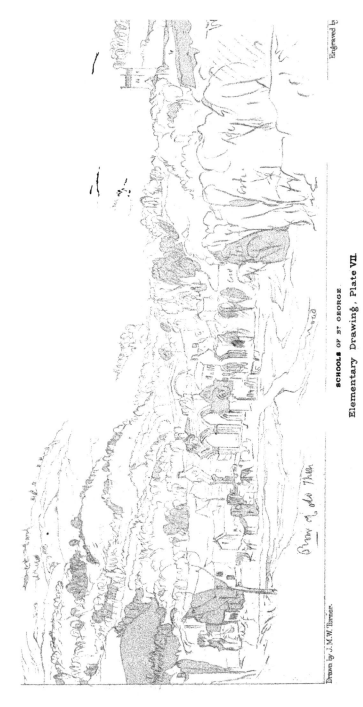

Drawn by J.M.W. Turner.

Engraved by

Elementary Drawing, Plate VII.

LANDSCAPE OUTLINE WITH THE LEAD.

meant to colour it or not.[1] He made at least a hundred sketches of this kind for one that he touched with colour: nor is it ever possible to distinguish any difference in manner between outlines (on white paper) intended for colour, or only for notation: in every case, the outline is as perfect as his time admits; and, in his earlier days, if his leisure does not admit of its perfection, it is not touched with colour at all. In later life, when, as he afterwards said of himself, in woful repentance, "he wanted to draw *every*thing," both the lead outline and the colour dash became slight enough,—but never inattentive; nor did the lead outline ever lose its governing proportion to all subsequent work.

15. And now, of this outline, you must observe three things. First, touching its subject; that the scene was worth drawing at all, only for its human interest; and that this charm of inhabitation was *always* first in Turner's mind. If he had only wanted what vulgar artists think picturesque, he might have found, in such an English valley as this, any quantity of old tree-trunks, of young tree-branches, of lilied pools in the brook, and of grouped cattle in the meadows. For no such mere picture-material he cares; his time is given to seize and show the total history and character of the spot, and all that the people of England had made of it, and become in it. There is the ruined piece of thirteenth-century abbey; the rector's house beside it;* the gate-posts of the squire's avenue above; the steep fourteenth or fifteenth century bridge over the stream · the low-roofed, square-towered village church on the hill; two or three of the village houses and outhouses traced

* Compare, if by chance you come across the book, the analysis of the design of Turner's drawing of "Heysham" in my old *Elements of Drawing*, § 244 [above, p. 207].

[1] [This plate was engraved by Mr. Allen from a facsimile by Mr. William Ward of a sketch in one of Turuer's sketch-books in the possession of the National Gallery. The subject appears to be Glastonbury; the words which Ruskin reads "row of old trees" seem rather to be "row of old *thorn*."]

on the left, omitting, that these may be intelligible, the
"row of old trees," which, nevertheless, as a part, and
a principal part, of the landscape, are noted, by inscription,
below; and will be assuredly there, if ever he takes up the
subject for complete painting; as also the tall group of
"ash"·on the right, of which he is content at present merely
to indicate the place, and the lightness.

16. Do not carry this principle of looking for signs of
human life or character, any more than you carry any other
principle, to the point of affectation. Whatever pleases
and satisfies you for the present, may be wisely drawn; but
remember always that the beauty of any natural object is
relative to the creatures it has to please; and that the
pleasure of these is in proportion to their reverence, and
their understanding. There can be no natural "phenomena"[1]
without the beings to whom they are "phenomenal," (or, in
plainer English, things cannot be apparent without some
one to whom they may appear,) and the final definition of
Beauty is, the power in anything of delighting an intelligent
human soul by its appearance,—power given to it by the
Maker of Souls. The perfect beauty of Man is summed in
the Arabian exclamation, "Praise be to Him who created
thee!" and the perfect beauty of all natural things summed
in the Angel's promise, "Goodwill towards men."[2]

17. In the second place, observe, in this outline, that
no part of it is darker or lighter than any other, except in
the moment of ceasing or disappearing. As the edge be-
comes less and less visible to the eye, Turner's pencil line
fades, and vanishes where also the natural outline vanished.
But he does not draw his ash trees in the foreground with
a darker line than the woods in the distance.

This is a great and constant law. Whether your outline

[1] [The reference here again (cf. p. 381 n., above) is to the first of the *Lectures
on Landscape*, where (§ 2) Ruskin defines landscape painting as "the thoughtful
and passionate representation of the physical conditions appointed for human
existence," imitating "the aspects" and recording "the phenomena" of visible
things.]

[2] [Luke ii. 14. The Arabian exclamation is familiar to readers of *The Arabian
Nights*.]

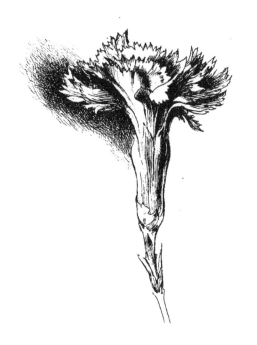

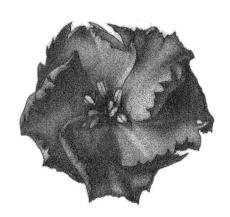

Drawn by J Ruskin

Engraved by G Allen

SCHOOLS OF ST GEORGE

Elementary Drawing Plate VIII

PEN OUTLINE WITH ADVANCED SHADE

be grey or black, fine or coarse, it is to be *equal* everywhere. Always conventional, it is to be sustained throughout in the frankness of its conventionalism; it no more exists in nature as a visible line, at the edge of a rose leaf near, than of a ridge of hills far away. Never try to express more by it than the limitation of forms; it has nothing to do with their shadows, or their distances.

18. Lastly, observe of this Turner outline, there are some conditions of rapid grace in it, and others of constructive effect by the mere placing of broken lines in relative groups, which, in the first place, can be but poorly rendered even by the engraver's most painstaking facsimile; and, in the second, cannot be attained in practice but after many years spent in familiar use of the pencil. I have therefore given you this plate, not so much for an immediate model, as to show you the importance of outline even to a painter whose chief virtue and skill seemed, in his finished works, to consist in losing it. How little this was so in reality, you can only know by prolonged attention, not only to his drawings, but to the natural forms they represent.

19-27.

[1] [§§ 19-27 (end of this chapter) in *The Laws of Fésole* are a reprint of the passage already given in Vol. XIII. pp. 242-249; but the following note was appended:

"I conclude the present chapter with the statement given in the catalogue I prepared to accompany the first exhibition of his works at Marlborough House, in the year 1857; because it illustrates some points in water-colour work, respecting which the student's mind may advisably be set at rest before further procedure. I have also left the 17th paragraph without qualification, on account of its great importance; but the student must be careful in reading it to distinguish between true outline, and a linear basis for future shadow, as in Plate VIII., which I put here for immediate reference."

The reference in this note to "the first exhibition" is an error for "second." The passages here quoted were from Ruskin's catalogue to the second exhibition, 1857-1858: see Vol. XIII. p. xxxv.]

CHAPTER IX

OF MAP DRAWING[1]

1. OF all the principles of Art which it has been my endeavour throughout life to inculcate, none are so important, and few so certain, as that which modern artists have chiefly denied, — that Art is only in her right place and office when she is subordinate to use;[2] that her duty is always to teach, though to teach pleasantly; and that she is shamed, not exalted, when she has only graces to display, instead of truths to declare.

2. I do not know if the Art of Poetry has ever been really advanced by the exercise of youth in writing nonsense verses; but I know that the Art of Painting will never be so, by the practice of drawing nonsense lines; and that not only it is easy to make every moment of time spent in the elementary exercises of Art serviceable in other directions; but also it will be found that the exercises which are directed most clearly to the acquisition of general knowledge, will be swiftest in their discipline of manual skill, and most decisive in their effect on the formation of taste.

3. It will be seen, in the sequel of the *Laws of Fésole*, that every exercise in the book has the ulterior object of fixing in the student's mind some piece of accurate knowledge, either in geology, botany, or the natural history of animals. The laws which regulate the delineation of these, are still more stern in their application to the higher branches of the arts concerned with the history of the life,

[1] [On this subject, see Vol. XIII. p. 503, and *Bible of Amiens,* ch. iii. § 7.]
[2] [See in *Lectures on Art,* Lecture iv. "The Relation of Art to Use," and compare Vol. XIV. p. 265.]

and symbolism of the thoughts, of Man; but the general student may more easily learn, and at first more profitably obey them, in their gentler authority over inferior subjects.

4. The beginning of all useful applications of the graphic art is of course in the determination of clear and beautiful forms for letters; but this beginning has been invested by the illuminator with so many attractions, and permits so dangerous a liberty to the fancy, that I pass by it, at first, to the graver and stricter work of geography. For our most serviceable practice of which, some modifications appear to me desirable in existing modes of globe measurement: these I must explain in the outset, and request the student to familiarize himself with them completely before going farther.

5. On our ordinary globes the 360 degrees of the equator are divided into twenty-four equal spaces, representing the distance through which any point of the equator passes in an hour of the day: each space therefore consisting of fifteen degrees.

This division will be retained in St. George's schools; but it appears to me desirable to give the student a more clear and consistent notion of the length of a degree than he is likely to obtain under our present system of instruction. I find, for instance, in the Atlas published under the superintendence of the Society for the Diffusion of Useful Knowledge,* that, in England and Ireland, a degree contains 69·14 English miles; in Russia, 69·15; in Scotland, 69·1; in Italy, 69; in Turkey, 68·95; and in India, 68·8. In Black's more elaborate Atlas,[1] the degree at the equator is given as 69·6, whether of longitude or latitude, with a delicate scale of diminution in the degrees of latitude to the pole, of which the first terms would quite fatally confuse

* The larger Atlas is without date: the selection of maps issued for the use of Harrow School in 1856 is not less liberal in its views respecting the length of a degree.

[1] [*Black's General Atlas of the World* (Longmans), 1862 and several later editions.]

themselves in a young student's mind with the wavering estimates given, as above quoted, in more elementary publications.

6. Under these circumstances, since in the form of the artificial globe we ignore the polar flatness of it, I shall also ignore it in practical measurement; and estimate the degrees of longitude at the equator, and of latitude everywhere, as always divided into Italian miles, one to the minute, sixty to the degree. The entire circumference of the earth at the equator will thus be estimated at 21,600 miles; any place on the equator having diurnal motion at the rate of 900 miles an hour. The reduction, afterwards, of any required distance into English miles, or French kilometres, will be easy arithmetic.

7. The twenty-four meridians drawn on our common globes will be retained on St. George's; but numbered consecutively round the globe, 1 to 24, from west to east. The first meridian will be that through Fésole, and called Galileo's line; the second, that approximately through Troy,* called the Ida line. The sixth, through the eastern edge of India, will be called "the Orient line"; the eighteenth, through the Isthmus of Vera Cruz, "the Occident line"; and the twenty-fourth, passing nearly with precision, through our English Devonport, and over Dartmoor, "the Devon line." Its opposite meridian, the twelfth, through mid-Pacific, will be called the Captains' line.[1]

8. The meridians on ordinary globes are divided into lengths of ten degrees, by eight circles drawn between the equator and each of the poles. But I think this numeration confusing to the student, by its inconsistency with the divisions of the equator, and its multiplication of lines parallel to the Arctic and Tropic circles. On our St. George's

* Accurately, it passes through Tenedos, thus dividing the Ida of Zeus from the Ida of Poseidon in Samothrace. See *Eothen*, Chapter IV.; and Dr. Schliemann's *Troy*, Plate IV.[2]

[1] [For explanation of the term, see below, § 36, p. 461.]
[2] [For Kinglake's *Eothen*, see Vol. VI. p. 269; and for Schliemann, Vol. XIII. p. 447.]

globes, therefore, the divisions of latitude will be, as those of longitude, each fifteen degrees, indicated by five circles drawn between each pole and the equator.

Calling the equator by its own name, the other circles will be numbered consecutively north and south; and called 1st, 2nd, etc., to the 5th, which will be that nearest the Pole. The first north circle will be found to pass through the Cape-de-Verde island of St. Jago; the second north circle will be the line of latitude on our present globes passing approximately through Cairo; the third will as nearly run through Venice; the fourth, almost with precision, through Christiania; and the fifth through Cape Fern, in Nova Zembla. I wish my students to call these circles, severally, the St. James's circle, the Arabian circle, the Venetian circle, the Christian circle, and the Fern circle. On the southern hemisphere, I shall call the first circle St. John's; thus enclosing the most glowing space of the tropics between the lines named from the two Sons of Thunder; the Natal circle will divide intelligibly the eastern coast of Africa, and preserve the title of an entirely true and noble,—therefore necessarily much persecuted,—Christian Bishop;[1] the St. George's circle, opposite the Venetian, will mark the mid-quadrant, reminding the student also, that in far South America there is a Gulf of St. George; the Thulë circle will pass close south of the Southern Thulë; and the Blanche circle (*ligne* Blanche, for French children,) include, with Mounts Erebus and Terror, the supposed glacial space of the great Antarctic continent.

9. By this division of the meridians, the student, besides obtaining geographical tenure in symmetrical clearness, will be familiarized with the primary division of the circle by its radius into arcs of 60°, and with the subdivisions of such arcs. And he will observe that if he draws his circle representing the world with a radius of two inches, (in Figure 18, that it may come within my type, it is only an inch

[1] [For Ruskin's admiration for Bishop Colenso, see Vol. XIV. p. 285.]

and a half), lettering the Equator Q R, the North Pole P, the South Pole S, and the centre of the circle, representing that of the Earth, O ; then completing the internal hexagon and dodecagon, and lettering the points through which the Arabian and Christian circles páss, respectively A and C, since the chord Q C equals the radius Q O, it will also measure two inches, and the arc upon it, Q A C, somewhat

Fig. 18

more than two inches, so that the entire circle will be rather more than a foot round.

10. Now I want some enterprising map-seller * to prepare some school-globes, accurately of such dimension that the twenty-four-sided figure enclosed in their ·circle may be exactly half an inch in the side ; and therefore the twenty-four

* I cannot be answerable, at present, for what such enterprise may produce. I will see to it when I have finished my book, if I am spared to do so.

meridians and eleven circles of latitude drawn on it with accurately horizontal intervals of half an inch between each of the meridians at the equator, and between the circles everywhere.

And, on this globe, I want the map of the world engraved in firm and simple outline, with the principal mountain chains; but no rivers,* and no names of any country; and this nameless chart of the world is to be coloured, within the Arctic circles, the sea pale sapphire, and the land white; in the temperate zones, the sea full lucia, and the land pale emerald; and between the tropics, the sea full violet, and the land pale clarissa.

These globes I should like to see executed with extreme fineness and beauty of line and colour; and each enclosed in a perfectly strong cubic case, with silk lining. And I hope that the time may come when this little globe may be just as necessary a gift from the parents to the children, in any gentleman's family, as their shoes or bonnets.

11. In the meantime, the letters by which the circles are distinguished, added, in Figure 19, to the complete series of horizontal lines representing them, will enable the student rapidly to read and learn their names from the equator up and down. "St. James's, Arabian, Venetian, Christian, Fern; St. John's, Naïal, St. George's, Thulë, Blanche"; —these names being recognized always as belonging no less to the points in the arcs of the quadrant in any drawing, than to the globe circles; and thus rendering the specification of forms more easy. In such specification, however, the quadrant must always be conceived as a part of the complete circle; the lines o q and o r are always to be called "basic": the letters q p, r p, q s, and r s, are always to be retained, each for their own arc of the quadrant; and the points of division in the arcs r p and r s distinguished

* My reason for this refusal is that I want children first to be made to *guess* the courses and sizes of rivers, from the formation of the land; and also, that nothing may disturb the eyes or thoughts in fastening on that formation.

from those in the arcs Q P and Q s by small, instead of capital, letters. Thus a triangle to be drawn with its base on St. George's circle, and its apex in the North Pole, will be asked for simply as the triangle G P g; the hexagon with the long and short sides, c P, P R, may be placed at any of the points by describing it as the hexagon Q A c,—

Fig. 19

J v v, or the like; and ultimately the vertical triangles on the great divisional lines for bases will need no other definition than the letters B P, T P, C P, etc.

The lines F f, v v, etc., taken as the diameters of their respective circles, may be conveniently called, in any geometrical figure in which they occur, the Fern line, the Venetian line, etc.; and they are magnitudes which will be of great constructive importance to us, for it may be easily seen, by thickening the lines of the included squares, that

the square on the Venetian line, the largest that can be included in the circle, is half the square on the equator; the square on the Christian line, the square of the radius, is again half of that on the Venetian; and the square on the Fern line, a fifth diminishing term between the square of the equator and zero.

12. Next, I wish my pupils each to draw for themselves the miniature hemisphere, Plate IX., Figure 1, with a radius of an inch and nine-tenths, which will give them approximately the twenty-four divisions of half an inch each. Then, verticals are to be let fall from the points J, A, etc., numbered 1, 2, 3, 4, and 5, as in Figure 19, and then the meridians in red, with the pencil, by hand, through the points 1, 2, etc., of the figure; observing that each meridian must be an elliptical, not a circular, arc. And now we must return, for a moment, to the fifteenth paragraph of the fourth chapter, where we had to quit our elliptic practice for other compass work.

13. The ellipse, as the perspective of the circle, is so important a natural line that it is needful to be perfectly familiar with the look of it, and perfectly at ease in the tracing of it, before the student can attempt with success the slightest architectural or landscape outline. Usually, the drawing of the ellipse is left to gather itself gradually out of perspective studies; but thus under a disadvantage, seldom conquered, that the curve at the narrow extremity, which is the only important part of it, is always confused with the right line enclosing the cylinder or circle to be drawn; and never therefore swept with delicacy or facility. I wish the student, therefore, to conquer all hesitation in elliptic drawing at once, by humbly constructing ellipses, in sufficiently various number, large and small, with two pins' heads and a thread; and copying these with the lead, first, very carefully, then fastening the lead line with pencil and colour.

This practice should be especially directed to the extremities of the narrow and long elliptic curves, as the

beauty of some of the finest architecture depends on the perspective of this form in tiers of arches: while those of the shores of lakes, and bending of streams, though often passing into other and more subtle curves, will never be possible at all until the student is at ease in this first and elementary one.

14. Returning to our globe work, on the assumption that the pupil will prepare for it by this more irksome practice, it is to be noted that, for geographical purposes, we must so far conventionalize our perspective as to surrender the modifications produced by looking at the globe from near points of sight; and assume that the perspectives of the meridians are orthographic, as they would be if the globe were seen from an infinite distance; and become, practically, when it is removed to a moderate one. The real perspectives of the meridians, drawn on an orange six feet off, would be quite too subtle for any ordinary draughtsmanship; and there would be no end to the intricacy of our map drawing if we were to attempt them, even on a larger scale. I assume, therefore, for our map work, that the globe may be represented, when the equator is level, with its eleven circles of latitude as horizontal lines; and the eleven visible meridians, as portions of five vertical ellipses, with a central vertical line between the poles.

15. When the student has completely mastered the drawing, and, if it may be so called, the literature, of this elementary construction, he must advance another, and a great step, by drawing the globe, thus divided, with its poles at any angle, and with any degree of longitude brought above the point o.

The placing the poles at an angle will at once throw all the circles of latitude into visible perspective, like the meridians, and enable us, when it may be desirable, to draw both these and the meridians as on a transparent globe, the arcs of them being traceable in completeness from one side of the equator to the other.

16. The second figure in Plate IX. represents the globe-lines placed so as to make Jerusalem the central point of its visible hemisphere.* A map thus drawn, whether it include the entire hemisphere or not, will in future be called " Polar" to the place brought above the point o; and the maps which I wish my students to draw of separate countries will always be constructed so as to be polar to some approximately central point of chief importance in those countries; generally, if possible, to their highest or histori-cally most important mountain;—otherwise, to their capital, or their oldest city, or the like. Thus the map of the British Islands will be polar to Scawfell Pikes, the highest rock in England: Switzerland will be polar to Monte Rosa, Italy to Rome, and Greece to Argos.

17. This transposition of the poles and meridians must be prepared for the young pupil, and for all unacquainted with the elements of mathematics, by the master: but the class of students for whom this book is chiefly written will be able, I think without difficulty, to understand and apply for themselves the following principles of construction.

If p and s, Figure 20, be the poles of the globe in its normal position, the line of sight being in the direction of the dotted lines, tangential to the circle at p and s; and if we then, while the line of sight remains unchanged, move the pole p to any point P, and therefore (the centre of the globe remaining fixed at o,) the pole s to the opposite ex-tremity of the diameter, s; and if a b be the diameter of any circle of latitude on the globe thus moved, such dia-meter being drawn between the highest and lowest points of that circle of latitude in its new position, it is evident that on the hemispherical surface of the globe commanded by the eye, the declined pole p will be seen at the level of the line p P; the levels b B, a A will be the upper and lower limits of the perspective arc of the given circle of latitude;

* The meridians in this figure are given from that of Fésole, roughly taking the long. of Jerusalem 35 E., from Greenwich; and lat. 32 N.

the centre of that curve will be at the level c c; and its lateral diameter, however we change the inclination of its vertical one, will be constant.*

18. On these data, the following construction of a map of the hemisphere to be made polar to a given place, will be, I think, intelligible,—or, at the very least, practicable; which is all that at present we require of it.

Let P and s, Figure 21, be the original poles; let the arc P Q S be the meridian of the place to which the map is

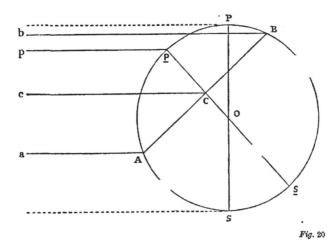

Fig. 20

to be made polar; and let x be the place itself. From x draw the diameter x y, which represents a circle to be called the "equatorial line" of the given place; and which is of course inclined to the real equator at an angle measured by the latitude of the place.

Through the point o, (which I need not in future letter, it being in our figures always the mid-point between Q and R, and, theoretically, the centre of the earth,) draw the line terminated by the ball and arrow-point, perpendicular to

* Always remembering that the point of sight is at an infinite distance, else the magnitude of this diameter would be affected by the length of the interval c o.

X Y. This is to be called the "stellar line" of the given place x. In the map made polar to x, this line, if represented, will coincide with the meridian of x, but must not be confused with that meridian in the student's mind.

19. Place now the figure so as to bring the stellar line vertical, indicating it well by its arrow-head and ball, which on locally polar maps will point north and south for the given place, Figure 22.

The equatorial line of x, (x y,) now becomes horizontal. Q R is the real equator, P and S the real poles, and the given place to which the map is to be made polar is at x. The line of sight remains in the direction of the dotted lines.

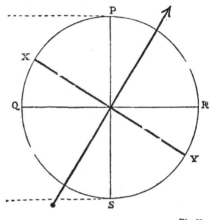

Fig. 21

20. As the student reads, let him construct and draw the figures himself carefully. There is not the smallest hurry about the business (and there must be none in *any* business he means to be well done); all that we want is clear understanding, and fine drawing. And I multiply my figures, not merely to make myself understood, but as exercises in drawing to be successively copied. And the firm printing of the letters is a part of this practice, taking the place of the more irksome exercise recommended in my first *Elements of Drawing* [above, p. 38]. Be careful, also, that they shall be not only clear and neat, but perfectly upright. You will draw palaces and towers in truer stability after drawing letters uprightly; and the position of the letter,—as, for instance, in the two last figures,—is often important in the construction of the diagram.

21. Having fixed the relations of these main lines well in his mind, the student is farther to learn these two definitions.

I. The "Equatorial line" of any place is the complete circle of the circumference of the world passing through that place, in a plane inclined to the plane of the equator at an angle measured by the degrees of the latitude of the place.

II. The "Stellar line" of any place is a line drawn through the centre of the Earth perpendicular to the equatorial line of that place.

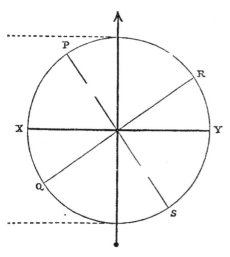

Fig. 22

It is therefore, to any such equatorial line (geometrically) what the axis of the Earth is to the equator; and though it does not point to the Polestar, is always in the vertical plane passing through the Polestar and place for which it is drawn.*

22. It follows from these definitions that if we were able to look down on any place from a point vertically and exactly above it, and its equatorial and stellar lines were then visible to us, drawn, the one round the Earth, and the other through it, they would both appear as right lines, forming a cross, the equatorial line running, at the point of intersection, east and west; and the stellar, north and south.

23. Now all the maps which I hope to prepare for St. George's schools will be constructed, not by circles of latitude and meridians, but as squares of ten, twenty, or thirty degrees in the side, quartered into four minor squares of five, ten, or fifteen degrees in the side, by the cross formed

* The Polestar is assumed, throughout all our work, to indicate the true North.

by the equatorial and stellar line of the place to which the map is said to be "polar";—which place will therefore be at the centre of the square. And since the arc of a degree on the equatorial line is as long as the arc of a degree on the equator, and since the stellar line of a place on a polar map coincides with the meridian of that place, the measurements of distance along each of the four arms of the cross will be similar, and the enlargements of terrestrial distance expressed by them, in equal proportions.

24. I am obliged to introduce the terms "at the point of intersection," in § 22, because, beyond the exact point of intersection, the equatorial line does not run east and west, in the ordinary geographical sense. Note therefore the following conditions separating this from the usually drawn terrestrial lines.

If, from the eastern and western gates of a city, two travellers set forth to walk, one due east, and the other due west, they would meet face to face after they had walked each the semicircle of the earth-line in their city's latitude.

But if from the eastern and western gates they set forth to walk along their city's equatorial line, they would only meet face to face after they had each walked the full semicircle of the Earth's circumference.

And if, from the eastern and western gates of their city, they were *able* to set forth, to walk along the lines used as lines of measurement on its polar map, they would meet no more for ever.

For these lines, though coinciding, the one with its meridian, and the other with its equatorial line, are conceived always as lines drawn in the air, so as to touch the Earth only at the place itself, as the threads of a common squaring frame would touch the surface of a globe; that which coincides with the Stellar line being produced infinitely in the vertical plane of the Polestar, and that which coincides with the equatorial line produced infinitely at right angles to it in the direction of the minor axis of the Earth's orbit.

25. In which orbit, calling the point of winter solstice, being that nearest the Polestar, the North point of the orbit, and that of the summer solstice South, the point of vernal equinox will be West, the point of autumnal equinox East; and the polar map of any place will be in general constructed and shaded with the Earth in vernal equinox, and the place at the time of sunrise to it on Easter Day, supposing the sun ten degrees above the horizon, and expressing therefore the heights of the mountain chains accurately by the length of their shadows.

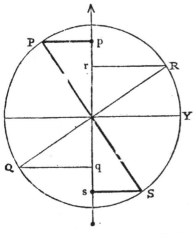

Fig. 23

26. Therefore, in now proceeding to draw our polar map for the given place x, Figure 22, we have to bring the two poles, and the place itself, to the meridian which coincides, in our circular construction, with the stellar line. Accordingly, having got our construction as in Figure 22, we let fall perpendiculars on the stellar line from all the four points P, S, Q, and R, Figure 23, giving us the four points on the stellar line p, s, q, and r.

Then, in our polar map, p and s are the new poles corresponding to P and S; q and r the new points of the Equator corresponding to Q and R; and the place to which the map is polar x, will now be in the centre of the map at the point usually lettered o.

27. Now this construction is entirely general, and the two zigzags, p P S s and r R Q q, must always be drawn in the same way for the poles and any given circle of latitude, as well as for the Equator;—only if the more lightly-drawn zigzag be for a north or south circle of latitude, it will not be symmetrical on both sides of the

line x y. Therefore, removing the (for the moment un_
necessary) line x y from the construction, and drawing,
instead of the Equator Q R, any circle of latitude L M,—
l and m are the corresponding points of that circle in our
polar map, and we get the entirely general construction,
Figure 24, in which the place to which the map is polar,
being now at the centre of the circle, is lettered x, because
it is not now the centre of the earth between Q and R, but
the point X, on the surface
of the earth, brought round
to coincide with it.

28. And now I should
like the student to fix the
letters attached to these con-
structions in his mind, as be-
longing, not only to their
respective circles, but always
to the same points in these
circles. Thus the letter x will
henceforward, after we have
once finished the explanatory
construction in the present
chapter, always signify the
point to which the map is

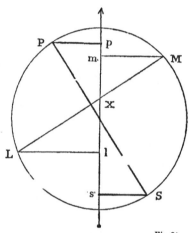

Fig. 24

polar, and Y its exactly antipodal point on the earth's
surface, half round the equatorial line. If we have to
speak in more detail of the equatorial line as a complete
circle, it will be lettered x, E, Y, w, the letters E and
w being at its extreme eastern and western points, in
relation to x. And since at these points it intersects the
Equator, the Equator will be also lettered Q, E, R, w, the
points E and w being identical in both circles, and the
point Q always in the meridian of x. Any circle of
latitude other than the stated eleven will be lettered at
its quarters, L, L 1, L 2, L 3, L 4, the point L being that
on the meridian of x; and any full meridian circle other
than one of the stated twelve, will be lettered M N, the

point M being that on the Equator nearest X, and N its opposite.

29. And now note carefully that in drawing the globe, or any large part of it, the meridian circles and latitude circles are always to be drawn, with the lead, full round, as if the globe were transparent. It is only thus that the truth of their delicate contact with the limiting circle can be reached. Then the visible part of the curve is to be traced with pencil and colour, and that on the opposite side of the globe, and therefore invisible, to be either effaced, or indicated by a dotted line.

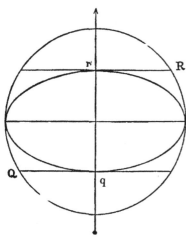

Fig. 25

Thus, in Figure 25, I complete the construction from Figure 23 by first producing the lines R r, Q q, to meet the circle on both sides, so as to give me a complete feeling of the symmetry of the entire space within which my elliptic curve must be drawn; and then draw it round in complete sweep, as steadily as I can, correcting it into a true ellipse by as much measurement as may be needful, and with the best fastidiousness of my sight. Once the perfect ellipse drawn, the question, which half of it is visible, depends on whether we intend the North or South pole to be visible. If the North, the lower half of the ellipse is the perspective of the visible half of the Equator; and if the South, *vice versâ*, the upper half of the ellipse.

30. But the drawing becomes more difficult and subtle when we deal with the perspective of a line of latitude, as L M, (Figure 24). For on completing this construction in the same manner as Figure 23 is completed in Figure 25, we shall find the ellipse does not now touch the circle

with its extremities, but with some part of its sides. In Figure 26, I remove the constructing lines from Figure 24, and give only the necessary limiting ones, ᴍ m and ʟ l, produced: the ellipse being now drawn symmetrically between these, so as to touch the circle, it will be seen that its major axis falls beneath the point of contact, and would have to be carried beyond the ellipse if it were to meet the circle. On the small scale of these figures, and in drawing large circles of latitude, the interval seems of little importance; yet on the beautiful drawing of it depends the right expression of all rounded things whose surface is traversed by lines —from St. Peter's dome to an acorn ʼcup. In Figure 27 I give the segment of circle from ᴘ to ʏ as large as my page allows, with the semi-ellipse of the semicircle of latitude ᴄ ᴍ. The point of contact with the circle is at ᴢ; the axis major, drawn through ᴄ, terminates at w,

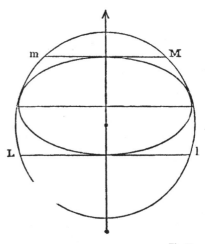

Fig. 26

making ᴜ w equal to ᴄ ᴍ; and the pretty meeting of the curves w ᴢ and ʏ ᴢ like the top of the rudder of a Venetian canal boat (the water being at the level x ʏ), becomes distinctly visible.

The semi-major axis ᴜ w is exactly equal to ᴄ ᴍ, as in Figure 25 the entire major axis is equal to ʟ ᴍ in Figure 24.

31. Lastly, if ᴄ ᴍ cross the stellar line, as in all figures hitherto given, the ellipse always touches the circle, and the portion of it beyond ᴢ is invisible, on the other side of the globe, when we reduce the perspective figure to a drawing. But, as we draw the circles of latitude smaller, the interval

between z and w increases, and that between z and m diminishes, until z and m coincide on the stellar line, and the ellipse touches the circle with the extremity of its minor axis. As m draws still farther back towards p, the ellipse detaches itself from the circle, and becomes entirely visible; and as we incline the pole more and more towards us, the ellipses rise gradually into sight, become rounder and rounder in their curves, and at last pass into five con-

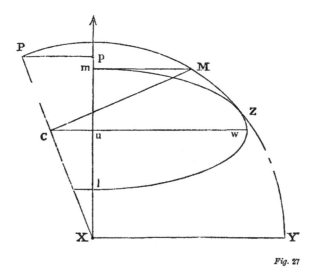

Fig. 27

centric circles encompassed by the Equator as we look vertically down on the pole. The construction of the small circle of latitude L M, when the pole is depressed to P, is given in Figure 28.

32. All this sounds at first extremely dreadful: but, supposing the system of the *Laws of Fésole* generally approved and adopted, every parish school may soon be furnished with accurate and beautiful drawings of the divided sphere in various positions; and the scholars led on gradually in the practice of copying them, having always, for comparison, the solid and engraved artificial globe in their hands. Once intelligently masters of this Earth-perspective, there

remain no more difficulties for them, but those of delicate
execution, in the drawing of plates, or cups, or baskets, or
crowns,* or any other more or less circularly divided objects;
and gradually they will perceive concurrences and cadences
of mightier lines in sea waves, and mountain promontories,
and arcs of breeze-driven cloud.

33. One bit of hard work more, and we have done
with geometry for the present. We have yet to learn how
to draw any meridian in true
perspective, the poles being
given in a vertical line. Let
P and s, Figure 29, be the
poles, P being the visible one.
The Q M R N is the Equator
in its perspective relation to
them; p, the pole of the stellar
line, which line is here coin-
cident with the meridian of
the place to which the map is
polar. It is required to draw
another meridian at a given
number of degrees distant
from the meridian of the
place.

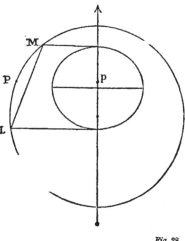

Fig. 28

34. On the arc p Q, if the required meridian is to
the east of the place, or on the arc p R, if the required
meridian is to the west of it, measure an arc of the given

* There are, of course, other perspective laws, dependent on the
approach of the point of sight, introduced in the drawing of ordinary
objects; but none of these laws are ever mathematically carried out by
artists, nor can they be: everything depends on the truth of their eyes and
ready obedience of their fingers. All the mathematicians in France and
England, with any quantity of time and every instrument in their possession,
could not draw a tress of wreathed hair in perspective; but Veronese will
do it, to practical sufficiency, with half a dozen consecutive touches of his
pencil.[1]

[1] [Compare Vol. V. p. 63.]

number of degrees, p n. Let fall the vertical n N on the
Equator, draw the diagonal M N through o; and the re-
quired meridian will be the visible arc of the ellipse drawn,
so as to touch the circle, through the four points P N S M.
These four points, however placed, will always be sym-
metrical, the triangles o P N and o M S, if completed, being
always equal and similar, and the points N and M equi-
distant from P and S. In Figure 30, I draw the curve,
showing only these points and
the stellar line; and you may,
by a little effort, imagine the
figure to represent two cups,
or two kettle-drums, brim to
brim, or rim to rim. If you
suppose them so placed that
you can see the inside of the
cup on the left, the north
pole is visible, and the left-
hand half of the ellipse. If
you suppose the inside of the
cup on the right visible, the
north pole is visible, and the
right-hand half of the ellipse.

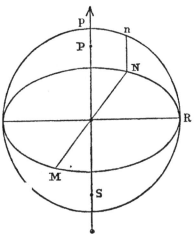

Fig. 29

35. And now, if you have
really read and worked thus
far, with clear understanding, I very gladly congratulate
you on having mastered quite the most important elements
of perspective in curved surfaces; a mastership which you
will find extremely pleasurable in its consequences, what-
ever the difficulty of its attainment. And in the meantime
you will without further trouble understand the construc-
tion of the second figure in Plate IX., which gives the
perspective of the globe on the line of sight polar to
Jerusalem; assuming the longitude of Jerusalem 35° east,
from the meridian of Greenwich; but engraving the St.
George's order of meridians, with the Devon, Captains',

Orient, and Occident in darker line. The student may, with advantage, enlarge this example so as to allow an inch to the widest interval of its meridians, and then try for himself to draw the map of the hemisphere accurately on this projection. If he succeed, he will have a true per-spective view of the globe, from the given point of sight, a very different thing from a map of it given on any ordi-nary projection : for, in the common geographical methods, the countries and seas are dis-torted into shapes, not only actually false, but which under no possible conditions they could ever assume to the eye; while on this rightly drawn projec-tion, they appear as they do on the artificial globe itself, and cannot therefore involve the student in any kind of mis-conception. Maps, properly so called, must include much less than the surface of the hemi-sphere; and the mode in which

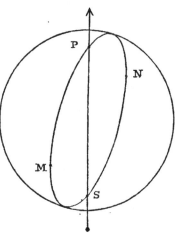

Fig. 30

they are to be drawn on this projection will be given in the eleventh chapter.[1]

36. It remains only to be observed that although in English schools the Devon and Captains' line (meaning, the line of the great Captains,) are to be taken for the first divisions in quartering the globe, and the Orient and Occi-dent lines, for *us* determined by them, the degrees of longi-tude are to be counted from Galileo's line, the meridian of Fésole. For if these laws of drawing are ever accepted, as I trust, in other schools than our own, it seems to me that their well-trained sailors may, waiving false pride and vulgar

[1] [No eleventh chapter was, however, issued.]

jealousy, one day consent to estimates of distance founded, for all, on the most sacred traditions of the Norman, the Tuscan, and the Argonaut; founded for the sailors of Mar seilles and Venice—of Pisa and Amalfi—of Salamis and the Hellespont,—on the eternal lines which pass through the Flint of Fésole, and the Flowers of Ida.

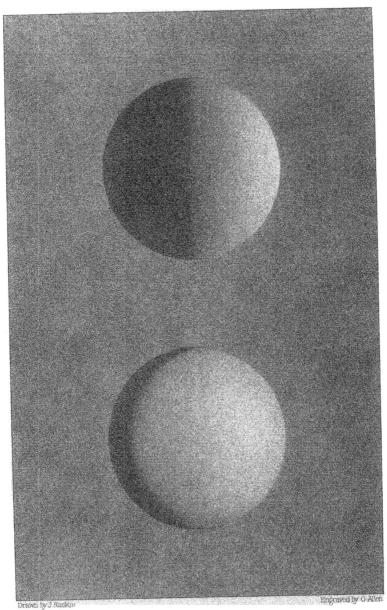

SCHOOLS OF ST GEORGE.

Elementary Drawing, Plate X.

**APPELLAVITQUE LUCEM DIEM,
ET TENEBRAS NOCTEM.**

CHAPTER X

OF LIGHT AND SHADE[1]

1. I DO not doubt that you can call into your mind with some distinctness the image of hawthorn blossom;—whether, at this time of reading, it be May or November, I should like you, if possible, to look at the description of it in *Proserpina* (ch. viii. § 2); but you can certainly remember the general look of it, in white masses among green leaves. And you would never think, if I put a pencil into your hand, and gave you choice of colours to paint it with, of painting any part of it *black*.

Your first natural instinct would be to take pure green, and lay that for the leaves; and then, the brightest white which you could find on the palette, and put that on in bosses for the buds and blossoms.

2. And although immediate success in representation of hawthorn might possibly not attend these efforts, that first instinctive process would be perfectly right in principle. The general effect of hawthorn is assuredly of masses of white, laid among masses of green: and if, at the instigation of any learned drawing-master, you were to paint part of every cluster of blossoms coal-black, you would never be able to make the finished work satisfactory either to yourself, or to other simple people, as long as the black blot remained there.

3. You may perhaps think it unlikely that any drawing-master would recommend you to paint hawthorn blossom half black. Nor, if instead of hawthorn, you had peach or apple blossom to paint, would you expect such recommendation for the better rendering of their rose-colour? Nor, if

[1] [With this chapter, compare *Notes on Prout and Hunt*, Vol. XIV. p. 407.]

you had a gentian to paint, though its blue is dark, would you expect to be told to paint half the petals black?

If, then, you have human flesh to paint, which, though of much mingled and varied hue, is not, unless sunburnt, darker than peach blossom;—and of which the ideal, according to all poets, is that it should be white, tinted with rose;[1]—which also, in perfect health and purity, is somewhat translucent, certainly much more so than either hawthorn buds or apple blossom,—Would you accept it as a wise first direction towards the rendering of this more living and varying colour, to paint one side of a girl's face black? You certainly would not, unless you had been previously beguiled into thinking it grand or artistic to paint things under "bold effects."

And yet, you probably have been beguiled, before now, into admiring Raphael's Transfiguration, in which everybody's faces and limbs are half black; and into supposing Rembrandt a master of chiaroscuro, because he can paint a vigorous portrait with a black dab under the nose![2]

4. Both Raphael and Rembrandt *are* masters indeed; but neither of them masters of light and shade, in treatment of which the first is always false, and the second always vulgar. The only absolute masters of light and shade are those who never make you *think* of light and shade, more than Nature herself does.

It will be twenty years, however, at least, before you can so much as *see* the finer conditions of shadow in masters of that calibre. In the meantime, so please you, we will go back to our hawthorn blossom, which you have begun quite rightly by painting white altogether; but which remains, nevertheless, incomplete on those conditions. However, if its outline be right, and it detaches itself from the green ground like a Florentine piece of mosaic, with

[1] [As in the passages from Spenser quoted in *Modern Painters*, vol. ii. (Vol. IV. pp. 130–131 *n.*]

[2] [For Raphael's "Transfiguration" in this connexion, compare Vol. VI. p. 68; and for Rembrandt's chiaroscuro, *Cestus of Aglaia*, §§ 50 *seq.*]

absolutely true contour of clustered petal, and placing of scattered bud, you are already a far way on the road to all you want of it.

5. What more you *exactly* want is now the question. If the image of the flower is clear in your mind, you will see it to be made up of buds, which are white balls, like pearls; and flowers, like little flattish cups, or rather saucers, each composed of five hollow petals.

How do you know, by the look of them, that the balls are convex, and the cups concave? How do you know, farther, that the balls are not *quite round* balls, but a little flat at the top? How do you know that the cups are not deep, but, as I said, flattish, like saucers?

You know, because a certain quantity of very delicate pale grey is so diffused over the white as to define to the eye exactly the degree in which its surfaces are bent; and the gradations of this grey are determined by the form of surface, just as accurately as the outline is; and change with the same mathematical precision, at every point of their course. So that, supposing the bud were spherical, which it is not, the gradation of shade would show that it was spherical; .and, flattened ever so little though it be, the shade becomes different in that degree, and is recognized by the eye as the shade of a hawthorn blossom, and not of a mere round globule or bead.

6. But, for globule, globe, or grain, small or great,—as the first laws of line may best be learned in the lines of the Earth, so also the first laws of light may best be learned in the light of the Earth. Not the hawthorn blossom, nor the pearl, nor the grain of mustard or manna, —not the smallest round thing that lies as the hoar-frost on the ground,—but around it, and upon it, are illuminated the laws that bade the Evening and the Morning be the first day.[1]

7. So much of those laws you probably, in this learned century, know already, as that the heat and light of the

[1] [Genesis i. 5.]

sun are both in a fixed proportion to the steepness of his rays,—that they decline as the day, and as the summer declines; passing softly into the shadows of the Polar,—swiftly into those of the Tropic night.

But you probably have never enough fastened in your minds the fact that, whatever the position of the sun, and whatever the rate of motion of any point on the earth through the minutes, hours, or days of twilight, the meeting of the margins of night and day is always constant in the breadth of its zone of gradually expiring light; and that in relation to the whole mass of the globe, that passage from "glow to gloom" is as trenchant and swift as between the crescent of the new moon and the dimness of the "Auld mune in her airms."[1]

8. The *dimness*, I say, observe; — not the blackness. Against the depth of the night—itself (as we see it) not absolute blackness, — the obscured space of the lunar ball still is relieved in pallor, lighted to that dim degree by the reflection from the Earth. Much more, in all the forms which you will have to study in daylight, the dark side is relieved or effaced, by variously diffused and reflected rays. But the first thing you have to learn and remember, respecting all objects whatever to be drawn in light and shade, is that, by natural light of day, half of them is in light, and half in shadow; and the beginning of all light and shade drawing is in the true, stern, and perfect separation of these from each other.

9. Where you stand, and therefore whence you see the object to be drawn, is a quite separate matter of inquiry. As you choose, you may determine how much you will see of its dark and how much of its light side: but the first thing to be made sure of is the positive extent of these two great masses: and the mode in which they are involved or invaded at their edges.

[1] [The references here are to Tennyson's *Princess*, iv. 160 ("Out I sprang from glow to gloom") and to the *Minstrelsy of the Scottish Border* ("I saw the new moon, late yestreen, Wi' the auld moon in her arm").]

And in determining this at first, you are to cast entirely out of consideration all vestige or interference of modifying reflective light. The arts, and the morality of men, are founded on the same primal order; you are not to ask, in morals, what is less right and more, or less wrong and more, until in every matter you have learned to recognize what is massively and totally Right, from what is massively and totally Wrong. The beautiful enhancements of passion in virtue, and the subtle redemptions of repentance in sin, are only to be sought, or taken account of, afterwards. And as the strength and facility of human action are undermined alike by the ardour of pride and the cunning of exculpation, the work of the feeblest artists may be known by the vulgar glittering of its light, and the far-sought reflection in its shadow.[1]

10. When the great separation between light and dark has been thus determined, the entire attention of the student is to be first put on the gradation of the *luminous* surface.

It is only on that surface that the form of the object is exactly or consistently shown; and the just distribution of the light, on that alone, will be enough to characterize the subject, even if the shadow be left wholly untouched. The most perfectly disciplined and scientific drawings of the Tuscan school consist of pure outlines on tinted paper, with the lights laid on in gradated white, and the darks left undistinguished from the ground. The group of drawings by Turner to which, in the schools of Oxford, I have given the title of the " Nine Muses," consists, in like manner, of firm pencil outline on pale grey paper; the expression of form being entirely trusted to lights gradated with the most subtle care.[2]

11. But in elementary work, the definition of the dark

[1] [Compare *Lectures on Art*, § 168.]
[2] [There is no group, among the Turner drawings given by Ruskin to Oxford, which, as now arranged, answers to this description, nor does Mr. Macdonald remember there being such a group, in any of the intermediate arrangements. Ruskin was, however, at this time selecting and rearranging the 250 drawings by Turner which he persuaded the Trustees of the National Gallery to lend for use in his Oxford school (see Vol. XIII. pp. liii., 560 *seq.*); and the "Nine Muses" may have been a title

side of the object against the background is to be insisted upon, no less than the rising of the light side of the object out of shadow. For, by this law, accuracy in the outline on both sides will be required, and every tendency to mystification repressed; whereas, if once we allow dark backgrounds to set off luminous masses, the errors of the outline in the shadow may be concealed by a little graceful manipulation; and the drawing made to bear so much resemblance in manner to a master's work, that the student is only too likely to flatter himself, and be praised by others, for what is merely the dissimulation of weakness, or the disguise of error.

12. Farther: it is of extreme importance that no time should be lost by the beginner in imitating the *qualities* of shade attained by great masters, before he has learned where shadow of *any* quality is to be disposed, or in what proportion it is to be laid. Yet more, it is essential that his eye should not be satisfied, nor his work facilitated, by the more or less pleasant qualities of shade in chalk or charcoal: he should be at once compelled to practise in the media with which he must ultimately produce the true effects of light and shade in the noblest painting,—media admitting no tricks of texture, lustre, or transparency. Even sepia is open to some temptation of this kind, and is to be therefore reserved for the days when the young workman may pretend to copy Turner or Holbein. For the beginner, pure and plain lampblack is the safest, as the most sincere, of materials.

It has the farther advantage of being extremely difficult to manage in a wash; so that, practising first in this medium, you will have no difficulty with more tractable colours.

which he thought of giving to some of these. Mr. Macdonald suggests that the words here " may possibly refer to the last nine drawings in the National Gallery series at Oxford (see Vol. XIII. p. 568), which are pencil drawings on grey paper, with the lights touched on with white. There are just nine of them, but the description does not apply very exactly, for there are some indications of form by shading in pencil lines, and the lights have either lost some of the white or cannot be said to be ' gradated with the most subtle care.' "]

13. In order not to waste paper, colour, nor time, you must be deliberate and neat in all proceedings: and above all, you must have good paper and good pencils. Three of properly varied size are supplied in your box;[1] to these you must add a commoner one of the size of the largest, which you are to keep separate, merely for mixing and supplying colour.

Take a piece of thick and smooth paper; and outline on it accurately a space ten inches high by five wide, and, cutting it off so as to leave some half inch of margin all round, arrange it, the narrow side up, on a book or desk sloping at an angle of not less, nor much more, than 25°.

Put two small teacup-saucers; and your two pencils— one for supply, and one to draw with; a glass of water, your ivory palette-knife, and a teaspoon, comfortably beside you, and don't have anything else on the table.

Being forced to content ourselves, for the present, with tube colours, I must ask you to be very careful and neat in their use. The aperture, in tubes of the size you are supplied with, is about the eighth of an inch wide, and with the slightest pressure (to be applied, remember, always at the *bottom* of the tube, not the sides), you will push out a little boss or round tower of colour, which ought not to be more than the eighth of an inch, or its own width, above the top of the tube. Do not rub this on the saucer, but take it neatly off with the edge of your knife, and so put it in the saucer; and screw the top of your tube nicely on again, and put it back in its place.

Now put two teaspoonfuls of water into one saucer, and stir the colour well into it with your supply pencil. Then put the same quantity of pure water into the other saucer, and you are ready to begin.

14. Take first a pencilful of quite pure water, and lead it along the top of your five-inch space, leaving a little ridge of water all the way. Then, from your supply saucer,

[1] [See above, p. 423.]

put a pencilful of the mixed colour into the pure water;
stir that up well with your pencil, and lead the ridge of
pure water down with that delicatest tint, about half an
inch, leaving another ridge all along. Then another pencil-
ful from the supply saucer into the other, mixed always
thoroughly, for the next half inch. Do not put the supply
pencil into the diluted tint, but empty it by pressing on
the side of the saucer, so that you may not dilute the
supply tint, which you are to keep, through the course
of each wash, quite evenly mixed. With twenty, or one
or two less than twenty, replenishings, and therefore darken-
ings, of the tint you are painting with, you will reach the
bottom of the ten-inch space; which ought then already
to present a quite visible gradation from white to a very
pale grey.

15. Leaving this to dry thoroughly, pour the diluted
tint you have been painting with, away; wash out the
saucer; put in another supply of clear water; and you are
ready to lay the second coat. The process being entirely
mechanical, you can read, or do anything else you like,
while the successive coats are drying; and each will take
longer than the last. But don't go on with other drawings,
unless indeed you like to tint two pieces of paper at once,
and so waste less colour—using the diluted tint of the first
for the supply tint of the second, and so gaining a still
more delicate gradation. And whether you do this or not,
at every third coat pour the diluted tint back into the
supply one, which will else be too soon exhausted. By the
time you have laid on ten or twelve tints, you will begin
to see such faults and unevenness as may at first be inevit-
able; but also you will begin to feel what is meant by grada-
tion, and to what extent the delicacy of it may be carried.
Proceed with the work, however, until the colour is so far
diluted as to be ineffective; and do not rest satisfied till you
are familiar enough with this process to secure a gradated
tint of even and pleasant tone. As you feel more com-
mand of the pencil, you may use less water with the colour,

and at last get your result in three or four instead of twenty washes.

16. Next, divide the entire space into two equal squares, by a delicate lead line across it, placing it upright in the same manner; and begin your gradation with the same care, but replenishing the tint in the pure water from the dark tint in as narrow spaces as you can, till you get down the uppermost square. As soon as you pass the dividing line between the two squares, continue with the same tint, without darkening it, to the bottom, so that the lower square may be all of one tone. Repeating this operation three or four times, you will have the entire space divided into two equal portions, of which the upper one will be gradated from white into a delicate grey, and the lower covered with a consistent shade of that grey in its ultimate strength. This is to be your standard for the first shading of all white objects; their dark sides being of an uniform tint of delicate grey, and their light sides modelled in tones which are always paler in comparison with it.

17. Having practised in this cautious manner long enough to obtain some ease in distribution of the tint, and some feeling of the delicacy of a true gradation, you may proceed to the more difficult, but wonderfully useful and comprehensive exercise, necessary for the copying of Plate X.

Draw first, with pencil compasses, the two circles with inch radius, and in the lower one trace lightly the limit of its crescent of shade, on the 22nd meridian, considering the vertical meridian that of Fésole. Then mix your tint of black with two teaspoonfuls of water, very thoroughly, and with that tint wash in at once the whole background and shaded spaces. You need not care for precision on their inner edges, but the tint must be exactly brought up to the circumference of the circles on their light sides.

18. After the tint is thoroughly dry, begin with the circle divided in half, and taking a very little pure water to begin with, and adding, with a fine pencil, a little of the dark tint as you work down, (putting the light part

upwards on your desk,) gradate, as you best can, to the shadow edge, over which you are to carry whatever tint you have then in your pencil, flat and unchanged, to the other side of the circle, darkening equally the entire dark side.

In the lower circle, the point of highest light is at the equator, on the 4th meridian. The two balls therefore, as shaded in the plate, represent two views of the revolving earth, with the sun over the equator. The lower figure gives what is also the light and shade of the moon in her third quarter. I do not choose to represent the part of the earth under the night as black: the student may suppose it to be in full moonlight if he likes; but the use of the figure is mainly to show the real, and narrow, extent of resources at his disposal, in a light and shade drawing executed without accidental reflected lights, and under no vulgar force of shadow. With no greater depths of tint than those here given, he must hold it his skill to render every character of contour in beautiful forms; and teach himself to be more interested in them, as displayed by that primal sincerity of light, than when seen under any accidental effects, or violent contrasts.

19. The tint prepared with two teaspoonfuls of water, though quite as dark as the student will be able at first to manage, (or as any master can manage in complex masses,) will not, when dry, give shadow more than half the depth of that used for the background in the plate. It must therefore be twice laid; the skill of the pencil management will be tested by the consistency of the two outlines. At the best, they are sure to need a little retouching; and where accurately coincident, their line will be hard, and never so pleasant as that left at the edge of a first wash. I wish the student especially to notice this, for in actual drawing, it is a matter of absolute necessity never to reduplicate a wash at the same edge. All beautiful execution depends on giving the outline truly with the first tint laid as dark as it is required. This is always possible with

well-prepared colours in a master's hand; yet never without
so much haste as must, unless the mastery be indeed con-
summate, leave something to be forgiven, of inaccuracy, or
something to be grateful for, in the rewarding chance which
always favours a rightness in method. The most distinctive
charm of water-colour, as opposed to oil,[1] is in the visible
merit of this hasty skill, and the entertaining concurrence
of accidental felicity. In the more deliberate laying of oil-
colour, though Fortune always takes her due share, it is
not recognizable by the spectator, and is held to the utmost
in control by the resolution of the workman, when his mind
is wise, and his peace complete.

20. But the student must not be discouraged by the
difficulty he will find at first in reaching anything like even-
ness or serenity of effect in such studies. Neither these,
nor any other of the exercises in this book, are "elemen-
tary," in the sense of easy or initial; but as involving the
first elements of all graphic Law. And this first study of
light and shade in Plate X. does indeed involve one law
of quite final importance; but which may nevertheless be
simply expressed, as most essential matters may be, by
people who wish it.

21. The gradation which you have produced on your
first ten-inch space is, if successful, consistent in its increase
of depth, from top to bottom. But you may see that in
Plate X. the light is diffused widely and brightly round
the foci, and fades with accelerated diminution towards the
limit of darkness. By examining the law under which this
decrease of light takes place on a spherical (or cylindrical *)
surface, we may deduce a general law, regulating the light
in impact on any curved surface whatever.

In all analysis of curved lines it is necessary first to
regard them as made up of a series of right lines, afterwards
considering these right lines as infinitely short.

* In the upper figure, the actual gradation is the same as that which
would be true for a cylinder.

[1] [See *Cestus of Aglaia*, § 86.]

22. Let therefore the line A B, Figure 31, represent any plane surface, or an infinitely small portion of any curved surface, on which the light, coming in the direction of the arrows, strikes at a given angle B A C.

Draw from B, B P perpendicular to A C, and make B P equal to A B.

Then the quantity of light, or number of rays of light, supposing each arrow to represent a ray, which the so inclined surface A B can receive, is to the quantity it

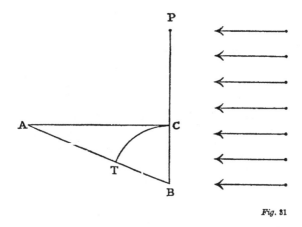

Fig. 31

could receive if it were perpendicular to the light, (at P B,) as the line B C is to the line P B, which is equal to the line A B.

Therefore if we divide the line A B, from A to B, into any number of degrees, representing the gradual diminution of light, uniformly, from any given maximum at A to any given minimum at B, and draw the circle C T with the radius B C, cutting A B in T, the point T, on the scale of shade so graded, will mark the proper tint of shade for the entire surface A B.

This general law, therefore, determines the tint of shade, in any given scale of shade, for the point of any curved surface to which the line A B is a tangent.

23. Applying this general law to the light and shade of a sphere, let the light, coming in the direction L V, Figure 32, strike the surface of the quadrant P A at the point V, to which the line x y is a tangent. B being the centre of the sphere, join B V, and from A draw A C parallel to x y, and therefore perpendicular to B V. Produce L V to M, and draw the arc of circle C T, cutting A B in T.

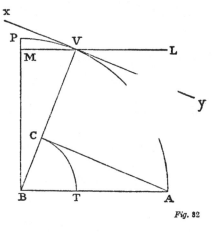

Fig. 32

Then, by the law last enunciated, if we divide the line A B uniformly into any number of degrees of shade from the maximum of light at A to its minimum at B, the point T will indicate, on that scale, the proper shade for the point of sphere-surface, V. And because B V equals B A, and the angle B V M equals the angle A B C, M V equals B T; and the degree of shade may at once be indicated for any point on the surface A P by letting fall a vertical from it on the uniformly gradated scale A B.

24. Dividing that scale into ninety degrees from A to B, we find that, on the globe, when the sun is over the equator, the Christian circle, though in 60 degrees north latitude, receives yet 45 degrees of light, or half the quantity of the equatorial light, and that, approximately,* the

* Calculated to two places of decimals by Mr. Macdonald, the Master of my Oxford schools;[1] the fractional values are 3·07, 12·06, 26·36, and 66·71, giving the regulated diminishing intervals 8·99, 14·03, 18·64, 21·71, and 23·29, or, roughly, 9, 14, 18, 21, 23.

[1] [Mr. Alexander Macdonald was appointed Master of the Ruskin Drawing School in 1871; Hon. M.A. of Oxford University and Deputy Keeper of the University Galleries, 1883; Keeper, 1890.]

losses of the strength of light in the climates of the five circles are,—

St. James's, 3 degrees loss, leaving 87 of light.
Arabian, 12 degrees loss, leaving 78 of light.
Venetian, 26 degrees loss, leaving 64 of light.
Christian, 45 degrees loss, leaving 45 of light.
Fern, 67 degrees loss, leaving 23 of light.

But it is always to be remembered that in the real passing of day into night, the transition from the final degree of shadow on the gradated curvature of the illuminated hemisphere, to night itself, is a much greater one than it is in our power to express by any scale: so that our 90 measured degrees do not carry us even into twilight, but only to the point and moment of sunset. They express, however, with approximate accuracy, the relation of the terrestrial climate so far as it depends on solar influences only, and the consequently relative power of light on vegetation and animal life, taking the single numerical expression as a mean for the balanced effect of summer and winter.*

25. Without encumbering himself, in practice, by any attempts to apply this, or any similar geometric formulæ, during the progress of his work, (in which the eye, memory, and imagination are to be his first, and final, instruments,) the student is yet to test his results severely by the absolute decrees of natural law; and however these may be prudently relaxed in compliance with the narrowness of his means, or concession to the feebleness of his powers, he is always to remember that there is indeed a right, and a wrong, attendant on the purpose and act of every touch, firm as the pillars of the earth, measured as the flight of

* The difference in effective heat between rays falling at large or small angles, cannot be introduced in this first step of analysis: still less is it necessary to embarrass the young student by any attempt to generalize the courses of the isothermal lines.

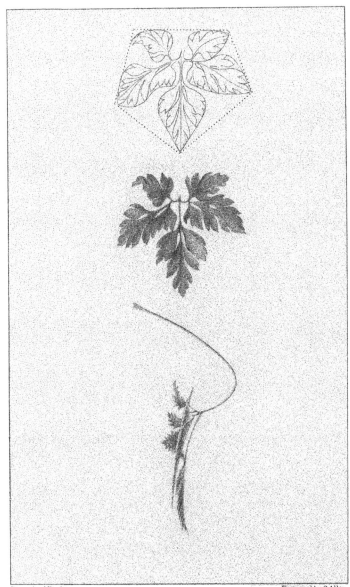

SCHOOLS OF ST GEORGE.

Elementary Drawing, Plate XI.

STUDY WITH THE LEAD AND SINGLE TINT.

LEAF OF HERB-ROBERT.

its hours, and lovely as the moral law, from which one jot or tittle shall not pass, till all be fulfilled.[1]

26. Together with these delicate exercises in neutral tint, the student cannot too early begin practice in laying frank and full touches of every zodiacal colour, within stated limits. He may advisably first provide himself with examples of the effects of opposition in colour, by drawing the square of the Fern line, measured on his twelve-inch globe, within the square of the Venetian line; then filling the interior square with any one of the zodiacal colours, and the enclosing space between it and the larger square, with the opponent colour: trying also the effect of opposition between dark tints of one colour and light tints of the other: each wash to be laid on at once, and resolutely left without retouching. The student will thus gradually gain considerable power of manipulating the pencil, with full colour; recognize more clearly day by day how much he has to gain; and arrive at many interesting conclusions as to the value and reciprocal power of opposed hues.

27. All these exercises must, however, be kept in subordination to earnest and uninterrupted practice with the pen-point or the lead; of which I give two more examples in the present number of *Fésole*, which, with those already set before the student, Plates V., VI., and VIII., will form a quite sufficient code for his guidance until I can begin the second volume.*

28. Plate XI. represents, as far as mezzotint easily can, a drawing of the plan and profile of a leaf of wild geranium, made lightly with the lead, and secured by a single washed tint above it.

Every care is to be given in study of this kind to get

* During the spring I must confine my work wholly to *Proserpina*.[2]

[1] [Matthew v. 18.]

[2] [The last "Part" of *The Laws of Fésole* (containing this chapter) was issued in March 1879. A "Part" of *Proserpina* (vi.) was issued in the following month, and four other Parts from 1882 to 1886, but no more of *The Laws of Fésole* was issued, though Ruskin made many notes for its continuation (see below, p. 495).]

the outline as right and as refined as possible. Both shade and colour are to be held entirely subordinate; yet shade is to be easily and swiftly added, in its proper place, and any peculiar local colour may be indicated, by way of memorandum, in the guarding tint, without attempting the effect of a coloured drawing. Neither is any finish or depth to be sought in the shade. It should rightly indicate the surges or troughs of the leaf, and the course and projection of large ribs, (when the plan drawing is made of the under surface,) but it must not be laboriously completed or pursued. No study of this kind should ever take more than an hour for plan and profile both: but the outline should be accurate to the utmost of the student's power, and as delicate as the lead will draw.

29. Although, in beginning, precise measurements are to be taken of the leaf's length and breadth, yet the mistakes inevitable during execution cannot be easily corrected without some variation in the size; it is far better to lose the exact measurement than the feeling of the form. Thus my profile is nearly a quarter of an inch too long for the plan because I could not get .the spring of it to my mind in its first proportion. The *plan* may generally be kept to its true scale; and at all events the measures should be marked for reference within their proper geometrical limits, as in the upper outline, of which I have more to say in another place.

30. Plate XII. gives example of an equally rapid mode of study when the object is essentially light and shade. Here the ground is a deeply toned grey paper; the outline is made with stern decision, but without care for subtlety in minor points; some gradations of shade are rapidly added with the lead,—(BB); and finally, the high lights laid on with extreme care with body-white. Theoretically, the outline, in such a study as this, should always be done first: but practically, I find it needful, with such imperfect skill as I have, to scrabble in the pencil shadows for some guide to the places of the lights; and then fasten everything down

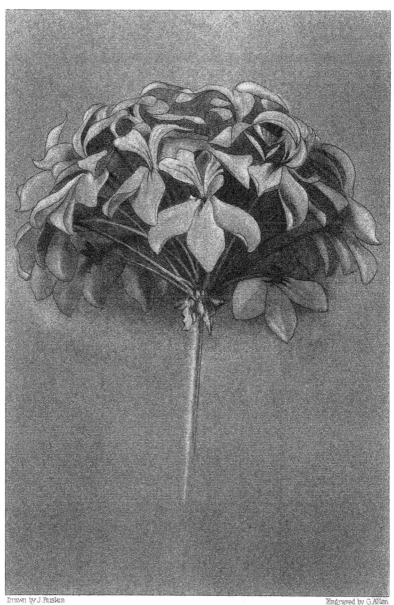

SCHOOLS OF S^T GEORGE.

Elementary Drawing, Plate XII.

LIGHT AND SHADE WITH REFUSAL OF COLOUR

PETAL-VAULT OF SCARLET GERANIUM.

firmly with the pen outline. Then I complete the shadow as far as needful; clear the lights with bread first; and then, which is the gist of the whole, lay the high lights with carefullest discipline of their relations.

Mr. Allen's very skilful mezzotint ground is more tender and united than the pencil shadow was, in this case; or usually need be: but the more soft it is the better; only let no time be lost upon it.

31. Plate VIII., given in the last number of *Fésole*, for illustration of other matters, represents also the complete methods of wholesome study with the pen and sepia, for advanced rendering both of form and chiaroscuro.

Perfect form never can be given but with colour (see above, Chapter VIII. § 22). But the foundational elements of it may be given in a very impressive and useful way by the pen, with any washed tint. In the upper study, the pen only is used; and when the forms are complete, no more should be attempted; for none but a great master can rapidly secure fine form with a tint. But with the pen, thus used, much may be reached by the student, in very early stages of his progress.

32. Observe that in work of this kind, you are not to be careful about the direction or separation of the lines; but, on the other hand, you are not to slur, scrabble, or endeavour to reach the mysterious qualities of an etching. Use an ordinary fine pen-point, *well kept down;* and let the gradations be got by the nearness or separation, singleness or crossing of the lines, but not by any faintness in them.

But if the forms be simple, and there be a variety of local colours which is important in the subject,—as, in the lower study, the paleness of the stamens of the pink in relation to its petals,—use the pen only for fine outline, as in Plate XII.; and when that is perfectly dry, complete the light and shade with as few washes as possible.

33. It is also to be noted that a dark background is admissible only, in chiaroscuro study, when you intend to refuse all expression of colour, and to consider the object

as if it were a piece of sculpture in white marble. To illustrate this point more strongly, I have chosen for the chiaroscuro plate, XII., a cluster of scarlet geranium ; in which the abstraction of the form from the colour brings out conditions of grace and balance in the blossom which the force of the natural colour disguised. On the other hand, when the rich crimson of the Clarissa flower (Plate VIII.) is to be shown in opposition to the paler green of its stamens, I leave the background pure white. The upper figure in the same plate being studied for form only, admits any darkness of background which may relieve the contour on the light side.

34. The method of study which refuses local colour, partly by the apparent dignity and science of it, and partly by the feverish brilliancy of effect induced, in engraving, by leaving all the lights white, became the preferred method of the schools of the Renaissance, headed by Leonardo : and it was both familiarized and perpetuated by the engravings of Dürer and Marc Antonio. It has been extremely mischievous in this supremacy ; but the technical mischief of it is so involved with moral faults proceeding from far other causes, that I must not here attempt its analysis. Every student ought, however, to understand, and sometimes to use, the method ; but all main work is to be with the severest respect to local colour, and with pure white background.

35. Note yet once more. Although for facility of work, when form alone is needed, the direction of the pen-stroke is to be disregarded, yet, if texture, or any organic character in the surface of the object, be manifest, the direction or manner of breaking, in the pen-touch, may pleasantly comply with such character, and suggest it. The plate of Contorta Purpurea (VII. in *Proserpina*) is thus engraved with the double intention of expressing the colour of the flower and the texture of the leaf, and may serve for enough example in this particular ; but it is always to be remembered that such expedients are only partial and

suggestive, and that they must never be allowed to waste time, or distract attention. Perfect rendering of surface can only be given by perfect painting, and in all elementary work the student should hold himself well disengaged from serfdom to a particular method. As long as he can get more truths in a given time, by letting his pen-point move one way rather than another, he should let it easily comply with the natural facts,—but let him first be quite sure he sees the facts to be complied with. It is proper to follow the striæ of an ophrys leaf with longitudinal touches, but not, as vulgar engravers, to shade a pearl with concentric circles.

36. Note, finally, that the degree of subtlety in observation and refinement of line which the student gives to these incipient drawings must be regulated in great degree by his own sense and feeling, with due relation to the natural power of his sight: and that his discretion and self-command are to be shown not more in the perseverance of bestowing labour to profit, than in the vigilance for the instant when it should cease, and obedience to the signals for its cessation. The increasing power of finish is always a sign of progress; but the most zealous student must often be content to do little; and the greatest observe the instant when he can do no more.

37. The careless and insolent manners of modern art study, (for the most part,) forbid me the dread of over-insistance on minutiæ of practice; but I have not, for such reason, added to the difficulty or delicacy of the exercises given. On the contrary, they are kept, by consistent attention, within the easy reach of healthy youthful hand and sight; and they are definitely representative of what should properly be done in *drawings*, as distinguished from the qualities attainable by the consummate line-engraver. As an example of what, in that more subtle kind, the human eye and finger can accomplish by severe industry, every town library ought to possess, and make conveniently accessible to its students, the great botanical series of the

Floræ Danicæ.[1] The drawings for the numbers produced before the year 1820 were in better taste, and the engravings more exemplary in manner, than in the supplementary numbers lately in course of publication: but the resolute and simple effort for excellence is unfailing throughout; and for precision and patience of execution, the ten plates, 2744 to 2753, may be safely taken as monumental of the honour, grace, and, in the most solemn sense, majesty, of simple human work,* maintained amidst and against all the bribes, follies, and lasciviousness of the nineteenth century.

38. Together with these, and other such worthily executed illustrations of natural history, every public institution should possess several copies of the *Trésor Artistique de la France*, now publishing in Paris.[2] It contains representations, which no mechanical art can be conceived ever likely to excel, of some of the best ornamental designs existing; with others, (I regret to observe, as yet, much the plurality,)

* With truly noble pride, neither the draughtsman nor the engraver have set their names to the plates. "We are Men," they say, "with the hearts and hands of Men. That is all you need know. Our names are nothing to you."

[1] [For note on this work, see Vol. XIII. p. 530, and see the woodcuts from it by Burgess in Vol. XIV. It was there stated (on the authority of the British Museum Catalogue) that the publication was continuing. In fact, however, the work was concluded with part No. 51, issued in 1883. The ten plates here referred to, in vol. xvi. (1871), are as follows :—

2744. Nitella Intricata ; 2745. Chara Polyacantha ; 2746. Chara Alopecuroides ; 2747. Chara Crinata ; 2748. Hypnum Sarmentosum ; 2749. Hypnum Hamulosum ; 2750. Isothecium Myosuroides; 2751. Fontinalis Dalecarlica ; 2752. Buabaumia Aphylla ; and 2753. Sphagnum Rubellum.]

[2] [The full title of this sumptuous book (100 francs) is : "Musée National du Louvre : Galerie d'Apollon. Le Trésor Artistique de la France. Publié sous la direction de M. Paul Dalloz. Paris : Imprimerie et Librairie du *Moniteur Universel*." Twelve parts were published (1880), and the work was then discontinued. The objects referred to by Ruskin, as figured in the *Trésor Artistique*, may all be seen in the Galerie d'Apollon in the Louvre. The coronation of the Queen of Henri II. (Catherine de Médicis) took place at St. Denis on June 10, 1549 ; the king and queen made their state entry into Paris on June 23, and the fêtes consisted of a tournament, in which the king took part, and a sham naval battle on the Seine. The Court then adjourned to witness the torture and execution of four offenders convicted of Lutheranism (see Sismondi's *Histoire des Français*, 1833, vol. xvii. pp. 352–354). It was from a wound accidentally received in another tournament that the king met his death ten years later. As he tilted against a Scottish knight, Montgomery, his antagonist's lance was shivered, and a piece of it, as it splintered upwards off his cuirass, tilted the king's visor from below, and pierced him in his eye. The king lingered two days and died.]

of Renaissance jewellery, by which the foulness and dulness of the most reputed masters of that epoch are illustrated with a force which has not hitherto been possible. The plates, which represent design of the greater ages, more especially those of the Boite d'Evangéliaire of St. Denis, with the brooch and cassette of St. Louis, had better be purchased by those of my students who can afford the cost; and with these, also, the uncoloured plates of the Coffret à Bijoux of Anne of Austria, which is exemplary of the best Renaissance wreathen work. The other pieces of sixteenth and seventeenth century toys, given in this publication, are àll of them leading examples of the essential character of Renaissance art,—the pride of Thieves, adorned by the industry of Fools, under the mastership of Satyrs. As accurately representative of these mixtures of bêtise with abomination, the platter and ewer executed in Germany, as an offering to the Emperor Charles V. on his victory at Tunis, are of very notable value: but a more terrific lesson may be read in the ghastly and senseless Gorgons of the armour of Henry II., if the student of history remember, in relation to them, the entertainment with which he graced his Queen's coronation; and the circumstances of his own death.

39. The relations between the rich and poor, on which the pomp of this Renaissance art was founded, may be sufficiently illustrated by two short passages, almost consecutive, in *Evelyn's Diary*:[1]—

"11 *May* (1651).—To the Palais Cardinal, where yᵉ Mʳ. of Ceremonies plac'd me to see yᵉ royal masque or opera. The first sceane represented a chariot of singers compos'd of the rarest voices that could be procur'd, representing Cornaro[2] and Temperance; this was overthrowne by Bacchus and his Revellers; the rest consisted of several

[1] [For other references to *Evelyn's Diary*, see the lecture on landscape (December 10, 1884), reported in E. T. Cook's *Studies in Ruskin* (pp. 290–291), and reprinted in a later volume of this edition.]

[2] [A note in the original adds: "The famous Venetian writer on Temperance."]

enteries and pageants of excesse, by all the Elements. A
masque representing fire was admirable; then came a Venus
out of y⁰ clouds. The conclusion was an heaven, whither
all ascended. But the glory of the masque was the greate
persons performing in it: the French King, his brother
the Duke of Anjou, with all the grandees of the Court,
the King performing to the admiration of all. The music
was 29 violins, vested à l'antiq, but the habits of the
masquers were stupendously rich and glorious.

"29 *January* [1652].—I sat out in a coach for Calais, in
an exceeding hard frost, which had continued some time.
We got that night to Beaumont; 30, to Beauvais; 31,
we found the ways very deepe wᵗʰ snow, and it was exceed-
ing cold; din'd at Pois; lay at Pernée, a miserable cottage
of miserable people in a wood, wholly unfurnished, but in a
little time we had sorry beds and some provision, wᶜʰ they
told me, they hid in yᵉ wood for feare of the frontier
enemy, the garisons neere them continually plundering what
they had. They were often infested with wolves. I cannot
remember that I ever saw more miserable creatures."

40. It is not, I believe, without the concurrence of the
noblest *Fors*,[1] that I have been compelled, in my reference
to this important French series of illustrative art, to lead
the student's attention forward into some of the higher
subjects of reflection, which for the most part I reserve
for the closing volume of the *Laws of Fésole*. Counting,
less than most men, what future days may bring or deny
to me, I am thankful to be permitted, in the beginning of
a New Year of which I once little thought to see the light,[2]
to repeat, with all the force of which my mind is yet

[1] [For the three meanings of "Fors," see *Fors Clavigera*, Letter 2.]
[2] [This part was published in March 1879. For Ruskin's illness in 1878, see
Vol. XIII. pp. liv., lv.]

39

Henry II. of the students. of history ... will remember in relation to them, the entertainment with which he granted his guide's connection the circumstances of his own death.

The depressed relation between the mild pen, on which the pump of this Roman act was that founded, never be sufficiently ... to two ... almost connection in Evelyn's claims

This can be shorten long as convenient

have occurred in the colours of the
Laws of Forms. Memory, by then the little
virtuous, what future days doing, the
doing, both or deny, I am loath
to permitted, and is in the beginning?
When green? which I owe little thought to
see the light, no to repeat, with all the force?
which my mind is yet capable, the labour I
endeavoured to teach through out my friendship
that the tree I dreamed of Human Art can
as flourish when it does in Affection, its
the Rock of its roots, and its sunshine,

Such Vol. 1

capable, the lesson I have endeavoured to teach through my past life that this fair Tree Igdrasil[1] of Human Art can only flourish when its dew is Affection; its air, Devotion; the rock of its roots, Patience; and its sunshine, God.

[1] [For the old Norse representation of Life by the Tree Igdrasil, see Carlyle's *Heroes*, Lectures i. and iii. The name "Igdrasil" was adopted, from the present passage, as the title of the organ of "The Ruskin Reading Guild" (1890).]

APPENDIX

DRAWING LESSONS BY LETTER

[THE following letters from Ruskin, not hitherto published, are given here as showing the kind of correspondence which led him to write and print *The Elements of Drawing* (see above, p. xvi.). The letters (except the second) are undated; the address and dates are here added from the postmarks on the envelopes. They have been communicated by Mrs. Brassington, of Leamington.]

[DENMARK HILL, *Aug.* 30, 1855.]

MY DEAR MADAM,—You are just in the position in which many earnest young people are, and in which it is at present singularly difficult to help them—for there is in reality no wholesome elementary book on drawing. It seems very egotistic, but it is the truth, and I cannot help saying it—that I think if you will wait for four months more, my third volume of *Modern Painters*, which will *D.V.* be out about Christmas, will tell you better what you want to know than anything else you could get; and soon I hope to be able to organize some system of school teaching and print a little account of it which may help you still more. But meantime—this much may so far help you—Drawing is the easiest of all accomplishments. But it cannot be learned in six weeks. To learn the piano, a girl gives, and must give, four hours a day for four years. And one hour a day, for one year, well applied, will teach her to draw well; not less. All good drawing consists merely in dirtying the paper delicately. All touch and dexterous trick is barbarism. In a fine drawing by Leonardo da Vinci you cannot *see* the finest touches —you only *feel* that something is there by the effect. Nearly the beginning and end of everything is gradation.

All form is expressed by subtility of this.

If for the four months of this autumn you will spend your time merely in trying to get the form of shading delicately—fumbling at it as best you can, and utterly despising all that will be said to you about boldness, dash, effect, etc., etc.—you will be making progress. If you would like I will send you a copy or two done by my workmen pupils; but I can't write letters nor give advice much at present, being *very* busy.

Truly yours,
J. RUSKIN.

I am not quite sure if the address is right, so have not yet sent off the parcel. Please say if you get this.

18th Sept. [1855].

My DEAR MADAM,—I am sorry to have been so long in answering your letter, but I could not find a drawing which I thought quite fit to send you, nor have I found one now—it being vacation time, and I am hardly ever at the College when the men draw—but I send you a bit of stem of tree, which copy with pencil, and wash a little prussian blue over to fix it. Try to get the *roundness*. Then take a real stem, any—the first that comes to hand—not too knotty, and try to draw it in the same way.

Also, try to copy with pencil as perfectly as you can the shading of the bud, and wash a little colour over it when it is done—buds don't depend on the colour. Try to get delicacy and character with the pencil.

Don't be disgusted if you cannot please yourself nor anybody else. If you can once draw *delicately* with the pencil, you can do anything.

Truly yours,

J. RUSKIN.

[*Sept.* 23, 1855.]

My DEAR MADAM,—I intended to have sent a line with the photograph and chalk drawing the other day—merely to say that the photograph is nature a good deal simplified—nature made easy. If with sepia you can manage to imitate the least bit of it, even this size only, you will have made immense progress. If any drawing-master tries to persuade you to *dash*—challenge him to do a bit of photograph. If he can do it, it will be a great help to you to see *how* he does it; but in most cases he will not be able to do it, and will say it oughtn't to be done.

Truly yours,

J. RUSKIN.

A REVIEW OF "THE ELEMENTS OF DRAWING": RUSKIN AND WILLIAM BELL SCOTT

TO THE EDITOR OF THE *PALL MALL GAZETTE* [1]

SIR,—The excellent letters and notes which have recently appeared in your columns on the subject of reviewing lead me to think that you will give me space for the statement of one or two things which I believe it is right the public should know respecting the review which appeared in the *Examiner* of the 2nd of this month (but which I did not see till yesterday), by Mr. W. B. Scott, of Mr. St. J. Tyrwhitt's *Letters on Landscape Art*.

1. Mr. Scott is one of a rather numerous class of artists of whose works I have never taken any public notice, and who attribute my silence to my inherent stupidity of disposition.

2. Mr. Scott is also one of the more limited and peculiarly unfortunate class of artists who suppose themselves to have great native genius, dislike being told to learn perspective, and prefer the first volume of *Modern Painters*, which praises many third-rate painters, and teaches none, to the following volumes, which praise none but good painters, and sometimes admit the weakness of advising bad ones.

3. My first acquaintance with Mr. Scott was at the house of a gentleman whose interior walls he was decorating with historic frescoes, and whose patronage I (rightly or wrongly) imagined at that time to be of importance to him. I was then more good-natured and less conscientious than I am now, and my host and hostess attached weight to my opinions. I said all the good I truly could of the frescoes, and no harm; painted a corn-cockle on the walls myself, in reverent subordination to them; got out of the house as soon afterwards as I could, and never since sought Mr. Scott's acquaintance further (though, to my regret, he was once photographed in the same

[1] [This letter first appeared in the *Pall Mall Gazette* of January 11, 1875, under the heading "Reviewing"; it was reprinted in *Arrows of the Chace*, 1880, vol. ii. pp. 238-240. The "letters and notes" refer especially to one signed "K" in the *Pall Mall Gazette* of January 1, and another signed "A Young Author" in the issue of January 4; the principal complaint of both writers was that reviewers seldom master, and sometimes do not even read, the books they criticise.]

plate with Mr. Rossetti and me).[1] Mr. Scott is an honest man, and naturally thinks me a hypocrite and turncoat as well as a fool.

4. The honestest man in writing a review is apt sometimes to give obscure statements of facts which ought to have been clearly stated to make the review entirely fair. Permit me to state in very few words those which I think the review in question does not clearly represent. My *Elements of Drawing* were out of print, and sometimes asked for; I wished to rewrite them, but had not time, and knew that my friend and pupil, Mr. Tyrwhitt, was better acquainted than I myself with some processes of water-colour sketching, and was perfectly acquainted with and heartily acceptant of the principles which I have taught to be essential in all art. I knew he could write, and I therefore asked him to write, a book of his own to take the place of the *Elements*, and authorized him to make arrangements with my former publisher for my wood-blocks, mostly drawn on the wood by myself.

The book is his own, not mine, else it would have been published as mine, not his. I have not read it all, and do not answer for it all. But when I wrote the *Elements* I believed conscientiously that book of mine to be the best then attainable by the public on the subject of elementary drawing. I think Mr. Tyrwhitt's a better book, know it to be a more interesting one, and believe it to be, in like manner, the best now attainable by the British public on elementary practice of art.

I am, Sir, your faithful servant,

JOHN RUSKIN.[2]

BRANTWOOD, *Jan.* 10.

[1] [This was a photograph taken in Rossetti's garden at Chelsea by Messrs. W. and D. Downey.]

[2] [The personal allusions in Ruskin's letter require explanation, and the controversy is of some interest in connexion with matters touched upon in the Introduction (above, pp. xx., xxvi.). Scott's signed review of Mr. Tyrwhitt's book (for particulars of which see above, p. 6), was severe, but not unamusing; the author's facetiousness fairly exposing him to similar treatment. But Scott also made the review a vehicle for an attack on Ruskin. He complained of Mr. Tyrwhitt's frequent reference to Turner; referred to the system of the Department of Science and Art "so impertinently scouted"; and then continued: "Of Mr. Ruskin himself we speak only with respect, because from the appearance of the first volume of the *Modern Painters*, for a number of years his influence was immensely beneficial, and his works admirable in some qualities, especially those works relating to architecture. But he took to teaching without being a practical artist, with a disastrous result." Scott then criticised Ruskin's system, objecting that it did not include study from the antique, and saying that it "has never made one good draftsman, and never will." The *Examiner* of January 16 contained a *jeu d'esprit*, in the shape of an imaginary letter from "John Fusskin," parodying Ruskin's letter to the *Pall Mall*. In the issue of January 23 it printed a long letter from Scott, including a reply by him to Ruskin's letter which had been sent to the *Pall Mall*, but not published by that journal. In the rejected letter Scott had written :—

"Mr. Ruskin's letter is entirely irrelevant to the question involved in my treatment of Mr. Tyrwhitt's book, and will not assist to save the system of niggling with fine pens and points in month-long imitations of the shine on single ivy-leaves, or of miniature woodcuts of whirligigs of brushwood, as an education in drawing. The system must be stamped out of existence, and it appears I am to take the ostensible responsibility. I say ostensible, because both gentlemen, no doubt, know that except among young ladies—ladies waste time with less compunction than men—it is already discredited ; that the pupils at the Working Men's College are now drawing from casts of the human figure ; and that those of the Women's College in Queen Square are

just beginning to do the same. What Mr. Ruskin may not know is that many of the elder pupils of the first-named institution, pupils of ten to fifteen years' practice, now acknowledge sadly that they can't draw. Some among them following decorative art complain that their employers place over their heads properly educated draughtsmen, German, Frenchmen, or Department of Science and Art men, educated on the artistic and universal system.

"Mr. Ruskin, however, whose memory is as good as even to embellish his history, must remember. during his 'first acquaintance' with me alluded to in the letter, how he petadded certain etchings of leaves done with a lithographic pen, assuring the listening ladies that the young man had thereby acquired a greater acquaintance with 'nature,' and greater power in expressing it, 'than the best artists then exhibiting possessed.' And he must know that the young man in question became, and still continues, a photographer's assistant, the only occupation Mr. Ruskin's educational course can aid. I believe that the anger shown in his letter arises from the secret consciousness that he has been the means of leading many astray.

". . . I do not know one volume from another of the *Modern Painters*, except that I remember the second was recommended by its thinness."

In his covering letter to the *Examiner*, Scott remarked: "The good man lost his chance of injuring me, and is now sorry for it! Will it be believed that *all* the pictures I had then and there to do were finished and placed at the time of his visit! . . . He knew then, and knows still, that not only true perspective, but also projection and construction were taught under my supervision."

In the *Examiner* of February 13 Scott returned to the charge, describing a recent visit to the Working Men's College; on which occasion he found that Ruskin's system was no longer in force, and that the pupils were drawing in the usual manner from the antique.

Ruskin did not reply to any of these later attacks; but Scott in his *Autobiographical Notes*, published posthumously in 1892, returned to the charge, giving also particulars of the encounter with Ruskin (referred to in Ruskin's letter) as well as a letter from him.

Scott was a protégé of Pauline, Lady Trevelyan, and when it was decided to decorate the interior court of Wallington House with paintings, she commissioned him to prepare a scheme. The panels were to be filled with historical pictures by Scott, the pilasters between being decorated with plants painted on the stone. Lady Trevelyan asked Scott to submit the scheme to Ruskin, who replied direct to her. Lady Trevelyan then wrote on the subject to Scott (May 1856): "The enclosed came yesterday. Mr. Ruskin was at Amiens when he wrote, on his way to Geneva. He was quite knocked up, and is obliged to be absolutely idle for some time. He says in his letter to me that even if he were well he does not think he could help us. He likes the plan very much." "The enclosed" was the following letter from Ruskin:—

"DEAR MR. SCOTT,—I am quite *vowed* to idleness for a couple of months at least, and cannot think over the plan you send. I am as much in a fix as you are about interior decoration, but incline to the *All Nature* in the present case, if but for an experiment. The worst of Nature is that when she is chipped or dirty she looks so very uncomfortable, which Arabesque don't. Mind you must make her uncommonly *stiff*. I shall most likely come down and have a look when I come back in October.

"So get on, that I may have plenty to find fault with, for that, I believe, is all I can do. Help you I can't.—But am always, truly yours,
"J. RUSKIN."

The spandrels were to have been decorated with arabesques. Ultimately Scott substituted scenes from the ballad of *Chevy Chase*.

In the autumn Ruskin invited Scott to dine at Denmark Hill, understanding that he "wished to gain some information about the teaching pursued at the Working Men's College." Scott regarded as an impertinence the suggestion that an official of the Department could learn anything from Ruskin's methods of teaching, but went to dinner and to the College. "I found drawing from copies as preliminary practice, drawing from beautiful ornamental objects or human figures—everything indeed to be seen in academic or Government schools of art practice—ignored. . . . Every one was

trying to put on small pieces of paper imitations by pen and ink of pieces of rough stick crusted with dry lichens." Scott came away feeling that such departure from academic or Government practice was "in a high degree criminal."

In 1861, after the last of Scott's eight historical pictures had been placed, Ruskin went down to Wallington. Scott's account of the encounter is both racy and naïve : " Lady Trevelyan had kept for him the great white lily, commonly called the Annunciation Lily, but the modesty of the professor would not allow him to take that sacred flower. No ; he would take the humblest—the nettle ! Ultimately wheat, barley, and other corn, with the cockle and other wild things of the harvest-field, were selected, and he began, surrounded by admiring ladies. . . . At dinner we heard a good deal about the proficiency of the pupils at the Working Men's College, and next morning he appeared with his hands full of pen-and-ink minute etchings of single ivy leaves the size of nature, one of which he entrusted to each lady as if they had been the most precious things in the world. He took no notice of me, the representative of the Government schools. I could stand by no longer" (*Autobiographical Notes of the Life of William Bell Scott*, vol. ii. pp. 6–12).]

PASSAGES FROM THE MS. OF THE IN TENDED CONTINUATION OF "THE LAWS OF FÉSOLE"

[RUSKIN intended to complete the *Laws of Fésole* by a second volume, "treating mostly of colour" (above, p. 346). This second volume was never published or put into shape, but among the author's MSS., collected with other matter in a bound volume now at Brantwood, are many sheets intended for it. Some contain the beginnings of chapters; others, notes, memoranda, and diagrams of intended exercises. Among this material are several sheets of diagrams, etc., showing that Ruskin at one time intended to carry further the examination "Of Elementary Organic Structure" (ch. vi.), and to enter upon an elaborate discussion of the mathematical laws of proportion, and of spirals in art. This material, however, is very fragmentary and incomplete. On other sheets, dealing with colour, there are a few passages which are intelligible in themselves, and of sufficient interest to be worth printing.]

1. STANDARDS OF COLOUR

Thus far I have been speaking only of hues of colour, absolute; I have next to state the laws regarding their texture and quality.

There are essentially three kinds of colours in natural objects: first, those of transparent substances, as of red wine; secondly, those of entirely opaque substances, with lustreless surface, as the colour of the bloom on a plum; and lastly, the colour of opaque substances burnished, polished, or wet, as of fine agates, marbles, and burnished metals.

Between these various modes of colour, where used by Nature, the mind and eye of man make no distinction involving relative excellence or inferiority. Each kind is equally valued in its time and place; all of us like to see the green sea curling into crests of crystal wave; all of us like to see the downy amber of the apricot and the bedewed darkness of the grape; and all of us rejoice in the gleam of inwoven gold through the peacock's plume and the lambent bronze and purple of the pheasant's breast. But in the application of these various orders

of hue to painting, the habits and prejudices of different schools interfere with our natural likings, and we are perpetually narrowing our enjoyments by pertinacity in favourite principles, and priding ourselves on consistency of method, instead of largeness of aim. These prejudices are in every case the consequences of provincial and imperfect education; and it is necessary for the establishment of any perfect school of art that the student should be able either within its walls or in the city to which it belongs, to see standard examples of these three modes of colour, namely, a perfect piece of glass painting, a perfect piece of missal painting, and a perfect piece of oil painting.

The first of these it will at present be difficult to obtain; even in our great central Kensington school itself I do not remember a piece of twelfth-century glass. The other two may be had, of course, as soon as our English gentlemen really wish to teach and raise the English people.

In the meantime, since journeying has become so cheap, it can scarcely be thought of as beyond the power of the poorest student to see the best painted glass in the world, that of the twelfth and thirteenth century, in the French cathedrals within two hours' railway journey from Paris: (the rose in the north transept of Notre Dame of Paris itself being standard enough, with the apse of the Sainte Chapelle, if nothing else can be seen). These, with the windows of Chartres, Amiens, and Rouen determine the laws of work in transparent colour.[1] Nothing better can possibly be ever done by human art; the slightest attempt to improve or refine the system of that French glass involving the introduction of artistic drawing, with its concomitant light and shade, which, as transparent substance, is a barbarism. Secondly, in my own schools at Oxford I had placed entirely standard examples of missal painting, unbinding my best manuscripts that I might give characteristic leaves of them,* and have no doubt that with such help as I may receive, when the need is known, from other gentlemen, every drawing school permanently established in the British islands may be furnished with good examples of this kind of art; while, lastly, in every public library there should be at least one good oil picture, in good light, by which any reader or student unable to travel may be enabled to know what oil painting means. Nor does it seem to me too exorbitant a hope, that when once art is understood to be a means of education, the municipalities of our country towns may concern themselves not only with the outside appearance but the interior usefulness of their public buildings, and may resolve

* There are literally thousands of manuscripts in the libraries of England, of no importance whatever as codices, but merely well written copies of the Psalter, Vulgate, or Hours of Virgin, of which a few leaves, dispersed among the parish schools, would do more to educate the children of the poor than all the catechisms that ever tortured them.[2]

[1] [Compare the "Letters on Painted Glass" in Vol. XII. pp. 435–447, and the references to other passages given in the same volume, p. lxv. n.]

[2] [Among the illuminated books which Ruskin thus cut up was his famous Psalter of St. Louis; see on this subject, Vol. XII. p. lxx.]

to possess themselves not of a gallery but a group of pictures which may accurately and honourably represent the good painting of the four great schools of Europe—Italian, Flemish, Spanish, and English.*

Supposing such examples accessible, in his earliest application of intelligence to the arts, the student should be taught the separate and incompatible excellences of the three modes of colour. Only in the perfect enjoyment of all, on their own terms, can he perfectly value any.

[MS. ends abruptly here.]

2. GRADATION IN COLOUR

Now the system of gradation of which we have thus determined the elements will be constant, whatever colour we use in the mass we have to divide. I have printed these diagrams in black; but had I printed them in blue, or rose colour, or primrose colour, all their gradations would have been equally complete. And the paler the colour in which it takes place, the more exquisite is the pleasure of the gradation to an educated eye.

It follows that any complexity of form may be represented with mathematical precision in the palest colour, if it is managed by a master's hand. And the really strong masters all take delight in the perfect expression of form by the palest tints; but to the uneducated eye these gradations of the higher orders over large space and delicate colour are simply invisible, and they imagine the work to be flat.

Thus Messrs. Crowe and Cavalcaselle[1] say of Carpaccio,[2] who is the

* The French, properly speaking, have no school except of decorative art. In painted glass and illuminations they were once unrivalled; but they lost all power of progress in the fourteenth century, and have never produced a single great painter. Watteau, their best, is still a mere room decorator; their heroic attempts (David, La Roche, etc.) are merely clever stage scenery, not paintings; their religious work (Le Sueur) pure abortion and nuisance; their modern genre (Gérome, Meissonier) first-rate in minor qualities, but for the most part extremely minor ones, and in the power of the rest, blameable more than notable.[3]

Under the Flemish school I include Holbein, who, in his quietness, belongs much more to the Fleming than the German. Reynolds alone, for England, and Velasquez alone, for Spain, are "schools" enough.

[1] [A History of Painting in North Italy, by J. A. Crowe and G. B. Cavalcaselle, 2 vols., 1871. See vol. i. pp. 202, 208 for the criticisms on Carpaccio's colouring, and complaints that "there is no subtle agency at work to blend tints together."]

[2] [For Carpaccio, see Vol. IV. p. 356 n.]

[3] [For Ruskin on the French School generally, see Vol. XIV. p. 141. For David, see Vol. I. p. 278; Vol. XII. p. 202. For Delaroche, Vol. V. p. 124 n., and Vol. XIV. p. 488. For Le Sueur, Vol. XII. p. 454 (a more favourable notice than here). For Gérome, a letter to Ernest Chesneau of February 13, 1867 (privately issued in Letters

greatest master of gradation * in the world, that his masses of colour are flat.

On the contrary, any vulgar and weak artist can produce gradations over short spaces, and from white to black, which the public at once see and applaud, and these black gradations are thus the infallible sign of a declining school.

3. THE TYPE OF PURE PURPLE[1]

Pure purple in the West is absolutely and faultlessly represented by the flower "purple with Love's wound"—Love-in-Idleness.[2] It grows wild on the Alps (luxuriantly on the Wengern) as large as any cultivated pansy; but I have one just now in my own garden, all *but* wild, which I think even exceeds the Alpine pansy for perfectness of unbroken purple, and certainly exceeds it in the exquisite transition of hue to its golden centre.

This golden centre is laid entirely on the root of lower petal, in an effulgence of starry rays of pure and intense crocus colour; over which the purple is first laid in spots microscopically minute, before it closes round the terminating rays. But at each side of this semi-star, the purple becomes pure radiant blue, connecting thus the lower petal with the roots of the two lateral ones. These have at their extreme base, above and below, pure blue also;—then on their *lower* sides, one minute gleam of the crocus-colour of the lower petal; and above that their own proper fringe; of one of the divinely ineffable colours which can be seen only in their floral life; even the living hand of the greatest painter cannot make these immortal.

' The way the pansy gets it is by touching a subdued primrose colour with infinitely minute spots of purple, laid on the under side of each thread of the fringe as the crimson is laid on a young daisy, and this primrose light, broken with blue, just as if on that fairy scale, wood

* Of gradation *pure*, that is to say, without addition of mystery. Of gradation mingled with ambiguity of shade, Correggio, Turner, and Titian are the standard masters. Leonardo is only an exquisite executant of the vulgar gradation from white to black. Luini could do whatever he liked either with shade or colour, but is satisfied in the subordination of both to expression.

to *Chesneau*, 1894, and reprinted in a later volume of this edition); *Cestus of Aglaia*, § 58; *Fors Clavigera*, Letter 35; *Ariadne Florentina*, §§ 121 *n.*, 240; *Lectures on Landscape*, § 43; and *The Three Colours of Pre-Raphaelitism*, § 22. For Meissonier, see Vol. XIV. p. 179 *n.*]

[1] [This passage is headed "Viola," and was first intended for the chapter so entitled in *Proserpina*. But it was held over, and Ruskin wrote at the head of the sheet, "Must be used in Fésole."]

[2] [" Yet mark'd I where the bolt of Cupid fell :
It fell upon a little western flower,
Before milk-white, now purple with love's wound,
And maidens call it love-in-idleness."
 —*Midsummer Night's Dream*, ii. 1. 168.]

hyacinths were sparingly scattered among real primroses (as they have been actually on the edges of the hyacinth clusters in my higher wood for the last fortnight)—this subdued primrose light, partly candied into hoar-frost, passes up into the blue of the higher edge of the petal with a perfect gradation—executed within the tenth of an inch.

In order to find out how this is done, I am obliged to take, not a microscope, with its plague of screw and stand and glare of reflector into my eyes, but the lowest in power of the three lenses of my microscope (the quite common one given me when I was a boy), and with this simply held between finger and thumb, I see all that I want; to wit, that the fringe is composed of tiny transparent glass bottles,—of an extremely delicate type of form, something between like what one could fancy a fine Greek workman would have made a soda-water bottle if he had one to make, and then, at the edge of the fringe, first let the purple be seen through each of them in the middle;—and they themselves are made of bluer and bluer glass, till, at the moment they efface themselves into the blue root of petal, they are blue altogether!

4. HARMONY IN PAINTING

The first and simplest meaning of a picture's being in harmony is that all its colours and lines are subject to some given modification in a rightly proportioned degree; as, for instance, that if twilight is to be represented, the brightness of colours should be subdued or their depth enhanced in a visibly proportionate degree—and not one colour checked while another remains vivid; or if sunlight is to be represented, that its warmth should raise the warm colours of the scene, and modify the cold colours of it, in a proportionate measure; or that if distance is to be represented, the forms of objects should all be affected with a proportionate degree of indistinctness, and so on.*

The word harmony, employed in this sense, signifies only the concurrence of many things in one purpose, or their subjection to the

* Yet this may take place with respect to colours which are in themselves so poor or so equal that the mind will not recognise anything in them worth calling harmonious ; and I believe a picture is never felt to be so by a fine eye, unless all the colours in it are composed of several blended colours, while some given hue of colour is distinctly dominant over all, or, at least, has influence through all. But observe that in order to reach this sense of harmony, the colours must not only each be composed of several others, but so composed that they shall look as if it were possible to separate them again. For indeed all so-called tertiary colours are composed of three ; but when they are mixed by bad painters, they look only like one, and that a very crude one. I believe that one of the secrets in this matter is that, in tertiary colours used by fine painters, the one of the primitives which is in least quantity is used with the necessary quantity of the other two which will make it a neutral grey, and then the remaining excesses of the other two are used pure. Thus supposing the tertiary be composed of red 10, blue 15, and yellow 20, and supposing that 10 red is neutralised by 7 blue and 4 yellow, then a fine painter would produce his required tertiary with a grey composed of red 10, blue 7, and yellow 4 ; and a green composed of blue 8 and yellow 16.

same influence: it does not mean anything in the least correspondent to what a musician intends by harmony. Thus a crowd of persons going towards the same place move harmoniously, or when pleased at the same moment shout or throw up their caps harmoniously, but there is nothing in such simultaneous action like the concord of a choir.

Put therefore, for a little while, this musical sense of the word "harmony" out of your head; and understand by it, in the first place, rather what a musician would call unison: the assemblage of many voices or instruments to produce a single note in an equally low or equally loud degree. In order to understand the meaning and use of this kind of unison in painting, take an H.H. pencil, and draw a pretty face with it as well as you can. Then take a pen, and put the pupil of one eye in with ink, and the corner of one side of the mouth, and you will find the effect very disagreeable. But ink all the pencil lines, and though the face may look coarser, it will not be offensive, for it will still be drawn in harmony. If it were drawn by a great master, it would still, in ink, give you an idea of as delicate a face as it did in pencil, though the lines might be twice as thick and ten times as dark, because it would have lost the fineness of all its lines in so perfectly harmonious degree that it would still suggest to you all it had lost.

No virtue of draughtsmanship is more conducive to the pleasure of the spectator than this of unison, and especially because it is one of the chief means of deceptive realisation. You may finish a picture or drawing with extreme care and perfection of imitation in separate pieces of colour and form: but if there is not also perfect concurrence and subordination of the parts, the picture will not deceive you into the idea of reality: while a very few lines or colours laid harmoniously, will make you think yourself at the place. I had for some time in my rooms at Oxford[1] a little water-colour drawing which I had bought at a modern exhibition, for the sake of its great truth in representing colour in shadow against afternoon sunlight. This was done wonderfully in each case for a large number of separate objects; but it was not done harmoniously over the whole picture. I had by chance placed beside it a light pencil sketch of a sunset on the tower of Cecilia Metella by Richard Wilson, in which there was no effort at complete effect on any one object; but everything was absolutely harmonious in the degree of its incompletion. I never looked at the Wilson without feeling myself warm, and in Rome; but when I looked at the other drawing, I only felt myself in the water-colour exhibition, and was obliged at last to put it away.

There is another character in lines for which we have no other word than harmony, namely, their concurrence in direction, or at least in tendency to some given point. Lines in true perspective are thus harmonious, because they all lead to some given point; but the harmony is much finer when, without absolutely leading to the same point or arising from it, they yet show evidence of some united tendency or common origin. Thus the branches of a palm tree are

[1] [*i.e.*, at Corpus, as Professor.]

harmonious in their expression of common origin; but those of an oak, discordant. The palm tree therefore becomes an element of beautiful ornamentation, and the so-called Greek honeysuckle ornament [1] is merely an abstraction of such a harmony; but the abstract form of an oak tree could never be used as an ornament because it is inharmonious.[2]

[1] [Compare *Laws of Fésole*, ch. vi. § 33; above, p. 412.]

[2] [The MS. then continues:—

"In considering what is called harmony in colour, we are at once liable to great inaccuracies of thought owing to the imperfection of language or the carelessness with which it is used. Arrangements of colour in which—as, for instance, in the windows of Chartres Cathedral—blue and yellow and red and purple and scarlet and green and white all melt together into a field of gold, like a great meadow of flowers in sunset, are properly in colour what a musician would call harmony in sound; but a" (here the MS. breaks off).]

END OF VOLUME XV

Printed by BALLANTYNE, HANSON & Co.
Edinburgh & London

Made in the USA
Monee, IL
20 October 2020

45632697R00315